Stealing the Mystic Lamb

Stealing
the
Mystic Lamb

*The True Story of the World's
Most Coveted Masterpiece*

NOAH CHARNEY

PUBLICAFFAIRS
New York

PublicAffairs books are available at special discounts for bulk purchases in the
U.S. by corporations, institutions, and other organizations. For more
information, please contact the Special Markets Department at the Perseus
Books Group, 2300 Chestnut Street, Suite 200, Philadelphia, PA 19103, call
(800) 810-4145, ext. 5000, or e-mail special.markets@perseusbooks.com.

Designed by Timm Bryson
Text set in Adobe Jenson Pro by the Perseus Books Group

Library of Congress Cataloging-in-Publication Data
Charney, Noah.
 Stealing the Mystic Lamb : the true story of the world's most coveted
masterpiece / Noah Charney. — 1st ed.
 p. cm.
 Includes bibliographical references and index.
 ISBN 978-1-58648-800-0 (alk. paper)
 1. Eyck, Jan van, 1390-1440. Ghent altarpiece. 2. Art thefts—Belgium—
Ghent. I. Title. II. Title: True story of the world's most coveted masterpiece.
 ND673.E87A63 2010
 759.9493—dc22

 2010019795

First Edition

10 9 8 7 6 5 4 3 2 1

TO URŠKA,
the love of my life,

and to

HUBERT VAN EYCK,
who taught me the joys of gnawing on one's own foot

CONTENTS

PROLOGUE
The Wolves and the Lamb

They found him in a whitewashed cottage nestled in a dark German forest. Hermann Bunjes was an art expert who had been an SS officer until he deserted the Nazi army. Gaunt and pale, Bunjes was hiding from three antagonists: the Allies, the Nazi army, and the German people, who feared and hated the SS to such an extent that his greatest worry was falling victim to their vigilante justice.

Captain Posey and Private Kirstein surveyed the small refuge where Bunjes lived with his young wife and baby. Though the front line raged mere kilometers away, the cottage was a tranquil contrast to the chaotic final months of the Second World War. It was full of flowers and art history books. Photographs were pinned to the walls—black-and-white prints of French Gothic art and architecture: Notre Dame de Paris, Cluny, La Sainte Chapelle, Chartres.

Posey and Kirstein, American officers of the Monuments and Fine Arts Division, a group of art historians, architects, and archaeologists charged with protecting art and monuments in conflict zones, were war-zone art detectives. They were assigned to General George Patton's Allied Third Army, gathering clues as to the whereabouts of stolen art. Since the start of the war, they had heard rumors of the wholesale looting of artwork from Nazi-occupied territories. It was clear that thousands of works of art had been seized by Nazi troops, but they did not know whether there was an overall plan or destination for the loot.

They had been given a list of major artworks that had disappeared since the start of the war. The list included the masterpieces from museums such as the Louvre and the Uffizi: Davids from France, Botticellis

from Italy, and Vermeers from the Netherlands. These works were symbols of state, of empire, of patrimony. Their value was incalculable, their destruction irrevocable. At the head of that list was *The Ghent Altarpiece* by Jan van Eyck.

Also referred to by the subject of its central panel, "The Adoration of the Mystic Lamb," *The Ghent Altarpiece* was perhaps the most important painting in the history of art. It was certainly the most frequently stolen and, it could be argued, the most desired. It had proved particularly elusive. Posey and Kirstein had been seeking it since rumor of its theft reached them in Paris, more than a year before. Through their research, they had learned of the many crimes involving van Eyck's masterwork. It had been the victim of every conceivable transgression that could imperil a work of art. Over the course of five centuries it had been involved in thirteen crimes, both attempted and successful, and had rarely remained intact in its place of origin for more than a few years at a time.

Its history of disappearances was all the more amazing considering that the Renaissance altarpiece consisted of twelve painted oaken panels that combined to weigh around two tons. An enormous triptych the size of a barn wall (14.5 by 11.5 feet), it had been painted for a church in the city of Ghent by the young Flemish master Jan van Eyck between 1426 and 1432. It was the first major oil painting in history, and it inspired centuries of artists to take up oil as their preferred artistic medium. It was also considered the fulcrum between the art of the Middle Ages and the Renaissance, and the origin of artistic realism.

The Ghent Altarpiece was the coveted trophy of both Hitler and Reichsmarschall Hermann Göring. Both men sought to outmaneuver one another to capture it for their personal collections. Its fame and beauty aside, they saw the work as a symbol of Aryan supremacy and idolized the artist who created it as an exemplary figure in Teutonic history. They were undoubtedly aware of its recent past. Panels owned, questionably, by the king of Prussia and on display in Berlin before the First World War had been returned to Ghent under the terms of the Treaty of Versailles, a source of outrage to the German people. If Hitler could recapture the altarpiece, then he would right a perceived wrong against Germany.

Rumor had it that Hitler was also convinced that the painting contained a coded map to lost Catholic treasures, the so-called *Arma Christi*, or instruments of Christ's Passion, including the Crown of Thorns and the Spear of Destiny. Hitler believed that the possession of the *Arma Christi* would grant their owner supernatural powers. Hitler and other Nazi officials were fascinated by the occult and assembled a research group, the Ahnenerbe, to study and seek out supernatural phenomena and magical objects. Hitler financed expeditions into Tibet to capture a yeti (the so-called abominable snowman) for military use; to Iceland to look for the entrance to Thule, a mythical land of giants and telepathic faeries, which was the real place of origin of the Aryans, according to Hitler's belief; and in search of religious relics whose magical properties could ensure Nazi triumph, including the Holy Grail and the Ark of the Covenant. As the prospect of a Nazi victory looked more precarious, Hitler escalated his efforts to find supernatural means to turn the tide.

But Göring outmaneuvered Hitler's agents and reached *The Ghent Altarpiece* first. Against the führer's direct orders, one of Göring's henchmen had stolen van Eyck's masterpiece from a castle in the south of France, at the foot of the Pyrenees, and brought it to Paris. Then it disappeared. The whereabouts of *The Ghent Altarpiece* were unknown to both Allies and most Nazi officials. Posey and Kirstein had gathered frustratingly contradictory tidbits of information on its location—until now.

A Harvard-educated scholar of thirteenth-century French sculpture, Hermann Bunjes had worked as an art advisor to Alfred Rosenberg, chief of the ERR (Einsatzstab Rosenberg), the Nazi art-looting division—the existence of which, at this point, was still unknown to the Allied army. He had also been a personal art consultant to Göring, who had used the disorder of war to steal thousands of works for his private collection. Bunjes had deserted the Nazi cause in disgust. The tipping point had been a dinner at the elite Aeroclub in Berlin, when Bunjes realized that his meal was being served on silver stolen from the Jewish baron Edmond de Rothschild.

Bunjes had records of what art had been stolen by the Nazis and where it was hidden. Drinking cognac in his cottage, he shared all he knew about

the Nazi art-looting program and Adolf Hitler's master plan to steal the world's art treasures. For the first time, the Monuments Men had a sense of what they were up against—and of the fate of tens of thousands of the world's most important and beautiful works of art.

Bunjes began to tell Posey and Kirstein about the citywide supermuseum Hitler was planning in his boyhood town of Linz, Austria, which was meant to house every masterpiece in the world. Aside from a place to view and study art, this museum would function as a gallery of defeated nations, their treasures stripped from them as countries fell before Hitler's storm troopers. In lieu of the severed, pike-pierced heads of deposed and decapitated rulers, Hitler would fill his supermuseum with the artistic masterpieces that Europe had been unable to defend.

Bunjes seemed to think that the Allies already knew of Hitler's dream to create this supermuseum. He thought that Posey and Kirstein were aware of the lists of masterpieces sought by the führer, by Göring, and by the ERR. Posey and Kirstein tried to disguise their surprise as the revelations kept flowing.

Finally, Bunjes revealed the secret hiding places of the stolen Nazi art. On a map of Europe, he indicated scores of secret Nazi art depots in castles, monasteries, and mines throughout Nazi-occupied territory. The biggest cache of all, he said, was in an abandoned salt mine in the Austrian Alps, at a place called Alt Aussee. It had been converted into a high-tech underground storehouse for all of the looted art destined for the supermuseum at Linz. The stolen collection already numbered over 12,000 works, including masterpieces by Michelangelo, Raphael, Vermeer, Rembrandt, Titian, Breughel, Veronese, Dürer, and Leonardo. Among the works in the mine was, it seemed, Leonardo's *Mona Lisa*. A mystery remains to this day as to whether it, or an exact copy, was stolen by the Nazis and stored in the mine. But the work that the Nazis prized above all was Jan van Eyck's *Ghent Altarpiece*.

Bunjes knew the local SS gauleiter, August Eigruber, who was in charge of the Oberdonau district, which included Linz and Alt Aussee. Eigruber was an exceptionally ruthless and fanatical Nazi. An ironworker

before the war, he was a founding member of the Upper Austrian Hitler Youth, rising to become its head by the age of twenty-nine. Early in the war Eigruber had served with wild enthusiasm as an executioner at the Mauthausen-Gusen concentration camp, which he had helped to establish. His complete loyalty was to Hitler—he sported an identical smudge moustache—and he mistrusted the commands of intermediaries and emissaries, whom he considered weak, hesitant, and overly merciful. He saw his appointment as head of the Oberdonau district, which encompassed Hitler's own hometown, as a reward for his staunch, iron-stiff commitment to the führer.

Hitler had declared that under no circumstances should the art under Nazi control ever return to the Allies. Eigruber had received a direct order from Hitler's secretary, Martin Bormann, instructing him to prevent the Alt Aussee treasure house from being captured by the Allies, if necessary, by sealing the mine shaft, locking the art inside but not damaging it. However, Eigruber willfully and secretly misinterpreted this order. He was determined to prevent the Allies from recovering the art—at all costs. Bunjes worried that he would blow up the art in the mine, despite his orders, if a Nazi defeat looked imminent. Messages relayed from Austrian Resistance members in Alt Aussee confirmed these fears.

Posey and Kirstein knew that General George Patton's Third Allied Army was making its way towards Alt Aussee, but it might arrive too late. They were unaware that a parallel, secret operation was under way. A courageous Austrian double agent was about to lead a team of covert operatives on a daring mission to stall the Alt Aussee mine's destruction. It was feared that if the Allies failed to reach the mine in time, every one of the thousands of artistic masterpieces stored inside would be destroyed.

The ability to defend art has been seen as an indication of a nation's strength or failure since biblical times. Great artworks have been the battle flags of warring factions, captured and recaptured by individuals and armies. During the Second World War, an unprecedented number of these battle flags simply disappeared from the homes, castles, churches,

and museums of Europe. It was the job of the Monuments Men to find these works of art and, above all, one monumental twelve-panel oil painting.

Since its completion in 1432, *The Ghent Altarpiece* has disappeared, been looted in three different wars, and been burned, dismembered, copied, forged, smuggled, illegally sold, censored, attacked by iconoclasts, hidden away, ransomed, rescued, and stolen time and time again. For some of its admirers the treasures hidden within *The Ghent Altarpiece* were tangible. For others, the treasures were of a more ethereal nature, revealing hidden truths about philosophy, theology, the human condition, and the nature of the Godhead. The altarpiece has been seen as so symbolically powerful that it must be destroyed and so literally powerful that its possession and deciphering might change the course of world wars.

This is the story of the most desired and victimized object of all time.

The Mysteries of the Masterpiece

As the oak door to the chapel swings open, one is first struck by the scents: the cool, ancient stone of the walls of Saint Bavo Cathedral, the smell of frankincense, and then the surprising notes of old wood, linseed oil, and varnish. The cathedral in Ghent, Belgium, abounds with stunning religious art, but one artwork stands out among the rest. After six hundred years of nearly constant movement, *The Ghent Altarpiece* is at last back in the cathedral for which it was painted.

Jan van Eyck's masterpiece has been involved in seven separate thefts, dwarfing the next runner-up, a Rembrandt portrait, lifted from London's Dulwich Picture Gallery on a mere four occasions. From enduring questions surrounding the movement, through theft and smuggling, of the altarpiece as a whole to the mystical symbolism of its content, the altarpiece has haunted scholars and detectives, hunters and protectors, interpreters and worshippers.

It is one of art history's great unsolved mysteries.

Those who stand before the altarpiece cannot but feel overwhelmed by its monumentality. *The Ghent Altarpiece* comprises twenty individual painted panels linked in a massive hinged framework. It is opened on its hinges for religious holidays but remains closed for most of the year, at which point only eight of the twenty panels, which were painted on both recto and verso (front and back sides), are visible. The subject matter of the verso panels, visible when the altarpiece is closed, is the Annunciation: The angel Gabriel tells Mary that she will bear the Son of God. Portraits

of the donors who paid for the altarpiece, and their patron saints, also grace the back.

The altarpiece has a puzzle-box appearance, and inside its treasures lie patiently in wait for decipherers. When open, the altarpiece's center displays an idealized field full of figures: saints, martyrs, clergy, hermits, righteous judges, knights of Christ, and an angelic choir, all making a slow pilgrimage to pay homage to the central figure—a Lamb on a sacrificial altar, standing proudly, while it bleeds into a golden chalice. This scene is referred to as "The Adoration of the Mystic Lamb." The precise iconographic meaning of the Adoration of the Mystic Lamb panel and the meaning of the dozens of obscure symbols within it have been the subject of centuries of scholarly debate.

Above the vast field of the Adoration of the Mystic Lamb, in the upper panels, God the Father sits enthroned, with Mary and John the Baptist on either side. The figure has a hand raised in blessing, a hand painted with an astonishing realism: veins bulge and tiny hairs curl out of the pore-scored skin. At his foot, a crown is clustered in light-reflecting jewels; the fringe of his cloak is woven in gold threads, and above his head arch rune-like inscriptions. Individual hairs were lovingly painted into his beard, and his almond eyes express a power and a weariness that are altogether human.

The level of minute detail in so enormous an artwork is unprecedented. Until the altarpiece was painted, only portrait miniatures and illuminated manuscripts contained such detail. Nothing like this intricacy had ever been seen before on such a grand scale, by artists or admirers. The great art historian Erwin Panofsky famously wrote that van Eyck's eye functioned "as a microscope and a telescope at the same time." Viewers of *The Ghent Altarpiece*, Panofsky explained, are privy to God's vision of the world, capturing "some of the experience of Him who looks down from heaven, but can number the hairs on our head."

In *The Ghent Altarpiece* jewels shine with refracted light. One can see individual hairs on the manes of horses. Each of the altarpiece's hundred-

plus figures have been given personalized facial features. Each figure's face is unique and retains the detail of a portrait—sweat, wrinkles, veins, and flared nostrils. Details range from the mundane to the elegant. Viewers can make out tufts of grass, the wrinkles in an old worm-eaten apple, and warts on double chins. But they can also see the reflection of light caught in a perfectly painted ruby, the folds of a gilded garment, and individual silvery hairs amid the chestnut curls of a beard.

The secret weapon that permitted such detail was oil paint. Because oil paints are translucent, artists can build up layer upon layer, without covering up what lies beneath. The preferred medium before van Eyck's time, egg-based tempera, was essentially opaque. One layer blotted out the previous one. Oil allowed for a great deal more subtlety and was also easier to control. Van Eyck used some brushes that were so small as to contain only a few animal hairs for bristles, permitting an entirely new level of intricacy. The result is a visual feast, a galaxy of painterly special effects that at once dazzle and provide days of viewing interest, prompting viewers to examine the painting from afar and up close, to decipher as well as to bask in its beauty.

The Ghent Altarpiece, the young van Eyck's first major public work, was also the first large-scale oil painting to gain international renown. Though he did not invent oil painting, van Eyck was the first artist to exploit its true capabilities. The artistry, realistic detail, and use of this new medium made the artwork a point of pilgrimage for artists and intellectuals from the moment the paint dried and for centuries to come. The international reputation of the painting and its painter, particularly taking into account its establishment of a new artistic medium that would become the universal choice for centuries, makes for a strong argument that *The Ghent Altarpiece* is the most important painting in history.

It is a work of art that centuries of collectors, dukes, generals, kings, and entire armies desired to such an extent that they killed, stole, and altered the strategic course of war to possess it.

Both the art and the artist are cloaked in mysteries.

The Ghent Altarpiece has been known by various names since its creation. Artworks were rarely given specific titles until hundreds of years later. Most of the titles by which artworks are known today were given by art historians to facilitate reference. In Flemish, the altarpiece is known as *Het Lam Gods*, "The Lamb of God." It has also been referred to by nicknames, such as *The Mystic Lamb* or simply and perhaps perceptibly, considering the frequency with which it has been imperiled, *The Lamb*.

Jan van Eyck painted *The Mystic Lamb* between 1426 and 1432, a tumultuous time in European history. King Henry V of England married Catherine of France, then died two years later. Joan of Arc was executed in the midst of the raging Hundred Years' War. Brunelleschi began to build the dome of the cathedral of Florence, Santa Maria del Fiore. Donatello's marvelous *Saint George* statue had recently been completed, a work that would influence sculpture much as *The Ghent Altarpiece* would influence painting. The very year that *The Lamb* was begun, Masaccio painted his celebrated Brancacci Chapel in Florence, which became a pilgrimage point for artists in subsequent centuries—what van Eyck did for panel painting, and Donatello did for sculpture, Masaccio did for wall painting. Soon after the completion of *The Lamb*, Leon Battista Alberti wrote his influential *Treatise of the Art of Painting*, mathematically and theoretically codifying the artistic rendition of perspective. A decade later, Gutenberg invented printing with movable type.

The fame of the altarpiece comes from its artistic beauty and interest—and also its importance to the history of art. This importance was constantly reasserted through the centuries, as one generation after another of artists, writers, and thinkers extolled the virtues of the painting, from Giorgio Vasari to Gotthold Ephraim Lessing to Erwin Panofsky to Albert Camus.

The painting both enchants the eye and provokes the mind. Elements of the work, such as the microscopically detailed crown that sits at God's

feet, are painted with raised, textural strips of real gold leaf, which catch the light like sparks on the painting's surface. Beyond the dazzle, the painting is filled with disguised symbols linked to Catholic mysticism. It exhibits detail far greater than any of the works of van Eyck's painter predecessors. The personalization of human figures, the stark naturalism of inanimate objects like that gilded, jewel-encrusted crown, forecast movements such as Realism by four hundred years.

In considering how to situate *The Ghent Altarpiece* in the history of art, one might pursue two different arguments, each of them convincing. One might argue that *The Ghent Altarpiece* was the last artwork of the Middle Ages, or one might state that this was the first painting of the Renaissance.

It was the last artwork of the Middle Ages because the form of the frame, the painted architecture, and the figures are Gothic in style. The extensive gilding, an effect added later by a gilder after the artist had completed his work, is also a Gothic characteristic. The gold makes the painted figures leap off the panels, lending them a halo of light and a striking delineation against the gilded sea behind them. Actual gold leaf, pounded so thin that it would disintegrate if touched by an oily fingertip, was applied by static electricity. A badger-fur brush was rubbed in the gilder's own hair, creating static strong enough to pick up the gold leaf, which was affixed to the gesso by egg-white glue. Gilding would be dropped in favor of naturalistic landscaped background later in the fifteenth century, so its selective presence suggests an allegiance to the medieval style. The mastery of perspective, as well as the integration into the painting of Neoplatonic artistic theory, the preferred philosophy of the Humanists who sparked the Renaissance, are all absent. This was, therefore, the last major artwork of the Middle Ages.

And yet one might easily argue that the masterpiece represents the first painting of the Renaissance. Though there is gilding, the work also abounds with naturalistic landscapes and backgrounds, characteristic of postmedieval painting. The altarpiece was created during the height of Humanism: the rediscovery of classical Hebrew and Greek texts, and the

particular idolization of the ancient Athenians. Its realism, unprecedented in the Middle Ages, was inspired by this Humanism. Part of the Renaissance Humanist philosophy was an empowerment of human capability and human lives. Only someone who embraced the value of humanity would bother to create an artwork full of such loving detail. During this era of the Christianization of pagan art and ideas, works of art reflected an attempt to reconcile the dominant Catholic religion with the contradictory philosophies and science expressed in newly discovered and translated classical texts. This Christianization of pagan imagery is integral to *The Mystic Lamb*. The fact that this painting was, in the decades after its creation, the most famous painting in the world among painters, and the fact that it effectively established the new artistic medium of the Renaissance, oil painting, demonstrate how it directly shaped Renaissance art and iconography.

Both cases are sound. There is a scholarly tendency to want to categorize at all costs, inserting artworks into particular "-isms" and overlooking the organic history of art, the way various styles overlap and intertwine. But part of the pleasure and wonder of great art is its mystery, its elusive qualities that haunt and intrigue us. Rather than relegating *The Ghent Altarpiece* to the Middle Ages or the Renaissance, the painting can be viewed more accurately as the fulcrum between the Middle Ages and the Renaissance, in art as well as thought—and it is all the more interesting because of its hybrid nature.

What is it a painting of? This seemingly simple question has a complex answer. Most religious paintings of the fifteenth century were inspired by, or precisely illustrated, a particular passage in the Bible, the Apocrypha, or biblical commentaries. *The Ghent Altarpiece* refers to many biblical and mystical texts, but is a synthesis rather than a precise illustration of any one of them. One must excavate the various layers of theological references and iconography before linking together the individual pieces into a constellation.

Pictures of this period were often puzzles. They led the viewer through a maze and only hinted at what lay at the center. It has often been said

that a great portrait should reveal a hidden secret about the person portrayed that the person would prefer remained secret—the artist is privy to it and weaves the secret into the pigment, hiding it in plain sight for determined viewers to find, if they know how to look.

What is subtle and enigmatic in portraiture is magnified in religious painting. The subtlety of the theme on which knowledgeable viewers may meditate was also considered an advantage. Mystical secrets of Catholicism were not for novices, but rather for those with extensive knowledge of the Bible and commentaries and also Greek and Latin pagan sources. For example, van Eyck's contemporary, the Italian monk Fra Angelico, painted a small fresco in each cell in the monastery of San Marco in Florence. The cells for novice monks contain simple biblical scenes, easy to understand, provoking more of a gut reaction, such as sympathy, with a Crucifixion or a Pietà. The scenes depicted are increasingly complex in the cells that Fra Angelico painted for the elder monks. The levels of theological complexity culminate in difficult concepts such as the Holy Trinity, images that would require wisdom, experience, and extensive reading in order to understand fully.

In religious paintings for public spaces, too, what one might describe as "mystery paintings" were favored. They would often include varying levels of complexity, depictions of biblical scenes that are easily recognizable for the simpler viewers, alongside erudite images, which often contained hybrids of various theological texts, references to mythology or pagan ideas, and time-and-place-specific references, what we might call "inside jokes" today, which were obvious to contemporary viewers but are like a foreign language to a twenty-first-century audience.

There was also a pleasure in deciphering. In a time before the printing press, one of the great pleasures of an educated life was to contemplate pictures over the span of hours, months, or years. Works such as *The Mystic Lamb* had a religious function, decorating and referencing the Mass that took place in the church at the altar beneath it. But they were also sources of intellectual and aesthetic pleasure, something to be debated with friends. Viewers showed their erudition by noting references

in painting, by identifying the various philosophical concepts raised by the painting, and by discussing how various ideas and images might be woven together into a sum that reveals a greater truth. Renaissance art conveyed ideas in images, painted stories, and pictograms, artists toying with ways of presenting concepts through the inherently silent, mostly textless medium of painting. Faces, landscapes, still lifes, and bodies had to tell stories. The great artists could use this mute medium to plumb emotional and theological mysteries.

The images in *The Ghent Altarpiece* are varied and theoretically diverse. The painting incorporates more than one hundred figures, many inscribed textual phrases, references and cross-references to biblical passages, apocryphal theologies, and even pagan mythology. Complicated symbolic works such as this one began with an overall iconographic plan that was designed by a scholar, a great theologian—rarely by the artist himself. The artist would be told the scheme of the painting, which figures should be included, which phrases, and perhaps even their relation to one another in the composition. It was up to the artist to execute the concept of the scholar. The more accomplished the artist, the less the art would be dictated to him.

In this case, Jan van Eyck was a relatively young up-and-comer. This would be his first major work for public display. Therefore he would have received a considerable amount of guidance. Under most circumstances, the implementation of individual concepts and the arrangement of figures were at the discretion of the artist, while the theme, any text, portraits of donors, and especially the number of figures would be expressed in the written contract. Painters were often paid by the number of faces they were asked to paint, so this was an important factor. The contract for *The Ghent Altarpiece* is lost, and we can only guess what it contained and how much of a free hand the artist was given in its conception. Likewise, no record remains of the scholar who designed the theme, although a probable candidate has been suggested. The scholar must have been inordinately well-read—a knowledgeable Humanist. One can imagine how difficult it must have been to summon up by memory or painstaking re-

search the many phrases and cross-references employed in this work, without the benefit of a computer, a concordance, or even the access that the invention of printed type would provide twenty years later.

What may strike some viewers as a simple painting of a room is in fact a masterpiece of minute details, each with a specific liturgical or symbolic reference. Paintings of this period did not contain details without a reason. The enormous material expense of the purchase of smooth, flat panels, pricy pigments to make the paint, the wood-carved frames, and the cost and time of the artist's work was so high that only the very wealthiest individuals and institutions—princes and kings and bishops and the wealthiest merchants—could commission art. Artists themselves could rarely afford the material to paint anything that had not been commissioned. It would be another two hundred years before the first artists began to paint "on spec," in hopes of a sale through a gallery. Four hundred more years would pass before the first ready-mixed tubes of paint were available for purchase. In van Eyck's day, artists created what they were paid for. Every detail was significant.

Art historians use iconography, the study of symbols in art, to determine the literary source that inspired paintings. Most religious works of the premodern period illustrate literary concepts or stories. Knowing the literary source reveals the theme of the painting, which might otherwise remain elusive. For religious works, the sources most often used are the Bible or *The Golden Legend*, the medieval biography of saints written circa 1260 by the monk Jacobus da Voragine, which was the second-most popular book (behind the Bible) through the Middle Ages and the Renaissance. A woman carrying her eyes on a silver platter might not have obvious meaning, until we know the literary source, *The Golden Legend*, and understand that the image comes from a biography of Saint Lucy, whose eyes were put out during her martyrdom.

A procession of the pantheon of saints, related to the All Saints sermon, moves slowly towards the Lamb on the altar at the center of a vast field. The theme of this central panel of *The Ghent Altarpiece*, called "The Adoration of the Mystic Lamb," is drawn from *The Golden Legend* as well

as the Revelation of Saint John. Therefore in the imagery of the altarpiece we find a series of interrelated theological themes, nested like Russian dolls, mutually referential while deepening the religious and iconographic mystery surrounding the painting. In the twenty-six individual scenes depicted across the twelve oak panels, we are presented with an A to Z of Christian mystical theology, from the Annunciation (Luke 1:26–28) to the Adoration of the Mystic Lamb in the final book of the New Testament, Revelation.

To unlock the mysteries of *The Ghent Altarpiece*, then, we must first approach its component parts, examining their content and symbolism and asking what the individual panels portray. Among its many mysteries are saints disguised as statues, floating prophets, and text written upside down.

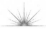

When the altarpiece is closed, the verso (back) of eight of the panels is visible, illustrating the Mystery of the Incarnation. The panels are divided into two registers, each four panels across. The upper register depicts an open room in which the Annunciation takes place, the moment that God sends the angel Gabriel to tell Mary that she will bear the Son of God (Luke 1:28–38). This scene is painted across all four panels, with Old Testament prophets and sibyls floating above the painted "ceiling" of the Annunciation room.

The panel on the left shows the angel Gabriel with a lily in hand, a flower that symbolizes Mary's virginity and purity and that Gabriel means no harm. Gabriel speaks the words of the Annunciation, which have been painted in gold onto the panel, emanating from Gabriel's mouth: *Ave Gratia Plena Dominus Tecum* ("Hail [Mary], full of Grace, the Lord salutes you"). Gabriel's body fills the room, in which he seems to float rather than stand. The room itself is contemporary to the painting, not biblically accurate, with exposed wooden crossbeams on the ceiling and a naturalistic light source: sunlight flooding through the open windows, which casts Gabriel's shadow against the back wall.

Mary kneels on the right-hand side of the upper register, receiving the annunciated words of Gabriel. Her response to Gabriel's words, *Ecce ancilla domini* ("Behold the slave of the Lord"), is written upside down. This may seem odd, until we realize that this reply is not for us, but rather for God and the Holy Spirit. The Holy Spirit, above Mary's head, and God, presumably high above in Heaven and gazing down at Mary on earth, would need the response to be inverted in order for the text to be clearly legible. This contrivance appeared with some frequency in northern Renaissance Annunciation paintings, most famously and first here. The Latin phrase uttered by Mary is often mistranslated as "Behold the hand-maiden of the Lord," a politically correct alteration of the literal translation, in which Mary offers herself as a slave.

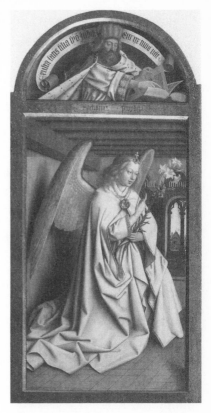

The Angel Gabriel approaches Mary with a lily in hand

The Holy Spirit, in the form of a dove, descends upon her, signaling her impregnation with the future Christ. Her hands are crossed on her chest in a gesture of humility. She kneels on the floor as a further reference to her humility—*humilitas* in Latin, meaning "close to the earth." A gorgeously rendered glass decanter, through which the window sunlight is cast, alludes to a medieval theological explanation for how Mary could become pregnant with Jesus yet still be a virgin. The rationale was that if a ray of light can pass through glass without breaking it, then Mary can be a pregnant virgin. This unusual validation worked to quiet the murmuring masses in the Middle Ages. Even back then, virgin pregnancy sounded a bit suspect.

The prophet Micah is in the crawl space above Mary. He indicates a passage in the Old Testament, inscribed in a waving painted banner, in

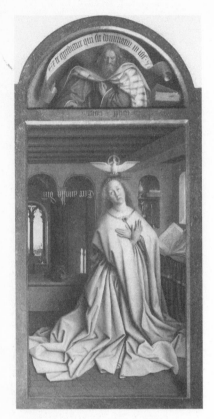

*Mary kneels as the Holy Spirit
descends upon her in the Annunciation*

which he predicted the coming of the Jewish messiah, a prophecy that medieval Christian theology appropriated as a prediction of the coming of Christ: "Out of thee shall he come forth unto me that is to be ruler in Israel." Van Eyck, like many artists, enjoyed paying homage to past artworks by quoting visual references to them. He chose to pose Micah identically to the 1417 sculptural relief of God carved by Donatello for the niche above his revolutionary statue of Saint George, which was on the façade of the church of Orsanmichele in Florence. This statue was considered the most important sculpture of its time, and Florence became a point of pilgrimage for fellow artists, who traveled across Europe to admire Donatello's work. The admiring artists often referenced his work in theirs. Such visual, formal references by one artist to another appear frequently, and they form an inside joke for art historians, who take perhaps inordinately great pleasure in recognizing such references. But in many cases, as in this instance, they also serve up a clue that would otherwise have eluded scholars.

There is no clear evidence that Jan van Eyck ever traveled to Italy. But he would have needed to see the Donatello relief in order to reference it in his own painting. Because Gutenberg had not yet invented moveable type, copies of an artwork, image, or text had to be made by hand, one at a time. In order to see an artwork, one had to travel to its location. Visual references such as this are strong indicators that the artist saw the referenced work in person.

The prophet Zechariah is also depicted in what appears to be the crawl space above the painted ceiling, beneath the rounded top of the panel. A

fragment of his messianic prophecy is inscribed in Latin, on a banner swirling over his head: "Rejoice greatly, O daughter of Zion, shout out behold, thy King cometh unto thee" (Zechariah 9:9).

The two central panels of the upper register show the open room in which the Annunciation takes place, with a view through the windows at the back to a contemporary, but unidentified, cityscape. Two women, known as the Erythraean and Cumaean sibyls, float above the room, in the same space occupied by the prophet Zechariah. A sibyl is an Old Testament female prophet, whose words were interpreted as foreshadowing the coming of Christ. Fragments of their prophecies are inscribed in swirling painted banners. The inscription on the banner of the Erythraean sibyl quotes from Virgil, a pagan Latin author dubbed by the church as one of the "good" pagans who, perhaps inadvertently, forecast the coming of Christ: "He speaks with no mortal tongue, being inspired by power

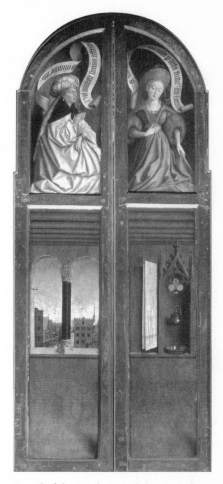

Detail of the windows and the view of fifteenth-century Ghent, from the Annunciation panels. The window, a part of the cathedral complex, still exists.

from on high." The Cumaean sibyl's banner flows with a quotation from Saint Augustine: "The King Most High shall come in human form to reign through all eternity."

Patterns involving clusters of three architectural elements refer to the Holy Trinity. One such may be found in the small trefoil, a window resembling a three-leaf clover, inside a sculptural niche crowned in a gothic pointed arch. Hanging in the niche is a bronze water pot above a shallow basin, a reference to the consecrated wine poured out at Mass. A towel

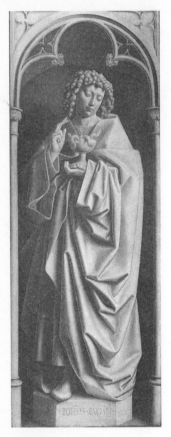

Saint John the Evangelist, painted in a gray-scale to suggest that this is a statue of the saint, not the saint himself

hangs in the sculptural niche. The decoration on the towel is reminiscent of the uniforms of altar boys. As with all altarpieces, this painting was literally meant for display above an altar, at which Mass would be performed. More than an object of beauty, it was also a meditative aid. Van Eyck cleverly inserted cross-references between the painted content of the altarpiece and the actual clergy performing Mass in front of it.

The bottom register of the closed altarpiece is, like the upper register, four panels across. The lower-middle panels depict Saint John the Baptist in the center left and Saint John the Evangelist in the center right. Both Johns are painted in a style called "grisaille"—a scaled monochrome, employed here to give the illusion that the painting is actually a stone sculpture. Van Eyck has not painted the two Saint Johns, but rather he has painted sculptures of the two Saint Johns.

An imaginary painted light source, coming from the top right of the panels, casts shadows behind the sculptural saints, indicating that they are, indeed, meant to be seen as statues in a shallow niche. Some art historians have suggested that van Eyck was the first painter to incorporate directed spotlighting, to create shadows and depth in such a way that painting could replicate sculpture, as in these two grisaille panels. This technique would be used almost universally in the Baroque period, a century and a half later. There is no extant earlier painting that incorporates the same effect, but given all of the works of art that have been lost over the centuries, it is difficult to declare art-historical "firsts" with certainty. Unless the galaxy of lost masterpieces is recovered from the ashes and hidden corners, the question marks remain.

Both of the painted sculptures of the Saint Johns stand on octagonal plinths. The dramatically rendered drapery of their garments is reminiscent of the unusually naturalistic drapery cut out of marble by Donatello in his Saint Mark sculpture, which, like his Saint George, decorates the exterior of Orsanmichele in Florence. This second visual link to Orsanmichele is a further clue to suggest that van Eyck may have traveled to Italy to admire the works of Donatello.

The Revelation of Saint John the Evangelist provides the theme of the central interior panel: the Adoration of the Mystic Lamb. The painted image of Saint John the Baptist carrying a lamb is of particular significance to the city of Ghent. The Baptist is the patron saint of Ghent. He is depicted on the earliest known seal of the city. The Lamb of God, *Agnus Dei*, the subject of *The Adoration of the Mystic Lamb*, is the image on the earliest known counter seal. A later city seal depicts John the Baptist carrying a lamb, as he does in van Eyck's panel. Ghent's wealth, having come primarily from the wool industry, is one reason for the symbolic use of a lamb in the city's seal

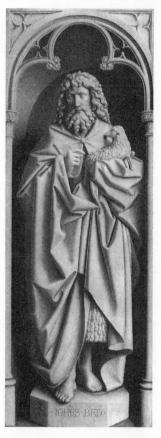

A painted statue of Saint John the Baptist, cradling a lamb, the symbol of Christ, in his arms

and iconography. Indeed, the original name of the church for which *The Ghent Altarpiece* was painted was the Church of Saint John. Its name was changed to the Church of Saint Bavo only in 1540, nineteen years before it was granted the status of cathedral, in honor of a local saint.

There was originally a predella to *The Ghent Altarpiece*, a strip of small square panels that ran across the base of the altarpiece. Documents from the time refer to the predella as depicting Limbo, but we know nothing more about it. The predella itself was irrevocably damaged when the altarpiece was badly cleaned by the painter Jan van Scorel, sometime before

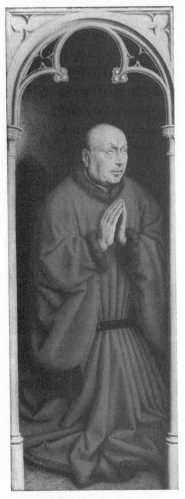

Portrait of the patron who paid for
The Ghent Altarpiece, Joos Vijd

1550. The bad cleaning resulted in the pre-della being discarded, placed in storage, and eventually lost. From the late sixteenth century on, *The Ghent Altarpiece* has remained incomplete.

Who paid for the creation of this altarpiece? Depicted on the far left and far right are the donors, who funded both the establishment of the chapel that houses the altarpiece and the painting of the altarpiece itself. On the far left panel is a portrait, wrinkled and accurate to life, of Joos Vijd (whose name was written a variety of ways, including the more exotic Jodocus Vydt), a wealthy knight and local Ghent politician. His wife, Elisabeth Borluut (sometimes spelled Burluut), is portrayed opposite him, also kneeling in prayer, in the far right panel. They are almost life-sized, painted as God made them, with none of the idealization employed by past artists, who would either "clean up" the less attractive aspects of those portrayed or paint them in a generic manner, bereft of identifiable characteristics. This warts-and-all portrait realism was another of van Eyck's great innovations.

Van Eyck's realism, described by the founder of modern art history, Jacob Burckhardt, as "supreme perfection at its very first attempt," both displays his artistic skill and emphasizes the humility of the donors who were willing to be preserved for all eternity as they truly looked, without any painterly plastic surgery—even if they were not so humble as to refrain from including themselves in the painting that they commissioned to demonstrate their wealth and piety.

Portraiture as a distinct artistic genre arose in the first decades of the fifteenth century, a time when Humanism emphasized the importance of individual human life, and led to the commemoration and glorification of individuals—people who were neither kings nor biblical figures but instead aristocrats, clergy, merchants, intellectuals, and artists who believed their lives on earth had meaning and value. A portrait, either alone in a panel painting or with other donors' images in a large religious work like this one, was a historical record, a way of preserving one's name, likeness, and legacy.

Van Eyck began his portraits by sketching in silverpoint (literally drawing with a piece of silver) on paper in the presence of the sitter. The sketch would include the outlines of the face and the key lines of the facial features, shadowed with cross-hatching. He would make notes to himself in his native Mosan jargon (the dialect from the region of Maaseyck) in the margins of his silverpoint drawing about color, garment texture, and similar details. He would then transfer the drawing onto his gessoed panel using a mechanical enlargement technique to alter the size.

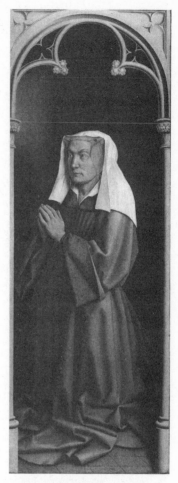

Portrait of the patron's wife, Elisabeth Borluut

There were two common methods of mechanical transfer used by Renaissance artists. The first method involved drawing a grid over one's sketch, and then drawing a grid with larger squares onto the support of the panel onto which one would paint. The artist could then copy the lines contained in each square of the grid over his sketch into the corresponding larger-scale square of his grid on the panel, enlarging the lines piece by piece. In the second method, the drawing would be placed over

the panel and pierced along the important lines, leaving a mark on the surface underneath the drawing. The resulting marks on the panel could be used as a reference point to draw lines around them in a larger scale on the panel itself. This is the method most likely used by van Eyck, as his only extant drawing contains marks of transfer.

The centerpiece of *The Adoration of the Mystic Lamb* is found in the lower central panel of the open altar and is the most important element to understanding the work as a whole. This panel alone measures 134.3 by 237.5 centimeters (4.4 by 7.8 feet) and spans the width of three other panels. Its subject is taken from the Revelation of Saint John the Evangelist, the last book of the New Testament.

The scene is set in a vast, idyllic flowery meadow embowered by trees and hedges. Here van Eyck's inordinate patience and attention to detail are on full display. Most of the plants, bushes, and trees are depicted with enough accuracy as to be identifiable to botanists. This cannot be any real field, as the combination of plant life, running the gamut from roses to lilies to cypresses to oaks to palm trees, could not coexist in one natural habitat. There is no sunlight, but rather the Holy Spirit, as a white dove, emanates light and bathes the scene in a midday glow. As is written in the Revelation of Saint John, "I saw the Spirit descending from Heaven like a dove."

The scene is viewed from on high, looking down at the sweep of meadow filled with hundreds of figures. Basic perspectival lines draw our eyes to the sacrificial altar at the center, on which stands the Lamb of God, *Agnus Dei*, to which the attention of everyone in the meadow, save one individual, is directed.

On the central panel's two penduli—swaths of red velvet draping down the side of the altar—is written *Ihesus Via* and *Veritas Vita*, "Jesus is the Way, the Truth, and the Life," also a quote from the Gospel of John. Scroll down the center of the panel, and we come to a fountain, the *Fons Vitae*

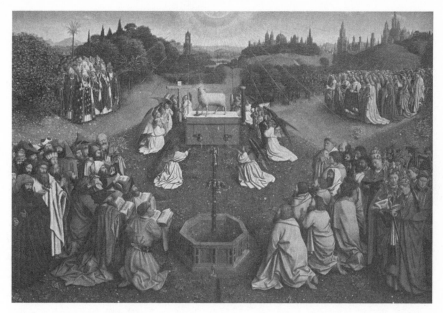

The central panel of The Ghent Altarpiece, *referred to as the Adoration of the Mystic Lamb*

or Fountain of the Water of Life, symbolic of the celebration of Mass, out of which flows endless grace for the faithful. The painted water streams out of the fountain through a gargoyle-mouthed drain that suggests that the water might even flow out of the painting itself and spill onto the stone altar beneath it, transcending the boundary between the painted reality and the chapel in which the viewers of the painting stand. Around the stone edge of the octagonal fountain (the base of which should recall the painted plinths on which stand the two Saint John statues on the other side of this very panel) is carved *Hic Est Fons Aque Vite Procedens De Sede Dei + Agni:* "This is the Fountain of the Water of Life proceeding out of the throne of God and the Lamb," a quotation from the Book of Revelation.

Angels with jewel-colored wings kneel in prayer around the Lamb on the altar, carrying the instruments of Christ's passion: the cross, the Crown of Thorns, and the column at which he was flogged. Their white robes resemble those worn by altar boys, who would participate in the Mass held

in the chapel beneath the painting. Even the multicolored wings of the angels have a symbolic origin. Two stories relate the colorful wings of birds to Catholic iconography: The origin of one is based on the misconception that a peacock's flesh does not decompose after death. The peacock was, therefore, associated with the body of Christ, resurrected before it had a chance to decompose. The other reference is to a different colorful bird— the parrot. Another odd rationale for Mary's having been a pregnant virgin ran: If a parrot can be taught to say *Ave Maria,* then why can't Mary be a pregnant virgin? This sort of pregnant logic pretty well silenced the questioning masses back in the Middle Ages and, as porous as the argument may sound today, resulted in the depiction of parrots in religious painting throughout the Middle Ages and the Renaissance.

The angels in the garb of altar boys swing censers, spreading powdered incense over the Lamb. The censers are caught in midair. The central scene is a snapshot, a frozen moment of action. In the Renaissance, particularly in Italy, painters preferred to depict their figures in stable, geometric poses that suggested calm, sculptural, eternal permanence. In the Baroque period, two centuries after van Eyck painted, particularly those artists who emulated Caravaggio favored dynamic, unstable tableaux, portraying figures at the moment of highest drama and movement—a cup falling off a table, a head peeling off of a severed neck. Van Eyck provides the High Renaissance stability in every element of his central painting, save for those swinging censers, which forecast Baroque dynamism, there to remind us that it is a moment we see, not an unmoving eternity.

The field is filled with figures. As is written in Revelation 7:9–10, the "great multitude, which no man could number, of all nations and kindred, and people, and tongues" surround the Lamb of God in the fields of paradise. In the case of this painting, the great multitude can be numbered. To be precise, there are 46 prophets and patriarchs (if you count heads and hats), 46 apostles and clergy (if you count portions of tonsured heads), 32 confessors (the sum total of tonsures and mitres), and 46 female saints (counting faces and variously colored head gear)—170 total individuals, plus 16 angels.

Each figure, particularly those from the foreground groups (the prophets and patriarchs in the left foreground and the apostles and clergy to the right) are painted with identifiable portrait faces. In most contemporary Italian paintings, portraits of individual patrons aside, figures such as saints were portrayed in a generic manner, with few if any distinguishing features beneath their beards. But van Eyck has provided knit brows and baggy eyes, faces full of character. One of the best tests for the vividness of a painted face is to ask oneself, Would I recognize this painted individual if I saw the person walking down the street? Unlike most Italian painted faces of the period, van Eyck's faces could be picked out of a crowd.

While most of the figures in the meadow have not been identified as particular historical individuals, a good number of them have. This recognition does not come from a portrait likeness, as no record exists of what these people really looked like. Iconographic attributes, such as the hagiographic icons of saints, act as badges or name tags that help us recognize key figures. Among the female saints, all of whom carry palm fronds, the symbol of having been martyred, we can locate: Saint Agnes, who carries a lamb as her hagiographic icon; Saint Barbara, who holds a tower (in which she was locked for refusing to marry a pagan); Saint Dorothy carrying a basket of flowers; and Saint Ursula with her arrow (the instrument of her execution at the hand of the Huns). Two members of the ensemble are abbesses, recognizable because they carry crosiers. White lilies bloom near this cluster of saintly women, symbolizing their virginity.

Among the apostles and clergy are three popes wearing the papal tiara: Martin V, Alexander V, and Gregory XII. Saints Peter, Paul, and John are present, as are Saint Stephen and Saint Livinius. Among the prophets and patriarchs to the left, one may find the prophet Isaiah, dressed in blue and carrying a flowering twig, referring to his prophecy: "There shall come forth a rod out of the stem of the tree of Jesse," Jesse being the forefather of the Old Testament King David, who in turn was considered, in apocryphal sources, to have been an ancestor of Christ. Perhaps surprisingly Virgil is also present, the only recognizable pagan in the field of paradise.

He wears a crown of laurel leaves, the symbol of poetic excellence (from which the term *laureate* is derived).

Despite the elevated vantage through which we are shown the scene, and despite the vast number of figures, van Eyck's level of detail is staggering. Intricacies are hidden in the mass of bodies that may only be seen upon close examination—even with a magnifying glass in hand they are difficult to pick out.

Take, for example, the three Hebrew letters painted in gold into the band around the red hat of the gentleman standing to the rear of the prophets. This was first noted by Canon Gabriel van den Gheyn, a brave clergyman of Saint Bavo Cathedral whose heroism would preserve *The Lamb* from theft and possible destruction during the First World War. Van den Gheyn published an article in 1924 noting the Hebrew letters *yod feh aleph*, which he thought were an abbreviation for the word *sabaoth*, which means "hosts" or "armies," as in the "Lord of Hosts." Van den Gheyn's rationale that these letters represented this word was not accepted by later historians, but the Hebrew letters were duly noted.

Yod feh aleph does not spell out a word in Hebrew, though, as we will see, it may be a transliteration rather than a literal word. The nearest word that would make sense is *yod feh aleph ramish*, meaning "He will beautify," a line from Psalms 4:149, which contains one more letter. A line from Psalms appears in the panel of the angelic musicians in the upper register, so this reference corresponds theologically to the rest of the altarpiece. If that one extra letter were present, the phrase "He will beautify" would make sense—and yet the Hebrew letters are so small as to make it nearly impossible to tell.

Van Eyck was at once coy and proud. He sometimes hid his signature, yet did so in plain sight, as in his work *The Arnolfini Wedding Portrait*, which he signed right in the center of the painting as a witness to the marriage ceremony, thought to involve Giovanni Arnolfini and Giovanna Cenami. He incorporated a trompe l'oeil painted phrase, his personal motto, into the frame of his *(Self) Portrait in a Red Turban*: *Ais Ich Kan* ("As well as I can"), knowing full well that what he had created was perfection itself. This was also a means of self-aggrandizement because,

traditionally, only nobles had mottos. So while the phrase "He will beautify" is a legitimate inclusion in this religious work, it could also be a statement about van Eyck's painting ability—he will beautify all that he touches with his brush.

Hebrew letters hidden in the band around a prophet's red hat

Van Eyck loved ambiguity, lacing his works with discussion points for even the most educated of his viewers. If the gold letters on the hat band are indeed *yod feh aleph*, this may be a subtle means of signing the work. One scholar has suggested that *yod feh aleph* could be transliterated into Jan van Eyck's initials. *Yod* is the "y" sound of Jan, *feh* is the Flemish pronunciation of "van" (which sounds more like "fahn"), and *aleph* is the start of Eyck.

A stretch? Perhaps, but it would not be uncharacteristic of van Eyck to insert this play on letters that would prompt active discussions among the most scholarly of his peers, those who could read Hebrew but would be clever enough to catch his inside joke.

Van Eyck's depiction of garments is another artistic innovation. The bodies beneath the clothes have a strength of form that was lacking in past works, where drapery clung amorphously beneath the painted heads of those who "wore" them. Van Eyck's garments again recall the novel way in which Donatello sculpted drapery at Orsanmichele. Donatello used a technique in which he would create a miniature clay mockup of his sculpture as a nude. Then he would soak cloth in clay and water, and drape it as clothing over the nude figure. In this way, he would see how the clothing fit around the body, with the body as a solid physical presence beneath it. Van Eyck's painted figures produce the same effect. They wear their clothes, rather than the clothes wearing the figures.

A cityscape appears in the distant horizon behind the altar and the Lamb. This represents the New Jerusalem, which will be founded, according to Revelation and the writings of Saint Augustine, upon the return of Christ to judge humankind. Only two buildings are architecturally identifiable. One is the tower of Utrecht Cathedral, at the center, considered an architectural wonder and tourist attraction in its

day. The other is just to the right of the Utrecht tower, the spires of Saint
Nicholas Church, in Ghent. The inclusion of the Utrecht tower, the icon
of a rival city, is unusual and has led scholars to believe that it may have
been added in 1550, during the first cleaning of the altarpiece, by the "con-
servator" who ruined the predella that he attempted to restore, Jan van
Scorel, who was a Utrecht native.

The panels on the far left and right of the upper register depict Adam
and Eve. Eve holds a gnarled lemon rather than the traditional apple,
symbolizing the Forbidden Fruit. Her expression is difficult to read—
at first glance she looks blank, while Adam's look suggests soulful mourn-
ing, brow slightly knit in distant concern. Beneath these figures are
inscribed: "Adam thrusts us into death" and "Eve has afflicted us with
death." These two are responsible for the "Fall of Man," the reason why
Christ had to be born—in order to die and, in doing so, to reverse their
Original Sin.

In contrast to the idealized populace of the rest of the artwork, these
two figures are the first *unidealized* nudes in painting of this period. They
are depicted in exacting detail, with nostril hairs and awkwardly bulging
stomachs—an affront to convention. While idealized nudes, like those
in Greek and Roman statues, were acceptable, because they showed the
human form as magnificent and perfect, van Eyck's Adam and Eve were
deemed too realistic by Enlightenment viewers. These panels were cen-
sored in 1781 and replaced by exact copies, on which bearskins were
painted, to cover up the naughty bits. Between the Adam and Eve panels
we see a heavenly choir singing to the left, and playing instruments to the
right.

The unusual iconography of the tiled floor beneath the angels requires
special examination. Beneath the musicians the minutely painted majolica
tiles, which at the time would have been imported to Flanders from Va-
lencia, are inscribed with "IECVC," an approximation of the name Jesus,

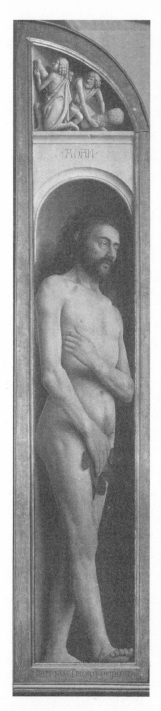
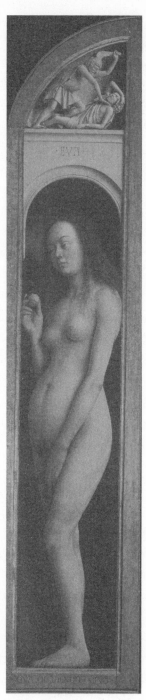

The original Adam and Eve panels, which so offended Emperor Joseph II that they were censored and eventually replaced by Victorian copies, in which bearskin covers were painted over the naked bodies

The tiled floor of the Angelic Choir panel

The Christogram, hidden in the tiles
of the Angelic Choir panel

likely chosen for its proximity to an abbreviated signature of the painter
(in Latin, Ioannes de Eyck). Also in the puzzle of the intricate green-and-
white tiles on the floor beneath the angelic choir, we can see a lamb with
a flag. Another seemingly enigmatic cluster of letters, in yet another of
the painted tiles, reads "AGLA." This is a Latin abbreviation for the He-
brew *atta gibbor le'olam Adonai*, "Thou art strong unto eternity, O Lord
of Hosts."

Also inscribed into the tiles is the so-called Christogram, the coat of
arms of Christ. This symbol was promoted by van Eyck's contemporary,
Saint Bernardino of Siena, in an effort to rally squabbling families and po-
litical groups, particularly the rival Guelphs and Ghibellines, under the
united battle flag of Catholicism. That van Eyck (or van Eyck and the the-
ologian/designer) should incorporate a symbol that was at the heart of
contemporary Italian politics shows a remarkable level of erudition and
awareness of current events. Yet the subtlety of it (it is difficult to see even
up close and with a magnifying glass) makes it more of a personal reference
than anything else. This level of detail would only have been seen by a
small group of peers and friends of the artist and the commissioner—
those given access to peruse the painting at leisure, rather than the

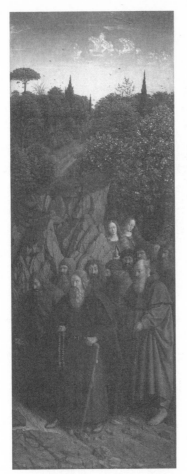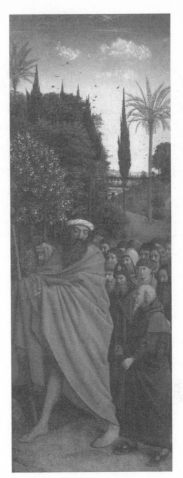

Panels displaying the Holy Hermits (left) and Holy Pilgrims (right)
processing towards the Mystic Lamb in the central panel

majority, who would see it only in a formal setting and at impersonal distance. Van Eyck was part of a rich tradition of artists who buried references that few could find, let alone recognize.

In the two panels on the bottom register to the right of the Adoration of the Mystic Lamb, a group of figures approach the meadow to pay homage to the Lamb of God. These figures are identified by inscriptions on the frames that surround them: *Heremite Sancti* ("the Holy Hermits") and *Peregrini Sancti* ("the Holy Pilgrims"). In the first of these two panels,

the Holy Hermits are led by Saint Anthony, identified by his T-shaped walking stick. It is probable that the local hermit and namesake of the cathedral, Saint Bavo himself, is depicted among the Holy Hermits, though he has yet to be identified. Two female hermits may be seen among the bearded men, one of whom is Saint Mary Magdalen, carrying her hagiographic icon, a jar of ointment. The Holy Pilgrims, in the panel to the farthest right, are led by the giant Saint Christopher, patron saint of travelers. Behind him walks Saint James (Santiago di Compostela), patron saint of pilgrims, identified by the scallop shell in his hat.

Although easy to overlook, the vegetation in the background of these two panels, particularly the cypress and palm trees, would have seemed exotic to Flemish viewers. These warm-weather plants were painted with such botanical detail that scholars have assumed that van Eyck must have seen the trees during his travels. A voyage to Portugal could account for the astonishing naturalism of his tropical plants and craggy, desert landscapes. The more tantalizing possibility is that van Eyck may have traveled to the Holy Land—a theory proposed by several scholars, for which no documentary evidence exists.

These panels also show van Eyck anticipating a technique made famous by Leonardo da Vinci a generation later. The human eye sees objects and landscapes in the far distance through a haze of atmosphere; therefore what is farthest away appears least clear, as if covered in a sort of translucent gauze. Van Eyck was the first artist to mimic this aerial perspective.

On the opposite side of the Adoration of the Mystic Lamb, the two panels on the far bottom left, are the *Cristi Milites*, "the Knights of Christ," on the inner left, and the *Iusti Iudices*, "the Righteous Judges." While none of the young knights have been identified with historical individuals, the coats of arms on their shields have. The arms of the Knights of Saint John of Jerusalem are on the shield with a silver cross. The arms of the Order of Saint George, from which the English flag is derived, show a red cross on a white ground. The arms of the Order of Saint Sebastian show a cross and four gold crosslets.

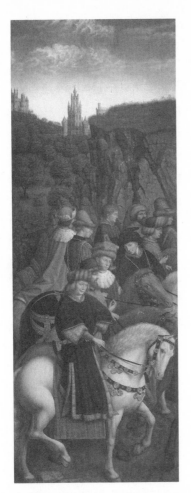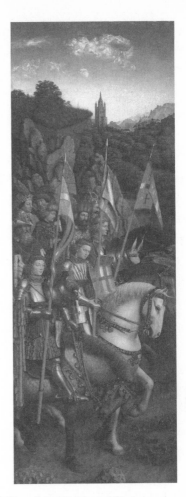

Panels depicting the Righteous Judges (left) and the Knights of Christ (right). The Righteous Judges panel would be stolen in 1934.

The banners flutter with an enigmatic phrase, the origin of which is unknown: *Deus Fortis Adonay T Sabaot V/Emanuel Ihesus T XPC A.G.L.A.*, "Mighty God, T, Lord of Hosts, V/God with us, Jesus, T, Christ, A.G.L.A." The "AGLA," also found in the tiles beneath the angelic choir, stands for *atta gibbor le'olam Adonai*, Hebrew meaning "Thou art strong unto eternity, O Lord of Hosts." The knights may have had a contemporary resonance, because, in 1430, Philip the Good the Valois Duke

of Burgundy planned—but never carried out—a crusade of his own to the Holy Land.

The panel on the far left depicts the Righteous Judges, a work that would be stolen in the most bizarre of the many crimes involving the painting and the one still unsolved. Portraits of some key contemporary figures, including van Eyck himself, are thought to be hidden among this throng. There is no contemporary document attesting to this, but if one compares the likeness in Jan's *Portrait in a Red Turban*, it seems clear that the man in the dark turban wearing a gold necklace, the only person besides God himself in the entire composition who stares directly out of the painting and at the viewer, is a self-portrait of Jan van Eyck. He would place himself in the background of a number of other paintings, including *The Arnolfini Wedding Portrait* and *Madonna of Chancellor Rolin*, always wearing a red turban.

To the right of van Eyck, wearing an ermine collar and riding a horse that looks out at the viewer, is a likeness of Philip the Good. The rider to van Eyck's left, wearing an unusual fur hat with the front flap pulled up, is thought to be the artist's brother, Hubert van Eyck. These portraits were identified in the sixteenth century and first published in the work of a biographer of Renaissance artists, Karel van Mander, in his *Lives of the Illustrious Netherlandish and German Painters* (1604): "Hubertus sits on the right-hand side of his brother, according to seniority; he looks, compared to his brother, quite old. On his head he wears a strange hat with a raised, turned-back brim at the front of precious fur. Joannes wears a very ingenious hat, something like a turban which hangs down behind."

The Vijd Chapel, for which the altarpiece was created, is too small to contain the altarpiece with the wings spread open fully—the width of the chapel is such that the wings can only be opened at an angle. This is an unusual feature, considering the fact that the chapel predates the painting and that van Eyck surely knew the intended location of the altarpiece. Perhaps this was a way of showing off the artist's skill. The altarpiece, as a work with the grandeur of wall painting but painted on panel, outdid even the frescoes of the time, which lacked the vibrancy of color

and the minute detail that oil painting boasts. The fact that the altarpiece could not be opened completely meant that the wings would thrust out towards the viewers at an angle, providing an extra dimensionality of which wall painting was wholly incapable. In this way, van Eyck emphasizes the fact that this is a work on panel, whose monumentality can only be compared with frescoes, but whose level of detail recalls tiny manuscript illuminations.

Finally, the upper register of the inside of the altarpiece features three monumental figures—the first monumental figures (much larger than those around them) to appear in Northern European panel painting.

In the center, God the Father is seated, face forward with a hand upraised in blessing. This panel overflows in both text and symbol. The pelican and the vine on the brocade over God's shoulder refer to the blood Christ spilt for humankind. Pelicans were erroneously thought to pierce their flesh in order to feed the young from their own blood in times of famine, while vines produce grapes that yield the sacral communion wine, representative of Christ's blood. The inscription in the triple molding behind God's papal tiara–clad head reads:

THIS IS GOD, THE ALMIGHTY BY REASON OF HIS DIVINE
MAJESTY; THE HIGHEST, THE BEST, BY REASON OF HIS
SWEET GOODNESS; THE MOST LIBERAL REMUNERATOR
BY REASON OF HIS BOUNDLESS GENEROSITY.

The inscription continues along the edge of the raised step on which God the Father is seated:

ETERNAL LIFE SHINES FORTH FROM HIS HEAD. ETERNAL
YOUTH SITS ON HIS BROW. UNTROUBLED JOY AT HIS
RIGHT HAND. FEARLESS SECURITY AT HIS LEFT HAND.

A description of Christ enthroned as the king of Heaven comes in Revelation, a direct quotation of which is embroidered into God's garment,

Rex Regnum et Dominus Dominantium: "King of Kings and Lord of Lords."

This quotation indicates an origin source for the imagery of this central figure in majesty as Revelation 19:12–16:

> His eyes [were] as a flame of fire, and on his head [were] many crowns; and he had a name written, that no man knew, but he himself. And he [was] clothed with a vesture dipped in blood: and his name is called The Word of God. And the armies [which were] in heaven followed him upon white horses, clothed in fine linen, white and clean. And out of his mouth goes a sharp sword, that with it he should smite the nations: and he shall rule them with a rod of iron: and he treads the winepress of the fierceness and wrath of Almighty God. And he hath on [his] vesture and on his thigh a name written, KING OF KINGS, AND LORD OF LORDS.

Though, for the sake of modesty, we are not privy to God's thigh, "King of Kings and Lord of Lords" may be found embroidered onto the "vesture dipped in blood," in this case a gilt-edged scarlet garment.

Theologically, the Godhead consists of three parts: the Father (God), the Son (Christ), and the Holy Spirit (usually rendered as a white dove). The Holy Spirit as a dove is in the panel directly below the enthroned God the Father, creating an imaginary vertical line linking the two. The dove, a symbol of divine light, radiates sunlight over the New Jerusalem described in the Book of Revelation, for New Jerusalem "had no need of the sun, nor of the moon, to shine above it; for the glory of God did illuminate it" (Revelation 21:23).

The Lamb of God on the altar in *The Adoration of the Mystic Lamb* is a symbol of Christ, who, like the lambs sacrificed by pagans to appease the gods, sacrificed himself to save humankind and reverse the Original Sin of the Fall of Adam. The Lamb, from whose head light shines and who bleeds into a golden chalice, is an icon that represents Christ and has been used as such since the earliest Christian artworks were scrawled

or mosaicked in underground catacomb churches, hidden from the persecutions of the Romans on the earth above them.

The image originates from the Gospel of Saint John: "Behold the Lamb of God, which taketh away the sins of the world." This quotation is inscribed in gold on the red velvet antependium of the painted altar on which stands the Lamb: *Ecce Agnus Dei Qui Tollit Peccata Mundi*. One must approach the altarpiece in order to read this inscription. In doing so, the viewer is physically drawn in to examine the naturalistic wonders of the painting. Van Eyck tricks the viewer into seeing the whole picture, an astounding wash of color and form and figures, as well as the loving minutiae that leap out.

In 1887 art historian William Martin Conway wrote: "Such a [poetic] symbol was the Lamb of God. Medieval sculptors and painters never represented the lamb as a mere animal. They always made it carry a banner, emblematic of the resurrection. . . . In the Ghent Altarpiece, on the contrary, the symbolic creature is painted with perfect realistic veracity. It does not look like a symbol, it

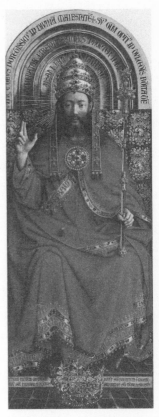

God the Father, enthroned. The crown at his feet has been considered a wonder of naturalistic detail since the fifteenth century.

looks like a sheep." Erwin Panofsky later showed how van Eyck used striking realism to convey the symbols of Christianity: "A way had to be found to reconcile the new naturalism with a thousand years of Christian tradition; and this attempt resulted in what may be termed concealed or disguised symbolism, as opposed to open or obvious symbolism. . . . As van Eyck rejoiced in the discovery and reproduction of the visible world, the more intensely could he saturate all of its elements with meaning."

In van Eyck's union of realism with Christian symbolism, art historians saw the union of two periods of art—the symbolic and often awkwardly

realized medieval paintings and the increasing naturalism, vibrancy, beauty, and detail of the Renaissance and periods thereafter. In 1860, German art historian and director of the Berlin Museum Gustav Waagen would describe *The Ghent Altarpiece* as "a perfect riddle" of the union of two artistic periods, the Middle Ages and the Renaissance.

> The three figures of the upper center picture are designed with all the dignity of statue-like repose belonging to the early style; they are painted too on a ground of gold and tapestry, as was constantly the practice in earlier times: but united with the traditional type we already find a successful representation of life and nature in all their truth. They stand on the frontier of two different styles and, from the excellences of both, form a wonderful and most impressive whole. [Van Eyck became the first to] express spiritual meaning through the medium of the forms of real life ... rendering these forms with the utmost distinctness and truth of drawing, coloring, perspective, and light and shadow, and filling up the space with scenes from nature, or objects created by the hand of man, in which the smallest detail was carefully given.

Perhaps the most dazzling example of this naturalism in the entire painting is the crown, placed on the floor at God's feet, sparkling as if spotlit, crusted in pearls, emeralds, rubies, sapphires, and diamonds. That the crown, a symbol of secular, earthly might (as opposed to eternal, heavenly sovereignty), is placed on the floor at God's feet shows its subordination to the rule of Heaven.

A close examination of the pearls on this crown reveals that most were painted in exactly three brush strokes. A dark sweep for the body of the pearl, a white lower edge to indicate the reflective curvature of the pearl's underside, and one dollop of bright white for the light caught in the pearlescent surface. Vermeer would study van Eyck's technique two hundred years later and go one better, painting the single pearl in his *Girl with a Pearl Earring* with exactly one brushstroke.

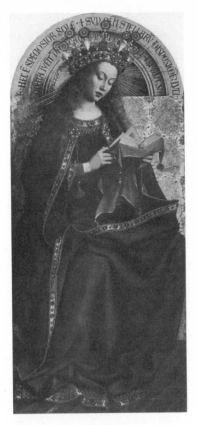 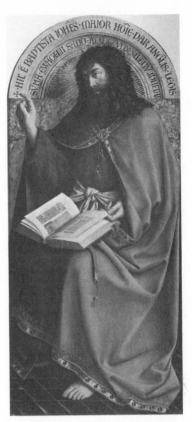

Mary, enthroned in Heaven, sits to
the right of God, while Saint John
the Baptist sits on God's left

Saint John the Baptist, enthroned

In its depiction of the Virgin Mary (center left) and John the Baptist (center right), van Eyck's altarpiece differs from the common use of these powerful saints. Usually they served in a role known as *intercessio*—that is to say, they were most often depicted vouching for the souls of the painting's donors, interceding on their behalf and recommending them for entry into Heaven. Traditionally the saint who shares the first name with the donor would be shown interceding on his or her behalf, while the donor is knelt in pious prayer.

It was unusual at the time to present Mary and John the Baptist removed from an *intercessio* situation, although the grisaille John the Baptist

painted beside Joos Vijd on the outside of the altarpiece might be inter-
preted as an *intercessio*. John the Baptist would normally be depicted in
the midst of a moment from his life, the Baptism of Christ for instance,
or interceding for a patron, rather than as a supplemental, monumental
figure as he is here. Even more unusual, John is not accompanied by his
hagiographic icon, a lamb, which indicates Christ. While John does carry
a lamb in the grisaille version on the outside of the altarpiece, here his
only identifying attribute is the hair shirt in which he is traditionally
painted. Thus, with the Baptist pointing at a bearded, enthroned holy fig-
ure, the natural assumption, which van Eyck wanted us to consider, is
that the central figure is Christ Enthroned. And yet, as we have discussed,
the central figure is, in fact, God the Father, not Christ. In encouraging
this confusion, van Eyck highlights the complex theological point that
the Holy Trinity consists of three persons in one Godhead—at once dis-
tinct from one another and yet inextricably entwined. It makes theological
sense, therefore, that we would be uncertain as to whether this figure is
God or Christ. In theoretical essence, it is both. In practical iconographic
terms, it is God the Father meant to evoke Christ.

Mary, as well as John, differs in van Eyck's treatment of her from the
traditional precedents. She would normally be shown with the Christ
child or alone, enthroned at the center of a choir of angels, as in the
Maesta paintings (of which Duccio and Giotto painted famous examples).
Yet here Mary and John the Baptist, while glorious and colossal, play a
subservient role, secondary to the overall theological theme. This tells nei-
ther Mary's story nor the Baptist's, and they do not intercede on behalf
of the donors—van Eyck has presented them in a new way.

These three top-register central panels place their subjects on a per-
spectively accurate tiled floor, the grout of the tiles indicating the orthog-
onal lines that lead our eyes back to the vanishing point, somewhere
behind God's head. This trick of perspective was new to artists and would
not become commonplace until the Italian architect Leon Battista Alberti
wrote a mathematical treatise on painting perspective in 1435, three years
after the completion of *The Ghent Altarpiece*.

The Ghent Altarpiece represents a series of firsts in the known history of art, sparking trends that would be praised and embraced by future generations of artists and admirers. For most artists of the premodern period, as many as two-thirds of the known works that they painted during their lifetime are considered lost. Because of this, we can only say that, of the *extant* works of European art, and based on extant Renaissance documents, *The Ghent Altarpiece* was the first to implement a wide array of innovations.

In *The Ghent Atlarpiece,* Jan van Eyck was the first artist to paint monumental works with an intricate level of detail usually reserved for portrait miniatures and illuminated manuscripts. He was also the first to observe naturalistic details. He was the first to portray the unidealized human nude. His incorporation of a painted haze over the landscape as it stretches into the distance makes him the first to re-create the illusion of aerial perspective. He first rendered individually detailed faces in a large crowd. The bodies, too, were the first to be articulated beneath painted clothing, giving the impression of people wearing the clothes, rather than of the clothes floating around the people. From an iconographic standpoint, van Eyck was the first to imbue realistically realized and situated objects with a covert Christian symbolism—a technique that would come to be called "disguised symbolism" and that played a prominent role in European painting over the next two centuries.

In terms of his role in establishing or foreshadowing future artistic movements, van Eyck was second to none in influence. Although he did not invent oil painting, he brought it to an unprecedented level of excellence, turning the mere binding of pigments with oil into a masterful medium that would be preferred by every painter thereafter. Along with Giotto in Italy, Jan may be considered the first Renaissance painter. In his unparalleled realism, Jan may be considered a forefather of Realism as an artistic movement.

Who, then, was Jan van Eyck?

The Magician in the Red Turban

Jan van Eyck has been called the last painter of the Middle Ages—but also the first of the Renaissance. Scholarship over the last two centuries has labeled him a Realist, and therefore a prophet of the modern period, working four hundred years before the Realist movement. Called an alchemist and the inventor of oil painting, van Eyck was also a respected courtier, ambassador, and secret agent. He was a legend even in his own time.

Jan van Eyck was born sometime before 1395 and died sometime before 9 July 1441. His probable birth place was Maaseyck, in the Limbourg region of what is now Belgium. Little of his life story can be stated with certainty, including his place of birth. It was only in the late 1570s that a reference was made to van Eyck having been born in "Maesheyck" (spelling at the time was creative and flexible, so this is the same town as modern Maaseik), in records kept by Ghent scholars and artists Marcus van Vaernewyck and Lucas de Heere. A further clue to van Eyck's birth region comes in the notes that he made on the only extant drawing attributed to him, his *Portrait Drawing of Niccoló Albergati*, which are written in a dialect unique to the Maasland region (now a part of the Netherlands but which once encompassed van Eyck's birthplace), called Mosan.

Still, a great deal more is known about Jan than most fifteenth-century figures because he was an influential member of two princely courts. He had at least two brothers who were painters, Lambert and Hubert, and a sister, Margaret, who also seems to have painted. He lived and worked

first in The Hague, in the service of John of Bavaria, the Count of Holland, from sometime before 24 October 1422 (when he is first mentioned in documents from the Holland treasury office) until 11 September 1424. These documents refer to a "Meyster Jan den maelre" (Master Jan the painter), whose primary task at this time, along with a bevy of assistants, was an extensive scheme for decorations and frescoes in the Binnehof palace in The Hague, the headquarters of the Counts of Holland, now lost. The Counts of Holland were, at this point, members of the German Wittelsbach family, the current head of which was John of Bavaria-Straubing, called "the Pitiless," whose official title was "Count of Holland and Zeeland."

Just how the young van Eyck entered the service of the Counts of Holland is unclear. John of Bavaria had been elected prince bishop of Liège, the largest city in the region of van Eyck's hometown of Maaseyck. Geographic proximity aside, the path of van Eyck from young apprentice to young master to leading painter at the court of the Counts of Holland is unknown.

This lacuna is particularly striking, and intriguing, because there is no artistic precedent for van Eyck's style of painting. For most artists in history, a clear path may be traced, from master to apprentice, with subtle new innovations, techniques, and improvements in each generation. But with van Eyck, as with the small handful of other revolutionary masters like Donatello, Michelangelo, Caravaggio, Bernini, and Turner, an entirely new way of depicting the world exploded out of thin air, a blossoming tree with no evident roots linking it to past masters.

The best guess is that van Eyck applied miniaturist techniques, made more malleable and facile through the use of oil paints, and transposed them onto large-scale works. But this does not account for the level of observational realism. It is one thing to be physically able to paint the pores on a man's skin; it is another to choose to do so, when no other artists had thought to. Even the possibility that van Eyck developed his penchant for detail by training as a manuscript illuminator is a flawed hypothesis. Jan's studio did produce illuminated manuscripts, including

some attributed to his hand alone (as opposed to his studio in general, where it might have been painted by assistants under van Eyck's supervision). But those pages attributed to van Eyck, such as the *Birth of Saint John the Baptist/Baptism of Christ* (circa 1440) are painted too thickly for a well-trained manuscript illuminator, suggesting that Jan did not have training in this medium, instead bringing his large-format talents to the microscopic medium, rather than the other way around.

The art that dominated the French and Burgundian courts at the cusp of the fifteenth century had an amalgam of influences ranging from imported Sienese painters who attended the papal court in Avignon (including Simone Martini), to Germanic sculptors (Claus Sluter), to portrait miniaturists and manuscript illuminators (Jacques Coene, Jacquemart de Hesdin, and the Limbourg brothers), and Burgundian proto-realists who best approximate a precursor to van Eyck (Melchior Broederlam and Robert Campin), although van Eyck went far beyond what they had achieved. But these stars do not form a cohesive constellation of van Eyck's artistry, and no specific works survive that indicate a gradual development from the earlier court artists to Jan van Eyck.

Perhaps a clue as to van Eyck's inspiration may be found in polychrome sculpture? We know that Jan polychromed (that is to say painted) sculptures while working for the Burgundian court; in 1432 he painted a series of statues of the Counts of Flanders to decorate the city of Bruges. The masterpiece of the great sculptor to the Dukes of Burgundy, Claus Sluter, called the *Well of Moses* (1395), also presented a level of realism not dissimilar to that in *The Ghent Altarpiece*, albeit in its own three-dimensional medium. The sandstone sculpture group, which incorporated a Calvary scene atop, supported by four life-size Old Testament prophets, was built above a well in the Charterhouse of Champmol, established by the Dukes of Burgundy in Dijon. The sculptures, which have a portrait-like realism to their faces and carved garments, were once painted and decorated with real human hair—one figure even wore a pair of real spectacles, to lend the work an almost eerie degree of realism: if you saw it out of the corner of your eye, you'd swear that you'd seen a group of real people.

The nearest approximation in painting is an anonymous altarpiece referred to as *The Norfolk Triptych* (circa 1415), once owned by the Duke of Norfolk. Like the work of van Eyck a decade after, this small household altarpiece has the same general panel design as *The Ghent Altarpiece*, albeit on a much smaller scale (it is 33 centimeters high by 58 centimeters across.) When closed, two raised portions of the wings meet each other at the center, and when opened, the altarpiece resembles a crenellated battlement, or perhaps a letter E turned on its side. Almost nothing is known about the creator of this altarpiece, a frustrating fact, since the creator is the most likely candidate to have been master to the young Jan van Eyck. We know that the painting came from the Maasland region, as did van Eyck. An analysis of the painting, which is currently in the Museum Boijmans van Beuningen in Rotterdam, shows that the paint is a combination of egg tempera and oil—suggesting that this particular work may have introduced van Eyck to the possibilities of oil paint. Indeed, given the date (when Jan would have been approximately twenty-five years old), *The Norfolk Triptych* could plausibly be attributed to him, although no documentary evidence suggests this. Further, the jump in skill and detail from *The Norfolk Triptych* to *The Ghent Altarpiece* is substantial. Either van Eyck would have had to experience his own personal artistic revolution in the decade separating *The Norfolk Triptych* and *The Ghent Altarpiece*, or, more likely, van Eyck was not the anonymous painter of *The Norfolk Triptych*.

Two other major artists have been suggested as possible masters to the young van Eyck, guiding his apprenticeship. Robert Campin, also known as the Master of Flemalle, was born in Valenciennes and resided in Tournai, while he worked for the Dukes of Burgundy. His skill and realism, while not as dramatic as van Eyck's, still provide a reasonable precedent for Jan, and his personal history might help to explain why no reference has been discovered linking young Jan to Campin. In 1429, Campin was convicted in court for having withheld evidence in a political scandal, and sentenced to go on pilgrimage. Then in 1432, the year *The Ghent Altarpiece* was completed, Campin was charged with adultery and banished

from the duchy for a year. Only through political intervention was the sentence commuted to a fine. These scandals may have made it prudent for van Eyck to distance himself from Campin, if indeed Campin had once been van Eyck's master.

The other candidate for master to the young Jan is Melchior Broederlam. Born in Ypres, he worked primarily for Duke Philip the Good's grandfather, Duke Philip the Bold, first as *valet de chambre* and then as official court painter—both roles that van Eyck would fill two generations later. Broederlam used oil paints, and some works that have been attributed to an anonymous Mosan artist have also been attributed to him. His role in the Burgundian court, his age, and his use of oils make him a candidate to have been van Eyck's master. But the styles of both Campin and Broederlam differ significantly enough from van Eyck's that the connection cannot be made on stylistic points alone, and no documentation survives to inform us of Jan's artistic mentors.

From the fall of 1424, Jan van Eyck entered the service of Philip the Good as official court painter, based primarily at the court in Lille. Records indicate that in this capacity van Eyck was required "to execute paintings whenever the duke wished him to." The Burgundian court moved from city to city as the duke's presence was required. Thus van Eyck's existence was nomadic, albeit within a fixed region of sumptuous residences. He was also active as a political member of court, holding the coveted position of *valet de chambre* in the Duke's personal retinue from 1425. The *valet de chambre* was like a personal secretary, with regular, direct access to the duke. This was an advantageous position, but because it required van Eyck to follow the duke constantly, he had little time to paint.

Beginning in the fourteenth century, the position was regularly given to artists and writers, whose advice and companionship were valued by the political elite in northern Europe long before artists would find acceptance in the aristocratic courts of the south. The desirable position came not only with a substantial salary of 1,200 livres per year (about $200,000 today), but also with benefits, including food, lodging, travel expenses, and even opulent clothing.

As *valet de chambre*, van Eyck had a strong political role by association, if not actively: with the ear of the duke, van Eyck was influential behind the scenes. His power and income also permitted him a financial independence that none of his fellow artists could boast. Free of the often Draconian restrictions of the local painters' guild (in fact the court painter was not permitted to work on the open market and could only accept a commission with the duke's blessing), van Eyck was as powerful an artist, politically, personally, and creatively, as any had ever been. Other painters held the coveted title of *valet de chambre* in France and Burgundy, including Melchior Broederlam, Francois Clouet, Paul Limbourg, Claus Sluter, and even a probable relative of Jan's, by the name of Barthelemy d'Eyck. In Italy, Raphael would play a similar role, the first prominent Italian painter to act as courtier and political advisor, as well as an artist. Of the French and Burgundian *valets de chambre*, Jan van Eyck was the most famous, the best paid, the dearest to his master, and the most active politically.

Van Eyck worked for Philip the Good as an ambassador and as a secret agent. Though little concrete documentary evidence has come to light, it is known from contemporary sources that Jan traveled on secret missions on behalf of the duke. Such is the nature of secret activities—the more successful they are, the less trace they leave. Most likely these missions involved confidential dealings of a political or economic nature. References to these activities in contemporary documents describe them as "secret" and "special," and note his significant remuneration for them, yet say little more. For example, a document from the winter of 1440 states that van Eyck delivered "certain panels and other secret items" to the duke, and he was reimbursed for expenses incurred in the acquisition of these "secret items" in January 1441. As an artist who might be sent to paint at various rival courts, van Eyck was almost certainly also a spy.

There are a number of Renaissance artists for whom we have fleeting archival evidence of their employment as secret agents on behalf of the court for which they worked. Famous artists or writers tipped as spies include poet Geoffrey Chaucer, Raphael, Benvenuto Cellini, Gentile Bellini, Rosso Fiorentino, playwright Christopher Marlowe, Albrecht

Dürer (who in 1521 made pilgrimage to see *The Ghent Altarpiece* and described it as a "very splendid, deeply reasoned painting"), the magician John Dee, and the philosopher Giordano Bruno. The fact that dukes and princes would loan artists to rival courts to pursue artistic commissions, an engagement portrait for instance, could be used as an excuse to place a trusted courtier deep inside an enemy's headquarters. We know that the playwright Marlowe was sent to spy for England in Venice because of a document signed by Queen Elizabeth I preserved in Cambridge. The letter asks Marlowe's Cambridge tutors to excuse his absence from classes, as he was abroad engaged in secret work for the queen. Gentile Bellini was sent by the Venetian Republic as a sort of diplomatic loan to the Turkish sultan Mehmet II. Bellini befriended the sultan, painting his portrait (which still exists) and a number of other works while in Istanbul. But Bellini was certainly acting as a spy as well, sent during the brief hiatus in the wars between Venice and the Ottomans.

So what was Jan van Eyck up to? We know that in 1425 he was sent to nearby Bruges and Lille on the first of his recorded secret missions. In July 1426 and again from August until 27 October of that same year, he was abroad engaged in secret activity, at an unknown location referred to in contemporary documents as "certain distant lands." Court treasury records indicate that he was reimbursed for expenses incurred on a "secret and distant journey." Some scholars believe that he was sent to the Holy Land, because of the uncanny accuracy of the landscape view of Jerusalem in *Three Marys at the Tomb*, attributed to van Eyck and his workshop. He was sent to Tournai on 18 October 1427 to attend a banquet in his honor, held by the local painter's guild on the Feast of Saint Luke, patron saint of painters. The event was probably attended by famous contemporary Flemish artists, Rogier van der Weyden and Robert Campin. He returned from another unknown location in February 1428, for which he was reimbursed and received a bonus on top of his annual salary for "certain secret journeys." He began his longest trip on 19 October 1428, when he was sent to Spain and Portugal as part of a Burgundian delegation, returning on Christmas day, 1429. This mission was undertaken

to secure Princess Isabella of Portugal's hand in marriage for his patron, ensuring an alliance between Burgundy and Portugal. It also involved a detour to visit the famed pilgrimage shrine of Santiago de Compostela. Although Jan's official assignment in Portugal was to paint two portraits of Isabella (one sent by sea and one by land, to ensure that at least one would reach Burgundy), he was also active in the political arena, helping to negotiate the terms of the marital alliance.

It is estimated that Elisabeth Borluut and Joos Vijd commissioned *The Ghent Altarpiece* in 1426, although no document confirming its date of commission survives. Elisabeth came from a wealthy Ghent family; her relatives had been abbots of the nearby Saint Bavo's Abbey. Joos was the son of Nikolaas Vijd, a knight whose family was raised in rank through military service. Nikolaas served honorably for decades under the last Count of Flanders, Louis de Male. When Louis de Male died in 1390, his daughter Margaret of Dampierre inherited the county of Flanders, including Ghent. She married Philip II (Philip the Bold), Duke of Burgundy. The territory would pass on to their son, John the Fearless, the father of van Eyck's patron, Philip III (the Good).

When the county of Flanders passed into the hands of the Dukes of Burgundy, a scandal unfolded. Account books from the city of Ghent were newly examined by Burgundian ministers, and Nikolaas Vijd was found guilty of embezzlement. This charge may or may not have been legitimate—perhaps it was an excuse to humble the right-hand man of the last, vanquished Count of Flanders. But Nikolaas was impelled to pay a large fine, and was stripped of his offices.

There is no record of how the Vijd children, Joos and Christoffel, took their father's disgrace. But in Joos's grandiose donation and patronage of an artistic masterpiece, there may have been a desire to erase the humiliation of his father's guilt.

Joos Vijd was a politician and a philanthropist. He served on the Ghent city council on four different occasions and was the city's principal alder-

man, the equivalent of its mayor, in 1433–1434. He traveled with Duke Philip the Good through Holland and Zeeland. He also worked as special emissary for Duke Philip in Utrecht. It was in these capacities, involved with the Burgundian court, that he met Jan van Eyck.

Joos founded a charitable hospice run by Trinitarian monks, with the twofold agenda of lodging poor pilgrims and arranging to pay ransom for Christian slaves taken during the Crusades and on pilgrimage. This charity may have been inspired by some of Joos's relations, who in 1395 had participated in a failed rescue mission under Duke John the Fearless to aid King Sigismond of Hungary and free Christian slaves held by Sultan Bayezid I. While Duke John's fighting prowess earned him the nickname "the Fearless," the mission was a disaster; it led to the imprisonment of the duke and his knights by the sultan until 1397, when, ironically enough, their own freedom had to be ransomed.

Joos Vijd's coat of arms may still be seen in the keystone of the vaulting of the chapel ceiling. The chapel was established for the celebration of a daily Mass in honor of the donors, in a deed dated 13 May 1435. There was a widespread Catholic belief at the time that once someone died, the deceased would ascend out of Limbo into Heaven more quickly if the living prayed for their souls. The more people who prayed, particularly monks (and the more frequently the better), the faster their souls would rise to Heaven. As a result, aside from the charitable support of a beloved religious institution, and the creation of a memorial, donors were essentially paying their way into the fast lane to Heaven.

To this end, part of the contract that Joos Vijd and Elisabeth Borluut drew up, when they paid for the chapel and the altarpiece, included provisions for the celebration of Mass on specific feast days and the prayer for their souls by a specific number of monks, a certain number of times per year. Joos and Elisabeth had no children, another potential reason to endow a chapel and the celebration of Masses. Without children to pray for their souls, they needed the monks to pray for them.

How do we explain the grandiosity of Vijd's commission? Why did he choose to work with the most prominent artist of the age on such a colossal scale? To underscore one's piety, to speed one's soul out of Purgatory,

to demonstrate one's wealth—these are all legitimate rationales for com-
missioning *an* altarpiece. But there is no precedent for any painting of
this scale, with this number of figures, this degree of realism, this combi-
nation of microscopic detail with a macroscopic vantage, in any previous
work of northern European panel painting. In order to secure Jan van
Eyck as an artist, services that were first and foremost promised to the
duke, Vijd would have had to have serious connections—or the duke a
rationale for permitting a local aristocrat, rather than himself, to bask in
the glory of having commissioned the greatest painting of the age. Such
questions have not been definitively answered, and the lack of closure has
prompted a variety of theories, several rather more conspiratorial than
sober, about why this masterpiece should rise like a leviathan out of the
sea: miraculous, without precedent, and provoking more questions than
answers.

A possible answer to the question of why *such* a work was created may
present itself if we recall that 6 May 1432 was the date of both the first
presentation of the altarpiece to the public and the baptism of Duke
Philip's son, also named Joos, who had been born April 24. The two
events took place in the same church, in the same chapel. Therefore the
altarpiece may represent not only the commission of the Vijd family but
also a literal backdrop for the baptism of the son of Duke Philip the
Good, a son on whom rested the hopes of the Burgundian dynasty. Of
course Philip could not know that the timing of the completion of the
altarpiece would coincide with the birth of his son, so this rationale would
only explain the date of the presentation of the altarpiece, not why its
commission was approved in the first place, years before. Alas, young Joos
of Burgundy was not to be the future duke, as he died just weeks after
the ceremony in which he was formally named.

It is noteworthy too that the duke's infant son and the patriarch of the
Vijd family shared the same first name. While there is no reason to think
that the infant was named after him, the coincidence would likely have
been seen as fortuitous to the local aristocrat Joos Vijd, who would have
been both honored and proud. The fact of the baptism coinciding with

the completion of the altarpiece would explain why Duke Philip permitted his personal courtier to paint such a monumental work on behalf of a local aristocrat. Philip might have imagined that the altarpiece would serve as a backdrop for some major event, the birth of *a* son, or perhaps even his third marriage (to Isabella of Portugal), as he could not have predicted, in the late 1420s, which events in his personal life would coincide with the completion of the altarpiece. Van Eyck, like so many great Renaissance artists, was engaged frequently in the mounting of temporary decorations to celebrate one-time events, from weddings to royal visits—decorations that would be dismantled soon after the event took place. As a result, a large chunk of the time and effort of Renaissance court artists was focused on temporary artistic installations never intended to outlive the events themselves—precious time that might otherwise have been directed towards the creation of more masterpieces for the ages. This is a frustrating fact for art lovers, who would welcome a few more extant van Eycks in today's museums, and was perhaps likewise so for the Renaissance artists themselves. With this in mind, we might consider that, while for van Eyck and for Joos Vijd, *The Ghent Altarpiece* was a monument for the ages, for Duke Philip the Good, the altarpiece served merely as a most elaborate and intricate stage set, a backdrop that would be used for the baptism of his son, born just as the altarpiece was completed.

It has generally been assumed that a learned theologian advised van Eyck on the iconography of *The Ghent Altarpiece*, designing an elaborate symbolic scheme, one that would require extensive knowledge of theological sources in a variety of languages. Most Renaissance artist contracts specified what the painter was to paint, which allegories might be represented, for example, and the biblical or literary scenes therein. The interpretation, or *invenzione*, as the Italians called it—what to do with the specifications—was up to the artist. But the scenes were, in the main, dictated ahead of time by the commissioners and their advisors.

What is particularly astonishing in the case of *The Ghent Altarpiece* is that no evidence has been found to suggest that elaborate predesigned

schemes for religious artwork played a role in Flemish or Netherlandish art of this period. That is to say, in terms of theological complexity, *The Ghent Altarpiece* is without precedent. That does not necessarily mean a theologian did not design the concept of the work, but it does mean, if one did, it was a first in the art of the time. It is only one generation later that documents have been found that attest to another Flemish master, Dirk Bouts, having been advised on his iconography by a theologian.

One scholar, Dana Goodgal, not only believes that a theologian was responsible for the altarpiece's iconographic scheme but has named an entirely plausible candidate for the role. Olivier de Langhe was the prior of the Church of Saint John (later renamed Saint Bavo) while the altarpiece was being painted. De Langhe's most notable known accomplishment was a treatise on the Eucharist—a subject that resonates with the Christ-as-sacrificial-lamb theme of *The Adoration of the Mystic Lamb*. Van Eyck scholar Craig Harbison draws parallels between De Langhe's text and *The Ghent Altarpiece*:

> De Langhe's thought also corresponds with the image in the way it presents a traditional view of the nature and necessity of Church ritual. As visualized by van Eyck, the saints, martyrs, prophets and highly-placed ecclesiastics, both bishops and confessors, lead the strictly regulated religious and social groups that adore the sacrificial Lamb of God. A mystical vision of the Godhead— Paradise—is only accessible through the carefully mapped paths of traditional Church leaders and theologians ... [reiterating] in a many-layered form the centuries' old claim of the Church hierarchy to absolute authority.

In this way, *The Ghent Altarpiece* could be seen as a collective affirmation of traditional Catholic values as the only way to access the Godhead. Although no documentary evidence confirms this, Olivier de Langhe was in the right place, at the right time, possessed the right knowledge, and wrote about relevant topics, all suggesting that he might well have been

the theologian who developed the iconographic scheme for *The Ghent Altarpiece.*

Van Eyck's role as court painter required his participation in a wide variety of painting and design-related enterprises beyond wall and panel painting. In fact, panel paintings were very low on the priority list for court painters, whose primary tasks involved wall painting to decorate official residences, manuscript illumination, and the design of events. There are strikingly few references to panel paintings in Flemish court inventories, indicating the low importance given to them. In the main, only portraits, kept for historical record, would be assigned to court painters. These artists would more likely be tasked with painting temporary installations for a ducal festival or banquet. In the mid-1430s Duke Philip held a banquet at which a huge pie was rolled out of the kitchen: A man dressed as an eagle leapt out of it, followed by a flurry of doves, which then landed on the tables of the guests. It is almost certain that designing banquets such as that one, and the decoration of foodstuffs, occupied van Eyck's time.

After the January 1430 wedding of Philip the Good and Isabella of Portugal, with his political and ambassadorial work well done, Jan finally settled in Bruges. He married a woman described in contemporary documents as "damoiselle Marguerite," suggesting that she may have had aristocratic lineage. Their first child was born in 1434 and christened Philippot, named after his godfather, Duke Philip the Good. A portrait of Mrs. van Eyck, painted by her husband in 1439, shows her clothed in garments associated with the nobility. It is the only extant stand-alone portrait of a girl or woman by van Eyck. Jan painted a self-portrait, a pendant to accompany the portrait of his wife, both of which hung in the Bruges painters' guild in the eighteenth century. The *Portrait of Marguerite* was lashed onto the guild wall with heavy iron chains, because the *Self-Portrait of Jan* had been stolen at an unknown date from the guildhall.

Some scholars have guessed that the *Man in a Red Turban*, which hangs in London's National Gallery, is the stolen self-portrait, as its size is nearly identical to that of the *Portrait of Marguerite*, as would be the case for matching pendant portraits.

From 1432 until his death, Bruges town records indicate that van Eyck made annual mortgage payments on a house and workshop, which was owned by the church of Saint Donatian, in which he would ultimately be buried. That same year, records note that the councilors of the city of Bruges visited van Eyck's studio in an official capacity, welcoming the great master to the city and lavishly handing out tips to Jan's twelve studio assistants. His career as a secret agent appears to have ended when domestic duties called, although he would undertake two more missions to "foreign lands" in order to conduct "secret business" on behalf of the duke in 1436, to an undisclosed location, for which he received double his normal pay. He undertook a final mission, to pick up "certain panels and other secret items" and deliver them to the duke, in the winter of 1440. There is a record of Jan having been repaid for the expenses related to this last mission in January 1441, just six months before he passed away.

Van Eyck's various travels certainly interrupted the painting of *The Ghent Altarpiece*. It was completed only after he had moved from Ghent to nearby Bruges. But Jan still kept in contact with the city of Ghent and its patrons—his *Saint Barbara* (1437) was commissioned by a man from Ghent.

Jan was close to Duke Philip, a confidante as well as an employee of the Burgundian leader and by some accounts his friend. The duke ultimately became godfather to one of Jan's children, Philippot (the Duke presented the van Eycks with six silver goblets as a birthday present). Through the end of his life, Jan retained the position of painter to the duke, along with the accompanying salary of 720 livres per year (around $120,000 today). The duke took pains to continue to pay van Eyck's widow even after the painter's death, granting "*damoiselle Marguerite . . . 360 livres en 40 gros,*" the artist's pension (half of his annual income while he was active), as a condolence and a sign of his affection for the great

painter and compassion for his family. As late as 1449, the duke paid for most of the entrance fee required for one of Jan's children, "Lyevine van der Eecke," to enter the convent of Saint Agnes in Maaseyck.

Once in Bruges, when he wasn't creating wall paintings for the duke's residence in Hesdin, Jan worked primarily for private patrons, whose portraits comprise the majority of his known paintings. The most renowned of these is *The Arnolfini Wedding Portrait*, also called *The Marriage Contract* (1434), now in the National Gallery in London. Only twenty-five extant paintings have been definitively attributed to Jan's hand—a tiny number, making them all the more precious. Records indicate many others, all of them lost. Another twenty or so paintings are tentatively thought to be by van Eyck, or at least by his studio, though all of these have been disputed at some point, making the attribution uncertain.

After a long, illustrious career, Jan died and was buried in Bruges on 9 July 1441, in the graveyard of the cathedral of Saint Donatian. Nine months later, his brother Lambert arranged for Jan's body to be exhumed and entombed in an honorable location inside the church. This same church would be looted and destroyed by French troops in 1799, a few years after they had stolen most of the panels of *The Ghent Altarpiece* and brought them to the Louvre. Lambert, a fine painter in his own right, took over Jan's studio, supervising the apprentices and the incomplete commissions, while Jan's widow, Marguerite, ran the business side of the workshop until 1450—the year in which van Eyck's home in Bruges was finally sold to a new family.

Jan was one of the rare early Renaissance artists to achieve renown and wealth during his lifetime. He was paid a bonus of six hundred gold coins upon the completion of *The Ghent Altarpiece* in 1432 and was in constant demand thereafter. This bonus alone was the equivalent of the annual salary of twenty skilled workers.

Duke Philip the Good placed extraordinary value on the service of his court painter. In a 13 March 1435 document, Philip berated his treasurers in Lille for paying Jan's wages late, stating that should Jan ever leave his court, Philip would never be able to find Jan's equal in his "art and science."

That same year Philip summoned van Eyck to Arras, where the artist accompanied his master during the delicate negotiations for a peace treaty between France, England, and Burgundy. It is tempting to wonder what might have been the "science" to which Philip referred. Painting was an art, and perhaps politics was the "science." Or was Jan engaged in alchemy, as sources one generation later would suspect?

Giorgio Vasari thought as much. The sixteenth-century Mannerist painter and biographer of Renaissance artists wrote glowingly about Jan van Eyck in his canonical *Lives of the Artists* (1550). His discussion of van Eyck in a chapter on the earliest great Italian oil painter, Antonello da Messina, represents a rare inclusion of praise for a non-Italian in a work dedicated to the glorification of Tuscan art, Michelangelo's in particular.

Vasari is responsible for a popular misconception that Jan van Eyck invented oil painting. It is the chemical concoction of oil paints that likely accounts for Vasari's reference to van Eyck as an alchemist. Before the early fifteenth century, the preferred medium for painting had been tempera, which uses egg as the binding agent for hand-ground pigment. Pigment is ground into a fine powder with a mortar and pestle, then mixed with raw egg yolk to produce a paste. The result is an opaque paint, in which each layer essentially covers over the layer beneath it.

Oil paint, as the name implies, uses a combination of oils, usually linseed and nut oils, instead of egg, as the binder. The result is a translucent paint that is easier to control, permitting finer detail, and one in which each layer may be seen slightly through subsequent layers. As a result, one can paint in oils with a great deal more subtlety.

There is no indication, beyond Vasari's comment, that Jan invented oil painting. But as the first art historian, and a friend (and sometimes rival) of many of the artists about whom he wrote, Vasari told stories that tended to stick. One might think that a contemporary, and a fellow painter, would be a highly reliable source as biographer. But much of Vasari's work is skewed by rivalries, and there is a clear propagandistic edge to his praise, which presents Michelangelo, Vasari's close friend and his own source of inspiration, as the greatest artist of all time. Many

would agree with this estimation, so that, in and of itself, is not grounds to dismiss Vasari. But in recent years art historians have noted the many inaccuracies in Vasari, and his *Lives of the Artists* has shifted from the number one source for research into Renaissance artists, the starting point for scholars, into one of many useful sources.

Vasari's primacy carried into the twentieth century, and his manner of writing, accessible and full of quirky anecdotes and gossip about the lives of the artists, means that what Vasari wrote was not only taken seriously but was memorable. It is perhaps odd, though, that Vasari should attribute the invention of oil painting to van Eyck, when works in oil exist that predate Jan's career. Vasari was likely unaware of *The Norfolk Triptych*, which was painted with a combination of tempera and oil, and of the oil paintings of Melchior Broederlam that came a generation before Jan, or at least unaware of their dates. For artists like van Eyck, whom Vasari did not or could not know, the biographer relied on hearsay, rumor, and legend to fill in the gaps. Yet there is no evidence that Jan's fellow countrymen in Flanders believed that he had invented oil painting, until after the publication of Vasari's book, at which point they began to tout their hometown hero as the inventor of the medium. One fact from Vasari is almost certainly true: Oil painting did not arrive in Italy until the Sicilian painter Antonello da Messina traveled to Flanders to learn the secret of painting in oils from van Eyck.

We may state with confidence that, among northern European artists, Jan van Eyck perfected the use of oil paints in a way that no one had before, and that would influence all artists thereafter. The Flemish painter and art historian Karel van Mander, a generation younger than Vasari, wrote a history of northern European artists in which he called Jan and his brother Hubert van Eyck the "founders of Netherlandish art," artists who began painting in egg tempera and first invented an oil-based varnish as a sealant to their works in tempera. Van Mander tells a story that Jan van Eyck was drying a varnished panel in the sun one day, when the wooden joins between the strips of wood that comprised the panel painting pulled apart, and the painting was ruined. He decided that he needed

to find a way to speed up the varnishing process, and tried to do so by mixing in quick-drying walnut and linseed oils. Success with varnishes led van Eyck to experiment with linseed oil as a binder for pigment—the resulting oil paints were easier to control, to layer, and to blend to a mirror-sheen surface.

The theory that Jan van Eyck invented oil painting was officially disproved in 1774, when the great philosopher and art historian Gotthold Ephraim Lessing, author of *Laocoön*, published his discovery of a twelfth-century monastic manuscript that described how one could use oil to bind pigments, in his translation of *De diversis artibus* ("On the Various Arts"), a book written by the Benedictine monk, artist, metallurgist, and armorer Theophilus Presbyter (the pseudonym for Roger of Helmarshausen) sometime between 1110 and 1125. Lessing's translation was published in 1774 as *Vom Alter der Ölmalerey aus dem Theophilus Presbyter* and was the first printed edition of Theophilus's treatise. Even after the book was published, the legend of Jan's invention persisted, as resonant myth will so often do when its primacy and beauty outshine the discovery of fact.

While oil paint was surely invented long before van Eyck, Jan was the man who transformed the mere binding of pigments with oil into Oil Painting, imbuing power, beauty, and delicacy into what would become the preferred painting medium from that point forth to this day. That van Eyck should not have invented oils did nothing to dull Lessing's admiration for the Flemish master. The great philosopher wrote: "If Jan van Eyck did not invent oil painting, did he not at least render it so very great a service, that this service may be prized as highly as its first invention and ultimately even be confused with it?"

But Lessing's publication did little to defuse the popular myths around van Eyck. Through the fog stirred up by legend, it is often difficult to distinguish historical fact from elegant fiction. In the mid-nineteenth century, for instance, a popular Romantic myth described van Eyck as a folkloric painter-cum-magician, an artistic genius who locked himself by night in a mad scientist's alchemical laboratory, trying to perfect his secret recipe for oil paint.

An illustrated serial printed in the French journal *L'Artiste* in 1839 told the story of two Italian painters famous in their own right, Domenico Veneziano and Andrea del Castagno, who were sent to spy on van Eyck and steal his recipe for oil paint to return artistic glory to Italy. Jan fled the nosy Italians by night along with his brother Hubert and his sister Margaret, returning to his family home in Maaseyck with the secret recipe. But before he left, he set an incendiary trap in his studio. The Italian painters tried to break in, and the studio went up in flames. Unharmed, the Italians hunted down van Eyck, catching up with him in Bruges. Andrea del Castagno, with his suave Mediterranean charms, seduced Margaret into providing him with the recipe for oil paints, which is how the medium first came to Italy.

A lovely story, but none of it true.

From his own day onwards, Jan was mythologized by many who came into contact with his work. A substantial biography of him predates Vasari by a century. In 1455 a humanist scholar from Genoa, Bartolomeo Facio, wrote *De viris illustribus*, "On Illustrious Men," in which he named Jan van Eyck "the leading painter of his day." This was strong praise indeed coming from a nationalistic Italian, particularly when artists such as Rogier van der Weyden, Fra Angelico, Fra Filippo Lippi, Masaccio, Robert Campin, Botticelli, and Ghirlandaio were van Eyck's contemporaries. We also learn from Facio that Jan was unusually well-read, with a particular passion for the Latin authors Pliny the Elder and Ovid. In an era with a sliver of a literacy rate, it was highly unusual that a painter who was not also a monk would be versed in Latin.

How would it have felt to stand inside a real painter's studio in midfifteenth-century Flanders? One might imagine the thick scent of oils in a poorly ventilated room. The sun slants in from windows along the southern wall. Dusty costumes and props are piled in a corner. On an oak table, pigments are churned to paste by pestles in marble mortars. Smooth oak panels, finely joined and destined to be the support of future paintings, were made at great cost by a specialist carpenter and now stand stacked carefully in a corner, separated by rags to prevent scratches. Clay pots line a shelf, covered in archaic labels and filled with powders and raw

materials to grind for paint: charcoal for black, orpiment for yellow, cinnabar for red, lapis lazuli for blue. The precious blue is reserved primarily for the garments of the Virgin Mary. Lapis lazuli was the single most expensive item by weight throughout the Middle Ages. One could judge the expense of a painting of this period not by the gilding but by the amount of lapis lazuli blue it contained. The cobalt blue ore was mined in what is now Afghanistan. It had to make its way by caravan along the bandit-infested Silk Road, through Constantinople to Venice, where it would be loaded onto a merchant ship and sail through the Mediterranean, past the Strait of Gibraltar, and up the coast of France to reach Flanders.

Adolescent apprentices are hard at work, preparing one of the oak panels with a layer of white gesso, a mixture of plaster and animal glue onto which the painter will add color. In 1432 van Eyck employed twelve such assistants, some of whom would go on to become famous painters in their own right (although unproven, it is thought that a young Rogier van der Weyden and Petrus Christus may have assisted van Eyck for a time). A human skull sits beside an easel, and a convex mirror hangs on the wall—staple props of an artist's studio. Portraitists often looked at their subjects through a mirror, rather than face them directly as they painted. The edges of the mirror provided a frame for the subject's image within it. The mirror served to transfer the three-dimensional reality of the subject onto a two-dimensional surface, mimicking the efforts of the artist to paint the sitter onto a flat canvas or panel, while giving the painted image the illusion of depth. Convex mirrors feature prominently in van Eyck's work, most famously in *The Arnolfini Wedding Portrait*.

And in 1432, propped against the studio walls, carefully brushed with its final layers of varnish by leather-smocked assistants, under the watchful eye of Jan van Eyck, lay the panels of *The Ghent Altarpiece*.

Among the many mysteries surrounding *The Ghent Altarpiece* is an enduring enigma about its creation. Indeed, one of art history's greatest

unanswered questions is whether Jan van Eyck painted *The Ghent Altarpiece* alone. Jan's story is inseparable from the history of the most famous painter who may have never existed.

In 1823 a hidden inscription was discovered on two of the twelve painted panels that comprise *The Ghent Altarpiece*. The inscription, a quatrain painted onto a strip of silver mounted on the back of the panels that depict the patrons who paid for the altarpiece, reads as follows:

PICTOR HUBERTUS EEYCK. MAIOR QUO NEMO REPERTUS

INCEPIT. PONDUS. QUE JOHANNES ARTE SECUNDUS

[FRATER] PERFECIT. JUDOCI VIJD PRECE FRETUS

VERS**U** SE**X**TA **MAI**. **V**OS **C**OLL**O**CAT A**C**TA T**U**ER**I** [1432]

THE PAINTER HUBERT VAN EYCK,

THAN WHOM NONE WAS GREATER, BEGAN THIS WORK.

JAN [HIS BROTHER], SECOND IN ART,

COMPLETED IT AT THE REQUEST OF JOOS VIJD

ON THE SIXTH OF MAY [1432].

HE BEGS YOU BY MEANS OF THIS VERSE

TO TAKE CARE OF WHAT CAME INTO BEING.

This inscription had been painted over at some unknown time and was only discovered when, after an unbelievable series of thefts and smugglings, the wing panels of the altarpiece ended up on display at the Kaiser Friedrich Museum in Berlin, where the frames were cleaned.

The word *"frater"* and the date "1432" were no longer legible even in 1823, and so may only be inferred. The precise date of the completion, or more likely the official presentation of the altarpiece, was presented in an ingenious fashion—in secret code. The letters in bold in the text above were painted in a color distinct from the rest of the text, in the inscription itself. If we read these colored letters as Roman numerals (reading U as V), then the sum of these numerals gives us the year of completion: 1432. The date of the inscription, the sixth of May, is of particular resonance, as this was a holy date for the Bishopric of Tournai, which presided over

the city of Ghent until it became a bishopric itself in 1559. The holy day was called Saint John at the Latin Gate, in honor of Saint John the Evangelist, who was portrayed in one of the panels of *The Ghent Altarpiece*. Recall that 6 May 1432 was also the day of the baptism of Prince Joos of Burgundy, the son of Duke Philip the Good and Isabella of Portugal, in the Vijd Chapel of the Church of Saint John. Therefore we might consider that Duke Philip's son and van Eyck's greatest creation share the same day of presentation to God and to the world.

The 1823 discovery of the inscription caused a huge stir within the art world. *The Ghent Altarpiece* had heretofore been regarded as the first masterpiece by the budding genius Jan van Eyck. All of a sudden there was a new name associated with it: that of Jan's brother, Hubert.

It was as though an inscription had been uncovered on Leonardo's *Last Supper* stating that the painting was begun by Larry da Vinci, or that Michelangelo's *Sistine Chapel* was also painted by Frank Buonarotti. Art historians were up in arms. Either a new genius had been uncovered, or this was a ridiculous forgery. Perhaps it was both?

At that point, and indeed to this day, there has not been a single painting convincingly attributed to Hubert van Eyck. Nevertheless, the Hubert van Eyck mystery has divided scholars for the better part of two centuries. Hundreds of pages of criticism have been published devoted to Hubert's artistic style.

So who was he?

Clues have risen from murky archives only in recent years. A Ghent city register for 1412 lists a "Meester Hubrech van Hyke," and "Hubrecht van Eyke" is noted in the register of 1422. A document dated 9 March 1426 relates that an altarpiece for a chapel in the church of Saint Saviour, also in Ghent, was still in the workshop of "Master Hubrechte the painter." A document from the Ghent accounts of the year 1424 tells of payment made to a "Master Luberecht" for two designs for an altarpiece commissioned by the city aldermen. In the city accounts for the year 1425, another document tells of a gratuity given by the aldermen out of the municipal funds to the pupils of a "Master Ubrecht." Only one other refer-

ence has been found: a record of inheritance tax paid to the city of Ghent by the heirs of a one "Lubrecht van Heyke" in 1426.

Variant spellings of names were entirely common in this period, before vernacular spelling of even nouns and verbs had been codified. So Masters Hubrechte, Luberecht, Ubrecht, and Lubrecht probably refer to the same person. Therefore though no works can be definitively attributed to Hubert van Eyck, authentic documents confirm that there was a painter of that name living and working in Ghent at the time of the creation of *The Ghent Altarpiece*.

What happened to his paintings?

Artistic attribution is often a tar pit for art historians. Before the nineteenth century, artists did not regularly sign their works, making it difficult to determine who painted what. Attributions are best made through linking primary source documents (contracts, letters, wills, legal documents, contemporary biographies) that mention the subject and sometimes size of works by certain painters and the destination or commissioner of the work. For most artists of the premodern period, we know *of* more works than we have access to. Art historians use the terms *lost* and *extant* to designate which artworks historians know of, through their mention in primary source documents, as opposed to which artworks are in an identified location. The term *lost* implies that a work might be found again. Once or twice a year there will be a major discovery of a masterpiece that was once lost. A prominent example was the 1990 rediscovery of Caravaggio's *Taking of Christ*, now at the National Gallery of Ireland, which had been misattributed as a copy after Caravaggio and had hung, dirty and ignored, in a shadowy corner of an Irish seminary.

Over time, even works that are in prominent collections may have their authorship altered, as new evidence arises suggesting that a reattribution is in order. When the Albert Barnes Collection was moved from a Philadelphia suburb to its new center-city location, its inventory was reevaluated. Many of its Old Master paintings were found to have been misattributed, assigned to more famous painters than modern scholarship

suggests. Famous paintings are just as susceptible to reattribution. The renowned *Polish Rider* in the Frick Collection has been alternately considered one of Rembrandt's greatest works and a work Rembrandt never touched. Attributions are made based on the evidence of historical documents and, less reliably, on a comparison of artistic style between known works by one artist and the unattributed work in question. If documentary evidence is insufficient, then connoisseurship may be called on to provide answers. Connoisseurship is an intrinsic, almost preternatural sense for authenticity and stylistic knowledge. As you might recognize your spouse from across the room, some art historians are considered to have an exquisite expertise in recognizing the work of certain artists. This talent, which was the predominant manner of attribution before the Second World War, has since become something of a parlor trick. Now, with technological advances and computers, scientists can analyze brush stroke and chemical composition (such as the percentage of various pigments mixed by artists to create their paints) to determine the presence of a particular painter's hand.

Connoisseurship has been notoriously prone to wishful thinking and ulterior motive. Everyone wants to discover works by famous artists, so collections such as some of the Old Masters in the Barnes were likely overattributed—paintings assigned to famous artists more through enthusiasm and wishful thinking than willful misattribution to demand a higher price. Even the likes of Bernard Berenson, perhaps the most famous art historian and connoisseur of all time, whose authentication was as close to an iron guarantee as anything could be, cooperated with the prince of art dealers, Joseph Duveen, to intentionally misattribute some paintings, most notably a Titian that Berenson said was a more valuable and rarer Giorgione, because Berenson received a commission based on the sale price of the paintings he authenticated—the more famous and rare the painter, the greater his paycheck.

So it comes as little surprise to learn that the authorship of even a monumental painting such as *The Ghent Altarpiece* could be questioned, and could shift, over the centuries. Before the 1823 discovery of the inscrip-

tion, Hubert van Eyck was not on the radar of the world's art historians, beyond references in several sixteenth-century sources (Karel van Mander, Marcus van Vaernewyck, Lucas de Heere) stating that *The Ghent Altarpiece* had been begun by Hubert van Eyck but was completed by Jan.

With the inscription uncovered, the art world was confronted with a great master whom they had overlooked. Suddenly works that had previously lacked attribution were assigned to Hubert. Many works in the world's museums are simply labeled as "anonymous" or "unknown artist." When one or more works seem to share an authorial style, art historians may give a name to the anonymous artist, whose real name has been lost over the centuries. A notable example is the work of the great Robert Campin, one generation older than Jan van Eyck (and possibly his master). His name was unknown until recently. Before it was discovered, his works, including the world-famous *Merode Altarpiece* now at the Cloisters in New York, were attributed to "The Master of Flemalle."

Was Hubert van Eyck the real name of one of these lost masters? After the discovery of the inscription, a number of well-regarded paintings, all in the style of mid-fifteenth-century Flanders, were suddenly attributed to Hubert. These include the *Crucifixion* and *Last Judgment* in the Hermitage, the silver-point drawing *The Betrayal of Christ* in the British Museum, the *Portrait of John the Fearless* in Antwerp, a *Crucifixion* at the Gemaldegalerie in Berlin, and *The Holy Women at the Sepulchre* from the Cook Collection in Richmond, England, among others. These works were attributed to Hubert, with a prominent question mark, based on the fallible and rather unscientific method of stylistic comparison. The comparison, of course, was to *The Ghent Altarpiece*—none of which may have been painted by Hubert. As the famous art historian Max Friedlander wrote in 1932, "Having read the entire literature on van Eyck . . . only one thing about the Ghent Altar is sure, namely that its famous inscription has caused stylistic criticism greater embarrassments than this discipline, not exactly short on blunders, has ever known before."

Despite the hunger to provide paintings for this newly discovered master painter, it is not clear that any of Hubert's paintings are extant. Still,

Hubert van Eyck's association with *The Ghent Altarpiece* is further indicated by the fact that he was buried in the Church of Saint John, in the wall of the Vijd Chapel—the church and the chapel for which *The Ghent Altarpiece* was painted. The grave was later moved and lost when the church's dedication was changed from Saint John to Saint Bavo. But the epitaph on Hubert's tomb is recorded in the 1550 notes of a traveler named Marcus van Vaernewyck. This epitaph gives Hubert's death date as 18 September 1426—perhaps only weeks after *The Ghent Altarpiece* was begun.

We may infer from this that, if Hubert van Eyck was indeed a painter associated with *The Ghent Altarpiece*, then his contribution to it included the layout, design, and perhaps a few unfinished figures, but little more. He died long before he could have made a major, or even substantially visible, contribution. Although the exact date of the commission of the altarpiece is unknown, the very fact that Hubert died in 1426 and the painting was not completed until 1432 indicates the extent of work still required as of 1426. In the six years following his brother's death, it was Jan who did the painting.

Yet travelogues from two other nearly contemporary tourists indicate that very soon after the completion of the altarpiece, Hubert was considered to have been its painter. Hieronymous Münzer, who visited Ghent in 1495, wrote that "the master of the altarpiece is buried before the altar." Jan van Eyck was buried in Bruges, so Münzer can only be referring to Hubert. The second tourist was Antonio de Beatis, secretary to a visiting ecclesiastical dignitary, Cardinal Luigi d'Aragona. De Beatis wrote of his 1517 visit that the "canons" of the church had told him that *The Ghent Altarpiece* had been painted by an artist from "La Magna Alta" (the old term for Germany, from which is derived the country's French name, *Allemagne*) by the name of Roberto and that Roberto's brother completed the work. Perhaps the Italian De Beatis Italianized the name he thought he heard, whether it was Hubrechte, Luberecht, or Ubrecht, and transformed it in his memory into Roberto.

But these archival documents suggesting that there was indeed a Hubert van Eyck painting in Ghent in the 1420s were only discovered in

1965. Many still consider that all-important inscription to be a sixteenth-century forgery. If so, it would be the first of thirteen crimes involving this one ill-fated painting.

In 1933, art historian and collector Emile Renders published an article claiming that the inscription was a forgery, perpetrated by Ghent Humanists who were dismayed that their city's treasure should have been painted by an artist associated with the rival city of Bruges. Renders argues that these forgers invented a brother from Ghent, Hubert, whose hand in the altarpiece could make it seem that Ghent's greatest treasure had been created by one of its own citizens. A contemporary equivalent of this theory might be to say that the greatest treasure of the city of Boston had been created by a New Yorker. Renders's theory remains intriguing and plausible. Just because archives have proven that a painter named, approximately, "Hubert" was working in Ghent in the correct century does not mean that Hubert was involved in *The Ghent Altarpiece*, nor that the inscription is original.

Another scholar, Lotte Brand Philip, wrote in 1971 that the inscription, while original, had in fact been misread. Hubert van Eyck was actually listed as *fictor*, not *pictor*. This would mean that Hubert created the sculptural framework for the altarpiece, while Jan did the painting. The deterioration of the inscription, in which certain words are completely obliterated, makes a misread plausible. This remains a possibility championed by a number of scholars, although it is contradicted by one of the aforementioned documents, from March 1426, which mentions an altarpiece for the Church of Saint Saviour that is still in the workshop of "Master Hubrechte the painter," which would make him a *pictor* and not a *fictor*.

To this day, art historians are divided on the authorship of *The Ghent Altarpiece*. Sit in on lectures by different art historians, and half will teach that the altarpiece is by the van Eyck brothers, and half that it is by Jan van Eyck alone.

Though the existence of an artist called Hubert in early-fifteenth-century Ghent is now beyond doubt, his involvement in *The Ghent Altarpiece* remains an unsolved mystery. It seems probable that he was commissioned

to paint the altarpiece but died so soon after the commission that none of his work may be seen in the finished painting, which was taken up by his brother Jan, with the blessing of Duke Philip the Good. Unless some new clue rises from the silt, the precise origins of the altarpiece will remain an enigma. And perhaps that is part of its allure? When all of the questions have been answered, we might cease to look. *The Ghent Altarpiece* proffers many tantalizing questions, supports intriguing answers, yet refuses to yield up definitive solutions. It haunts us still, as it has haunted and beckoned six hundred years of art lovers and thieves—all the more powerful because of the unparted mists that remain around it.

A work of art rarely has intrinsic material value—so much painting is just wood and linen and pigment. It is the way these materials are used, and even more so the story of their past and what they have meant to people and nations, that imparts value to humble ingredients. Rarely discussed by scholars, the history of art crime is a human psychological drama, a tug-of-war of ownership woven with ideological, religious, political, and social motivations that are provoked or embodied by the art in a way that no other inanimate object sustains. And *The Ghent Altarpiece*, with its biography of twists and turns, is an ideal lens through which to examine this phenomenon.

Now let us turn to the story of the painting as a physical object: coveted, desired, reviled, damaged, nearly destroyed, stolen, smuggled, and recovered, only to be stolen again. We shall see how the masterwork that began as a point of pride for the community in which it was housed, the treasure of the city of Ghent, evolved into the icon of the country of Belgium, and became ultimately a symbol for the preservation of civilization against evil.

CHAPTER THREE

The Burning of the Lamb

T he first century of *The Ghent Altarpiece*'s existence was the only period in which it was unmolested. Beyond the Hubert van Eyck mystery, which many scholars still feel was the result of an early-sixteenth-century forgery, and the damage done by cleaning that resulted in the loss of the predella, *The Lamb*'s first 140 years were quiet. Then, in 1566, *The Lamb* became the victim of an unprecedented and unparalleled string of crimes. It began as the whipping boy for a series of ideological causes, each framing the altarpiece as a symbol of all they hated.

The Lamb's hometown, the stalwart and oft-burgled city of Ghent, has a fascinating history, one inextricably linked to the story of its master-piece. Ghent (Gent in the local language, Flemish, Gand in French) has retained the flavor of its rich and dark history, as the city was largely spared damage from the many wars that charged across its threshold. The story of Ghent is integral to the understanding of what happened to the city's greatest treasure, particularly in the early period of *The Lamb*'s history as the victim of crimes.

Though archaeological elements have been found at Ghent dating back to prehistoric times, the city began, as so many European cities did, as a Roman fortified encampment. The name of the city probably comes from the Celtic word *ganda*, meaning the confluence, or meeting point, of several bodies of water—in this case the rivers Lys and Scheldt. What began as a simple settlement rose to prominence in 630 with the establishment of

the Abbey of Saint Peter, soon to be renamed the Abbey of Saint Bavo. A second abbey, called Blandijnsberg, followed. Abbeys at the time were not only religious centers but nuclei of trade. A town rose out of the gathering of craftsmen and traders around these abbeys.

It was about this time that a wealthy local landowner by the name of Allowin was born in the nearby settlement of Brabant. Allowin married and had a daughter, but felt unhappy despite his wealth and family. When his wife died, Allowin had something of a midlife crisis. He turned to God, giving away all of his land and possessions to the poor, entrusting himself as disciple to a wandering bishop who later became Saint Amand of Maastricht.

Saint Amand had been a hermit for fifteen years before beginning a successful missionary career at age forty-five. Pope Martin I (later a saint himself) had granted Amand a bishopric without a fixed see. Amand had a bishop's privileges but no cathedral. Amand wandered, preaching in Flanders and among the Slavic tribes of the upper Danube. He founded several abbeys and was the probable founder of Ghent's Abbey of Saint Peter. There he first encountered Allowin.

Moved by the piety and strength of the future Saint Amand, Allowin followed the bishop on his missions in Flanders. Amand baptized Allowin with the name Bavo (Baaf in Flemish, alternately spelled Bavon in English). Relatively little is known about Bavo's life postbaptism. The only enduring story is of an occasion when Bavo ran into a man whom he had sold into serfdom long before. Bavo insisted that the man lead him in chains to the town jail, as a retributive, penitent gesture. After his missions with Amand, Bavo was given permission to live as a hermit in the forest behind the Abbey of Saint Peter in Ghent. Bavo died on 1 October 653 and was buried in the abbey that, from that point on, bore his name.

Ghent achieved sufficient importance that Charlemagne granted it a fleet with which to defend itself against Viking incursions along its rivers. The settlement had been attacked and plundered by Vikings on two occasions, in 851 and 879. Vikings were unprepared for either open-field

combat or siege and breach of fortifications, so, after the second of the two devastating Viking attacks, in 879 Ghent developed its first substantial wooden fortifications.

Ghent blossomed in the twelfth century, when it became an international center for the cloth trade, importing English raw wool and producing high-quality cloth for export. In 1178 Count Philip of Alsace, the ruler of the area, gave Ghent official trade privileges and built the city's first stone citadel, the formidable Castle of the Counts, which still stands today. By the thirteenth century, Ghent was the second-largest city in Europe, after Paris, with a population of 65,000.

Thirteenth-century Ghent saw the unusual oligarchic governance of a board of merchant patricians. This board oversaw governmental and judicial matters in the city, keeping the reigning Counts of Flanders at arm's length and defending their mercantile interests. Ghent continued to flourish as a center of trade, functioning with a surprising amount of independence and distance from the feudalism of the countryside around it.

This division of power between the merchant patricians in Ghent and the Count of Flanders destabilized at the start of the Hundred Years' War in 1337. While the Count of Flanders allied with France, Ghent wanted to preserve its profitable relations with England and its wool imports, the cloth from which was the primary source of Ghent's substantial wealth. The city needed England. The ruling lord of the region sided with France. What was Ghent to do?

Ghent was in no military position to resist its overlord, Count Louis de Male of Flanders (for whom Joos Vijd's father, Nikolaas, worked), so it relied on policy and politics. The merchant patricians enlisted the aid of wealthy cloth trader and civic leader Jacob van Artevelde, who tried to preserve relations with England despite the Hundred Years' War. Van Artevelde unified several towns in Flanders, including Bruges and Ypres, and supported the English king Edward III openly from 1340. But eventually he was suspected of conspiring to install Edward's son as the new Count of Flanders, and he was murdered by the townspeople in 1345. His son Fillip continued where his father had left off, administratively

defending the interests of Ghent against the military allegiance of the overlord Count of Flanders.

With the death of Louis de Male, Flanders shifted to the fiefdom of the Dukes of Burgundy. It was under their rule, particularly that of Duke Philip III (Philip the Good), that the area blossomed artistically. This was the period during which Jan van Eyck painted *The Mystic Lamb* for the church of Saint John, which was formerly the church of the seventh-century Abbey of Saint Bavo and would later become the Cathedral of Saint Bavo.

It was not a happy time for the citizens of Ghent. Ghent was the most populous, rich, and powerful city in the Burgundian lands. But years of exorbitant taxes levied by Burgundy prompted the people of Ghent to rise in rebellion. Duke Philip the Good assembled 30,000 soldiers and met the rebels at the Battle of Gavere on 23 July 1453. Ghent had an army of equivalent size. Soon after the battle began, there was an accidental explosion within the Ghent artillery battery, and most of the rebels' heavy artillery was destroyed. The duke thoroughly defeated the people of Ghent, who suffered 16,000 casualties. The surviving citizens feared that the duke would level the city by way of punishment. When asked about this, the duke replied, "Were I to destroy this city, who would build for me one like it?" The irreplaceable city was spared, but Ghent was once more under the firm control of the Burgundian Empire.

The Dukes of Burgundy retained control of Ghent until the young, brotherless duchess Mary of Burgundy married Maximilian of Austria, a member of the Hapsburg family, on 18 August 1477. Flanders bloodlessly became a part of the Hapsburg Empire. But much blood was about to be shed in a war for its independence after Ghent's most famous son became its greatest enemy.

The future King Charles V, the Hapsburg Holy Roman Emperor and the destroyer of Rome, was born in Hapsburg Ghent in 1500. The city received no leniency from the emperor, who sent troops against them in 1539, when the city leaders refused to pay the exorbitant taxes Charles needed to fund his campaigns abroad. Charles personally came to the city to lead his soldiers. He subdued the people of Ghent and forced the city's

nobles to show their subservience by walking in front of him barefoot with nooses around their necks. The Flemish word for noose, *strop*, was later adopted into the nickname of the people of Ghent, who became known as *Stroppendragers*, or "noose bearers."

After the imperialist warring of Charles V, the rule of his son Philip II saw the most carnage that would mark the city's history. As with many northern European cities during the Reformation, the population of Ghent was divided into embattled religious factions, Catholic versus Protestant. Among the various Protestant sects in Ghent, including the nonaggressive Anabaptists and Mennonites, the Calvinists frequently resorted to violence and iconoclasm.

In 1559 the church of Saint Bavo—the original name, Saint John, was discarded in 1540—was elevated to the status of cathedral. Ghent became the seat of a bishopric. This was in part an attempt to strengthen the Catholic hold on the region at this dangerous time of religious conflict. So impressed was he with the altarpiece, Philip II commissioned that same year an exact copy of its central and wing panels for display at his court in Madrid. Philip's collection already included van Eyck's *The Arnolfini Wedding Portrait*, acquired upon the death at the Spanish court of its owner, Mary of Hungary, in 1558. The artist who received the commission to paint the copies was a Flemish master called Michiel Coxcie. Coxcie was a renowned and adept imitator of the great masters of his time, particularly Raphael, for which he received the nickname "the Flemish Raphael." Coxcie's copy of *The Ghent Altarpiece* was never meant to be passed off as the original and therefore was not a forgery. But five hundred years later, an unscrupulous Brussels art dealer who would twice profit from crimes involving *The Mystic Lamb*, would sell Coxcie's copy as the stolen original.

The city of Ghent's official religion alternated between Catholicism and Calvinism, depending on who was in power at any given moment. The year 1566 saw violent Protestant riots during a period of brief power seizure

before the Catholics regained control in 1567. This would become known
as the Ghent Iconoclasm. Foremost among the Calvinist complaints was
the Catholic fascination with icons. Calvinists argued that Catholics had
begun to pray *to* icons, violating one of the Ten Commandments, rather
than praying through icons in order to inspire a more vivid prayer.

Coupled with this perceived "worship of graven images," Calvinists in
particular were outraged by the capitalistic tendencies of the church and
the inordinate wealth and corruption of the clergy. Buying "indulgences"—
paying clergy in exchange for a promise that once you die you'll get into
Heaven faster—was a booming medieval industry. Popes themselves al-
ternately bemoaned and benefited from this endless source of income.
The Calvinists found it repulsive that people could buy their way into
Heaven through gifts and patronage. They wore only dark clothes and
banned singing, dancing, or buying alcohol on Sundays. They condemned
the money spent on Catholic decadence, particularly in the form of gilt
artworks and overdecorated churches. Iconoclasm, the destruction of
icons, carried a symbolic force for Protestant rioters, who destroyed or
irrevocably damaged thousands of artworks during the Reformation. The
gorgeous, incandescent *Adoration of the Mystic Lamb* proved an irresistible
target.

To Calvinists, an altarpiece such as *The Lamb* was the perfect example
of what was wrong with Catholicism. In their view, *The Lamb* encouraged
two types of Catholic sin: prayer to an icon and the ungodly payment for
indulgences. In paying for such an outstanding religious artwork for his
local church, Joos Vijd had essentially bribed his way through the Pearly
Gates.

It had to be destroyed.

The Lamb was such an obvious target for the destructive rioting
Calvinists of Ghent that the Catholics set up an armed guard inside the
cathedral, specifically to protect the altarpiece. On 19 April 1566, Calvin-
ist rioters wreaked destruction near and around the cathedral. They tried
to open the locked cathedral doors. The Catholic guards inside were
vastly outnumbered by the rioters. They would have heard the sounds of

the crowd outside, of crackling wood and falling masonry, as they waited breathlessly in the nave for the rioters to break through and burn *The Lamb*. But the rioters could not get inside. Apparently without a battering ram of any sort, they left.

Two days later the Calvinists returned. Using a tree trunk as a battering ram, they broke open the cathedral doors. As the doors cracked and splintered, buckling at the center beneath the heave of the ram, the first of the rioters burst through. They carried torches in the night, disturbing the quiet dark of the cathedral interior, so vast and ribbed with arches, like the chest cavity of a great whale. They ran to the Vijd Chapel, prepared to drag the altarpiece into the square outside so that all could see the pyre on which they would burn this inspirer of heresies.

But when they reached the chapel, the altarpiece was gone.

In the heat of the riotous night, the Calvinists hadn't time to stop and think. Perhaps they thought that one of their lot had arrived earlier and taken the painting away. Perhaps they thought its disappearance was an act of God to preserve it. Perhaps they didn't think at all. They had demolished other art and statuary inside the cathedral, but they never found *The Lamb*. Where had it gone?

After the rioters' first attempt at breaking in, the Catholic guards, realizing that their numbers would be insufficient to protect *The Lamb*, had devised another plan. They took apart the twelve panels of the altarpiece and hid them at the top of one of the cathedral towers. Each night they stationed guards along the tower's narrow spiral staircase, easy to defend, as it had to be mounted single file. They then locked the door on the ground floor leading to the tower. As the rioters tore the nave of the cathedral apart, *The Lamb*'s bodyguards remained undetected in the darkness of the spiral stair. The Calvinists hadn't the wherewithal to search out the altarpiece. When it was not found where expected, the rioters gave up and moved on. Little did they realize that *The Lamb* was only a few meters away, in the tower above their heads.

The Catholics of the city did not wait for the Calvinists to figure out where *The Lamb* was hiding. After the near miss of the night of 21 April,

the Catholics moved the altarpiece to the fortified town hall. *The Lamb* remained locked there until the riots died down.

By 1567 the firm and retributive Catholic Duke of Alba assumed complete control of Ghent. He executed a great many of the Calvinist leaders, scattering the local Protestant communities to lands outside of Ghent. The Duke of Alba ruled until 1573. But the city's allegiance continued to shift. From 1577 to 1584 Ghent was officially Calvinist. During this period, the altarpiece remained in storage in the town hall. There was talk among the Calvinist leaders of sending it to Queen Elizabeth I of England as a token of their appreciation of her support, both moral and financial, of Protestant seizure of control of the city. It would be sent to the Protestant queen not as an icon but simply as a beautiful artwork. But a respected member of the community and descendant of the original donor, by the name of Josse Triest, insisted that the altarpiece remain in Flanders. His request was granted, and *The Lamb* remained sequestered in storage.

In 1584 the tide of religious supremacy turned once again, as the city was occupied by the Spanish Hapsburgs. A Hapsburg ruler, Alexander Farnese, was instated, and the city was once more Catholic. With the Catholic ruler, *The Lamb* was returned to the Vijd Chapel in the cathedral, once more displayed as it was meant to be. It was already without its predella, which had been ruined prior to 1550, but the rest of the altarpiece was intact. It would remain there, undisturbed even through further religious changes, until 1781.

In the late sixteenth and seventeenth centuries, decimated and divided by religious conflict, the city of Ghent fell into a long recession. The situation began to improve beginning in 1596, under the reign of the Austrian Hapsburg Archduke Albert VII and his wife, Isabella, who financed the cutting of a canal between the harbor of Ghent and the city of Ostende. This renewed Ghent's position as a center for trade.

But Flanders was, and would continue to be, a battleground for the power-hungry empires of Europe. King Louis XIV of France repeatedly tried, and failed, to conquer Austrian-controlled Flanders in 1678. After his thwarted attempts, Ghent saw another brief period of quiet and economic prosperity. The Austrians brought new industry to the lands outside of Ghent in the form of refineries for sugar (imported from the colonies), kick-starting its economy once more.

Then the Holy Roman Hapsburg emperor Joseph II of Bohemia and Hungary arrived. Patron of Mozart and Beethoven, Emperor Joseph was an aficionado of Enlightenment thought, believing that reason should govern all. He cited Voltaire as his formative influence and Frederick the Great as his hero. When Frederick II of Prussia met Emperor Joseph in 1769, he described the emperor as impressive but not likeable, ambitious and "capable of setting the world afire."

The emperor's Enlightenment rationalist views condemned religious fanaticism, particularly of the Catholic persuasion, although he himself had been baptized as a Catholic. While he was no violent iconoclast, his opinions dictated what others were permitted to think and to believe, at least publicly.

Emperor Joseph's mother, Maria Theresa, had been a devout Catholic. An outwardly obedient son, the emperor waited until the death of his mother in 1781 to redirect the government in a manner he found more suitable. Strong religious practices would not be persecuted, but they would be discouraged. Education, the rock of the empire's greatness, would be prized above all.

In that year, Emperor Joseph implemented a decree known as the Patent of Tolerance, which provided a limited guarantee of freedom of worship. Rather than forcing unity of the empire through religion, the most common route of kings and emperors for the past millennium, Emperor Joseph sought unity through language. His subjects could practice what religion they wished, but everyone would speak German.

As a decree of a Rationalist despot, Emperor Joseph's Patent of Tolerance accorded with Enlightenment thought. Education would be the top

priority. Church lands and possessions would be secularized; religious orders would submit all of their powers of governance and justice to the state. But religions would be neither persecuted nor outlawed.

To preserve religious artworks for their beauty but strip from them their iconic religious status, the emperor ordered a large number of artworks to be moved from their original location in churches and displayed in museums. In one year, 1783, and in one region, the Austrian Netherlands (comprising what is now Belgium minus the East Cantons and Luxembourg), the emperor secularized 162 monasteries and abbeys, sending thousands of works of art found within them to museums across his empire or selling them abroad for a hefty profit. When Sir Joshua Reynolds, the British master portraitist and director of the Royal Academy of Arts, heard about the emperor's sales of ecclesiastical artistic holdings, he set off for the Austrian Netherlands at once. In 1795 he wrote back to England that he had purchased "every picture from Brussels and Antwerp which was for sale and worth buying."

In that same year, Emperor Joseph traveled to Ghent, one of his empire's most prosperous industrial cities. During his visit, he went to Saint Bavo Cathedral to see its world-famous treasure. As a good Enlightenment thinker, the emperor admired art for its beauty and its ability to morally elevate the viewer. But he disdained Catholic decadence and the worship of icons, and his rationalism carried with it a sense of moral prurience. He would exert his influence on *The Adoration of the Mystic Lamb*, but not in the way that Ghent feared.

The emperor did not seek to strip Ghent of its prized artwork. One reason for this may have been *The Lamb*'s fame as a work of art since its creation. In the view of the late eighteenth century, it was not worshipped as an icon but venerated for the artistic ability of its creator and as the mascot of the city of Ghent. In this capacity it had always been a destination for the educated tourist. When one went to Ghent, one paid a visit to *The Ghent Altarpiece*. Pilgrimages to it were undertaken by connoisseurs of art, not pious Catholics. In this way it posed no threat to the Rationalist emperor.

But the altarpiece did serve to shock. While Emperor Joseph admired its beauty, its skilled execution, its emotional power and scope, he was scandalized by two of the panels: the nude Adam and Eve. The extreme naturalism of these panels was, in his view, gratuitous, pornographic, and—worse—likely to incite irrational behavior.

Nudes had been portrayed before, of course. The sixteenth century had seen hundreds of reclining nudes as Venus, goddess of love. But they had always been painted in an idealized manner, removed from the way humans really look, and modeled on classical nude statuary. In Masaccio's Brancacci Chapel, painted in 1426, which van Eyck may have visited on an undocumented trip to Florence, a nude Adam and Eve are expelled from Eden by a sword-wielding angel. Though they are fully naked, their bodies adhere to the acceptable classical ideal. But Emperor Joseph might have been inspired by Cosimo III de Medici, ruler of Florence, who one generation earlier had ordered fig leaves to be painted over the genitals of Masaccio's Adam and Eve.

Van Eyck's figures both cover their genitals with well-placed hands and therefore might have been less shocking than Masaccio's nudes. Yet they were highly offensive to the Enlightenment moralist Hapsburg emperor. Van Eyck's Adam and Eve were too earthly. They held a mirror up to nature, showing pock-marked Man, naked as a jaybird, physically flawed, and therefore degraded. One could count the individual hairs painted against Eve's skin, and, perhaps most suggestively, one can see the tops of pubic hair on both figures, barely emerging from behind their hands.

For Emperor Joseph, this was too real. It was not the morally elevating nudity of classical Greece. To the Enlightenment thinker, van Eyck's nudes demeaned; they made Man look awkward. They had to go.

It is not clear whether Emperor Joseph threatened to confiscate the altarpiece if the Adam and Eve panels were not removed or if he specifically ordered them to be replaced. But the mayor of Ghent, not wishing to be in the emperor's bad graces, acted immediately. He placed the Adam and Eve panels in storage in the cathedral archives. Eighty years later, the city

of Ghent would commission an artist to paint exact copies of those panels, with the unacceptable nudity covered over by the addition of bearskin clothing.

The altarpiece would remain in Ghent for only thirteen years more before being swept away.

The stealing was about to begin.

CHAPTER FOUR

Thieves of Revolution and Empire

Two consecutive events in French history resulted in a massive movement of European art, the scale of which would not be rivaled until the Second World War: the plunder of the French revolutionary army, followed by that of the army under Napoleon. The evolution of French revolutionary and Napoleonic policies on the seizure of art would influence the fate of *The Ghent Altarpiece*, along with many of Europe's artistic treasures.

To understand the French theft of art during and after the Revolution, it is useful to know a bit about how art had functioned before the French Revolution forever altered who art was for and why art was created.

Before the seventeenth century, artists did not create simply for pleasure or in hopes of future sale. They worked almost exclusively on commission for the wealthy: princes and dukes and cardinals and kings. During the seventeenth century, this began to change in the Netherlands, as a rising merchant middle class began to buy art for home display and enjoyment. This was a new clientele for painters, who for the first time created works on spec for sale in galleries. This movement was slow to spread beyond the Netherlands. Elsewhere in Europe, and particularly in Italy, art still consisted of commissions by the wealthy and the powerful. While artists were respected in Holland and in Italy, at the same time Spain's greatest artist, Diego Velazquez, struggled for acceptance despite his renowned skill, forced to take on a series of time-consuming jobs in the king's entourage in order to gain status and earn a living, leaving little time to paint. In most countries, artists were considered little more than

skilled craftsmen, making art for the socioeconomic elite of the clergy and
nobility, as they had always done.

Then came the French Revolution, and with it a new attitude towards
art collection and looting. From 1789 onwards, art collecting in Europe
would no longer remain the realm of aristocrats, kings, and clergy. The
period saw a radical change in the sociopolitical fabric of Europe. The ab-
solute monarchy that had ruled France for its entire history was over-
thrown, and with it the trappings of aristocratic privilege, serfdom, court
favoritism, and the entire mechanism on which medieval Europe relied.
The new emphasis was on Enlightenment principles of the inalienable
rights of human beings, citizenship, popular representation, and at least
some measure of equality and democracy, although it would be some time
before democracy would take hold as we know it today.

The scale of art theft, in the form of the systemized looting that took
place during the French revolutionary and imperial periods, knew no
precedents. Individual cities had been plundered before, to be sure, but
the looting of this era began with the entire nation of France, stripped of
its treasures by the revolutionaries and then extended with the Republi-
can and then imperial armies throughout the continent. Knowledge of
the causes of the French Revolution is critical to understanding why this
massive movement of art took place and how the art market would be
forever changed in its aftermath.

When the French Revolution erupted in 1789, the common people
took to the streets of Paris and began mob riots. The royalty fled the city.
The soldiers of the French army, now leaderless and of common stock,
sided with the rioters. The city armory, the Bastille fortress, was taken on
14 July. Now the common people had arms and control of Paris. Riotous
mobs rose throughout France, destroying the frills of title and aristocracy.
They burned deeds and contracts, killed aristocrats, looted castles, incit-
ing general mayhem in what became known as the Great Fear.

Other monarchs of Europe offered aide to King Louis XVI, but he re-
jected this as potentially treacherous. The European monarchies feared
that the wildfire success of a revolution in France would provide a dan-

gerous precedent for their own nations to rebel. They also saw, in France's inner turmoil, an opportunity to wrest power for themselves. On 12 April 1792 the Austro-Hungarian Empire solicited allies for future action against France. A Republican convention in France responded by declaring war on the empire. The people wanted to export their revolutionary principles to neighboring oppressed states, thereby strengthening the Revolution at home. Meantime, Louis XVI saw war as a chance to increase his popularity, seize booty for profit, and reassert his authority. It provided an opportunity to unify disparate groups under the banner of nation.

On 20 April 1792 France declared war on Austria, with Prussia joining the defense of Austria a few weeks later. It was this war in which the young Corsican Napoleone da Buonaparte, who later "francified" his name into Napoleon Bonaparte, would shine as a general, eventually taking over control of the French army and later declaring himself emperor.

Responding to the declaration of war, a joint Austrian and Prussian force invaded northeastern France in August 1792, capturing Verdun on 2 September. The rights of the French monarchy had been suspended a month earlier, and the monarchy was officially abolished on 21 September 1792. France was declared a republic.

The Republican army confronted Austrian and Prussian forces on 20 September at Valmy. The unusual battle involved much bluster and few deaths. It was recorded that 40,000 cannon rounds were fired, but the total number of deaths on both sides combined amounted to fewer than five hundred. It was a French victory nonetheless. The invading army withdrew to the far side of the Meuse River that flows east-west across Belgium. Seizing the opportunity, the French army followed the retreating coalition, and by early November Austria had abandoned most of the Austrian Netherlands. The French army continued to victory at Aachen, securing all of the territory once known as Flanders, later known as Belgium, including the city of Ghent.

This area was officially annexed by France in 1795. The territory of Flanders/Austrian Netherlands/Belgium, an area the size of Maryland, was

destined to remain the battlefield of major European powers for centuries to come, the taut and fraying rope at the center of the imperial tug-of-war.

The Austro-Hungarian and Prussian factions began to plot the reinstatement of the French monarchy, in what is known as the Brunswick Manifesto. Had they succeeded, the grateful French king would have made France subservient to them. Learning of this plan, the French Republican leaders quickly executed the royal family. The execution of Louis XVI by guillotine took place in Place de la Concorde in Paris on 17 January 1793. This sparked the Reign of Terror, spearheaded by the director of the Committee for Public Safety, Maximilien Robespierre, who led a hunt for perceived and actual enemies of the French Republic, executing all he could find. Archives record the deaths of 16,594 people, most by guillotine, though some historians place the total number of deaths in this two-year period at nearer 40,000.

During the Reign of Terror, the Austrians, Prussians, Spanish, and British attempted to gain control of France, but the Republican army resisted them all. Successful battles led the Republic to take offensive measures. The French army invaded the Austrian Netherlands in 1794, not just seeking a pitched battle with the Austrian and Prussian forces, as had been fought two years prior, but intent on territorial conquest and pillage, as a means to increase revenue to repair damages and fund further campaigns. In 1793 and 1794 they instituted the Vendôme Decrees, which permitted the confiscation of the belongings of exiles and opponents of the Republic, ostensibly for redistribution to the needy.

Just as Emperor Joseph II had disapproved of the "irrational" veneration of Catholic art, the revolutionaries hated the idea that art was the sheen and plumage of the elite aristocracy. Emperor Joseph II had divested churches of their artwork, their instruments of awe, in order to encourage rationality and the power of individual human beings. The revolutionaries' goal was less to empower individuals than to empower the people as a collective.

In an effort to transfer power from the elite to the common people, as well as for the more practical motivation of gathering valuable artworks for sale, the revolutionaries confiscated the art of the executed and the

soon-to-be-headless. Without concern for ownership or historical context, the revolutionaries stripped France of those art treasures owned by the former oppressors, the church and the aristocracy, and brought the plunder back to Paris for display to the people.

Although the principle of revolutionary art theft was to overturn the concept of elitist personal property, much of the art was sold to the wealthy, flooding the market with freshly gathered aristocratic possessions. Many works considered of a secondary importance by nonconnoisseur citizens and officers were sold to finance the war effort. This was rationalized by the need to raise funds for the war and the fact that the buyers were not French aristocrats but foreigners. The most famous of these sales, that of the collection of the Duke of Orleans in 1792, resulted in the enrichment of British collections above all, as a consortium of English nobles purchased the majority of the works for sale. The core of the Orleans collection consisted of plunder: 123 paintings that had once belonged to Queen Christina of Sweden, having been stolen by Swedish troops during the Thirty Years' War, from Munich in 1632 and from Prague in 1648.

Along with the rolling heads of the Revolution came an art-looting spree the scale and breadth of which had never before been seen and would not be seen again until the Second World War. The finest pieces taken from deposed aristocrats were not sold but brought to Paris. The art seized by revolutionaries from French aristocrats was greatly augmented by the later military looting under the French Republican and imperial armies. By the time Napoleon achieved control over the army, Paris's galleries had become a citywide display case for the trophies of war. Public museums were established to respond to this new state of affairs, displaying art to anyone who cared to see it. The new National Museum was established on 26 May 1791 and housed in the recently converted Louvre, once the royal palace. The Louvre opened on August 10, 1793, during the Reign of Terror, and was popular from its inception.

The motivations for art looting followed closely those of the French Revolution: to transfer power from the elite to the common people. Seized art symbolized the impotence of those from whom it had been

taken. In addition to the severed, guillotined heads on display on the Bastille walls, the art collections, severed now from their decapitated owners, were proudly displayed. What had once been the realm of the wealthy elite only, a private delectation, was now shown in the recently converted Louvre, formerly the royal palace and now a public museum. Paintings were hung along with the names of the aristocratic families to which they once belonged. In theory, through the revolutionaries, art received a new audience. Art collections were no longer for the select few who could afford and "understand" them.

In practice, however, art remained remote from the masses. Seven days out of ten, the Louvre was open only to artists and scholars. The other three days it was open to the general public. There was a contradiction in the theories and practice of revolutionary France. Governmental control was billed as popular, a democracy for the people, but while rights by birth were no longer the criterion to hold office, the state was in actuality controlled by an intellectual elite. The "masses," once abominably oppressed, were to be liberated and helped, but they were considered in no way fit to run a country. This new Republican politics was mirrored in the availability of the Louvre's collection to the public: three-tenths for everyone, with seven-tenths reserved for the educated elite.

Whether the looted art was appreciated by the masses on those three days out of ten is another question. During the throes of the Revolution, visiting a gallery to see the possessions of those deposed would have brought a satisfaction altogether distinct from enjoying the art itself. The galleries of Paris could easily have displayed the rich clothing of the fallen aristocracy, their furniture, or even, as was arrayed on the city battlements, their lifeless bloody heads. Art served as a trophy of success. What was once the prized possession of the fallen, of inconceivable monetary value to the common people, was now captured in the glass cage of the gallery, to be enjoyed for what it symbolized as a looted object, not for its intrinsic beauty.

Looting within France lasted from the Revolution until around 1794, at which point the French armies spread their conquests north into the

Austrian Netherlands and south into Italy, the rest of Europe receiving the brunt of the pillage. Behind the victorious armies followed a new breed of military unit, one with the sole purpose of seeking out, stealing, and shipping back to France works of art from the defeated nations.

In June 1794 the French established the Committee for the Education of the People and proposed sending "knowledgeable civilians with our armies, with confidential instructions to seek out and obtain the works of art in the countries invaded by us." It is not clear whether this directive came from the government in Paris or the army itself, but on 18 July 1794 the following order was issued to the army:

> The People's commissioners with the Armies of the North and Sambre-et-Meuse have learned that in the territories invaded by the victorious armies of the French Republic in order to expel the hirelings of the tyrants there are works of painting and sculpture and other products of genius. They are of the opinion that the proper place for them, in the interests and for the honor of art, is in the home of free men.

The declaration, which referred specifically to the newly conquered territory of the Austrian Netherlands, went on to order the confiscation of these "works of painting and sculpture and other products of genius." Two officers in particular, Citizen Barbier and Citizen Leger, were told to search out artworks. The army was to give them every assistance.

Citizen Barbier had some training in forced art redistribution—barely distinguishable from art theft. Antoine Alexandre Barbier began his career as a priest but was officially dismissed by the pope in 1801 for his antipapal activity, helping Napoleon to loot the Vatican of nearly everything that wasn't nailed into place (and much that was). Barbier was a bibliographer and librarian, an accountant of objects, whose first official role was to redistribute to the libraries of Paris books and manuscripts that had been seized during the French Revolution, ostensibly from enemies of the state, but in practice from anyone whose collection looked promising. Barbier

was the official librarian to the French Directory and, from 1807, worked as a special agent for Napoleon. He was a key figure in the establishment of the libraries of the Louvre, Fontainebleau, Compiegne, and Saint Cloud, whose collections were in large part acquired through forced seizure, first from revolutionaries in France and then from Napoleon's victims abroad. Fascinated with words and their origins, Barbier produced two books during his career: the massive, four-volume *Dictionnaire des ouvrages anonymes et pseudonymes* (Dictionary of Anonymous and Pseudonymous Works, 1806–1809) and the *Examen critique des dictionnaires historiques* (Critical Examination of Historical Dictionaries, 1820).

Though Barbier knew books, the revolutionary art hunters under the direction of Barbier and Leger were not particularly knowledgeable about fine art, and their looting lacked follow-through. Much of the looted art was moved to a collection point but never carried on to Paris. For example, although the forty-six columns looted from Aix-en-Provence that formerly stood in front of Charlemagne's palace were seized in October 1794, they were still sitting in the courtyard of a palace in Liège, awaiting transport to Paris, in January 1800. It was not until the better-organized looting spree under Napoleon's imperial army that the museums filled in earnest with the plunder of fallen nations.

The French revolutionary army had first arrived in the Austrian Netherlands in 1792 to liberate the area from the Austrian and Prussian forces. The second coming of the army, in 1794, brought the Revolution along with it—and resulted in the mass displacement of the region's art treasures. Religious institutions were abolished, and their possessions were confiscated, including those of Saint Bavo Cathedral.

In the city of Ghent, the central panels of *The Lamb* fell into the hands of the French Republican army. The panels were removed from the cathedral by the army under General Charles Pichegru on 20 August 1794. The officer in charge of art confiscation in Holland and the Austrian Netherlands was Citizen Barbier. It is not known why the French took only the central panels of the altarpiece, and not the wings. The original Adam and Eve and the wing panels, stored in the chapter house of the

cathedral, were all left behind. Though it is not recorded in extant documents, they might have been *hidden* in the chapter house, or perhaps the simple fact that they were in storage while the central panels remained in the Vijd Chapel on display meant that they were overlooked by the French soldiers. The central panels were taken directly to Paris, where they went on display immediately as one of the museum's top attractions.

Citizen Barbier addressed the National Convention in Paris mere weeks after capturing the central panels of *The Mystic Lamb*, only days after the first shipment of looted art arrived from Holland: "Too long have these masterpieces been sullied by the gaze of serfs. . . . These immortal works are no longer in a foreign land. . . . They rest today in the home of the arts and of genius, in the motherland of liberty and sacred equality, in the French Republic." This was no doubt a crowd-pleasing speech, but it lays bare some of the hypocrisies inherent in the Republican expansion. Was it not the "serfs" who rose up to become the French revolutionaries? Why then have "these masterpieces been sullied by the gaze of serfs"? According to the revolutionary dogma, the commoners should now gaze upon the art that was once sullied by the aristocracy. And the art had just been taken from a country now liberated and indoctrinated by the Revolution—in effect stealing from the recently converted.

Confused dogma aside, the point was clear. Paris, the home of the free, was to be the depository of the art of the world. The revolutionary publication *La Decade Philosophique* became the prime annunciator of the new trophies of the Republic. In October 1794 it announced the arrival in Paris of the first shipments of looted art, with more than one hundred of the world's finest pictures still en route. Paris would become the home of world art and the cradle of future artistry.

In July 1795, after orchestrating over a year of bloodshed, Maximilien Robespierre was executed, and the Reign of Terror came to an end. The running of the Republic was transferred to the Directory, formed by a new constitution on 27 September 1795.

Meanwhile, there was a good deal of rationalizing in print over the looting that was taking place. As the army conquered and stripped the

treasures of Italy, an art student named Antoine Chrysostome Qua-
tremère de Quincy published a seventy-four-page pamphlet in opposition
to the looting of Rome, arguing that art was only properly appreciated in
situ, in its native surroundings. De Quincy bravely petitioned the Direc-
tory to desist, saying that Europe was one great nation where art was con-
cerned, and that art should serve to unite. Forty-three artists and eight
members of the Academy of Fine Arts signed the petition.

The Directory responded on 3 October 1796 with a publication in the
official government newspaper, *Le Moniteur*: "If we demand the assembly
of masterpieces in Paris, it is for the honor and glory of France and for
the love we feel for those very artworks." In other words, we like them
and want them for ourselves—end of discussion. To speak out against
the looting was, according to the Directory, unpatriotic. *Le Moniteur* con-
tinued: "We form our taste precisely by long acquaintance with the true
and the beautiful. The Romans, once uneducated, began to educate them-
selves by transplanting the works of conquered Greece to their own coun-
try. We follow their example when we exploit our conquests and carry off
from Italy whatever serves to stimulate our imagination."

Thus "transplanting" became the preferred euphemism for stealing art.
If Rome, the exemplar of empire, did it, then so could France. Only a few
years later, Napoleon would declare himself emperor in his attempt to
retake for France the extent of the former Roman Empire.

If Napoleon's road towards empire was paved with military success, it was
signposted with looted art. On 27 March 1796 the bold young Corsican
general became commander in chief of the French Republican army in
Italy. He was charged with driving the Austrians and their allies out of
the country and defeating the papal armies. The Republican army was in
a dreadful state. It had relied on forced contributions from occupied ter-
ritories to supply its upkeep and payment. At the time of Napoleon's ar-
rival, the soldiers had received no pay for months. In order to avoid a

mutiny, Napoleon sanctioned looting as a method of payment for the up-keep of the army.

Napoleon was calculating and precise. He did his best to control the looting of his soldiery. In an order on 22 April 1796, Napoleon stated: "The Commander-in-Chief commends the army for its bravery and for the victories it has wrested from the enemy day after day. He sees with horror, however, the dreadful looting committed by pathetic individuals who only join their units when the fighting is over, because they have been busy looting." The soldiers paid little heed. Shortly thereafter, Napoleon issued another order: "The Commander in Chief is informed that in spite of repeated orders, looting in the army continues, and houses in the countryside are stripped," that any soldier found looting would be shot, and that no objects could be confiscated without written permission of specified authorities. Napoleon, not his soldiers, would be permitted to loot.

Napoleon managed to turn around a disastrous campaign in Italy and transform a disheveled, hungry, mutinous mass of soldiers into a disciplined, professional army. The Republican army became his diehard supporters. His phenomenal success in the Italy campaign featured a telling armistice with the defeated Duke of Modena. Among the conditions of the armistice, signed 17 May 1796, was written, "The Duke of Modena undertakes to hand over twenty pictures. They will be selected by commissioners sent for that purpose from among the pictures in his gallery and realm." This set a precedent for payment and reparations in the form of artworks that would enrage and dismay surrendering peoples for centuries to come.

Napoleon gave strict instructions on the proper removal of artworks. Special agents were ordered to use the army to commandeer art, arrange transport to France, and make a precise inventory. This inventory was to be presented to the army commander and the government attaché to the army. Records of each confiscation were to be made in the presence of a French army–recognized official. Army transport was to be used to bring loot back to France, and the army was to cover the costs. In fact, these

careful instructions served to veil the personal circumvention of them by Napoleon and his officers.

The coyly named Commission of Arts and Sciences was led by an artist, Citizen Tinet, and consisted of a mathematician, Citizen Monge, a botanist called Citizen Thouin, and another painter, Citizen Wicar—the most notorious of the lot, who proved to be a thief for the ages.

Jean-Baptiste Joseph Wicar was an artist and art collector in his private life. He studied under the leading painter of French Neoclassicism, Jacques-Louis David, a master whose importance to the history of painting is but one strata down from van Eyck's and who managed his politics well enough to be the favorite of both the revolutionaries and Napoleon. Wicar accompanied the great David on a Grand Tour to Rome in 1784 and returned to reside there from 1787 to 1793. This proved a good opportunity to identify works throughout the city that would look nice in the Louvre—and in his bedroom, should the opportunity arise.

In 1794 Wicar was appointed keeper of antiquities at the Louvre, a powerful position, second only to the new museum's director. That same year, Wicar was called on to lead the Commission of Arts and Sciences during the Italian campaign, in charge of art confiscation in the wake of Napoleonic victories. Wicar would retire from official service in 1800 and move to Rome permanently, where he set up shop as a highly successful portraitist, sought out by Grand Tourists, and as a dealer in stolen drawings. There he was at leisure to admire the city that he had helped Napoleon to pillage—and a good portion of the plunder remained in his apartment, gathered for private delectation but also for sale, if the price was right.

Led by Wicar, the Commission of Arts and Sciences made their first Italian stop in May 1796: recently vanquished Modena. There they confiscated not only the agreed-on twenty pictures for the Republic but the duke's collection of cameos and an unrecorded number of other works for themselves. Citizen Wicar proved an ingenious criminal, siphoning off fine works, particularly those in the easily smuggled medium of works on paper, then selling them to international dealers for a vast fortune. He

single-handedly stole fifty paintings and an undisclosed number of draw-
ings from Modena for himself. The private looting of the Duke of Mo-
dena's collection ended only when Napoleon arrived on the scene. He
prevented his commissioners from taking anything more. Then he chose
two paintings for himself.

The precedent was set, one that would be followed in victories over
Parma, Milan, Mantua, and Venice, among others. Art was demanded as
payment in the armistice. This demand would be followed by looting well
in excess of the armistice agreement, when the time came to collect.
Works by Michelangelo, Guercino, Titian, Veronese, Correggio, Raphael,
and Leonardo were among those taken, as well as antiquities like the fa-
mous Quadriga, the bronze horses of Basilica San Marco in Venice,
looted from Byzantium in 1204 during the Fourth Crusade and now
"transplanted" to Paris.

Other cities in Napoleon's path took measures to protect their artistic
treasures. Naples did not engage Napoleon in combat, but rather signed
a treaty immediately, as did Turin. As a result, these two cities lost the
least to plunder.

Pope Pius VI agreed to terms with Napoleon in June 1796, but paid
heavily. In addition to the payment of 21 million livres in money and
goods (approximately $60 million today), Article 8 of the Treaty of To-
lentine stated that the pope was to hand over: "A hundred pictures, busts,
vases or statues to be selected by the commissioners and sent to Rome,
including in particular the bronze bust of Junius Brutus and the marble
bust of Marcus Brutus, both on the Capitol, also five hundred manu-
scripts at the choice of the said commissioners." Among the one hundred
works were eighty-three sculptures, including the great *Laocoön* and the
Apollo Belvedere and Raphael's marvelous painting *The Transfiguration*.
Adding insult to injury, the Vatican was required to pay for the transport
of all of the art forced from it by the French, for an astonishing sum of
800,000 livres, about $2.3 million today. Forty paintings were taken from
papal dominion in Bologna and ten more from Ferrara. The looted art of
Bologna alone required eighty-six wagons to transport. Napoleon wrote:

"The Commission of experts has made a fine haul in Ravenna, Rimini, Pesaro, Ancona, Loretto, and Perugia. The whole lot will be forwarded to Paris without delay. There is also the consignment from Rome itself. We have stripped Italy of everything of artistic worth, with the exception of a few objects in Turin and Naples!"

Along with the "official," that is to say regime-legitimized, looting, there were thousands of private art thefts, works siphoned off by officials during the looting process or by civilians taking advantage of the wartime chaos. The handiwork of Citizen Wicar exemplifies the scavenger thefts of the Napoleonic era. What the keeper of antiquities for the Louvre stole from the Duke of Modena was just an appetizer. Throughout the Napoleonic campaigns, Wicar swiped literally thousands of drawings, becoming one of the preeminent suppliers of art, stolen or otherwise, in history. Wicar stole so many drawings, in fact, that despite selling most of them during his lifetime, he had enough left to will 1,436 drawings as a gift to his birthplace, the city of Lille, upon his death in 1843.

While records remain of the official confiscations of artwork in the wake of Napoleon's victories, we can only imagine the extent of the thefts off the record. From Italy alone, leaving aside the multitudinous thefts from Rome, officially recorded confiscations amount to 241 paintings. The seizures from Rome itself were in the thousands. How many more were taken unofficially, or how many records were lost or altered, remains unknown. Italy was by no means alone in being stripped of art. Greece, Turkey, and Egypt lost vast quantities of antiquities, but it was the rich collections of central and western Europe that yielded the largest measure of plunder. In one region of Germany, Brunswick, at least 1,129 paintings were removed, both officially and covertly, as well as 18,000 antique coins and 1,500 precious gems. Of these, 278 works of art were directed for display at the Louvre.

Citizen Wicar was out for personal gain more than for the glory of the Louvre. He happily exploited a chaotic situation, but he was not influential in Napoleonic policy. He did not have access to the general's ear, and he would not leave a legacy beyond his colorful story and reputation (and

the 1,436 stolen drawings bequeathed to his hometown). One man had all the power that Wicar did not, and proved instrumental not only to Napoleon's arts policy but to the history of museums themselves. He was Napoleon's mastermind art hunter.

Dominique Vivant Denon served as the architect of the art looting and assembly at the Louvre during Napoleon's reign. As an artist in the court of Louis XV, Denon gave drawing lessons to the king's favorite mistress, Madame de Pompadour. Highly intelligent, charming, and cultivated, he was also active in the political arena, working as an ambassador in Saint Petersburg to the court of Catherine the Great and in Naples, which was then the capital of the Kingdom of the Two Sicilies. He was wise enough to be abroad in 1789, when the Revolution began—in Venice, where he had plans to live with his mistress and establish an engraving studio. But he was expelled from Venice under suspicion of collaboration with revolutionary exiles, which may in fact have been true, as his allegiances swung wherever advantage lay. He moved to Florence and might have remained there, but he learned that his name was listed among those whose property could be confiscated by the revolutionaries. Denon made the brave and perhaps foolish decision to return to France in an effort to save his property.

Though a royalist, he was saved from the guillotine in 1798 by the intervention of the leading painter of the Revolutionary period (and the former teacher of the nimble-fingered Citizen Wicar), Jacques-Louis David. David was able to dissuade the revolutionaries from executing Denon because Denon had commissioned David to document meetings of the revolutionaries in Paris. While this was surely an action motivated by artistic rather than revolutionary ideals, it sufficed to persuade the revolutionaries that Denon did not need to be killed. Denon would begin a new life in support of the French Republic.

Denon's allegiance shifted with the prevailing winds. He had begun his life with the aristocratic title of Chevalier de Non. But, in that era, to save oneself, a certain degree of flexibility was necessary. From minor nobility, he became Citizen Denon, designing the uniforms for the

French Republican army (he would shift once more, becoming Baron Denon when Napoleon reinstituted the ancien régime system of titles). In 1797 he befriended the young Josephine de Beauharnais, recently married to Napoleon, at that time a general. Through Josephine, Denon grew close to Napoleon. He was chosen to accompany the general as an official artist on his 1798 campaign in Egypt. During this campaign Napoleon's men stole the Rosetta Stone, the Sphinx was damaged by his soldiers, and Denon became one of Napoleon's confidantes and his main artistic advisor.

Napoleon was no connoisseur of art. He admired works based on their size and their lifelike naturalism. Denon gently guided Napoleon in matters of taste but was largely content to siphon off for the Louvre the works most important to the history of art, those that required greater knowledge or more subtle tastes to appreciate, leaving the large realistic paintings for Napoleon's personal collection. Denon would accompany Napoleon on most of his later campaigns, advising on which artworks to confiscate and send to the Louvre. His nickname was *l'emballeur*, "the packer," for his constant supervision of the packing and shipping to Paris of looted artworks.

Denon was a pocket philosopher, capable of some intriguing insights, but most often at a superficial level. He spent his time on the Napoleonic campaigns drawing monuments and occasionally sketching battles as they took place—it is said that he supported his drawing board across his saddle as he rode on horseback alongside a raging battle, sketching frantically, cannon fire all around. When the French army reached the ruined Greek city of Thebes, Denon wrote of an incident that was wonderfully romantic, if it can be believed: "[The ruined city was] a phantom so gigantic . . . that the army, coming in view of its scattered ruins, stopped of its own accord and, in one spontaneous moment, burst into applause." He waxed poetic on the subject of war and how history can rewrite itself: "War, how brilliant you shine in history! But seen close up, how hideous you become, when history no longer hides the horror of your details."

This line would prove prophetic: History writers deftly cleaned up the looting of art during war, as Denon did himself on 1 October 1803. On

that day, one hundred cases packed full of antiquities looted from Italy arrived at the Louvre without a single object broken en route. Denon took the opportunity to make a speech to the members of the Institut de France, an intellectual salon group with mystical/religious interests that had been established in 1795 by former members of the French Masonic Lodge. Presenting treasures that included the Venus de Medici and the Capitoline Venus, Denon proclaimed, "The hero of our century, during the torment of war, required of our enemies trophies of peace, and he has seen to their conservation."

Denon was the first director of the Louvre, officially rising to the post in 1802. His role in art looting notwithstanding, Denon was an ingenious museum director, helping to shape the way we conceive of museums today. He thought that a museum should present a "complete set" of the best representations of every artistic movement that one could acquire, from "the Renaissance of the arts until our own time." In this way, the museum should provide "a history course in the art of painting," presenting its collection with "a character of order, instruction, and classification," as Denon wrote in a letter to Napoleon in 1803. To this end, Denon reinvented the manner of displaying paintings. Before this time, works were hung from floor to ceiling in a rather haphazard manner, covering the walls with frames. Denon came up with the idea of isolating art for better contemplation, framing each work in the center of the wall, and displaying works of art that would have an artistic or theoretical dialogue near each other. He believed that one could learn through the way that art was displayed, not merely from the art itself.

When Napoleon became emperor in 1804, Denon was made inspector general of French museums, ostensibly the director of all national collections. Both he and Napoleon understood that there was symbolic power in the capture and display of the cultural treasures of fallen nations. When he was not traveling recently conquered Europe, seizing thousands of artworks of the highest quality, Denon installed himself at the Louvre, surrounded by an art historian's fantasy. The museum would become the Hall of Wonders, starring the jewels of the conquered world, available for the delectation of triumphant France.

The Louvre—originally known as the Muséum Français, then the Musée Central des Arts, then the Musée Napoléon from 1803 to 1814, before becoming the Musée du Louvre—developed into a popular pilgrimage point for the cultured traveler. The accumulation of looted art in Paris was a constant point of discussion in European publications and elicited a great deal of interest in what might be called "illicit art tourism."

In 1802 Henry Milton, an Englishman traveling to Paris specifically to see the loot-stocked Louvre, wrote: "Bands of practiced robbers who could not find an outlet for their talents in their homeland were shipped abroad to commit crimes under another, less discreditable name. . . . Hordes of thieves in the form of experts and connoisseurs accompanied their armies to take possession, either by dictation or naked force, of all that seemed to them worth taking." Milton's indignation, a feature of his 1815 book *Letters on the Fine Arts Written from Paris*, did not prevent him from visiting and admiring the art itself. One might object in principle to a circus display of caged endangered creatures, yet buy a ticket to the show all the same.

Milton exemplified a new breed of tourist, one who traveled to Paris to admire the new and best museum in the world, comprising the choicest plunder from all of Europe. The general consensus was some balance between horror and awe. The French had done something of which past powers might only have dreamt and to which future powers, particularly the Nazis, would aspire. They had turned their national gallery into a supermuseum, containing the cream of the art of the Western world.

At the Louvre, Denon's goal was to assemble the world's finest, and most complete, collection of art. Napoleon was proudest of having stolen the prized *Apollo Belvedere* from the Vatican—less because of its importance as an antiquity, but because he had pried it loose from the papal collection. Denon was more interested in paintings, and now he ruled over one of the world's most important paintings, *The Ghent Altarpiece*. But Denon was painfully aware that the stolen prize was incomplete. The Louvre displayed the glorious central panels: the glowing jewels in God the Father's crown, the individual hairs on John the Baptist's cas-

cading beard, the blood spilling into the chalice from the neck of the lamb on the altar. But Denon wondered about the wings, and Adam and Eve. Why had Citizen Barbier not confiscated them as well, eight years prior? For a true connoisseur, an incomplete masterpiece was a source of frustration, an unclosed wound. To have only the central panels of van Eyck's masterpiece was like having Michelangelo's *David* on display without its legs or Leonardo's *Mona Lisa* with no hair.

In 1802, finally at the reins of the Louvre, Denon sought to right this confiscation oversight. Since the 1795 annexation of the Austrian Netherlands to France, relations with Ghent were no longer such that Denon could easily arrange further thefts from the cathedral. So Denon tried another tactic—negotiation. He contacted the bishop of Ghent and mayor of the city, asking if they would sell him the wing and Adam and Eve panels, so that *The Lamb* could be whole once more, albeit in Paris.

The bishop and the mayor declined. They would not sell off a national treasure. So Denon offered a trade: paintings by Rubens, another Flemish master, in exchange for the remaining panels. They could swap one national treasure for another. But Rubens was from Antwerp, a rival city to Ghent. A neighboring masterpiece would not do. The morale of the city was linked to the maintenance of its flag—*The Adoration of the Mystic Lamb*. It was insult enough that the central panels had been taken. The wings at least must remain.

This was the first of several wars in which *The Ghent Altarpiece* was a prized spoil. Much of the desire to possess the painting was due to the fact that so many other people sought it, for either personal or national collections. The desirability of the artwork accrued with each high-profile incident of its capture and return. Denon sought it for the Louvre, and because of the high esteem in which he held the painting, its fame grew.

While Denon was building the Louvre through military-imposed theft, all the while portraying his efforts as noble, the city of Ghent could claim a heroic thief of its own. By the end of the eighteenth century Ghent had lost its status as an industrial and economic presence. Then a singular

event, a theft of an altogether different sort, resurrected the battered and weak city.

In 1799 the English had a brief monopoly on Europe's cotton industry after the spinning mule, the key mechanical component of a cotton mill, was invented by Samuel Crompton. This invention made it possible to mechanically convert raw cotton into yarn, from which textiles could be made. Thanks to the spinning mule, England was the cotton leader of the Western world—a position of incredible economic value that lasted only one year.

In order to revive the flagging economy of his beloved native city, a Belgian entrepreneur named Lieven Bauwens traveled to England, stole the blueprints for a spinning mule, and smuggled them out of England and back to the continent.

From the blueprints, the first cotton mill in continental Europe was built in Paris in late 1799, breaking the short-lived English monopoly. In thanks for the efforts of its citizens on behalf of France and all its territories, Ghent was permitted to build the second cotton mill on the continent in 1800. The city that had, historically, thrived on the textile industry would do so once more. Ghent sprung from war-torn silence into an economic power, one of the most important in French-occupied territory.

Bauwens was visited by Napoleon in 1810 and awarded the Legion of Honor, France's highest honor, for his heroism. He became a leading industrialist in the city and was even made mayor for one year. The city whose greatest treasure would be stolen again and again was resuscitated by its own daring act of theft.

That same year proved tragic for another great Belgian city. French troops occupying Bruges stripped its cathedral, Saint Donatian, of all its art, including another van Eyck masterpiece, the *Madonna with Canon van der Paele* (1436). Then they demolished the cathedral. The tomb of Jan van Eyck was destroyed along with it. The Austrian Netherlands had been a hotbed of religious passion, with the University of Louvain a Catholic stronghold. In 1789 there had been a collective dismay at the religious

reforms of Emperor Joseph II. Once the region of Bruges and Antwerp was officially annexed to France, the Directory began to enforce the French manner of public worship and monastic practices throughout the Austrian Netherlands. There was concern that the fervent Catholicism of the region could become a rallying point for rebellion against French control. Religious orders were suppressed, including the diocese of Bruges, as was the wearing of clerical garb. Many religious institutions, aside from those dedicated to teaching or caring for the ill, were closed. The diocese of Bruges was suppressed from 1794 to 1795, as the region of Bruges and Antwerp was officially annexed to France. No bishop held see there until 1834, as the region was absorbed into the nearest French bishopric.

It would take a formidable team of European military superpowers, assembled and reassembled in five different incarnations, to stop the spread of the French army and ultimately lead to the return home of the central panels of *The Ghent Altarpiece*.

In 1809 the Fifth Coalition—international powers assembled to stop Napoleon's goal of world conquest—finally succeeded. The Coalition vastly outnumbered and outclassed Napoleon's army, but the great general's tactical superiority evened the playing field. He assumed direct control over his troops for the first time in years, but the Coalition swarm proved too much. By January 1814, Napoleon had lost Italy, the Rhineland, and the Low Countries (Belgium and the Netherlands).

After successful battles against the Austrian and Prussian armies in early 1814, Napoleon's forces were battered, and it was clear that the end was imminent. The Coalition armies entered Paris on 30 March 1814. Napoleon's marshals deserted him in the first days of April, and on 4 April Napoleon abdicated.

In the Treaty of Fontainebleau of 11 April 1814, Napoleon was exiled to the Italian island of Elba by the victorious Fifth Coalition. In this treaty, Napoleon took particular pains to state that the art collected at the Louvre, which included both works owned by France and works looted by Napoleon, should be "respected" as "inalienable property of the Crown." In other words, the Fifth Coalition should not be permitted to

do what Napoleon had done and "steal back" what France had looted, nor to exact art as reparations. Most of the art would remain at the Louvre. But the Duke of Wellington insisted, as Napoleon had, that art constituted a legitimate trophy of war, and much of the looted art was returned to its countries of origin (although the quick-handed English managed to sequester the Rosetta Stone for themselves).

Even the return of looted objects had a profound effect on how we understand art today. The restituted art was not reinstalled in churches, which were the major victims of looting; rather it was installed in newly established museums, with the idea that such institutions could better protect, preserve, and present a nation's masterpieces. This was perhaps an inadvertent but potent legacy of Denon's that is still dominant. National cultural heritage would migrate into the museum, to be displayed in a manner, though removed from its context, that would best educate the museumgoers and preserve the works themselves.

Distraught at the dissolution of his carefully curated collection, Denon resigned. In retirement, he would open up a private museum in his Paris apartment along the Quai Voltaire—a cabinet of curiosities, more a reliquary than an art gallery, which displayed everything from the moustache hairs of King Henri IV to Voltaire's teeth to a drop of Napoleon's blood. Through a combination of diplomatic efforts, intentional misadministration, and a lack of coordination on the part of some of the looted countries, more than half of the art looted by Napoleon and by the revolutionaries remained in the Louvre. Much of it is still there today, including seminal works like Titian's *Crowning with Thorns*, Veronese's *Marriage at Cana*, and yet another of van Eyck's great works, *Madonna with Chancellor Rolin*, stolen from a church in Autun in 1800.

With Napoleon deposed, Royalist factions back in Paris reinstated the French Bourbon monarchy, in the person of Louis XVIII. Always ambitious, he was unhappy with his position as king-in-exile, and welcomed the reinstatement. He was an avid collector of books and curiosities as much as art, and enjoyed a lavish lifestyle, although this was tempered by his rationality. The one thing about which he could not be reasonable was

his food intake—he was a passionate gourmand and bon vivant of the highest rank, with the predictable results for his waistline. Louis proved an intriguing combination of some of the characteristics that led to the deposition of his ancestors: He was selfish, pompous, luxurious, and indulgent, but with Enlightenment characteristics of rationality, impeccable manners, and an awareness of the sociopolitics of the world around him.

Louis XVIII had been living safely abroad throughout the Revolution. The younger brother of the beheaded Louis XVI, Louis XVIII became heir upon the death of his elder brother's ten-year-old son, Louis XVII, who died while in prison during the Revolution on 8 June 1795. Louis XVIII then declared himself king and set up a court-in-exile in Venetian-controlled Verona, until he was expelled at the request of the Directory in 1796. He was a wandering monarch, self-declared as king of France, but he had no power nor any subjects beyond his immediate retinue. He lived briefly in Russia, England, and Latvia during this time. There is a pathos to this ghost of a king, inheritor of an overthrown, intangible throne.

Louis XVIII strategically corresponded with Napoleon during Napoleon's time as consul. He offered to pardon regicides, to give titles to the Bonaparte family, and even to maintain the changes Napoleon and the revolutionaries had made since 1789. But Napoleon replied that the return of the Bourbon monarchy would lead to civil war and hundreds of thousands of deaths. Napoleon would not play second fiddle, even if he could be the puppet master behind the throne.

Following Napoleon's defeat in 1814, Louis XVIII was granted the French throne by the victorious Allied powers. His rule was more symbolic than actual, as he was forced to implement a newly written constitution, the so-called Charter of 1814, guaranteeing a bicameral legislature that would prevent monarchic abuses of power.

Louis's reign was interrupted by Napoleon's dramatic escape from Elba on 26 February 1815. News of his flight quickly reached the king, who sent the Fifth Army to engage Napoleon at Grenoble. On 7 March 1815, Napoleon dismounted from his horse and approached the army on foot,

eyeing his former soldiers. His words are recorded for posterity: "Soldiers of the Fifth, you recognize me. If any man would shoot his emperor, he would do so now." There was a cold silence. Then the army shouted, in unison, "Long live the emperor!" And that was that. He retook the leadership of the army, gathered a force 200,000 strong, and marched on Paris.

King Louis XVIII fled and took shelter in the city of Ghent. He remained in Ghent for less than one year. When Napoleon was finally defeated at the Battle of Waterloo in June 1815, Louis returned to Paris and was restored to the throne by the victorious powers for the second time. In an interesting side note, Citizen Barbier contrived to get himself employed by Louis XVIII. He was briefly engaged as chief administrator of the king's private libraries, before he was fired from the job and deprived of all offices in 1822—perhaps only then did the king realize that he had hired one of Napoleon's master thieves.

The fleeing king's brief stay in Ghent proved of vital importance to his host city. Had they not sheltered him, the central panels of *The Ghent Altarpiece* would almost certainly still be on display at the Louvre today. Grateful to the city, Louis took measures to repay the kindness he was shown. Indeed, he made more of a positive impact on the history of Belgium and the Netherlands than he did on his own kingdom of France. Louis XVIII officially united with Holland the newly French Netherlands (the former Flanders and the future Belgium) in late 1815. The result was the United Kingdom of the Netherlands. He then returned the stolen central panels of *The Adoration of the Mystic Lamb* to the city of Ghent. A long-time sufferer of gout, Louis remained wheelchair-bound until his reign ended with his death on 16 September 1824.

The central panels of van Eyck's masterpiece were among at least 5,233 indexed looted objects that were returned to their places of origin during the reign of Louis XVIII. How many were stolen in total, between the ravages of the revolutionary French soldiers and Napoleon's confiscators, will never be known.

The Ghent Altarpiece was whole once more, proudly displayed in the cathedral of Saint Bavo. And it would remain there—for barely a year.

Illicit Collectors' Paradise

No sooner had *The Lamb* returned to the cathedral from its imprisonment in France than it was stolen in the night. Yet another kidnapping would follow, and *The Lamb*'s nomadic existence was not even halfway over. This time the thief would be an insider, stealing on commission from a wealthy criminal dealer who exploited the turmoil of the war-torn period for personal profit.

Jan van Eyck's art achieved the zenith of its international popularity when *The Ghent Altarpiece* was displayed at the Louvre. This launched a century of van Eyck mania among collectors, viewers, and critics, during which time his works sold for significantly more than anything by other star artists like Michelangelo, and legends grew up around him. Grand Tourists, artists, and intellectuals traveled out of their way to see his paintings, most of all *The Ghent Altarpiece*. In 1876 the French painter and art critic Eugene Fromentin wrote, "As long as van Eyck stands on the horizon, a light shines to the edges of the present world; under this light, the present world seems to awaken, recognize itself, and grow brighter"—a sentiment shared by all. An examination of the nineteenth-century obsession with van Eyck offers important insights into the history and psychology of art collecting.

During this time, various factions claimed van Eyck as the exemplar of their own national styles. For the nineteenth-century Germans, the artist's archaic quality harkened back to German Gothic art, but perfected it as never before. The celebrated writer Johann Wolfgang von Goethe,

the great philosopher Georg Friedrich Wilhelm Hegel, and a cavalcade of German art historians were among those who traveled expressly to see the altarpiece, in a kind of pilgrimage of art appreciation.

The French saw van Eyck as the inventor of Realism, a mid-nineteenth-century art movement of their own. During Napoleon's time, the many stolen van Eycks on display at the Louvre enraptured the greatest painter of the period, Jean-Auguste-Dominique Ingres, who visually quoted God the Father from the upper central panel of *The Ghent Altarpiece* in his portrait *Napoleon on the Imperial Throne*. Ingres's appreciation of van Eyck fueled popular and artistic sentiment. And the market for van Eycks in England ran wild, particularly after the purchase by the National Gallery of his *Arnolfini Wedding Portrait* (also called *The Marriage Contract*) in 1842. This was further augmented by the 1851 acquisition by the same museum of the *Portrait of a Man in a Red Turban*, itself likely stolen from the Bruges painters' guild a century before.

This popularity, both scholarly and commercial, coincided, perhaps unsurprisingly, with a lively market in fake van Eycks. An early such example came from noted English forger William Sykes, referred to gently by the novelist Horace Walpole as a "noted tricker." In 1722 he conned the Duke of Devonshire into buying a painting by forging an inscription on the back that suggested it was painted by van Eyck on commission from the English king Henry V. Today the work in question, the *Enthronement of Saint Romold of Malines* (circa 1490, now in the National Gallery of Ireland), is attributed to an unknown artist. Most van Eyck fakes were like this one—not wholesale forgeries but rather legitimate fifteenth-century Flemish paintings attributed to Jan van Eyck in order to command top prices.

The nineteenth century was a time when art collectors, through legitimate and illicit means, built up enormous collections, profiting from the turbulent political climate and the newly impoverished aristocracy, who sold off their art collections to a new class of nouveau riche with aristocratic aspirations. Art became a trophy for the nouveaux riches to show off their wealth and social standing. This century also saw the evo-

lution of *The Ghent Altarpiece* from a work of art, capable of inciting religious outrage and prurience, and representative of the city of Ghent, into the battle standard of the fledgling nation that would become known as Belgium.

In the years preceding the next theft of *The Mystic Lamb*, the city of Ghent featured prominently on the world's stage—not for a shift in its own fortunes, but because of the role it played in U.S. history.

On 24 December 1814 the Treaty of Ghent was signed, officially ending the War of 1812 between the young United States under President James Madison and the United Kingdom of Great Britain and Ireland. The United States had hoped to conquer Florida and Canada but failed to make much headway. The British had little retaliatory success of their own, beyond the burning of Washington, DC. The Treaty of Ghent, a site chosen because of its neutrality, resulted in almost no alterations from the prewar situation. The slow lines of communication between Ghent and the United States meant that the celebrated Battle of New Orleans took place two weeks *after* the official treaty had been signed, because the participating generals, including the fabled American Andrew Jackson, had not received word in time of the war's end. News of the treaty finally reached the United States and was ratified by President Madison on 15 February 1815.

On 19 December 1816, barely a year after the restitution of the central panels, *The Lamb* was dismembered again. While the bishop of Ghent was out of the city, the vicar-general of Saint Bavo Cathedral, a Monsieur Jacques-Joseph Le Surre, stole the six panels comprising the wings of the altarpiece. Tantalizingly few details remain about this theft as a result of the disappearance, over a century later, of files from both the cathedral archive and the Ghent city hall.

It is known that Le Surre was a French-born priest, a nationalist, and an imperialist, as were the bishop of Ghent, a French nobleman called

Maurice de Broglie, and a possible henchman in the theft, the cathedral's canon, Joseph Gislain de Volder. Le Surre disapproved of the reinstatement of King Louis XVIII and looked with dismay upon the exile of Napoleon and the return of much of the Louvre's looted art collection. Napoleon was a great man, the greatest France had ever known. The art was the symbol of French victory and should remain in France. More than all this, Le Surre recognized that there was profit to be had.

It is not known how thoroughly premeditated was Le Surre's theft of the wing panels or how many other people were involved, though Canon de Volder has been suspected as a probable accomplice. Some answers may be inferred from the limited information that survives.

Vicar-General Le Surre could not have acted alone, for the simple reason that the six wing panels are too heavy for one person to move, even one panel at a time. Each panel weighs approximately sixty to a hundred kilograms. It would have been extremely difficult to "shop" the wing panels from *The Lamb*, easily one of the ten most important and recognizable paintings in Europe. The theft would have been futile if there was no one to whom one could sell the panels without questions being asked. Logic points to a premeditated, opportunistic crime, one that was at least encouraged—and probably commissioned—by a wealthy and influential pirate among art dealers. The theft was almost certainly commissioned by the buyer who appeared on the scene: a thoroughly unscrupulous man and notorious profiteer of the French army's confiscation and sales of artworks from across Europe.

As a wealthy dealer based in Brussels, Lambert-Jean Nieuwenhuys had already proven himself a war profiteer. Portly and regal, but with a sharp and merciless eye for opportunities both legal and questionable, Nieuwenhuys handled an astonishing number of major Flemish works during this period. Once he had established an art dealer dynasty in Brussels, scores of paintings passed through his hands, as he took full advantage of the chaos of the French invasion and occupation, and the redistribution of art that accompanied it. His influence extended from Germany to Spain, and he was involved in dozens of legitimate and illegitimate acquisitions and sales, along with knowing misattributions and

the dissemination of forgeries. His name and the name of his son, C. J., may be found in the provenance of works around the world—an indication of the power and influence of opportunistic dealers during this period of political turmoil.

During the French occupation of what was then called the French Netherlands, a window of opportunity was open for wily dealers like Nieuwenhuys to buy prime artworks from the ignorant French confiscators. In Brussels alone, fifty churches and seminaries were plundered by the French Commission. So much art from this area entered the market, almost every item of which was stolen, that the flood did not begin to recede until after 1815, when hungry English, German, and Russian collectors descended with open wallets on the newly independent United Kingdom of the Netherlands. Nieuwenhuys, the prince of Belgian art dealers, mopped up the lion's share of profits from the illicit Flemish art market.

Nieuwenhuys had already been involved in deals with *The Ghent Altarpiece*—or at least a copy of it. English art dealer W. Buchanan wrote in his *Memoirs of Painting* that Nieuwenhuys had sold panels from the Michiel Coxcie copy of *The Ghent Altarpiece*, painted for Phillip II in 1559, after they had been stolen by one of Napoleon's generals. But Nieuwenhuys sold them as the originals.

The Coxcie copy of *The Ghent Altarpiece*—its panels were displayed at this time in Berlin, Munich, and Ghent—was considered nearly indistinguishable from the original to the untrained eye. One of Napoleon's generals in Spain, Auguste-Daniele Belliard, had seized the copied altarpiece from a monastery while serving there in 1809.

We do not know whether Belliard thought that Coxcie's copy was the original. Most likely he was taken in by the likeness, even though he already knew, or learnt quickly, that the original van Eyck was divided between the Louvre and the cathedral of Ghent. In any case, he surely saw an opportunity.

Belliard brought the Coxcie copy to Brussels, where he sold it through Nieuwenhuys, one panel at a time. Nieuwenhuys passed off each individual panel as one of the originals. His story was that the originals had been

captured and dispersed in the turmoil of the period. During the Napoleonic era, there was every possibility that a territory seized by one imperial force would remain within that empire indefinitely. Therefore art taken in war was, for all intents and purposes, the property of the nation that took it. Only in recent decades has there been, among dealers, a widespread reluctance to deal in works with a questionable provenance, partly because of lawsuits brought by descendants of owners whose art was stolen from them in past wars.

So when word circulated that *The Ghent Altarpiece* had been seized by French forces, it was not inherently problematic for potential buyers to see its panels on the art market. The Nieuwenhuys family thrived on this shift in ownership on a massive scale and benefited from the lack of concrete information as to which works were where and owned by whom. Nieuwenhuys and his son, C. J., who inherited his father's business acumen and slippery ethics, sold several real van Eycks, including the *Lucca Madonna* (1436), as well as quite a few fakes and paintings with intentionally enhanced attributions. For instance, Nieuwenhuys sold Rogier van der Weyden's *Triptych of the Nativity* as the work of Hans Memling, whose paintings were of greater value than van der Weyden's at the time.

Also in 1816, French soldiers confiscated a second complete, full-size copy of *The Ghent Altarpiece* that had been painted by an anonymous artist in 1625 for display in the Ghent Town Hall. This copy, now on display in Antwerp, had been in Paris since 1796. As a copy, it was not considered important enough for the Louvre to retain and so was sold off in 1819 to a German collector based in England, Carl Aders. Aders's purchase coincided with the acquisition by the London National Gallery of van Eyck's *Portrait in a Red Turban* and *The Arnolfini Wedding Portrait*, launching van Eyck mania on the island.

So many forged or misattributed van Eycks circulated at this time that at an 1830 exhibit of Flemish painting in Manchester, England, of five "van Eycks" on display, none was real. A contemporary article in the *Manchester Guardian* admitted as much but did not seem fazed by it: "Of van Eyck's genuine works we really cannot feel satisfied that the Old Trafford

Exhibition contains a single specimen." The nature of the art trade, like other economic markets, requires that supply meet demand—and when dealers run out of authentic pictures, demand may be met through forgery, misattribution, and theft.

Nieuwenhuys engaged in all three.

The difficulty in navigating the art market without the strong hand of an experienced dealer such as Nieuwenhuys indicates that Vicar-General Le Surre acted on Nieuwenhuys's orders. Le Surre was the inside man. Taking advantage of a moment when the bishop was out of the city, he stole the altar wings and passed them to Nieuwenhuys for the paltry sum of 3,000 guilders (around $3,600 today).

Le Surre may have taken only the altar wings because there was a greater likelihood that they would go unrecognized as having been recently stolen. The central panels, back from Paris only one year prior, were at the forefront of everyone's mind. But the wings had remained in the cathedral archives since 1794.

There also seems to have been an odd consensus within the diocese that the wings were of only peripheral importance to the work as a whole and that it was the central panels that were critical emblems of Saint Bavo and of Ghent. This sense might have been heightened by the fact that the French soldiers had only seen fit to steal the central panels for the Louvre, even though Denon reacted swiftly when he saw the error in seizure, attempting to reconstitute the entire altarpiece in Paris.

That Adam and Eve were spared may have been a simple matter of logistics, of what Le Surre had access to, and how difficult it would have been to smuggle more panels out of the city. Regardless of the reason why, the tiny sum Le Surre received for the stolen wings suggests that this was a fee for services rendered, not a sale price hard-won through negotiation, further indication that Nieuwenhuys commissioned the theft.

When the sale of the wings was discovered, it caused a huge uproar in Ghent, but the damage had already been done. Remarkably, Le Surre was not punished for his action, at least not publicly, outside the confines of the diocese. He claimed that the diocese considered the wings to be

superfluous and that he had not stolen them but rather sold them on be-
half of the bishopric.

There was a suggestion of collusion within the diocese, particularly
when Le Surre retained his position even after the sale came to the at-
tention of the public. When the bishop, Maurice de Broglie, was ap-
pointed to his position in Ghent, Le Surre was the one man he brought
with him from his previous appointment. The two were friends and long-
time colleagues. Could the pro-French bishop have approved of the sale?
Motive is lacking for the Bishop de Broglie's involvement. If Le Surre had
permission, why would he have sold these panels of international renown
for only 3,000 guilders? If it was an ideological theft, a pro-French, pro-
imperial statement that what Napoleon stole should remain the property
of France, then the panels would not have been sold to a Belgian dealer
who would pass them on to an English collector in Germany.

This scandal also raised a question, discussed in newspaper articles in
the years to follow, as to whether *The Ghent Altarpiece* belonged to the
nation that was soon to become known as Belgium or whether it was the
property of the bishopric. This was long before the establishment of in-
ternational legal action to repatriate cultural heritage. Today, both the
private owner and the nation would have claim to a work deemed offi-
cially to constitute cultural heritage. In most countries the work would
remain the property of the private owner, but it would not be permitted
to leave the nation, either on loan or for sale, without the approval of the
nation's government. But in 1816, once a work was out of its country of
origin, even if its location was known, there was little to be done.

Today there are requirements in place, however frequently evaded, that
oblige proof of due diligence and good faith in order to avoid culpability,
should a purchased artwork be found to have been stolen. Due diligence
means that the buyer (and also the merchant) must prove that they
sought out lists of stolen works and checked with authorities to ensure
that the artwork in question is not of known illicit origin. Good faith
means that the buyer must show that the artwork was bought under the
genuine belief that it had no illicit background.

Neither obligations such as these, however, nor international laws on the preservation of cultural heritage were enforced at this time. Nor was provenance carefully maintained on objects, once they were looted. With the added difficulty of disseminating information in the pre-electronic age, it was all too easy to buy and sell stolen art.

Italy tried to institute the first preservation laws in the early nineteenth century. In 1802 the Vatican, in an effort to preserve what remained of the papal collections after Napoleon tore through, forbade the export of old artworks or quality contemporary ones. But due to the chaos of the time, the first enforcement of this decree did not come until 1814. Even then, little could be done to catch illicit exports.

The wing panels of *The Lamb* in hand, L. J. Nieuwenhuys found a buyer in Edward Solly, the influential Berlin-based English collector. Solly would surely have known the illicit origins of this prize, but either this did not matter to him, or the trophy was too good to turn down. He bought the six two-sided wing panels of *The Lamb* for 100,000 guilders (around $120,000 today) in 1818. They instantly became the most valuable and important works in his collection. In one year, and in one sale, Nieuwenhuys made a tidy profit of 97,000 guilders ($116,400).

Having made his fortune in the timber trade, Edward Solly fed his love for art by collecting and eventually dealing. Along with a good many art dealers of the time, he settled in Berlin. After the fall of Napoleon, the Austro-Hungarian Empire was revitalized and set about reclaiming the art looted from it, as well as expanding its imperial collections. Italian paintings, which France had flushed out of Italy during its occupation, flooded the market and were snapped up by ravenous English and German collectors. It was during this period that most of the Italian art that fills England's museums today made its way to the island. So much excellent Italian art crossed the English Channel that for the first time scholars began to travel to England in order to study Italian art.

In Berlin, Solly profited mightily from the shakeup of the art collections of Europe during and after the French Republic and Empire. The magnitude of the trade in art at this time is indicated by the quantity of

works in Solly's possession alone. By 1820 Solly had purchased over 3,000 paintings and works on paper, the largest percentage of which comprised the art of Italian Renaissance masters, including Bellini, Raphael, Titian, and Perugino. The collection was housed in Solly's massive residence at 67 Wilhelmstrasse in Berlin. His Italian pictures occupied seven galleries in his home, which also served as his warehouse. Solly admitted to a friend that his trade in Dutch and Flemish paintings was never his passion. He said that it was "only a means of providing the wherewithal to satisfy my real desires": Italian paintings.

In 1821 the Prussian king, Frederick William III, bought Edward Solly's entire collection. His plan was to accumulate a Prussian National Gallery that would rival the glory of the Louvre. The prize of Solly's collection was the six wing panels of *The Ghent Altarpiece*.

Solly negotiated for the sale of his collection to the Prussian state over a period of three years. Both Solly and Prussia wished to keep the details of the sale secret for as long as possible. Though Solly did not want word to get around, his business had slowed, and his acquisitions outran his sales. For its part, Prussia did not want known, either internally or abroad, the vast sum of money it was spending on art during this period of social turmoil. Too many voices would weigh in that Prussia should be spending on infrastructure, not the accumulation of an art collection to outdo the Louvre.

King Frederick Wilhelm III had seen the looting under Napoleon, had felt the threat to his own cultural patrimony, and had suffered losses. On the advice of the renowned German art historian Gustav Friedrich Waagen, the Prussian king began to build a royal collection. As many of the stolen works housed in the Louvre were making their way back to their places of origin, and the European market was a snowstorm of fine art, Frederick William III saw a great opportunity for the glorification of his kingdom through the acquisition of masterpieces.

Solly's collection was eventually sold to Prussia in two batches. The first group consisted of the 885 most important paintings, for which Prussia paid £500,000 (approximately $55 million today). The second group,

of less important works but all still of museum quality, involved 2,115 paintings and drawings, sold for a further £130,000 (around $10 million today). Solly was aware that he was selling these works for a fraction of their actual value, and indeed a fraction of what he himself had paid for them. But he was pleased to see the collection remain together, a legacy that would outlive him. He viewed his discounted sale as a graceful gesture en route towards his retirement.

Not even the panels of *The Ghent Altarpiece* that remained in Ghent were exempt from danger. In 1822, a fire broke out inside Saint Bavo Cathedral, damaging and destroying many of its artworks. Only through the rapid intervention of the cathedral staff and the local firefighters were the panels that remained in the cathedral preserved from harm, suffering only minor smoke damage.

In 1823, under Gustav Waagen's supervision, the panels were given a harsh cleaning, which revealed the hidden inscription referring, for the first time, to a "Hubert van Eyck." This sent the art world into fits and further catapulted van Eyck, and now *the van Eycks*, to the fore.

The territory that had begun as Flanders (and which then became the Austrian Netherlands followed by the French Netherlands, and then the United Kingdom of the Netherlands) officially seceded from Holland and became the country of Belgium in 1830. The name Belgium was selected in reference to the Celtic tribe originally from the region, dubbed "Belgae" by the conquering Romans.

The occupational history of this small territory is long and dense. From Celts to Romans to the Counts of Flanders, who had yielded the parcel of land to the Burgundian Empire, which fell to the Hapsburgs, it passed through centuries of religious conflict and power shifts, before the French Republican and then imperial armies made it their own. Since 1830, it has been known as Belgium. But throughout its existence, through many names and many occupying powers, its greatest treasure has always been *The Adoration of the Mystic Lamb*. And now that treasure was dispersed, its limbs stolen, smuggled, and sold off to crown the Prussian royal collection.

In 1830 the Prussian king built the Königliche Gallerie in Berlin to house the fruits of his labors. The collection of Edward Solly joined the relatively small but precious Giustiniani collection, 157 paintings, which had been also purchased by Prussia to form the seedling of its new museum in Berlin.

Art lovers expanded their travels to include this new Berlin Museum and to see its highlight, the wings of *The Lamb*. An English critic, George Darley, noted during his 1837 visit that the change of scene seemed to do wonders for van Eyck's painting, which displayed "the most refreshing transparency, after the foul and ferruginous atmosphere which in Ghent rolled over them for four hundred years. Their azures, greens, and crimsons, like the richest jewels reduced to pure and many-colored water, which swam and stayed itself in lucid mirrors on the various parts of the surface, seem rather waved thither by the magician-painter's wand." Darley went on to write that an examination of the surface of van Eyck's painting reveals no trace of brushstroke: "scarce a touch rises from the general level to betray that the tints were successive: yet no work can have less of the licked appearance so usual and so hateful in smooth execution." Darley's lyricism is indicative of the level of admiration for van Eyck's paintings during this period. As the most expensive painter of the nineteenth century, van Eyck was the most desired artist by the English, French, and Germans.

The Berlin Museum evolved into the Kaiser Friedrich Museum in 1904, when it was moved to a grand new space on what is now called Museum Island in Berlin. It was only then, with the press that accompanied the opening of the new gallery, that the full significance of Solly's collection came before the eyes of the general public at an international level. The London *Times* published in 1905 a confirmation of both Solly's prowess as a collector and the success of his shadowy dealings, calling him "one of the most remarkable collectors who ever lived, and one of the most conspicuously in advance of his time."

At the Kaiser Freidrich Museum, the six wooden wing panels of *The Lamb* were split vertically, so that both sides, recto and verso, could be

displayed and seen from one angle. This sort of severe surgery would never be sanctioned today, and indeed the dismemberment of a masterpiece, even at that time, was something drastic. It shows a prioritization of presentation value above respect for, and conservation of, the work. This critical alteration would aid the theft of both sides of one of the vertically split panels in 1934. The wing panels would remain on display in Berlin until 1920.

The final intrigue in the story of *The Ghent Altarpiece* before the First World War came in 1861. The Belgian government persuaded the staff of Saint Bavo Cathedral to sell them the Adam and Eve panels for display in the national gallery in Brussels and for safekeeping. The sale price was set at 50,000 francs (around $115,000 today), a badly needed cash influx for the underfunded diocese. The Belgian government also gave Saint Bavo the copies of the wing panels that had been painted by Coxcie in 1559, the only panels in their possession from Coxcie's copy, to replace those that had been stolen and currently resided in Berlin. As the final part of the deal, the government paid the Belgian artist Victor Lagye to paint copies of the Adam and Eve panels to be displayed in situ, replacing those that would go to Brussels. These new Adam and Eve panels did not depict their subjects naked, as in the original. Rather, taking the cue from Emperor Joseph II eighty years earlier, the Belgian government asked Lagye to cover the nudity with strategically located bearskin garments. These new Adam and Eve panels, adapted to satisfy the Victorian prurience of the era, were placed in the cathedral in 1864.

With the Homeric twists and turns of *The Lamb*'s journey, it is understandably difficult to remember which panels were where at any given time. From 1864 until the First World War, the locations were as follows.

On display in the original location, the Vijd Chapel of Saint Bavo Cathedral in Ghent, were the new copies of the Adam and Eve panels by Victor Lagye, the wing panels copied by Michiel Coxcie in 1559, and the original van Eyck central panels, returned from Paris.

The Belgian government had the original van Eyck Adam and Eve panels. They remained in the Brussels Museum, save for a few months in

1902, when they were on loan as the centerpiece of an exhibit of Flemish masters in Bruges.

The Berlin Museum, inheritor of the Prussian royal collection, owned the six original van Eyck wing panels. In 1823, the museum acquired the Coxcie copy of the central panels of *The Lamb*, which had been on display in the Munich Pinakothek, after having been acquired from L. J. Nieuwenhuys. Therefore Berlin now displayed a semblance of the complete *Ghent Altarpiece*, with nearly as much original material as Ghent could boast.

The far-flung panels of the altarpiece could rest—briefly.

Then came the First World War.

The Canon Hides the Lamb

G hent was the site of the 1913 World's Fair: a brief respite before the tumult of the First World War, and the next installments in the illicit whirlwind tour of Jan van Eyck's masterpiece, which is, in itself, a journey through the history of art theft.

Germany's 1871 victory in the Franco-Prussian War led to an influx of income, fueled initially by the French indemnity payments, much of which was spent on enriching German state art collections. Led by the charismatic new director of the Berlin Museum, the successor to Gustav Waagen, Wilhelm von Bode, Germany began to purchase not only individual pieces but entire collections. This art harvest included the financing of archaeological excavations, such as Heinrich Schliemann's famous excavation of Troy, the findings of which filled German galleries. A competition to purchase the artworks of the increasingly impoverished European aristocracy arose between the German state museums and American private collectors.

The onset of the First World War saw an entirely new approach to how art should be handled in wartime. For the previous few thousand years, the rules of engagement had been simple: The conqueror plunders the conquered. Artworks and monuments were first seen as icons of the defeated to be destroyed. Then with the ancient Roman love affair with art collecting, initiated most overtly after the 212 BCE capture of Syracuse, which introduced Rome to the wonders of Hellenistic art, artworks were

trophies to be seized by conquest, even to the point of altering military strategies in order to abscond with the art of the enemy.

This trend continued unabated through the barbarian plundering of Rome under King Alaric and his Goths in 410 CE, and again under King Genseric and his Vandals in 455. In 535 Justinian, Emperor of Byzantium, sent his general Belisarius to Carthage in North Africa to defeat the Vandals in order to capture the loot that they had taken from Rome, so that he could have it for himself.

The Crusades epitomized the gratuitous declaration of war for plunder. Crusaders diverted their route to liberate the Holy Land from the heathens in 1204 to pillage Constantinople, the world's wealthiest city—and one populated by fellow Christians. The stories of wars begun, or broadened, to steal art would fill a book of their own, and they reached their zenith under Napoleon. For centuries it had been considered self-evident that war involved the plunder of the defeated.

It was therefore most unusual that there should be an open dialogue in the years preceding the First World War, primarily in articles published in art journals by scholars around the world, on the subject of whether art should be involved in war, when and how art should be protected, and whether it should always remain in its country of origin. This discussion continued into the First World War, the first war in which both sides at least claimed that monuments should be preserved, even at the cost of military advantage, and that plunder of artworks should never occur.

When Germany conquered France and Belgium in the early days of the war, two preservationist officials were assigned the supervision of art and monuments during the German occupation. Dr. Paul Clemen, a professor at University of Bonn, was appointed by German High Command as guardian of monuments in France and Belgium. His colleague, Dr. Otto von Falke, director of the Museum of Industrial Art in Berlin, was made commissioner for art within the German civil administration in Belgium. Both men were dedicated to the preservation of art not only from damage, but also from displacement.

The Leipzig-born Clemen began his career in Strasbourg, where he wrote his dissertation on the portraits of Charlemagne. He was named

provinzialkonservator for the Rhineland region, in which capacity he was responsible for cataloguing and conserving art and monuments. He spent the academic year 1907–1908 as a visiting professor at Harvard, before returning to his professorship at Bonn.

Clemen spent much of his tenure in 1914 drawing up official reports on the condition of the monuments entrusted to him. In December of that year, he published an article in the *International Monthly Review of Science and the Arts* entitled "The Protection of Monuments and Art During War." This article became a book in 1919 and drew published responses from a variety of fronts, all expressing support for the new concept and policy that art in conflict zones must be protected. That art should be safeguarded was, for the first time, taken as a given. The discussion was rather about whether all sides were taking every possible precaution to ensure the protection of works of art. Clemen was determined to protect the art in Belgium that was under his charge.

Clemen was a preservationist hero, his work distinct from the handiwork of so many of his countrymen during both world wars. His heartbreaking legacy was the extensive list he kept of art and monuments in the Rhineland area of Germany, while serving over forty-six years as editor in chief of the publication series entitled *Die Kunstdenkmäler der Rheinprovinz* (Monuments of the Rhine Province). Most of the works catalogued were either severely damaged or destroyed during the Second World War. Clemen's obituary was published in an American journal, which praised his work in Belgium during its occupation by the German army: "Far from despoiling the occupied country of its art objects this commission saw its purpose in the cataloguing and photographing of Belgian monuments." Clemen was one of the few public figures with power during the First World War whose actions lived up to the standards articulated by the press and academic journals. In an incident of dark irony, his home, including an extensive library of rare books and manuscripts, was destroyed by an air bombardment in 1944.

During the First World War, art provided a lens through which to debate heated sociopolitical issues. When French bomber planes flew across the sky above Alsace, the German press expressed fear for the safety of

Matthias Grünewald's masterpiece *The Isenheim Altarpiece*, which was housed in a monastery at Colmar. The issue bubbling beneath the surface was about the control of Alsace, a region that had only recently moved from French territory to German and that rivaled Belgium as the scarred battleground of European superpowers.

One of Germany's greatest fears was the looting of its cultural heritage by the Russians, a fear that would be fulfilled to a frightening extent after the Second World War. There was a German tendency at this time to attribute to the Russians barbarities of which they may or may not have been guilty.

One incident particularly raised German hackles. In the autumn of 1914, the Russian army seized and displaced the contents of the Ossolinski Museum in Lemberg, bringing its treasures to Saint Petersburg. This museum was on the recently won Russian side of the frontier with the German Empire. Russians claimed to have removed the art in order to protect it from future conflict. Germans called it plunder. The numbers of objects confiscated from that one museum were staggering:

+ 1,035 paintings
+ 28,000 works on paper (watercolors, drawings, prints)
+ 4,300 medallions
+ 5,000 manuscript pages

These Polish treasures were never returned.

The majority opinion at this time was that art merited better protection from the damages of war than did human beings. In this discussion the French and Belgians declared that no historical building would be endangered by their soldiery, even if the enemy were concealed within or behind it, irrespective of military advantage or loss of life. Through their writings, they competed for the role of protector of cultural artistic heritage during the First World War.

In an issue of the respected art journal *Die Kunst*, scholar Georg Swarzenski, the director of the Frankfurt Museum of Art who would

later direct the Boston Museum of Fine Arts from 1939, when he escaped
Nazi Germany, until 1957, wrote:

> Popular sentiment will, indeed must, declare that we have not sac-
> rificed life and property in order to add to our artistic possessions.
> The damage done by war, the values it destroys, are so great that
> we must not regard even a fraction of these spiritual values as an
> indemnity. [This would imply that] the purpose of war was not
> the insurance and strengthening of a country's own economic and
> political life, but the weakening and destruction of the enemy's
> spiritual and cultural existence. This aim, which would lead to the
> impoverishment of mankind, is not perhaps acceptable to any of
> the countries at war, and certainly not to the German Empire.

It sounded good, but in the heat of the war, would German actions
match the high-minded banter in the press and in academic journals? All
wars involve casualties, whether intentional or not. But only in rare cases
had there been incidental battle damage to art before the First World War.
During the Medici reclamation of Florence in 1512, Michelangelo had
frantically gathered mattresses to buttress the wonderful frescoes of San
Miniato al Monte, which were put at risk by the vibrations from a cannon
placed in the church bell tower to shower Florence with shells. The
Akropolis in Athens was damaged in an explosion from a Venetian bom-
bardment in 1687, aggravated by the fact that the occupying Ottoman
forces used the Parthenon as a powder magazine. Notable exceptions
aside, historical monuments had not suffered accidental subsidiary dam-
age in past wars. Art was either targeted for destruction, looted, or left
intact.

This war, however, was different. Advances in military capability pre-
sented new threats to monuments and historic buildings. The firepower
involved, the use of airplanes, and the skirmishes throughout Europe's
landscape, not restricted to open battlefields and besieged city walls, meant
that historical buildings were commandeered by soldiers, and errant

bombs and artillery would cause unintended cultural casualties. An early example in the Great War was the 1914 destruction of the Belgian city of Louvain, including its richly endowed university library.

From 25 to 30 August 1914, the small city that sat between Brussels and Liège was almost completely destroyed. The tragedy of the situation was that Louvain had surrendered to the German First Army on August 19. The city was intact, and peaceably accepted the German occupation for six days, before the German army was attacked by a Belgian relief force that had come from Antwerp, just outside the city. The army units withdrew into Louvain, causing a panic among the other soldiers in the city, who fell victim to the rumor that the Allies were launching a major attack. When the Germans realized that this was not the case, the occupying leaders convinced themselves that the confusion of their own soldiers had been sown by local citizens. In reprisal, the Germans looted and burned Louvain for five days. Hundreds of citizens were executed. The University of Louvain's library of ancient manuscripts, the cathedral of Saint Pierre, and more than one-fifth of the buildings in the city were destroyed. The German army saw the ravaging of Louvain as a useful tool to intimidate the rest of Belgium into quick submission.

This incident horrified the world, igniting the very fears that so much righteous preservationist dialogue had sought to quell. International headlines unified the general public against German barbarism and sent dread of another Napoleonic art earthquake coursing throughout the rest of Europe.

To excuse the destruction of the library at Louvain, *Kunstchronik*, another internationally read German art journal, wrote: "Implicit confidence may be placed in our Army Command, which will never forget its duty to civilization even in the heat of battle. Yet even these duties have their limits. All possible sacrifices must be made for the preservation of precious legacies of the past. But where the whole is at stake, their protection cannot be guaranteed." The First World War consumed one-third of the population of Europe. When the strategies of generals paid little heed to the lives of soldiers, it reads as ironic that so much ink was spilt in de-

manding the protection of artworks. And yet art was seen as the eternal heritage of any civilization. It had outlived, would outlive, must outlive every human who played a part in the war.

In the first years of the Great War, the theory held that war was a matter of weapons and armies and that monuments and artworks should be protected from conflict. Article 27 of the 1907 Hague Convention declares:

> In sieges and bombardments all available precautions must be adopted to spare buildings devoted to divine worships, art, education, or social welfare, also historical monuments, hospitals, and assembly points for the wounded and the sick, provided that they are not being used at the same time for military purposes. It is the duty of the besieged to mark these buildings and assembly points with easily visible marks, which must be made known beforehand to the besieging army.

As the war continued, however, the hopeful ideology of preservation, which proved increasingly difficult to assure, fell by the wayside. In the heat of battle, contingencies arose as monuments fell. Louvain was only the first victim.

At the outset of the war, despite the preservationist dialogue in art publications, there was a justified fear that the German army was willing to destroy art and monuments if they stood to gain strategically. In these early days of the war, the rules of engagement, if any rules were to be actually implemented, were as yet unknown. But the German army had looted not only in Louvain but also in Malines, setting an initial standard of destruction despite their publications to the contrary.

When the first bullets of the First World War cut through the air, the twelve panels of *The Ghent Altarpiece* were scattered. But *The Lamb*'s wild ride had just begun.

When Germany invaded Belgium, the officials of Ghent and Brussels feared that their respective panels from *The Lamb* would become targets.

After all, the Kaiser Friedrich Museum in Berlin already had the wings, thanks to the nocturnal opportunism of Vicar-General Le Surre and subsequent sales. It was an easy step for the German imperialists to seize the panels still in Belgium and reunite one of the world's greatest masterpieces in Berlin.

An unlikely hero stepped forward to protect the altarpiece during the Great War: Canon Gabriel van den Gheyn of Saint Bavo Cathedral. In addition to his ecclesiastical duties, Canon van den Gheyn was custodian of the cathedral treasures. This suited him well, as his true passion was archaeology. When asked, he described himself as an archaeologist and historian first, a cathedral canon second.

Gabriel van den Gheyn had a boyish face, accentuated by the close-cropped haircut smoothed flat on either side of a central part that gave him an air of a local newspaper boy hiding inside a corpulent body. His infectious enthusiasm for history, art, and, in particular, Catholic mysticism shone through, despite the gently downward-sloping eyes of a man sadder and wiser than his age suggested. The young canon would prove to be a central figure in the story of *The Ghent Altarpiece* in both world wars and in the infamous theft of one panel in 1934. But for the time being, the greatest worry was for the safety of the altarpiece in the face of the fast-approaching German army at the start of the First World War.

With genuine concerns about the safety of the central panels of the altarpiece, Canon van den Gheyn met with the bishop and the burgomaster, or principal magistrate, of Ghent to decide on a plan. Portly, rose-cheeked, almost Rubenesque, Burgomaster Baron Emile Braun was given the affectionate nickname *Miele Zoetekoeke*, "sweet cake," by his constituents. Emile-Jan Seghers was the twenty-sixth bishop of the diocese of Ghent. Wise and wily, the bishop was willing to hear out the canon's plan, even to risk death to protect the treasures of his church. To do nothing but wait for the German army to arrive was unacceptable. The three men de-

termined that *The Lamb* should be smuggled out of Ghent and hidden until the war ended.

But time was short. The German advance had been so rapid, the army would be on them any day. There was also the fear of German repercussions upon the discovery that the trophy of the city of Ghent had been denied them. It was so certain that the Germans would resort to torture and wanton destruction in retaliation for having been denied the treasure they sought that Burgomaster Braun refused to take any action. Better to hand over *The Lamb* intact and appease the German dragon than risk retributive death and destruction by attempting to hide it. Bishop Seghers was torn. Only Canon van den Gheyn firmly believed that *The Lamb* could, and must, be saved.

There were patriotic and symbolic reasons to preserve the Belgian national treasure, beyond any artistic interest. *The Lamb* had long been a symbol of the highest artistic achievement of Belgian culture, the rock of their patrimony. In times of war, such a treasure became a battle standard. *The Lamb* was for Belgium what Michelangelo's *David* might be for Italy, Delacroix's *Liberty Leading the People* for France, the Brandenburg Gates for Germany. Should it fall into enemy hands, the impotence of the country, unable to defend it, would be brought to the fore. The flag would be gone.

The canon believed that *The Lamb* must be defended. And what he lacked in might, he made up for in cunning. He convinced Bishop Seghers to agree, in secret, to at least passively aide him in the hiding of *The Lamb*. The condition was that the bishop should never know any details about it, as he would certainly be the first one questioned.

With the Burgomaster of Ghent bowing out of operations, the canon then turned to a Belgian cabinet minister, whose name has remained secret. The minister agreed that *The Lamb* should be protected, but what could he do? It was too late and too dangerous to have it shipped abroad.

The canon had a plan. During lunch hour, when the cathedral was closed, he and four Ghent residents took the panels from the archives of Saint Bavo into the Episcopal Palace, which adjoined. The names of these

four friends, whose help was so essential, have not been preserved—wartime heroism is often cloaked in anonymity. Because of the turbulence of the times, fear and confusion at the impending German occupation, and the panels' having been kept in the archive, several days passed before any of the cathedral staff noticed that *The Lamb* was missing. There was a brief panic among the staff, who feared that it had been looted already. The canon assured them that *The Lamb* was safe, and invented the white lie that it had been taken abroad for safekeeping. This was designed to protect his staff against interrogation.

How to move the altarpiece from the Episcopal Palace out of town? The canon and his colleagues prepared four large wooden cases in which to transport the altarpiece. The cases had to be brought to the palace in pieces and assembled there, so as not to arouse suspicion. The difficulty in hiding cases large enough to fit *The Lamb*, even subdivided into more portable panels, cannot be exaggerated. They must have felt the eyes of the city upon them. If anyone saw the cases being brought to the bishop's residence, they would have guessed that *The Lamb* was inside, and the operation would have been blown. Possible German collaborators lurked everywhere.

By night in the Episcopal Palace, against the glow of lamplight, they cleaned *The Lamb* of dust and moisture, wrapped it in blankets, and sealed it inside the wooden cases. But how could they move four enormous cases containing a painting the size of a barn wall and the weight of an elephant? The canon had an idea.

At the time it was not irregular for junk merchants to travel through the city, selling a wide variety of wares from a horse-drawn cart. From a sort of portable flea market on wheels, they would sell objects both new and used, from kitchenware to clothing, from blankets to carpets, from farm equipment to horseshoes. Nothing would look suspicious on the back of a junk cart as it wheeled its way through town.

The canon commandeered a junk cart, already loaded with bric-a-brac. On 31 August 1914, his friends drove it through town by night, its contents clattering along the cobbled streets. They backed the cart into the

courtyard of the bishop's residence and closed the gate. In the dark of night they carefully, as quietly as possible, unloaded the junk from the cart: pans and pots, carpets and lamp sconces, brooms and scythes, books and bridles. They slid the four wooden cases onto the bottom of the empty cart, then began to reload it. First they spread out carpets; then they carefully piled on the rest of the junk so that the appearance was haphazard.

Their camouflage complete, they opened the courtyard gate and drove the loaded cart through town. Had anyone observed them, they would simply have thought that the bishop's housekeepers had made an evening purchase from the local junkman. The horse clopped along cobbles past the rail station, making two stops at private homes nearby. At each stop, two of the cases were carefully pulled out from under the junk heap and hidden inside the houses, secreted between walls and beneath floorboards.

The Lamb was safe, for the time being. It would not be safe for long.

The canon and bishop expected to be questioned as to the whereabouts of *The Lamb*. Their plan to claim that it had been shipped abroad would require proof, if it were to be believed. The cabinet minister provided the necessary documentation. He mailed a letter to Canon van den Gheyn on stationery of the Belgian Ministry of Science and Fine Arts, signed by the minister. It contained no text, and the canon could add what he felt was necessary to the situation. The canon typed a letter to the effect that the clergy of Saint Bavo had been ordered to deliver Jan van Eyck's *Adoration of the Mystic Lamb* to the minister's deputy, who would then ship the painting to England for safekeeping during the war.

This seemed plausible, as other Belgian treasures had already been sent to England. Many significant artworks elsewhere in Europe were moved from their traditional locations to places considered further from the line of fire. Austrian air raids prompted the removal in 1918 to Rome of many of northern Italy's greatest works. The equestrian statues of *Bartolomeo Colleoni* by Verrocchio in Venice and Donatello's *Gattamelata* in Padua made the trip south, as did the Quadriga, the four bronze horses that

decorated the balcony of Basilica San Marco in Venice. Their history of displacement by war plunder rivals that of *The Ghent Altarpiece*. So the Canon's story was plausible. He backdated the letter. A sanctioned forgery was complete.

When the German army arrived in Ghent, polite inquiries began immediately regarding the location of *The Lamb*. Initial interviews with Canon van den Gheyn were couched in terms of concern for the welfare of the altarpiece. The devastation at Louvain was, perhaps impoliticly, cited as a rationale for Germany to be informed of the relocation of *The Lamb*. The Germans claimed to want to ensure its safety—if they didn't know its location, the altarpiece might be bombed inadvertently.

The canon produced the forged ministry letter on the first occasion that he was interviewed. When they read it, his inquisitors laughed aloud. Of all the stupid plans to safeguard artwork, what could be worse than sending it to the English, who would certainly never give it back? The Germans had a point. England, through a variety of methods ranging from legitimate to underhanded, had gathered and retained a significant quantity of art not their own. The 1816 purchase of the Parthenon Marbles by Lord Elgin from the hostile Turks occupying Athens was still a fresh memory. When Greece regained sovereignty of its capital city and first politely, and then not so politely, requested the return of their national treasures, England refused. The sculptures had been purchased legitimately, albeit from the government of a conquering foreign power. The Parthenon Marbles remain in the British Museum to this day and will almost certainly never be returned.

Once the laughter subsided, the German interviewers remained unsatisfied. They first asked, and then demanded, to know the name of the ministerial deputy who took *The Lamb* and how it had been transported. And hadn't the deputy provided a written receipt? Canon van den Gheyn consistently replied that he wasn't permitted to say.

The canon, the bishop, the burgomaster, and the cathedral staff were questioned on multiple occasions. The staff knew only what the canon had told them—that *The Lamb* had been moved to England. The bur-

gomaster knew nothing beyond that initial, preemptory conversation with the bishop and canon, which had ended with the conclusion that nothing should be done. The bishop had intentionally remained uninformed of particulars, so he did not need to lie. The canon remained silent.

In January 1915 orders came from Berlin, demanding a certificate from the bishop stating that the Germans had not stolen *The Adoration of the Mystic Lamb*. Word had reached the outside world that the altarpiece was no longer in Ghent. The assumption was that the Germans had taken it, to reunite it with its long-lost wings in the Kaiser Friedrich Museum in Berlin. An Italian magazine had published a report to that effect in December 1914. Europe was indignant. Germany had no wish to be accused of art confiscation—especially when, in this case, it happened to be innocent.

Not for lack of trying, however. Based on the enthusiasm with which they interviewed the canon and cathedral staff, the Germans certainly would have taken *The Lamb* had it been waiting in Saint Bavo Cathedral when they arrived. Yet the Adam and Eve panels were never seized from Brussels. Perhaps if the main central portion of *The Ghent Altarpiece* could not be found, the Germans would not waste time and negative publicity in taking its lateral portions.

This set the stage for the publication of an article that scandalized international scholars. In early 1915, in the journal *Die Kunst*, art historian Emil Schäffer posed the question: "Shall we take pictures from Belgium for display in German galleries?" The article suggested that the time was ripe to reassemble the disparate portions of *The Ghent Altarpiece*. Not mincing words, Schäffer wrote, "The best pictures captured as booty in Belgium should be handed over to German galleries." The wing panels were already in Berlin. Belgium was occupied. Why not remove the remaining sections from Brussels and Ghent and unite the masterpiece once again, in Berlin?

Scholars from all sides responded, condemning the article and the very idea of robbing a conquered country of its national treasure. The Napoleonic plunder was most frequently cited as a horror never to be repeated. German published responses expressed universal outrage at the

idea. Imperious, bespectacled, and brilliant Wilhelm von Bode, his sloped moustache a mirror to his jawline, was, at the time, the best-known figure in the international art world and the figurehead for German artistic theory and policy. He published his response: "My conviction is that all civilized countries should have their own artistic creations, and all their lawful artistic possessions, left them intact; and that the same principles of protection should be exercised in enemy territory as at home." But it was not clear that actual operations matched the publicly articulated virtuous sentiment. In Ghent, in the heat of war, the interest shown by Germans in the location of *The Lamb* suggested that its seizure was a strong probability.

The Italians made further accusations, particularly against Bode, who was director-general of the royal museums of Prussia from 1905 to 1920, including the Kaiser Friedrich Museum. Bode felt compelled to denounce the attacks; his response was published in a Turin newspaper: "The assertion that I have drawn up a list of works of art as plunder is ridiculous to the point of being farcical." Were these accusations simply paranoid fear that millennia-old habits of plunder would inevitably repeat themselves despite the current climate of change? Or was the scholarly discourse a veil of wishful thinking?

In the summer of 1915 the German commissioner of art in Belgium, Dr. Otto von Falke, made a public declaration in the name of the German imperial government that not a single work of art had been removed from Belgium, nor would it be. German military orders for the protection of art and historic monuments were strict and clear.

Yet art had already been taken from Malines. Was Falke lying, or had circuits been crossed?

In the wake of these accusations and defenses, Canon van den Gheyn had a brief respite from interviews about *The Lamb*. The period of quiet ended with the arrival in Ghent of two German art historians. They played up the good-cop angle, pleading for the safety of the altarpiece. If the German army did not know its location, they might accidentally destroy it. The art historians would not say, but they seemed certain that

The Lamb was still in or around Ghent. Had someone informed? Who could have?

The art historians were replaced by a less friendly German officer. He was blunt. The Germans had heard about the junk cart smuggling. Had someone seen them? Or could one of the canon's friends have talked? That couldn't be, or the Germans would have the panels already. What had happened?

The officer showed his cards, admitting that three theories existed about the fate of *The Lamb*: (1) It was hidden in Ghent. (2) It had been sent to England. (3) It was stashed on board a ship at Le Havre, where the Belgian government had retreated to safety. The canon shrugged his shoulders. Only the Belgian minister of culture knew the exact location of the altarpiece. Why didn't the officer ask him? Of course the canon knew that the minister was safely in Le Havre, out of the interrogators' reach. Canon van den Gheyn must have smiled to himself. What the officer did not know was that *The Adoration of the Mystic Lamb* was hidden only a few hundred meters from where they sat.

The Germans were losing patience. On 18 October 1915 the bishop of Ghent received a forceful letter from the German inspector general of cavalry. Threatening severe repercussions, he demanded to know the hiding place of *The Lamb*. The bishop replied in all honesty. He had no idea.

Then another period of quiet. The war stole attention away from the location of the hidden *Lamb*, and Canon van den Gheyn began to think that the trouble had blown over. A year and a half passed without incident.

In May 1917 came a knock at the door to the bishop's residence. Two German civilians requested permission to photograph several important paintings in the cathedral collection, including the altarpiece. They acted as if they had no idea that the altarpiece was not simply sitting in the cathedral, a few meters away—as though they were unaware of all the inquiries by German officials as to its whereabouts. The bishop referred them to the canon or the Belgian ministry. It became clear that it had been some sort of test, to see if passed time had softened resolve. Their

bluff called, the German civilians revealed that they knew that *The Lamb* was hidden nearby.

Ten days later they returned with an armed escort and searched the Episcopal Palace. They tapped walls to look for hollows. They checked for loose floorboards. They found nothing. *The Lamb* had been moved nearly three years earlier. Why search the palace, when other German officers had stated that they knew the altarpiece had been moved by junk cart? The searchers seemed disorganized.

But a new danger rose. The Germans began to commandeer private residences for use as barracks. This process escalated. More and more homes were being taken over in a path that was encroaching on the first of the two homes in which *The Lamb* was hidden. If one of the houses should be occupied by German troops, they would almost certainly find the panels secreted inside.

On 4 February 1918 the canon and the same four citizens moved the panels to a new location north of the city center: the Augustinian church of Saint Stephen. Whether they tried their luck with the junk cart or came up with a new transport strategy remains unknown. As a church, Saint Stephen's was unlikely to be appropriated, and an ideal hiding place was selected inside it. A confessional was pulled away from the wall inside the church, the panels were slid vertically into place behind it, and the confessional was replaced.

This was the last move they would make. There would be no more inquiries. The war was nearing its end, the outcome in little doubt. The Germans lost the luxury of searching for buried treasure.

But with their impending defeat went any ethical pretense about the protection of art and historic buildings. Weeks before the Armistice, the Germans announced publicly that they would blow up the entire city of Ghent as they withdrew.

Now Canon van den Gheyn was torn. Should he finally reveal the location of *The Lamb*? Better it fall to retreating German hands than be destroyed forever. Or should he risk his life by attempting to move it out

of Ghent altogether, when the war's end was so near? After many sleepless nights, he could not decide.

Then history made a decision for him. The Germans withdrew, leaving the city intact. *The Lamb* was safe. On 11 November 1918 the war ended.

Thanks to the bravery and guile of Canon van den Gheyn, Belgium's national treasure remained in its birthplace throughout a long and terrible war, through countless interrogations, through near-misses, through midnight maneuvers, through secret caches. Nine days after the Armistice, the panels were brought out of hiding and displayed once again in Saint Bavo Cathedral.

In the weeks leading up to the Armistice, there was German concern that the peace terms would include not only financial reparations but also the surrender of German artworks. The precedent for such exactions had been formalized by Napoleon, whose price for cease-fire always included a further payoff in artworks. Adding to the German fears, an article published in the Parisian newspaper *Lectures pour Tous* in August 1918 listed works of art in German museums that the defeated empire would have to pay to France, by way of indemnity for a "wantonly inflicted war."

This list was divided into two categories. The first group comprised works to be surrendered on historic grounds, including everything that had been stolen by Napoleon and repatriated after his defeat in 1815, as well as trophies stolen by the French during the Franco-Prussian War. For the French author of this article, anything that a Frenchman had stolen was to be considered the rightful property of France.

The second group of artworks was simply an art historian's wish list of the most important and beautiful pieces in German collections. No rationale, however porous, was given. Cologne should offer up its extensive wealth in medieval art. Dresden had some lovely paintings by Poussin, Rubens, and Claude Lorrain. Berlin and Munich had far too

many works by French masters and should surrender them all. While they were at it, they should send over their Italian collections and the choicest German masterpieces. This article could only have been designed to twist the knife, to inspire fear in once-fearsome Germany.

The Ghent Altarpiece, which had been so brazenly demanded in that ill-received 1915 article in Die Kunst, was once more in a position to be reunited—but this time Berlin would have to give up its portion. The unification would be in The Lamb's birthplace.

It was coming home.

The truce terms came shortly before the peace treaty in 1918. Article 19 of the Treaty of Versailles made concrete the fears fueled by the article in Lectures pour Tous. The French wanted to recover all of the art that had been in France, even if it had been there only because the French had stolen it. At one sitting of the truce commission, the French representative warned that Germany would be required to auction off artworks. Germany would pay twofold: It would pay financial reparations, but this money would come through forced sales of its cultural heritage. The commission excused this decision on the basis that they had heard a rumor that the ex-kaiser had accepted an offer from a group of art dealers that included the sale of art that had been rightfully stolen by the French before the war. That sale would run against Article 19, and the Germans would be punished for it.

Another French article, this time published in early 1919 in Revue des Deux Mondes, demanded additional forfeits of art. This time it was the Bamberg Rider, the first equestrian statue of the Middle Ages, and effigies from Naumberg and Magdeburg cathedrals. No rationale was given. Perhaps the author felt that none was necessary. Or perhaps it was a test: How far could the victors go to exploit the situation and enrich their national holdings?

The French were not the only opportunists. The Italians seized pictures and manuscripts from Vienna at the time of the truce. As they had encountered little opposition in doing so, they made another demand in early 1919, just before the signing of the peace treaty that would codify

all reparations and limit such exploitation. This demand included manuscripts, armor from the Austrian Army Museum, and twenty-seven of the finest paintings from the Vienna Gallery, most of them by Italian artists. In response, the Vienna Gallery director, Dr. E. Leisching, wrote:

> It is hard to keep a cool head and yet give this affair its right name. A glance at the long list is enough to make the heart contract. . . . What is at stake now is nothing less than the loss of works which are the spiritual possession of all those untold thousands who lay claim to a sense of beauty, to education, to culture, and to a feeling for spiritual greatness and human dignity transcending all national boundaries. They are almost exclusively works of native origin, the loss of which would be deeply felt throughout the whole population, works which have found their way to the hearts and mind of the people. . . . In a word, [the Italians] want to take from us with a refinement of cruelty what would hurt us most, possessions imbued with the personality and spirit of our city in the highest degree and which express to all the world the fame, the charm, the very soul of Vienna.

Melodramatic though it may sound, the sentiment expressed by Dr. Leisching was genuine and heartfelt.

The 1919 Treaty of Versailles laid out the final terms and brought an end to speculation and wish lists. Articles 245–247 dealt extensively with art and reparations for art. A look at each article reveals the fate of the Berlin wings of *The Adoration of the Mystic Lamb*.

France was taking the opportunity to undo its losses from not only this war but a previous war. Article 245 dealt with reparations to France of looted objects from the Franco-Prussian war, as well:

> Within six months of the coming into force of the present Treaty, the German Government must restore to the French Government the trophies, archives, historical souvenirs, or works of art carried

away from France by the German authorities in the course of the
[Franco-Prussian] war of 1870–71 and during this last war, in ac-
cordance with a list which will be communicated to it by the
French Government; particularly the French flags taken in the
course of the war of 1870–71 and all the political papers taken by
the German authorities on 10 October 1870 at the chateau of
Cerçay, near Brunoy (Seine-et-Oise) belonging at the time to Mr.
Routher, formerly Minister of State.

Article 247 dictated the reparations for the destruction at Louvain and
the fate of *The Ghent Altarpiece*.

Germany undertakes to furnish to the University of Louvain,
within three months after a request is made to it and transmitted
through the intervention of the Reparation Commission, manu-
scripts, incunabula, printed books, maps, and objects of collection
corresponding in number and value to those destroyed by Ger-
many in the burning of the Library of Louvain. All details regard-
ing such replacement will be determined by the Reparation
Commission.

 Germany undertakes to deliver to Belgium, through the Repa-
ration Commission, within six months of the coming into force of
the present Treaty, in order to enable Belgium to reconstitute two
great artistic works:

 (1) The leaves of the triptych of the *Mystic Lamb* painted by
the Van Eyck brothers, formerly in the Church of Saint Bavo at
Ghent, now in the Berlin Museum;

 (2) The leaves of the triptych of the *Last Supper*, painted by
Dirk Bouts, formerly in the Church of Saint Peter at Louvain, two
of which are now in the Berlin Museum and two in the Old
Pinakothek at Munich.

The reparations would reunite the dismembered limbs of *The Ghent
Altarpiece*.

One other treaty was pertinent to the fate of art in the wake of the First World War. The Treaty of Saint Germain, signed 2 September 1919, dealt with the dissection of the Austro-Hungarian Empire and the fate of its possessions, distinct from the war. Article 196 dealt with the dreaded reparations in the currency of artworks, beyond what was destroyed or looted. How much of Germany's punishment would come in the form of cultural bloodletting?

The treaty essentially deferred to further negotiations with individual countries the exact nature and constitution of distributed Austrian possessions, with the provision that objects may only be distributed that "form a part of the intellectual patrimony of the ceded districts," and that the distribution would be in "terms of reciprocity." There was no fire sale included in the Treaty of Saint Germain, a point that must have disappointed some French and Italian scholars. The phrasing of the treaty seemed lenient to Austria. Its enactment was less so.

The treaty's requirements were not enforced until 1921, when a conference was held in Rome among the succession states of the dissolved Austro-Hungarian Empire. The location of this meeting, in the former Austrian embassy in Rome, was designed to highlight all that Austria had lost. The Austrians present at the conference reported that Austria was told its fate without room for discussion. The country and citizens of Austria would be punished for the actions of the warlords.

The Austrian report from the meetings sheds light on the psychology of the reparation demands: "It may be asked how Austria ever got into the position of having such extensive claims made on her cultural possessions. It was due in the first place to the attitude of the conqueror to the conquered and the wish to take from Austria what she valued most in what was left her, her cultural heritage." The seizure of art was designed to humiliate the defeated. But there was another element noted by the Austrian delegation: one of national enrichment, normally the goal of the invader. In this case, when the defender proved victorious, he would exact the same penalties: "To this must be added the definite aim of the Succession States to outdo dethroned Vienna by enriching their own institutions, archives, and museum, and to exalt their own institutions,

archives, and museums, and to exalt their own national status by recovering whatever could be described as belonging to their own past."

The Austrian report goes on to say that "these destructive aims were energetically opposed by the great Western Powers." As they saw it, the "Succession States" were seizing a once-in-history opportunity to rob their old overlords and fatten their comparatively diminutive holdings.

At first, Italy tried to overstep legitimate demands and requested major reparations, but backed off completely at the first sign of argument. Poland was singled out for praise for not taking advantage of the situation. Czechoslovakia made "exorbitant demands for the reparation of injustices suffered from the Habsburgs," seeking recompense without regard to the provision in the treaty that only goods of "intellectual patrimony" could be sought. Their demands were rejected completely by the commission. Hungary sought the most and gained the most. But the complications of the Hungarian negotiation required a separate agreement reached only in September 1927 and signed in November 1932. In the end, Austria yielded to Hungary 180 works, of which 18 were deemed "of outstanding importance."

Belgium tried and failed to convince the committee to force Austria to return two of its artistic treasures that had been legally purchased for Austrian collections: the gold jewelry that comprised the treasure of the Burgundian military Order of the Golden Fleece, the chivalric order founded in 1430 by van Eyck's patron, Duke Philip the Good, and the *Ildefonso Altarpiece* by Rubens.

In the end, the Treaty of Versailles was more lenient with respect to the return of works of art than historical precedent, particularly as set by Napoleon. It sought to usher in a new era, one that would exclude artworks and cultural heritage from war reparations. This enlightened policy was in harmony with the scholarly discourse at the beginning of the First World War, on the privileged position of art. With the prominent exception of *The Ghent Altarpiece* wings, which had been purchased, it was claimed, in good faith on their way to the Berlin Museum, and the Dirk Bouts *Last Supper* taken from Louvain, the only artistic compensations in the Treaty of Versailles were for works that had been destroyed.

The Treaty of Saint Germain was phrased in similarly reasonable terms. Nevertheless, a few of the Succession States had sought to exploit the situation. But a firm committee, while leaning in the moral direction of the Succession States, all the same prevented legalized pillaging and made reasoned decisions. The major Western powers (the United States, England, and France) were intent on preserving the nucleus of Austrian culture, which had long been the historical and cultural capital of central Europe. A few outspoken French aside, France was one of the strongest proponents of saving postwar Vienna as a cultural center, once the hot wartime tempers had died down.

Of all of the 440 articles in the Treaty of Versailles, none rubbed the Germans raw as much as the forced return of the six wing panels of *The Ghent Altarpiece*. The panels had not been stolen—at least not by the Germans. They had been stolen by Vicar-General Le Surre from his own cathedral and sold first to Brussels dealer L. J. Nieuwenhuys, and then to their subsequent owner, the English collector Edward Solly. The fame of the panels made them impossible not to recognize. But by the time Solly's entire collection was purchased by Prussia, enough time had elapsed since the original theft of the panels that the Prussians could claim that they were innocent of any complicity in the crime. So when the panels were donated to the Berlin Museum, any wrongdoing was a distant memory. The hands of the inheriting Kaiser Friedrich Museum, with reference to the Ghent panels at least, were cleaner than those of many of the world's top museums today, with their numerous acquisitions of questionable origin.

After the treaty, when the Kaiser Friedrich Museum had finally returned the six wing panels, along with the Dirk Bouts triptych taken from Louvain, the museum staff found a way to express their resentment. Where the panels had once been displayed, a placard was placed in the gallery that read: "Taken from Germany by the Treaty of Versailles."

Years later, in the wake of the post–World War II reparations, discussion of Article 247 continued. Charles de Visscher, a distinguished Belgian lawyer and member of the International Court of Justice, wrote an article called "International Protection of Works of Art and Historic

Monuments," published by the U.S. State Department in 1949. In it, he explores the reparation of the Ghent panels in the Treaty of Versailles.

> The restitution required of Germany did not mean the recovery of works of art taken away by force, or appropriated by treaty. The Belgian government refrained from contesting the regularity of these transactions. When the works were returned to Belgium, the Minister of Science and Fine Arts, in an address delivered on the occasion of a Van Eyck/Bouts exhibition in Brussels acknowledged that the paintings had been acquired [by Berlin] in the proper manner. Their cession to Belgium, therefore, in no way represented restitution or recovery, properly speaking. In principle, it was justified by Belgium's right to compensation for the works of art destroyed by the German armies during the war. As for the choice of the works claimed, it carried out the thought, as expressly stated in the text, of restoring the integrity of two great artistic works. Since the return of the works of art specified in Article 247 was required of Germany as reparation, it was of course to be without recompense. However, Germany later put forward a claim to have placed on her credit a total amount of their value, which is set at 11,500,000 gold marks, and which [Germany] proposed to charge against the annual payment obligated as [monetary] reparation. This claim was unanimously rejected by the Reparation Commission.

The return of the six wing panels from Berlin was triumphant, the panels borne like a wounded war hero. A special railcar decked with Belgian flags was fitted to transport the panels safely. The train stopped at each Belgian town along the trail from Berlin to Brussels, where crowds gathered to welcome the return of the kidnapped wings of their national treasure, singing the Belgian national anthem and waving flags.

The entire altarpiece would be reunited for the first time in over a century. After two weeks of display alongside the Dirk Bouts *Last Supper* at

the Royal Museum in Brussels, the entire *Adoration of the Mystic Lamb* was returned by rail to Ghent. Receptions were held. Officials gave speeches to crowds of thousands. Every church bell in the city's skyline tolled in unison, ringing the reunion of Jan van Eyck's masterpiece, a painting that symbolized, to the Belgian people, the survival of their nation.

Thieves in the Cathedral

Plump and disheveled Beadle van Volsem made his final rounds of the day at Saint Bavo Cathedral, ushering the last of the parishioners and sightseers out the door. He checked the clock. He was due for dinner at the bishop's residence.

The sun dipped behind the chimneys and gabled roofs on the horizon, as the beadle stepped out into the mild April air. He fiddled with his cumbersome set of keys until he found the right one, which he fit into the lock on the cathedral door. The cathedral was closed for the evening.

The staff swept, emptied the coin box offerings beneath the bank of votive candles, dusted the niches behind stone sculptures. The last of the maintenance crew exited out a side door, which they locked behind them.

Darkness fell. Inside the sleeping cathedral, a figure climbed down from the shadows of the rood loft.

At five the next morning, 11 April 1934, Beadle van Volsem made his first rounds. He went about his morning routine, unlocking doors, straightening draperies, checking the maintenance staff's handiwork. He noticed that a side door to the church had been left open. Curious, he thought, but it had been accidentally left open on a number of occasions in the past.

It was not until 7:30 AM that he saw the broken padlock on the door to the Joos Vijd Chapel.

No, he thought, his heart rate rising. Not that door.

The door swung open with a squeal on aged hinges. There was *The Ghent Altarpiece* on display inside the chapel, its wings closed. And yet the beadle could see the panel depicting the Lamb of God—which could only be seen when the altar wings were open.

One of the panels was missing.

The beadle ran to the office of Canon van den Gheyn, the man who had so valiantly defended the altarpiece during the First World War. It was 8:35. They summoned the police, but not before word got out. A crowd gathered inside the cathedral to see the scene of the disappearance, erasing any clues that might have been present. The police arrived in the wake of the crowds.

Pushing through the throng of people that had gathered to gawk at the gaping hole in the bottom left-hand corner of *The Ghent Altarpiece*, police investigator Patijn saw a note pinned to the frame. It read, in French, "Taken from Germany by the Treaty of Versailles."

Had this been a retributive crime, revenge for *The Lamb*'s wings having been forcibly repatriated from the Kaiser Friedrich Museum in Berlin? The stolen panel was too famous to be shopped to buyers and sold. Or was it? Nieuwenhuys had found a buyer for six stolen panels just a generation before. Might a collector want only one panel of the twelve-panel masterpiece?

The missing oak panel was from one of the wings of the altarpiece. It was one of the panels that had been split vertically for display in Berlin. It contained a painted front and back, recto and verso, both of which had been taken. When the altarpiece was closed, on weekdays, the recto of the panel displayed the painted sculpture of Saint John the Baptist, in grisaille. When the altarpiece was opened, on weekends and holidays, the verso of the panel showed the so-called Righteous Judges on horseback, traveling to see the sacrificial Lamb at the center of the painting. It was said that several portraits were hidden among the painted judges, including that of Duke Philip, Hubert van Eyck, and a self-portrait of Jan.

Antique iron hinges that had held the panel in place had been removed, and then the panel had been pried from its frame, possibly with a large screwdriver. The removal of the hinges required some carpentry skill. The frame around the now-empty space was splintered, but there was no damage to the other panels. There were no fingerprints, footprints, or other telltale clues. Had there been any, the curious crowd ruined them.

Why this panel in particular? Both sides of the panel had a special resonance with the city of Ghent, more so than any of the other panels of the altarpiece. As the patron saint of Ghent, John the Baptist adorned the city seal, and, until 1540, the cathedral of Saint Bavo had been called the Church of Saint John. The Righteous Judges panel may have been a choice barbed with irony, the judgment of the Reparations Commission of the Treaty of Versailles having forced Germany to return that very panel. There were other potential reasons why the thief chose the Righteous Judges. In 1826, an engraving of that panel alone by British artist John Linnell began to circulate, increasing the fame of the Judges in particular. And if in fact the Judges panel contains portraits of not only Jan, but Hubert and Philip the Good, then that particular panel was of further historical and regional resonance.

From the outset, the theft was investigated in a strange and surprisingly unprofessional manner, one that led conspiracy theorists to assume that there was a cover-up involved.

First, Chief of Police Patijn arrived late to the crime scene. He had been investigating, of all things, a report on the theft of cheeses from a Ghent cheese monger, and was delayed because of it. After having arrived at the cathedral, he neglected to evacuate and seal the premises, and the mass of people milling about erased any clues that might have been left. He ordered no investigation of the surrounding area, took no fingerprints nor any photographs. He did not call the federal police, and yet they came anyway. Inspector Antoon Luysterborgh arrived at the scene soon after Patijn himself. Most bizarre and ridiculous of all, after a cursory look around the crime scene, Patijn excused himself to resume the investigation of the stolen cheese.

Luysterborgh was left to investigate, but he was no more thorough. The official police report only mentioned the theft of one panel, neglecting to include the information that the panel had been split vertically and, therefore, there were effectively two panels that had gone missing, the recto and the verso.

Van Eyck's altarpiece had been back in its home, whole, and intact, only since 1921, barely more than a decade. In July 1930, for the centenary celebration of Belgian independence, *The Lamb* had been triumphantly displayed out-of-doors, symbolizing a united and independent Belgium. And now this.

The theft of the Righteous Judges occurred during a difficult period for the newly formed country of Belgium. In the wake of a national recession, triggered by the Depression in the United States, unemployment was rampant. As the recession grew progressively worse, religious fervor rose. Between 1932 and 1933 multiple visions of the Virgin Mary were reported in the area of Beauraing. The site suddenly became a pilgrimage point.

The first three months of 1934 were plagued by national crises. On 18 February 1934 the Belgian populace was horrified to learn of the strange death of their monarch, King Albert I. The king had been hiking in a desolate location called Marche-les-Dames when he slipped and fell to his death. Many suspected that this was no accident. Then on 28 March, the Socialist Bank of Labor declared bankruptcy. Thousands of small investors lost all their savings. Only weeks later Belgium's largest bank, the General Bank Union, announced losses of millions, nearly going bankrupt itself. After the theft of the Righteous Judges was discovered on 11 April, national and local newspapers picked up the story, expressing outrage at the lack of security in the cathedral and the chapel itself. No guard had been posted, nor was there any barrier between visitors and *The Lamb*.

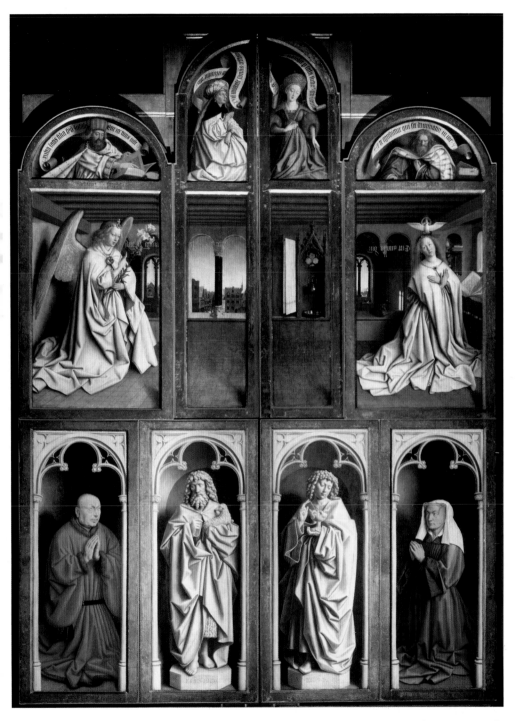

Closed view of *The Ghent Altarpiece*, featuring an Annunciation and portraits of the donors who paid for the altarpiece.

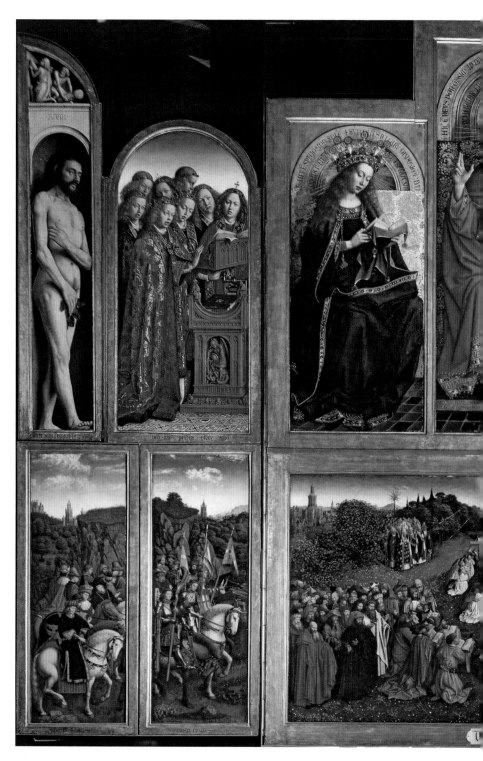

The Ghent Altarpiece with its wings open, as it would be seen on holy days.

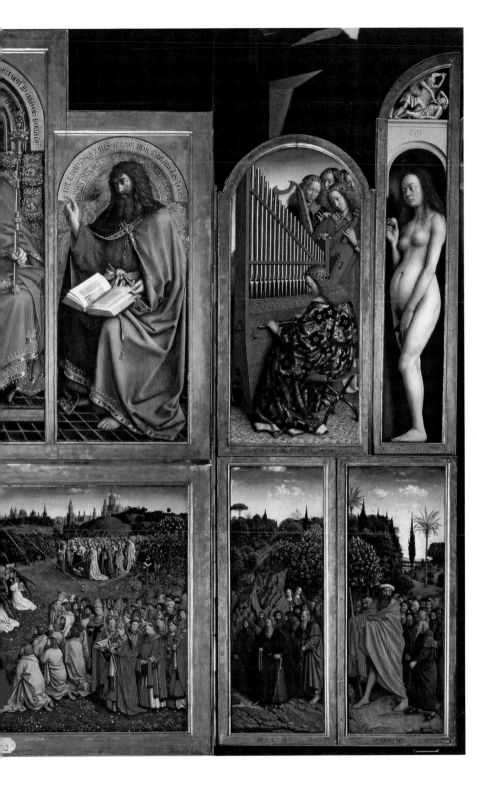

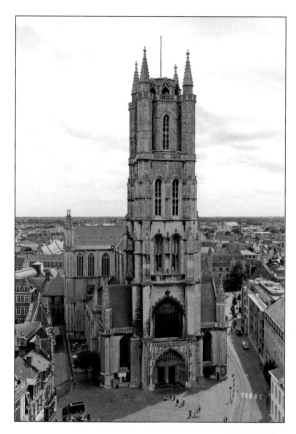

Saint Bavo Cathedral, home to *The Mystic Lamb*, in the heart of Ghent.

Portrait of a Man in a Red Turban by Jan van Eyck, universally considered to be a self-portrait. It was stolen in the eighteenth century from the Bruges Painters' Guild, and is currently on display in the National Gallery in London.

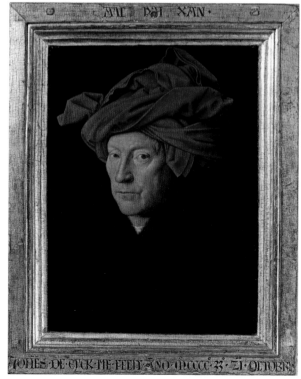

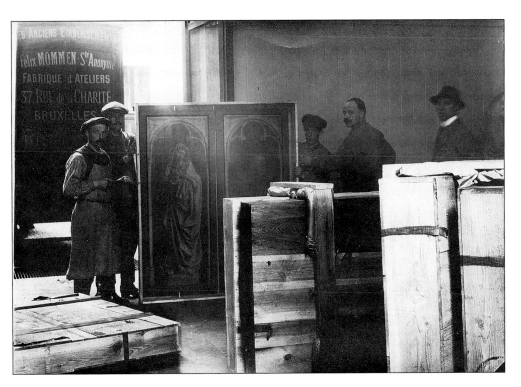

The return of *The Mystic Lamb* from its hiding place after the First World War.

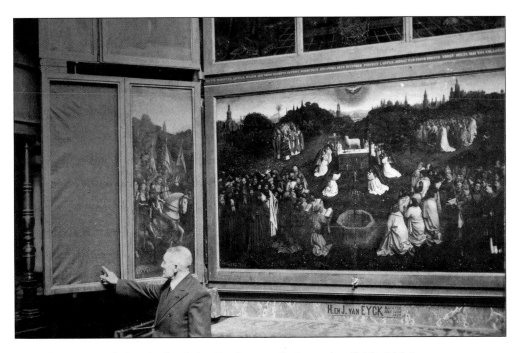

The discovery of the theft of the Righteous Judges, April 10, 1934.

Conservator Jef van der Veken painting his replacement copy of the Righteous Judges panel, during the Second World War. In 1946 his copy would be displayed with the original altarpiece, to replace the panel stolen in 1934.

Portrait of Gauleiter August Eigruber, head of the Oberdonau region of Austria, in which the Alt Aussee mine was located.

The Alt Aussee mine was converted into a high-tech, secret warehouse for art stolen by the Nazis from across Europe.

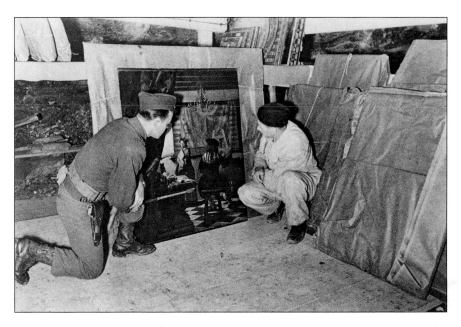

Among the thousands of works discovered at the Alt Aussee mine were masterpieces by Michelangelo, Raphael, Rembrandt, Titian, Dürer, and Leonardo. Here a Monuments Man and a mine worker examine Jan Vermeer's *The Artist's Studio*.

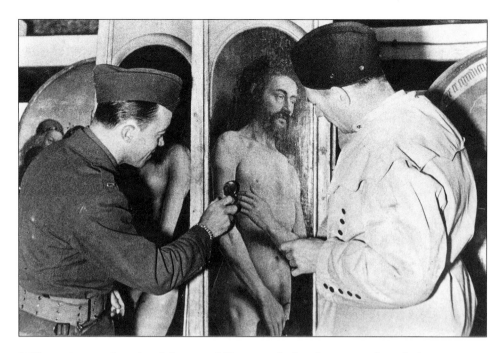

Officers inspecting the Adam and Eve panels for damage, after their discovery in the Alt Aussee salt mine.

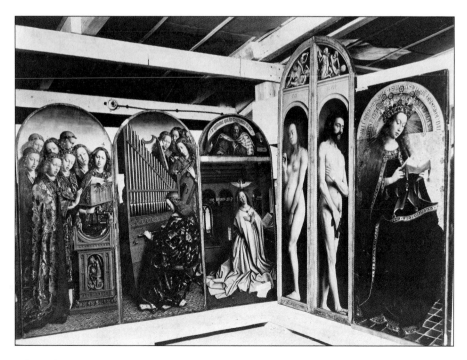

The Ghent Altarpiece as it was found inside the Alt Aussee mine.

Visitors could easily touch the painting, if they didn't know better than to do so. Belgian columnists wondered in print: Is this how we protect our national treasure?

This was the most prominent theft since Leonardo's *Mona Lisa* had been stolen from the Louvre in 1911, and international newspapers printed their share of recrimination. After the tribulations of *The Lamb*, how could the Belgians let it slip away?

Though the thief's calling card suggested a nationalistic motivation in its reference to the Treaty of Versailles, it was unimaginable that the German government should sponsor such a crude, aggressive act as this. Perhaps the Righteous Judges panel had been stolen by an angry vigilante who planned to take it as a trophy back to Germany?

There were no further clues at the scene of the crime. The only useful piece of information came from a passerby, who had seen a light shining in the Vijd Chapel around 11:15 PM. The police had no further leads. Three days after the theft, Canon Gabriel van den Gheyn said, in an interview for the newspaper *La Flandre Liberaleé*, "I imagine this must be the work of foreigners, and I am close to certain that it is for the purposes of blackmail." One day later the canon published an editorial in the newspaper *L'Indépendance Belge* in which he stated, "Now that I've had time to recover my senses and consider it, I think that this must be a crime of vengeance."

Was he guessing, or could he have known more about this crime than he let on?

An answer came on 30 April 1934, when the bishop of Ghent, Monsignor Honoré-Joseph Coppieters, received a letter in the mail in a pale green envelope.

It was a ransom note typed in French. It read:

> It is our privilege to inform you that we possess the two paintings by
> van Eyck which were stolen from the cathedral of your city. We feel that
> it is better not to explain to you by what dramatic events we now possess

these pearls. It happened in so incoherent a manner that the current lo-
cation of the two pieces is known only to one of us. This fact is the only
thing that should concern you, because of its terrifying implications.

We propose to deliver the two paintings to you on the following con-
ditions. First, we will give you the grisaille Saint John. After you have
received this you will hand over, to a person whose address we will give
you, the amount of a million Belgian Francs in 90 notes of 10,000
Francs, and 100 notes of 1,000 Francs. The money will be wrapped in
a package, sealed with the seal of the diocese. Then you will wrap every-
thing in brown paper, sealed with an ordinary signet.

Furthermore you must ensure, Monsignor, that you will avoid giv-
ing us notes with registered serial numbers. And finally, you must com-
mit yourself to convince the proper authorities to stop all legal action
and drop the case indefinitely. Once we have the notes and satisfy our-
selves that there have been no difficulties, the place where you can collect
the Righteous Judges will be indicated to you.

We understand that the demanded amount is high, but a million
can be regained, whereas a van Eyck can never be painted again. Fur-
ther, what authority would dare to take the responsibility of having re-
jected our proposal, which contains an ultimatum? We know very well
that the artistic and scientific world would react with outrage, should
they learn about your refusal, and the circumstances of our proposal.

If you accept our conditions, something that we do not doubt, you
will publish the following text under the "Miscellaneous" Classified ad-
vertisements in the newspaper "La Dernière Heure," on 14 and 15
May: "D.U.A. In agreement with the authorities, we accept your
propositions totally."

D.U.A.

Bishop Coppieters wanted to pay, but the crown prosecutor, Franz de
Heem, and the Belgian minister of justice would not allow it. The police,
under Antoon Luysterborgh, instead advised the bishop to feign compli-
ance. Attorney de Heem and the police placed the Classifieds ad, as in-

structed, but not with the requested phrase. Their response read: "D.U.A. Exaggerated proposition."

On 20 May a second letter arrived. It was polite but insistent. If total agreement was not proffered, the ransomers would begin to cut off sections of the panels and mail them to the diocese. The letter ended, strangely enough, with this postscript: "Monsignor, because we handle this case almost as a commercial one, and the objects actually belong to a third party, it is fair to pay you a commission of 5%, of which you may dispose freely." The bribery attempt made on the bishop added insult to injury.

Attorney de Heem took over the negotiations, writing in the name of the bishop. Matters were made more difficult when the Belgian government applied pressure to recover the panels, by ransom payment if necessary. The government claimed that they were the true owners of the altarpiece, not the diocese, and that the painting, as a *national* treasure (not merely an ecclesiastical treasure), was property of the nation on loan to the bishopric. The panel's recovery was, therefore, a matter of national urgency.

The bishop offered a reward of 25,000 francs for the recovery of the panel. This sum seemed paltry in comparison to the inestimable value of the panel and the ransom demand. It smacked to many contemporaries of a strange lack of enthusiasm on the part of the bishop for the recovery of the panel, though the bishopric did not have sufficient funds to mount more of a ransom attempt, even if it had wished to do so. But if this theft were a national issue, why then did the government not intervene with funds of its own? These questions are still unresolved. A more appropriate reward of 500,000 francs was offered by an anonymous benefactor, identified only as a Mason. Neither reward yielded any real clues.

The ransom notes did, at least, suggest one thing. The note about the Treaty of Versailles probably was a red herring. The theft was no act of misguided nationalism. It was a crime for profit in a time of recession— though one cleverly laid with a false lead. Had it really been a reprisal after the treaty, the revenger would have ensured that Ghent would be definitively deprived of the panel.

Under pressure from the Belgian government to continue negotiations, the bishop and the police submitted another Classifieds ad: "D.U.A. As agreed with authorities, we accept your proposition fully."

Then the bishop received a third letter: "We have read your answer in the paper of 25 May and take full note of your obligations. Observe them conscientiously, and we will preserve ours.... We suggest you tell no one anything about the hand-over of the S.J." The pale green envelope contained a ticket for the Brussels Nord train station luggage check.

Inspector Luysterborgh and De Heem rushed to Brussels. When they presented the luggage ticket at the train station, they received a fifty-two by twenty inch package wrapped in black wax paper. The luggage check attendant recalled only that the depositor of the package was a man, about fifty years old, without remarkable features beyond a pointy beard.

This package was taken to the Ghent Episcopal Palace, the same bishop's residence where van den Gheyn had hidden the panels during the First World War. There it was examined by museum experts. It was indeed the original recto half of the panel; there was the painted statue of Saint John the Baptist. But then the police made another questionable move. They kept the panel secreted at the Episcopal Palace, telling no one about its return.

Despite this attempt at secrecy, on 31 May the newspaper *L'Indépendance Belge* published an article about the return of the Saint John panel. How had they found out? Was there a rat among the police or at the diocese?

Letter number four arrived on 1 June:

> *Corresponding to our agreement and our previous instructions, we ask you to personally hand over the package that contains our commission to Father Meulapas, Sint-Laurentius Church, Antwerp. You could let him know that it concerns a restitution of papers and letters involving the honor of one of the most dignified families. Please hand over the enclosed vertically torn newspaper page, together with the package. The person that will present himself to collect the package will, in order to prove his identity, give you the other part of the torn paper.*

Who was this new middleman? Vicar Henri Meulapas was resident at the Church of Saint Lawrence on Markgravelei Street in Antwerp. When interviewed by the police, he convinced them that he knew nothing about the incident. All that he could report was that, through the brass grate of a confession booth, he had been asked if he would help a prominent Belgian family recover some letters that would have brought about the ruin of the Belgian royal house. He had agreed to help. No, he responded to the police, he did not know who was confessing, as confession relied on anonymity. Nor, if he knew, would he tell anyone, lest he violate his vows as a confessor.

Was he telling the truth, or was he Belgium's best actor? One thing was clear—the ransomer was using the secrecy of the confessional booth to profit from a crime.

De Heem continued to feign compliance in the bishop's name, and tried to lure the ransomer into a trap. He replied via the Classifieds: "Letter received. Pursuant to indiscretions involved, please be patient for a few days." The police began to formulate a plan. They next published, "Package will be handed over 9 June."

The next few letters and Classified responses exposed the ransomers' increasing wariness at the slow pace at which events were unwinding. Though publication in a newspaper's Classifieds section was hardly a legal contract, the ransomers repeatedly insisted that the bishop publish his renunciation of legal proceedings, as if that would make the ransomers exempt from possible conviction. This showed both a lack of understanding of legal matters and a reliance on a strangely moral "gentleman's agreement." They would return the painting and collect the reward, and the bishop should play along like a good and honorable victim. Two letters insisted on a specific phrase, which was finally published by de Heem on June 13: "Full pledge that secret will be kept. Act without concern." These hollow guarantees in print provided moral support, if nothing else.

The police presented the sealed package containing payment to Father Meulapas in Antwerp, just as the ransomers demanded. On 14 June,

Meulapas's housekeeper saw a taxi driver pull up outside the vicarage. The driver got out, carrying a torn piece of newspaper, and knocked on the vicarage door. Meulapas, matching the half of the newspaper that the police had given him to the one held by the taxi driver, handed over the package.

But the sealed package did not contain the 1 million Belgian francs demanded. Instead, the police had included 25,000 francs only, with the serial numbers carefully noted, and a letter of their own:

> *In this envelope Monsignor hands over, for the grisaille, 2 notes of 10,000 F and 5 notes of 1000 F, or 25,000 F, of which he ensures you that he has not noted the serial numbers and that no one has seen them. Contrary to his expectations, he cannot raise the demanded amount, but he will pay the amount of 225,000 F afterwards, or at the moment the J are delivered.*
>
> *These are take it or leave it conditions. The Bishop cannot do more. Because of the nature of this case, it is not possible to call for a public subscription. . . . The Bishop gives you the certainty that the case is closed, and that nothing will be done to further seek out the persons responsible.*

De Heem and the police were giving the ransomers a taste of their own medicine. There would be no gentleman's agreement with these criminals. They lied outright about the serial numbers on the ransom payment notes. And the bishop could not grant them immunity. This was a police matter, and only the police could decide when the case was closed.

Throughout the negotiations, the ransomers seemed under the impression that they were corresponding exclusively with the bishop. In actuality, Bishop Coppieters had ceased long ago to have any involvement and handed all letters, still sealed, directly to de Heem. In this letter, de Heem dropped the subterfuge that the bishop was involved in the negotiations, referring to him in the third person.

The next ransom letter expressed dismay:

It seems unnecessary to underline how distressed we were reading [the enclosed letter]. Breaking up an agreement at such a moment, while we have committed ourselves, at the payment of a relatively small commission, to hand over to you the most valuable object in the world, the loss of which will keep troubling those who are the cause of this. It is incomprehensible. And to undermine the mutual trust, so essential for the delicate and difficult negotiations on this enormous piece of art. It is dreadful. . . . We risked our lives to come into possession of these two jewels and we keep thinking that what we ask is not excessive or impossible to realize.

Expressing their sense of betrayal at the lack of cooperation, the ransomers seemed to have forgotten that they were criminals. At the least, the bishop could have the good manners to pay the ransom.

The police only replied: "Regret to have to maintain the proposition in our letter." They were clearly dealing with amateur criminals. The ransomers could not bring themselves to say that they would destroy the Judges panel altogether if the ransom were not paid. They skirted the threat, suggesting that something terrible would happen. The police felt confident that they would never let the painting come to harm.

Further, the ransomers had returned their only bargaining chip, the Saint John panel. If they cut up the Righteous Judges panel, they would receive no ransom. It was in no one's interest, least of all the ransomers', to destroy the panel. That would be like setting fire to a suitcase full of money. The police would wait and let the ransomers expose themselves.

On the sixth of July, the eighth letter arrived. The first half further reprimanded the bishop for his failure to deliver ransom payment. Having gotten that out of their system, the ransomers were prepared to alter their demands slightly. They countered with a demand of 500,000 francs now, and another 400,000 within twelve months of the return of the painting.

To this, the remarkably blasé police replied, "Maintain our last proposition."

Letter number nine bubbled over with frustration. The ransomers were repeatedly granting extra time, bending to the call of their bluff.

> *Because you did not respond at all to our last letter . . . the situation is very clear. . . . But since the cessation of negotiations depends on us, we will offer you one last opportunity to reach us, in the usual manner, by 28 July. When at that moment no suitable solution has been reached, this will mean a definite break in negotiations, with all the consequences connected to it. And no one in this world, not even one of us, will get the opportunity to see the immortal piece, which will be lost forever. It will stay where it is now, without anyone being able to touch it. That will be the implication of your decision.*

This emotionally charged response was just what the police had sought. In this letter, the ransomers inadvertently provided some clues.

In the last few lines of the letter, the ransomers revealed that the panel was hidden someplace where it would be in no danger of being discovered. It was not in the immediate possession of the ransomers. There was no true threat of the panel being destroyed after all. It was simply hidden and would remain hidden if no ransom were paid.

The police decided to stall further. They responded: "Confirming last proposition."

In the ransomers' next letter they expressed their confusion. Which "last proposition" was being confirmed, theirs or the bishop's? "Because we do not want to break negotiations due to a misunderstanding," they wrote, "we hurry to ask you for a more explicit response." This letter, like the others, went on at some length to chastise the bishop for not keeping his end of the bargain—even though the police had dropped the artifice that the bishop was involved in negotiations several letters earlier. The ransom letter ended with the promise of no more letters and an open offer: They would read the newspaper the first of every month, should the bishop decide to comply in the future.

After all their toying with the ransomers, the police were no nearer to solving the crime. If this were truly the last letter, then the panel would not be recovered. The police still had no leads.

But the ransomers could not keep away from their typewriter, failing even to follow through with the threat to cease writing. Letter 11 arrived on 8 September. The tone had changed. Gone was the politesse. The author of the letter no longer pretended to be the man who signed his name as D.U.A. at the end of each correspondence. The ransomers had finally realized that the bishop was not involved in the negotiations. They switched to speaking about the bishop in the third person as well, though they also referred to the police reading their letter in the third person—perhaps as a mark of disrespect.

> *We regret it personally that you have not given him [the bishop] the means that would have avoided our anger at the qualified authorities, who have not kept their word and promises. . . . D.U.A. is not able to say more about this, nor to give further instructions, but he dares to believe that this letter will make you think seriously. . . . Meanwhile, the masterpiece still rests in the same place that only D.U.A. knows, and of which he has not even entrusted the secret to a piece of paper.*

Despite the bluster and new tactics, the police remained firm. They responded, "Letter received. Regret to have to maintain earlier proposition."

There would be only two more letters.

The pretext of third-person address was discarded in the twelfth note, a tirade against the underhanded way that the criminals were being treated, by both the bishop and the authorities.

> *I already foresaw that you would not pay enough attention to my personal letter [number eleven]. I regret this firmly. . . . One will have to admit that you and the authorities have a different opinion than us in this case, about the meaning of a commitment. . . . I personally start to*

*believe that you have never possessed the 250 [thousand Francs prom-
ised in the counteroffer], and that you may never have had any inten-
tion to pay it. Allow me now to say: you maneuvered badly and it
would have been better if you had let me keep the S.J.*

One wonders how the bishop would have been better off if the ran-
somers had kept the Saint John panel. This logical oversight aside, the
letter's author slipped up. For the first time, he used "I," indicating, as the
police had long suspected, that there was no criminal gang ransoming the
panel. It was an individual criminal and, from the hurt tone of his letters,
one who was lonely and thoroughly dismayed.

The last letter arrived on the first of October. With the flavor of a ju-
dicial proclamation, the ransomer claimed that the whole disaster was
the fault of the bishop for not being a good sport and complying with the
ransom demands:

*You thought it unnecessary to reply to my last personal letter. I under-
stand that you did not like certain phrases in it, because no one likes
to have his back against the wall, the wall you built yourself. But that
is of subordinate importance. . . . We have come to the dead end, the
point where you will have to accept our conditions to once more possess
the work, or bear upon your shoulders everything you provoked, with-
out hope to recover what only I can deliver to you. Allow me to conclude
that I have tried everything in my power to save the Righteous Judges.
After having tried everything within our power, and despite your con-
tinuously repeating impossible to realize counteroffers. I believe I fully
performed my duty as a Leader.*

The letter slips between "I" and "we," likely indicating the author's fa-
tigue. The ransomer also shifts blame completely away from himself and
onto the bishop. The repeated focus on the bishop, who had nothing to
do with the negotiations, suggests that perhaps the ransomer knew the

bishop personally and somehow assumed that the bishop would "play ball," fueling his disappointment.

The police had done a reasonable job in handling the ransom demands but were stringing along a fish that they could never reel in. The rest of the investigation would be pocked with oversights, bumblings, and inexplicable decisions.

Six weeks passed in silence. Then something happened that sounded to all involved so preposterously melodramatic that it could only appear in a work of fiction.

On 25 November 1934 at Holy Mary College in the town of Dendermonde near Ghent, at a meeting of the local chapter of the Catholic Political Party, the fifty-seven-year-old Arsène Goedertier collapsed from a heart attack. Carried to a nearby inn, he was given an injection by his friend and physician, Dr. Romain de Cock, and then taken to the home of his brother-in-law, the jeweler Ernest van den Durpel, accompanied by de Cock and a Benedictine priest who had attended the meeting. While being carried into the house on Vlasmarkt Street, Goedertier passed out once more, only to be revived by de Cock. As he stirred, dazed, Goedertier whispered, hoarse-throated, to his doctor, "Am I in any danger?"

Lying on what would be his deathbed, Goedertier refused a last confession from the priest Father Bornauw. Bornauw pressed the matter, but Goedertier waved him away, saying, "My conscience is at peace." Goedertier instead summoned his lawyer, Georges de Vos. De Vos arrived and met with Goedertier in private for fifteen minutes, as van den Durpel's children recalled when they were interviewed about the matter decades later.

Then Arsène Goedertier died.

When Georges de Vos emerged from the death chamber, he was pale. He said nothing to anyone present, not to the priest Father Bornauw, nor to the physician, nor to their host, Ernest van den Durpel. Nor to

the police. In fact, the dead man's lawyer never went to the police, despite having vital information regarding a high-profile case of theft.

Only one month later did Georges de Vos reveal that, with his dying breath, Arsène Goedertier had admitted to being the thief of the stolen van Eyck panels. De Vos had leaned in close to hear the murmurs of his client. Goedertier said that he was the last person on earth to know the hiding place of the Judges panel. With gasping breaths, Goedertier whispered, "I alone know the location of *The Mystic Lamb* . . . my study, in the file marked *Mutualité* . . . armoire . . . key . . ."

And then, with operatic timing, he died.

Who was Arsène Goedertier? The information that exists about him suggests that he was, in many ways, the least likely candidate to steal and ransom a national treasure from a cathedral.

Arsène Théodore Victor Léopold Goedertier was a stockbroker, overweight and short with a thick, curly, waxed moustache, pince-nez glasses, a receding hairline, and oversized elven ears that seemed too low on his head. Born on 23 December 1876 in the town of Lede near Ghent, he was one of twelve children of a primary school headmaster. After his father, Emile, resigned from his post over a school funding controversy, he was offered a post as sacristan at the local church of Saint Gertrude in the village of Wetteren, just outside of Ghent. When Arsène's mother passed away in 1896, young Arsène became the organist at Saint Gertrude, where he eventually succeeded his father in the role of sacristan, from 1911 to 1919. He said, rather enigmatically, "the biggest mistake my father made was turning me into a sacristan."

Arsène Goedertier was an artist of minor distinction, having studied at both the Royal Academy of Art in Dendermonde and the art academy in his hometown of Wetteren, of which he would later become managing director. One of his portraits has hung in the town hall of Wetteren since 1913. His favorite subject to paint was church interiors.

He began his studies in Berlare, where he was a schoolmate of Honoré Coppieters, the man who would become bishop of Ghent. In addition to acting as sacristan, Goedertier worked as a clerk in the suburb of Wet-

teren from 1911 to 1919, avoiding military service because of an ocular defect that made it impossible for him to see in low-light conditions. He worked as a stockbroker from 1919 onwards, a regular face in the financial circles and power-lunch cafés of downtown Ghent. Always an active member of Catholic political and social groups, he also taught drawing and weaving at the Professional School of Kalken, and was an accomplished amateur tailor. He enjoyed puzzles, particularly those involving mechanics. His creativity extended into design. He created blueprints for a new airplane model, which he took to the Bréguet factory in Paris, although the company did not purchase his design.

Goedertier also owned an extensive collection of detective and spy novels. The investigators would conclude that Goedertier's library contained useful information, because his entire book collection would be confiscated by one of the magistrates taking on the case, Joseph van Ginderachter. The library included the complete works of the author Maurice LeBlanc, whose recurring character was a gentleman thief called Arsène Lupin, with whom Arsène Goedertier may have felt a kinship. According to his wife, Goedertier spoke frequently and with a great deal of fascination about the Judges theft.

On 3 November 1915, Arsène Goedertier married the Paris-born Julienne Minne, heiress to a knitting goods company. They had one son, Adhémar, or Dédé for short. Dédé was born in 1922 and would live only to age fourteen. The child was plagued with health problems, including a chronic eye disease that made it difficult for him to see in the dark, an illness he likely inherited from his father, and signs of mental illness. Dédé received his confirmation at Saint Bavo Cathedral, anointed by Bishop Coppieters. When the young Dédé eventually died on 2 May 1936, two years after the theft, he was babbling incoherently, repeating the words *police* and *thieves* over and over.

Goedertier was a man of great activity—professional, social, and charitable. In 1909, he cofounded a Christian National Health Service in Belgium, called *De Eendracht*. He later founded two more Catholic charitable organizations: *De Volksmacht*, in 1920, and *Davidsfonds*, of which

he became president in 1932. His colleagues spoke of his desire to gain political importance within Catholic organizations. He was a regular at political gatherings, Catholic events, and parties held at the Episcopal Palace adjoining Saint Bavo's Cathedral.

After the First World War, Goedertier and his wife established a brokerage office, housed in a former Dominican convent in downtown Ghent, from which they profited considerably in a short period of time. They lived in a spacious home in Wetteren, complete with unusual amenities such as central heating, servants, two telephone lines, and, most luxurious of all, a gleaming white Chevrolet automobile.

In 1928, Goedertier founded an organization called Plantexel, short for the Société de Plantation et d'Exploitation de l'Elaeis au Kasai. The goal of this business was to establish coffee and palm oil plantations in the Congo. Plantexel declared bankruptcy a few days before Goedertier's death. Had the theft been an attempt to save his company? This does not seem plausible, as it came to police attention that Goedertier died a wealthy man. His bank account was found to contain 3 million francs—three times more than the ransom he seemed to have demanded.

The mysteries continue. Since 1930, Goedertier had been in possession of a fake passport, containing his photograph but registered under the name "van Damme." He clearly had secrets, but of what nature—and what had he really told de Vos, his secular confessor, on his deathbed? De Vos was sole witness to the confession, and therefore no one can vouch for what he claims to have heard. Did it happen as he said? And why did he speak to no one, not even the police, upon leaving Goedertier's deathbed, instead driving to Goedertier's home in Wetteren, eight miles southeast of Ghent?

De Vos was let into the home by Goedertier's wife, Julienne. He checked the location that Goedertier had indicated with his last breath. In the study, in the top right-hand drawer of Goedertier's desk, in a file labeled *Mutualité*, De Vos found carbon copies of every one of the ransom notes, all signed "D.U.A." The folder contained no other information, but it did hold a final, undelivered handwritten letter. The letter goes on for several rambling pages, an unedited stream of thought, full of cross-outs

and incomplete sentences. It was written on Plantexel letterhead paper, much of it incoherent and with an odd syntax in the original French, in a leaning cursive script:

> *I am obliged to undergo a rest cure to recover fully. I take the necessary time to think calmly about the case that interests us. After the disappearance of the panels, we have been able to come into possession of the panels, and after several unforeseen incidents I am the only one in this world who knows that place where the Righteous Judges rests.*
>
> *It might be essential to underline the importance of the situation, for it releases me of any barrier before friends or other persons. And as a consequence, I can work on the solution of this case quietly, and without any stress. . . . We started off from the basic thought that we might believe and have confidence in the word of a bishop. On the other hand, we wanted to prove to you, by handing over the Saint John, that you can trust our word. We had confidence, you did not have confidence, and unfortunately we were both wrong.*
>
> *That is indirectly the cause of why the case was not solved, and there is the risk that it will never be settled, when you implement unsuitable tactics. The second fact that does not sound good in your correspondence is the conclusion that you dare take the responsibility to write that your proposal is "take it or leave it." In such circumstances, it is dreadful to dare to write such a thing.*
>
> *We have come to a dead end, from which we can only escape by your good will. I am prepared to make your task easier, as I have done during the course of our correspondence, but you cannot ask us the restitution of the . . . without us getting something in return, as we have done for the Saint John. You must admit that I make much effort to allow the returning of the master work, and that it only depends on you to settle this situation without too much damage and bitterness.*

Goedertier did not live long enough to send this final letter. But in his last several correspondences he had provided tantalizing information. The panel was hidden somewhere prominent, in a public place. It was

not in his direct possession, nor could any potential accomplices reach it without attracting public attention. Perhaps it was even hidden in plain sight.

The other clues in Goedertier's dying words, his mention of "armoire" and "keys," did not yield any results. De Vos claimed to have found no other papers or clues of any kind in the house regarding *The Lamb*.

Or did he? Can it be believed that de Vos did, in fact, discover carbon copies of the ransom letters and the final unsent letter? No one double-checked or even followed up his claims. De Vos was in the death chamber of Arsène Goedertier for more than fifteen minutes. Surely the dying man whispered more than the abbreviated, melodramatic fragments that de Vos reported.

The elegant, well-spoken Georges de Vos was born in 1889 in the Belgian town of Schoten. He received a doctorate in law, worked as a respected attorney, and would serve as a senator, representing the Catholic Party from the district of Sint Niklaas, Dendermonde. Conspiracy theorists have long believed that de Vos was covering up the truth, that Goedertier himself may have been a red herring. What de Vos did next is even more suspicious.

Instead of notifying the police, de Vos went directly from Goedertier's house to meet with four colleagues, legal magistrates of Dendermonde: Joseph van Ginderachter, the president of the Tribunal of Dendermonde Court of Appeals, who would soon after confiscate Goedertier's library as evidence; Chevalier de Haerne, president of the Ghent Court of Appeals; District Attorney van Elewijk; and the chief prosecuting attorney to the king, Franz de Heem, the man who had taken over the ransom negotiations from Bishop Coppieters.

These peers of the realm met privately and decided to conduct their own investigation, without involving or informing the police in any way. While magistrates could be charged with preliminary investigation of minor crimes, it was irregular for them undertake the investigation of a major theft without police collaboration or consultation. They investigated for one full month before the police, led by de Heem, began their own inquiry into Goedertier's involvement.

This unusual behavior has never been explained. Why would the police stand aside and wait for the private investigation of a group of lawyers, albeit one led by the crown prosecuting attorney? Why didn't Georges de Vos go directly to the police if he believed that his deceased client had been involved in the theft of a piece of Belgium's national treasure? If not de Vos, then de Heem should surely have involved the police, as soon as he learned of this development. Even at the time, the strange procedure smacked of conspiracy.

The lawyers announced their findings after one month.

1. They had located the typewriter on which the ransom letters had been written in Goedertier's home. It was found at the luggage check of the Ghent Saint-Peters rail station on 11 December. The luggage check ticket had been stored in the *Mutualité* file in Goedertier's desk.

2. The Royal Portable typewriter had been rented under the name van Damme from a shop called Ureel, located around the corner from Ghent Cathedral, on 28 April, for a deposit of 1,500 francs. That explained at least one use of Goedertier's fake passport.

3. On 24 April, Goedertier had opened an account at the National Bank in Ghent, depositing the sum of 10,000 francs.

Beyond that, they found nothing of clear relevance.

But one bizarre decision followed another. The investigating magistrates began to use the very same Royal Portable typewriter that had written the ransom notes and had been seized as evidence from the rail station as their office typewriter, because they did not have one of their own.

The only other item that the magistrates cited was the discovery of an "odd key, recognized by no one, that fit no lock in the house." This key may indeed be relevant, if we believe that Goedertier's whispered dying words included "armoire . . . key." This key was of a generic type that opened many basic locks. It was discovered years later that the key fit the door to the rood loft of Saint Bavo Cathedral—the probable method of entry during the theft.

Only after the magistrates announced their findings did the police begin their investigation of Arsène Goedertier, in late December 1934. Goedertier's death, and the discovery of the carbon copies of the ransom notes, had been unknown to the police until this time. Now a month after the fact, the house pored over by the lawyers, the chances of the police discovering a meaningful clue were thin. They dismantled the house and garden and interviewed Goedertier's friends and relatives. They learned almost nothing. Some of his work colleagues said that Goedertier had many debts, but the police also found the 3 million francs in his bank account.

Neither his family nor his wife ever affirmed or denied that he had been the ransomer—they only claimed not to know. But they stuck to a story that, if Goedertier was indeed the ransomer, he was doing it on behalf of an important person in debt. No, they wouldn't say who that person might be.

If this is true, the lawyers whom Georges de Vos consulted may inadvertently have provided a clue. As crown prosecuting attorney, Franz de Heem had represented the recently deceased Belgian king, Albert I. Could the king have been in any way involved? It is hard to believe that someone would risk imprisonment for a 1 million franc ransom, a sum so relatively paltry (approximately $300,000 today) that it would hardly affect a wealthy personage like the king. And if Goedertier wanted to help the Belgian royal house, why not use some of his own 3 million franc savings? Might there have been some larger conspiracy of which this incident was a part? King Albert I died while hiking, which contemporaries considered highly suspicious of foul play. Was there some link?

Goedertier's résumé further suggests that stealing from a Catholic institution would have been his least likely course of action, even in desperation. As the president of several Catholic charitable societies, and the recipient of public honors for years of participation, Goedertier was a model citizen and model Catholic. A skeptic might say that his elevated status would give him unusual access to, and connections within, the Catholic Church of Belgium. Did he use his status as the perfect cover

to infiltrate and steal from the cathedral? Then there was a separate problem of logistics, if Goedertier was the thief. The size and weight of the panels meant that Goedertier could not have acted alone.

The following year, on 9 May 1935, Crown Prosecutor De Heem placed a placard on a wall in Ghent requesting information that might lead to the recovery of the panel and offering a reward of 25,000 Belgian francs (about $7,500 today). This public appeal, months after the fact, was considered by contemporaries to be insufficient and belated.

To make matters odder, it was only at the end of April 1935 that the police and the magistrates informed the diocese of Ghent about Goedertier's deathbed confession—five months after it had occurred. The diocese welcomed this news—finally someone whom they could blame, albeit a deceased peer of the secular arm of Catholic politics and one who seemed to be something of a deus ex machina. But why had neither the secretive magistrates nor the ineffectual police informed the diocese sooner? One can only assume that members of the diocese were suspected of involvement in the crime but ultimately dismissed as innocent—whether or not they truly were.

Six days later, when word of Goedertier and the ransom notes had leaked to the press, Dr. de Cock was asked about his late friend by a journalist for the Flemish daily newspaper *De Standaard*. He said:

> [Goedertier] was a very eccentric man. Arsène Goedertier was no ordinary man. He had his own particular way of doing and thinking that was very peculiar. He certainly never seemed insane to me, but he would never have been accused of being a normal person. He dove into everything, doted on the most trivial of matters, to the point where we [his friends] sometimes had to separate ourselves from him, because he would go on ad nauseam if something interested him, explaining endlessly.

An enigmatic way to describe one's deceased friend, suggesting that even those close to Goedertier were at a loss.

The only promising lead that seemed free of conspiratorial subterfuge came after the placement of Attorney de Heem's placard. *De Standaard* published their first of many articles about the theft on 27 July 1935. The next day they published a second article, written by the paper's editor in chief, Jan Boon. It referred to the placard hung in May and included the following:

> During the 3rd week in the month of June, therefore last month, the Judges panel would have been found, in particular circumstances still unknown today, in the left-hand portion of a public Ghent building. The panel was extracted in the presence of four people. We are making an appeal to the conscience of the witnesses there present, in order that they take all necessary steps for the Mystic Lamb to be reestablished in all its glory at the cathedral. In the happiness of this discovery, its return will make all forgotten and erased. If one persisted to drag things out, we would be forced to reveal all the names and facts to the public.

It was a reverse blackmail. The newspaper threatened to reveal the names and facts about the theft, particularly the panel's removal from a public hiding place, if the panel were not returned.

But why wouldn't the newspaper's editor simply take his information to the police? Why not let the officials handle matters? Probably he lacked confidence that the officials would follow through appropriately, or he believed they were involved in the conspiracy. Or was it all a bluff?

The published threat was never followed up. It may indeed have been one of many false leads that sprung up in the months, and years, after the theft. On another occasion, anonymous letters were sent to a variety of Belgian journalists, telling them to gather at the cathedral, where the hiding place of the Judges would be revealed—the anonymous host never showed up on the night prescribed.

The police gave up officially in 1937. Their closure of the case included the following conclusions:

1. Goedertier stole the painting.
2. Goedertier hid the "Righteous Judges" panel.
3. Goedertier composed and sent the ransom notes.
4. On his deathbed Goedertier tried to atone but died before he could relate sufficient information to recover the panel.
5. Goedertier acted alone.

In police files, the panel was—and still is—labeled "lost." In art terms, *lost* means that the work may have been destroyed or damaged, or simply that its location is unknown. In police terms, it indicates that the authorities have given up trying.

An array of theories, ranging from the plausible to the wildly conspiratorial, would come from a number of "weekend" detectives—amateurs fascinated by the case. In several instances such investigators were able to make progress where the suspiciously ineffectual official investigation fell short, often noticing glaring oversights missed, or overlooked, by the police. In the end, one theory, regarding a failed investment group, appears the most plausible in a case that is still unsolved and very much alive to the people of Belgium to this day. The various theories are worth examining, because even the most imaginative succeeded in advancing the case.

The first conspiracy theorist regarding the Righteous Judges was the fantasy novelist Jean Ray (the pseudonym of John Flanders). In 1934, mere months after the theft took place, he noted an important clue, and yet another one overlooked by the police, either intentionally or through incompetence. Goedertier had rented the typewriter de Vos found at his home, the one that matched the type on the thirteen letters of ransom from D.U.A., under a false name: Arsène van Damme. He pointed out that the initials of this false name, A.V.D., when reversed, could look like D.U.A. Was it a real break in the case, or was Ray looking too hard for an answer that would fit?

Journalist Patrick Bernauw was intrigued by the unsolved crime and began his own informal investigation in the 1990s. Bernauw suspected that Goedertier may have been the ransomer and mastermind but not the thief. He also found the manner and sudden nature of Goedertier's death suspicious. Might Goedertier have been murdered? After the heart attack, Goedertier was lying prostrate on a couch at his brother-in-law's house. Georges de Vos spent fifteen minutes alone with Goedertier, during which time he expired. The police did not conduct an autopsy as, at the time, a natural heart attack seemed the obvious cause of death.

Bernauw thought that Goedertier may have been murdered, perhaps by de Vos or perhaps by two men whom Bernauw suspected had done the stealing on Goedertier's behalf: Achiel de Swaef and Oscar Lievens. Both had been born in the town of Lede, as had Goedertier. Childhood friends, all three sported nearly identical moustaches and goatees; Bernauw likened them to the three Musketeers. De Swaef and Lievens died suddenly within a few years of Goedertier's death, and both were suspected of having been German spies. No homicide inquiries were made into any of the deaths.

Another weekend detective contemporary to Bernauw who wrote a book on the Judges theft, Maria de Roo, claimed that Lievens was the man with the pointy beard who returned the John the Baptist panel via the Brussels rail station luggage check. She argued that he was the only one who ever confessed to the theft—to a blind man from the town of Schellebelle, near Wetteren, shortly before he died. De Roo also said that Lievens died in his home outside of Schellebelle "with an egg in his left hand, the phone off the hook, and the walls spattered with blood. As cause of death, an 'ulcer' was listed." The source of de Roo's information is not stated.

Bernauw noted two things Goedertier had said, which Goedertier's wife recalled after the fact. These quotations were never considered by the police. If real, then they are indeed telling.

Though Goedertier's wife claimed that she had no idea whether her husband was guilty, she never denied that he might have been. According

to her, he had made two comments that could have been relevant to the case:

1. "If I had to go looking for the panel, I would look on the outside of Saint Bavo."
2. "What's been displaced is not stolen."

It had been suggested that the panel was hidden somewhere in plain sight, in the Ghent city center, on the left-hand side of a prominent building. For the sake of convenience of theft, transport, and the return of the panel after a ransom payment, the panel may never have left the premises of Saint Bavo Cathedral. The Judges may have been removed from its frame and simply hidden elsewhere inside or outside the cathedral. This would explain why no trace of the panel was found in or around Goedertier's home.

The second quotation could explain Goedertier's rationalization of the crime. He didn't steal the panel. He simply displaced and hid it on the premises, where it was still on the property of its owner, the bishopric. This may be why Goedertier had sent away the priest Father Bornauw, saying that his "conscience was at peace."

Larger questions are raised, however, if the above hypotheses are a legitimate possibility.

What was the motive for the theft? Even in the time of recession and with his company bankrupt, Goedertier had plenty of money. The ransom was for a sum insufficient to help a government or the king.

Why the inept, laissez-faire police investigation, leaving a group of lawyers to run their own inquiry for a month before the police began theirs? The ransom negotiations were run in an acceptable manner, thanks largely to Attorney de Heem, but afterwards none of the leads was convincingly followed up.

Why the seeming lack of enthusiasm from the bishopric? Why the pressure from the government for the case to be settled, but no governmental offer of aid?

Most importantly, where is the panel now? If it was hidden and then removed by those "four individuals" when no ransom was forthcoming, where was it taken and by whom?

The mysteries of the theft of the Judges remain unsolved.

Several of these points would be contested by a brilliant investigator, chief of the Ghent police from 1974 to 1991, Commissaire Karel Mortier. His dynamic investigation, which he undertook privately, as the case was officially closed, was the first to operate without the murk of conspiracy and ulterior motive.

Commissaire Mortier, a man whose kindly face is offset by dramatic, inverted-V eyebrows that make him look forever in stern thought, pursued the case as a hobby, out of fascination. The tantalizing final letter, suggesting that the panel was hidden somewhere prominent, where no one could retrieve it without attracting public attention, was a lure too great to resist.

Mortier studied the case from 1956 onwards but began his investigation full-time in 1974. His search for the lost panel led him to look for the case file of Heinrich Köhn, a Nazi art detective sent by Josef Goebbels to find the Judges as a gift for Adolf Hitler. The file was thought to have been lost, but Mortier found it in the possession of Köhn's widow, back in Germany. The file indicated that it was the Nazi occultist and leader of the SS, Heinrich Himmler, who most fervently spurred the Righteous Judges investigation. When Köhn failed to locate the stolen panel during the Second World War, he was punished by being sent to the Eastern Front. Yet even with Köhn's file in hand, after years of pursuing a seemingly endless stream of false leads, Mortier finally gave up. He wrote four books about his investigations, the most recent in 2005. To date none are published in English translation. Although the mystery remained unsolved, Mortier reached some dangerous conclusions as to why this was so.

He noted that only one justification could explain the slipshod police work, defiance of standard procedure, and roadblocks placed in the path of anyone else, himself included, who sought answers: There was a conspiracy to hide the truth.

Commissaire Mortier gathered a dossier of convincing evidence. Potentially the most fruitful was an account taken down by police in 1947 but strangely ignored, perhaps because the case was officially closed or perhaps for the same reasons that the investigation was mishandled in the first place. It seems that there was an eyewitness to the theft, one who not only saw a light in the Vijd Chapel but saw two thieves and their getaway car—and recognized them.

Caesar Aercus, a small-time crook from Dendermonde, Belgium, was arrested thirteen years after the Judges theft. In a plea-bargain attempt, he revealed what he saw on the night of 11 April 1934—an account that Mortier and others believe but that was oddly dismissed by police at the time.

In the dead of that April night, Aercus claimed to have seen a black car loitering suspiciously along Kapittelstraat, the street that runs parallel to the nave of Saint Bavo. A portly man in a dark hat and overcoat waited beside the car, pacing nervously. Suddenly a second man emerged from the shadows of the cathedral with what Aercus described as "a plank" tucked under his arm—or at least something plank-like, as it was covered in a black sheet. It was 12:30 AM. The second man put the plank in the backseat of the car and climbed in the passenger's side. The first man attempted to start the car, but it would only sputter and cough.

It was then that Aercus, who had been lurking on the opposite side of Kapittelstraat, crossed the street and offered to help. He had, after all, some experience with cars and thought he could get the engine started. He also recognized at least one of the two men—the portly one who had been waiting by the car. Aercus referred to him, at first, as "Den Dikke," which translates roughly as "the fatty." Aercus's offer of engine assistance was waved away, and the car finally grumbled into ignition. The two men and their black-shrouded plank drove off. Aercus was left to return to the activity that brought him to Kapittelstraat in the first place—he had been stealing cheese from the shop across the street.

Aercus was the cheese thief whose activities were considered sufficiently diabolical that Chief of Police Patijn left the scene of the Righteous

Judges theft in order to pursue him. When Aercus was finally arrested for another crime (he got away with the cheese theft, presumably by eating the incriminating evidence), he tried to amend his plea bargain, claiming not only that he recognized Den Dikke, as he had first stated, but later adding that he recognized the second man, as well. Now that Aercus was in jail, he tried to parlay his recognition of Den Dikke into a shorter sentence and identified him as one Polydor Priem, a Belgian smuggler who had lived in the United States and maintained criminal contacts there.

Aercus's recollection must be taken with a shovel full of salt: It was, after all, a plea bargain attempt, and the convict had incentive to provide useful information that would put him in a good position to negotiate. The word of a career thief like Aercus, whose professional and personal life was knotted with deceit and double-cross, might reflect grudges or opportunism.

Even so, either this follow-up to the investigation was curiously ill-handled by the police, or their work was obstructed. Though the 10 June 1947 police document noted Den Dikke, who Aercus claimed was the mellifluously named Polydor Priem, it failed to note the name of the second man whom Aercus said that he'd recognized.

It was only during Commissaire Mortier's private inquiry that the full extent of the strange investigative procedures undertaken on all sides came to light. In addition to this key eyewitness account, which attests to the involvement of multiple thieves, Karel Mortier made the following discoveries about the Judges case:

1. All of the files relating to the theft had disappeared from the city archives.
2. All of the files relating to the theft had disappeared from the cathedral archives.
3. Ghent ecclesiastical authorities obstructed journalistic attempts to revisit the case.

4. Even the Nazi officer Oberleutnant Heinrich Köhn, with his persuasive interrogation methods and with the backing of Himmler and Goebbels, found no definitive leads when he tried to investigate the theft during the Second World War.

5. The files on Köhn's investigation disappeared from the city archives, though some aspects of them were uncovered by Mortier. He learned that it was Canon van den Gheyn who accompanied Köhn on his investigations. It was to Köhn that Goedertier's widow spoke of her husband's fascination with the Maurice LeBlanc character, the gentleman art thief Arsène Lupin, in particular with one of the novels in which he features, called *The Hollow Needle*. Köhn, as well as the four investigating magistrates, had been especially interested in the contents of Goedertier's library.

6. If the Goedertier family's insistence that Goedertier only tried to ransom the panel to help a prominent Belgian in need were true, then perhaps the cover-up was an attempt to preserve the integrity of that prominent Belgian turned criminal?

7. The police never even interviewed Goedertier's lawyer, Georges de Vos, the most obvious person with whom to begin the investigation. Who's to say that Goedertier's melodramatic deathbed whispers to de Vos actually took place, with de Vos as the only witness? Mortier called the botched police investigation "a caricature."

8. No authorities seemed to have noted that Goedertier was a short, fat, physically weak man. It is highly unlikely that he could have lifted and carried the panel alone. Who else was there?

9. No one had connected the fact that Goedertier suffered from an eye disease that made it difficult for him to see in low-light conditions. He could not have navigated sufficiently in a dark cathedral by himself, to avoid tripping over pews, much less steal a painting.

10. On 9 February 1935 Goedertier's brokerage office officially declared bankruptcy and closed. Before the building was cleared out, Goedertier's brother, Valere, and his widow, Julienne Minne,

searched it thoroughly, suspecting that the panel might be hidden there. They found nothing.

11. The servant of Canon Gabriel van den Gheyn's aunt was stealing art from the area around Ghent in the months leading up to the theft. Could he have been involved?

Despite these key observations, Mortier could not solve the mystery. His best guess was that the Judges had been hidden somewhere behind the medieval wood paneling that runs throughout Saint Bavo Cathedral. In 1996, with a half million francs in funding from the Ministry of Culture, Mortier and a team of technicians began searching the inside of the cathedral with x-ray equipment. But after little more than a week, the tests yielded nothing, only a portion of the vast cathedral had been searched, and the funds were already running dry. The investigation was halted.

Many of the theories that have risen from this crime sound far-fetched. But such is the nature of unsolved mysteries, the documents and files for which have disappeared. Bernauw, perhaps the widest-read scholar of the Judges mystery, believes that Goedertier and the two accomplices he named, de Swaef and Lievens, were acting as Nazi agents. Hitler came to power in 1933, mere months before the Judges was stolen. *The Lamb* was one of Hitler's top targets in his sweeping theft of Europe's finest artworks, as will be discussed in the next chapter.

One of Hitler's motivations was the desire to right the perceived wrong of the wing panels having been forcibly repatriated to Belgium from their display in the Kaiser Friedrich Museum through the Treaty of Versailles. Bernauw believes that there is a link between *The Mystic Lamb* and the famous relic of the Holy Blood that has been kept in van Eyck's hometown, Bruges, since it was brought from the Holy Land by Thierry d'Alsace, the Count of Flanders, in 1149. Knights Templar are also depicted, Bernauw thinks, in the Knights of Christ panel of the altarpiece. There may have been, he suggests, an actual object or document hidden inside the physical panel on which van Eyck painted the Judges. Bernauw's

theory posits that Goedertier and the thieves were killed after they stole the panel and delivered it to a Nazi agent. Though the involvement of de Swaef and Lievens is far from certain, the possibility of Nazi murder is very real. Georges de Vos, the only man privy to Arsène Goedertier's last words, died unexpectedly on 4 November 1942 in a Ghent cinema— shortly after speaking with the Nazi art detective Heinrich Köhn, telling him what he knew of the lost panel.

Dutch author Karl Hammer proposes a theory that Hitler was after *The Lamb* not only because of his interest in stealing art and as revenge for the Treaty of Versailles, but because the painting was thought to have contained a coded treasure map that led to the *Arma Christi*, the instruments used at Christ's Passion, which might include the nails, the sponge, the Spear of Destiny, Christ's robe and reed, the column and scourge from the Flagellation, the Holy Grail, and the Crown of Thorns. Hitler's interest in the occult and the interest of many of the Nazi leaders (Himmler foremost among them) are well documented, as are the Nazi expeditions launched through the Ancestral Research and Heritage Group, the Ahnenerbe, which might be described as the Nazi supernatural research center. Hitler ordered expeditions to Tibet in search of the yeti, to the Holy Land to find the Spear of Destiny with which Longinus pierced Christ's side as he hung on the cross, and to the Languedoc to find the Holy Grail. The Nazi Party itself began as an underground occult confraternity.

It is certainly possible that Hitler believed that *The Ghent Altarpiece* contained a coded map to supernatural treasure. The Ahnenerbe was hard at work looking for a secret code in the Icelandic saga *The Eddas*, which many Nazi officials thought would reveal the entrance to the magical land of Thule, a sort of Middle Earth full of telepathic giants and faeries, which they believed to be the very real place of origin of the Aryans. Whether such a map is in *The Ghent Altarpiece* is another matter, one most scholars dismiss out of hand, though it is tempting to interpret the complex, enigmatic iconography and disguised symbolism of van Eyck's masterpiece in terms more exotic than those in the average

art history textbook. Some believe that the signature on the ransom notes, D.U.A., stands for *"Deutschland Über Alles,"* and that Goedertier, De Swaef, and Lievens were murdered by agents of the Ahnenerbe.

Karl Hammer argues that the ulterior motive of van Eyck's secret mission to Portugal—ostensibly undertaken to paint a portrait of Princess Isabella of Aviz for Philip the Good—was to meet with famed Portuguese cartographers. Together, Hammer claims, they concocted a cartographic cipher with which to hide the whereabouts of the *Arma Christi* within *The Ghent Altarpiece.* According to Hammer, the theft of the Judges panel was a preventative measure, to ensure that a key piece of the treasure map was missing so that the *Arma Christi* remained safely lost.

Writer Filip Coppens focuses on the most obvious treasure of all of the *Arma Christi,* hidden in plain sight at the heart of the altarpiece. In the Adoration of the Mystic Lamb panel, front and center, the Lamb bleeds from its chest into a golden chalice—the Holy Grail. Coppens links this to the subtly drawn AGLA in the Angelic Choir panel, the abbreviation for the Kabbalistic protective magical incantation *atta gibbor le'olam Adonai* ("The Lord is mighty forever"), first noted as such in the 1970s by the Belgian historian Paul Saint-Claire. Hammer extrapolates from the AGLA, suggesting that a secret society known as the Allahists (a corruption of Agla-ists) are the historical protectors of the *Arma Christi.* Though this sounds rather far-fetched, it is another rationale for the theft of the Righteous Judges panel that has found considerable popular support.

Perhaps the Judges panel was stolen in order to hide it from the Nazis or from one Nazi in particular? Hammer suggests that it was being hidden from renowned Nazi grail scholar Otto Rahn, one of the earliest historians to search the Languedoc for the Holy Grail and to write about the Cathars and the Templars in his fascinating, scholarly, and nonconspiratorial 1933 book, *The Crusade Against the Grail.* Rahn was certainly searching for the Grail from the early 1930s until his mysterious death in 1939. As Patrick Bernauw suggests, if *The Mystic Lamb* was a key to it, then perhaps Goedertier and his accomplices were murdered by Nazi secret agents, who

then seized the panel? Perhaps Goedertier thought that Hitler would not be interested in hunting down an incomplete masterpiece?

One historical point interferes with these conspiracy theories: If the theft were in any way preventative, why would Goedertier have tried to ransom the stolen painting back to the bishop?

The case is heavy with "perhaps" and "what if" and short on conclusive evidence. But one explanation, while difficult to believe, fits the clues while providing a feasible motive. While it has not been proven, it seems the most plausible, based on the incomplete information that has survived the cover-ups.

An alternative theory has been proposed, one that includes Arsène Goedertier as the ransomer, though not the thief, and explains the conspiratorial nature of the enduring mystery of the Righteous Judges. Though it does not involve Holy Grails and treasure maps, it is highly controversial, because it implicates the very victim of the Judges theft— the diocese itself. While unproven, it is the only explanation that accounts for all of the extant, confirmed information and provides what has been lacking from other interpretations: a logical motivation for Goedertier's involvement and a rationale for a case that seems to have been subject to a massive cover-up from the start.

It is possible that Goedertier knew about the theft but had no direct involvement in it, only in the subsequent ransom negotiation. It seems improbable, perhaps impossible, for the pudgy, poor-sighted Goedertier to have been the lone thief, as the police had determined. But he could have been the ransom negotiator. Perhaps his slip in the ransom notes from initially describing himself and the criminals in the plural to using the singular in the final ransom notes was no mistake, but rather an indication that what was once a group effort had fallen to him alone to solve. If he could pull off the ransom demand successfully, then there could be both a cash reward and a pardon for those involved.

What would Goedertier stand to gain from his involvement? Though his company, Plantexel, had gone bankrupt, he died with money in his account. He seems to have been a staunch and steadfast Catholic, far more

likely to seek the recovery of church art than to steal it. Could his role have been that of a middle man, brought in after the theft was complete and when other avenues of criminal profit seemed closed, in order to barter with the church—a role that he accepted in order to ensure the return, unharmed, of the Righteous Judges? Some historians believe that this was the case, but it is far from conclusive.

The most probable motive for the theft is also the most complex of those suggested and contains elements drawn from the investigations of various aforementioned "weekend detectives" and the amateur scholar Johan Vissers, who mapped out the theories and personages implicated. It involves an illegal investment group comprising prominent members of the Ghent diocese, including a new cast of characters, all intimately linked to Goedertier, as well as some familiar faces who may have had a more sinister involvement than anyone could have believed. The theory suggests that this group of investors had gathered money from wealthy Catholic families and invested it, along with the majority of the funds of the diocese, in a variety of enterprises that all failed during the financial crisis of 1934. The crisis culminated in the bankruptcy of the Socialist Bank of Labor, which held most of their funds, and prompted them to devise a criminal solution to their losses.

The "investment-group theory" involves the following individuals:

Henri Cooremans was a stockbroker and chair of the cathedral choir, whose father, Gerard Cooremans, had been the minister of the Catholic Party in the 1890s and was chief of the Belgian cabinet until 1918. Henri had founded an investment company called Flanders Land Credit and served in a number of governmental positions.

Investor and secretary of the diocese of Ghent, Arthur de Meester was a priest in the Waasland region of Belgium. He acted as financial advisor to the diocese, selecting the investments into which this group channeled its resources. De Meester died, ostensibly, of problems brought on by al-

coholism, on 30 May 1934, barely one month after the Judges theft. The timing raised suspicions that his death was not entirely of natural causes.

Kamiel van Ogneval had been director of a retirement facility in Ghent called Saint Antone, run by the Ghent diocese, from which he stepped down in 1930. He then became cantor of Saint Bavo. His brother, Gustave van Ogneval, was a local Catholic politician. Also involved in the scheme was Arsène Goedertier, though his role in the group before the Judges theft is unclear.

Finally, it has been suggested that both Bishop Coppieters and *The Lamb*'s greatest defender, Canon van den Gheyn, were complicit—an unsettling inclusion that would explain many of the cover-ups that have clouded the Judges investigation from the start.

According to the theory, Kamiel van Ogneval supervised the collection of money from wealthy Catholic families throughout the region, many of whom had relatives linked to the Saint Antone retirement home, with the promise that their funds would be invested in Catholic charities. The money was invested by Arthur de Meester, while legal contracts between the investors and the group were drawn up by Henri Cooremans. The exact nature of the investments made by this group is unclear—based on Goedertier's other projects, the investment group may have used a portfolio of real and fake projects, ranging from for-profit projects like Goedertier's Plantexel (a failed attempt to establish coffee and oil plantations in the Belgian Congo) to charities that may or may not have existed. It is not clear as to whether there were criminal elements to the investment group's purported activities (such as selling shares in nonexistent companies) or whether the group's activities were aboveboard, and they resorted to crime only when they lost their investors' money and could conceive of no other way to repay it. Bishop Coppieters invested all of the money of the diocese into the legitimate projects pursued by the investment group, and then he would receive a percentage of the profits for himself. Van den Gheyn might have felt compelled to play along, as by this time he was the acting treasurer of Saint Bavo, but it seems that he was not directly involved in the scheme.

In the winter of 1933–1934, Arthur de Meester received a tip about a particularly lucrative investment, but one that would require a lot of money to be raised in a short period of time. The funds were raised, but the timing could not have been worse. On 28 March 1934 the Socialist Bank of Labor, which held the money of this investment group, declared bankruptcy, and they lost everything.

Panicked and frightened at the financial loss, the money owed to the investors, and loss of face for both the Catholic families and the diocese itself, the group devised a plan to recuperate the money through the theft of the altarpiece. The plan offered two possible means of remuneration, and the group fervently argued over which avenue should be pursued. Bishop Coppieters, Canon van den Gheyn, Arthur de Meester, and Arsène Goedertier wanted to keep the Judges panel on the cathedral premises but feign its theft and try to coerce the Belgian government into paying the ransom for its return. Kamiel and Gustave van Ogneval and Henri Cooremans wanted to sell the panel abroad. They thought they could get more money by cutting the panel into pieces, one piece for each painted figure in the Judges scene, and selling them individually. They knew the smuggler Polydor Priem, then living on a houseboat in Ghent, who had a wealth of foreign contacts thanks to some years spent in America. Priem was certain that he could procure an American buyer, even for this most famous of paintings. But ultimately, before the actual theft took place, the group agreed on the safer and more practical plan—ransom.

The cheese thief, Caesar Aercus, had named Polydor Priem as one of the two men he saw outside of Saint Bavo on the night of April 11. But when Aercus was arrested a decade later, the police document failed to note the name of the other man whom Aercus claimed to recognize.

According to the investment-group theory, Kamiel van Ogneval was the second thief who emerged from the cathedral carrying a plank, wrapped in black cloth, under his arm. Most people have assumed that this plank was both the recto and verso, John the Baptist and the Righteous Judges. In actuality, it was just the recto—John the Baptist. The Righteous Judges had always remained on the cathedral premises, hidden.

Many have argued that there must have been at least two men inside the cathedral to steal and carry the unwieldy panels. If there was a third thief that night, it was almost certainly Gustave van Ogneval. The van Ognevals, like Goedertier, were residents of the Ghent suburb of Wetteren. When Kamiel van Ogneval and Polydor Priem drove off that night, they headed straight to Wetteren, where they passed the John the Baptist panel, carefully wrapped, to Arsène Goedertier. His task in this scheme was to act as ransomer. The John the Baptist panel remained hidden in Goedertier's attic, beneath a false panel at the top of a closet, until it was returned via the Brussels luggage check as part of the ransom negotiations. The plotters may have assumed that the Belgian government would finally have succumbed to the ransom demand, and thereby covered their losses.

The loophole in this interpretation comes down to numbers. The ransom demanded seems too small a sum to necessitate criminal measures to replace the funds—particularly considering the stature of the individuals involved and Goedertier's own comfortable financial situation at the time. Why not pass the hat around the group of failed investors and replace the church funds privately, rather than go to the elaborate ends of staging a theft and ransom from your own church, thereby igniting the interest and scrutiny of the world media?

There does not seem to be extant proof of this investment-group scheme, a crime that seems to lack a motive. So many details remain unknown that the story is not entirely convincing. Yet a number of private investigators see it as the best explanation of the Judges theft. It involves real figures engaged in the political and social dynamics of the diocese of Ghent. It explains the strange, conspiratorial cover-ups, the refusal of the diocese to cooperate with investigations as one would assume they should, and the link to Arsène Goedertier, a man who otherwise seemed like the least likely candidate to orchestrate a cathedral theft but whose convenient death by heart attack would make him the fall guy for the entire criminal group.

Most difficult to swallow is Canon van den Gheyn's cooperation in a scheme to dismember the very treasure that he had risked his life to protect during the First World War and that he continued to defend. He

may have been coerced into involvement in the Judges scheme, particularly because of the role of Bishop Coppieters. Were he to expose the bishop or not play along, he might have put the good name of the diocese on the line. Van den Gheyn's dedication to the diocese and to the Catholic Church may have forced at least a silent acceptance.

Though his role in the theft and the motivation behind it remain very much a mystery, it is generally agreed that Goedertier was behind the ransom notes. In addition to the discovery of the carbon copies of the ransom note and the eventual finding of the typewriter on which they were written (about which we must take Georges de Vos's word), Goedertier's enthusiasm for the detective novels of Maurice LeBlanc, which feature the famous fictional art thief Arsène Lupin, provides a fruitful line of inquiry.

Goedertier's wife spoke of his feeling of some personal connection, almost an idolatry, for the Lupin character, who, after all, shared Goedertier's first name. Of his fictional creation, LeBlanc wrote: "[He does] everything above average, and he deserves to be admired. This man beats everything. From his thefts come a wealth of understanding, strength, power, dexterity, and a nature which I unabashedly admire." If Goedertier were to model himself on someone whose manner could acquit him of some of the moral guilt of committing a crime, Arsène Lupin was the fellow to choose.

It was the fantasy writer Jean Ray who first noted the link between Arsène Lupin and Arsène Goedertier. Lupin is a gentleman cat burglar whose primary target is paintings. Goedertier's attempts to ransom the Judges painting recall Lupin's preferred modus operandi, negotiating a ransom for stolen paintings through newspaper advertisements, which he signs with the initials ALN, an abbreviation for his own name. Goedertier's various ransom letters reveal a childlike sense of betrayal at his counterpart's refusal to play by the rules of the game—in novels like LeBlanc's, the elegant criminal is rewarded for his efforts by the ransom payment. Lupin is a master of disguise, variously concealing his identity in the guise of a painter, a banker, and a politician—all of which were Goedertier's professions. In one instance, Lupin concealed an artwork at the scene of the crime itself, all the while negotiating for the ransomed

return of the painting that had never been removed from the property of its owner. Could this indicate a solution to the mystery of the Righteous Judges?

In LeBlanc's 1909 novel *L'Aiguille Creuse* (*The Hollow Needle*), Lupin is on the hunt for a hollowed-out stone, roughly in the shape of a needle, which was a secret treasure storehouse for the kings of France. The location is hidden in code, but Lupin deciphers it and finds the stone on the coast of Normandy. The "hollow needle" is used to hide two artworks: a painting of the "Virgin and Agnus Dei" by Raphael and a statue of Saint John the Baptist. The world's most famous Agnus Dei, the Lamb of God, is *The Adoration of the Mystic Lamb* by Jan van Eyck, and the recto of the stolen Judges panel showed the grisaille rendition of John the Baptist. These particularities, in addition to Goedertier's lifelong love of LeBlanc's novels, suggest that Goedertier modeled himself, and his crime, on his hero Arsène Lupin and *The Hollow Needle*.

There would be a series of codas to the Judges theft, like the false endings to Beethoven symphonies, each one leading to further mysteries—but that ultimately point to one logical, however improbable, conclusion.

In 1938, Belgian minister of the interior Octave Dierckx was approached by a lawyer who, on behalf of an anonymous client, offered to return the Judges panel for 500,000 francs. The minister contacted the bishop. Bishop Coppieters was willing to pay and claimed that he could get the money. The matter was brought before the Belgian prime minister, Paul-Henri Spaak, who rejected the negotiations out of hand. He said, "One doesn't do business with gangsters. We're not in America."

One year later, a Belgian conservator would begin work on an excellent replacement copy of the Righteous Judges—a copy that many, to this day, think is far too good to be a copy.

In 1939, under his own auspices, the conservator to the Royal Fine Arts Museum, Jef van der Veken, began to paint a copy of the missing Judges panel. He used as his support a two-hundred-year-old cupboard door of

the precise correct dimensions and painted with the aid of photographs and the Michiel Coxcie copy in order to re-create the panel as accurately as possible. Van der Veken made only three alterations from the original in his version of the Judges. He added a portrait of the new Belgian king of the time, Leopold III, whose face was placed on one of the judges in the painting in profile. He removed a ring from the finger of one of the judges. And he manipulated one of the judges so that his face was no longer hidden behind a fur hat.

Born in Antwerp, Jef van der Veken was an amateur Surrealist painter and a conservator of the highest acclaim. Specializing in the fifteenth-century Flemish masters, he was entrusted with the restoration of some of Belgium's greatest masterpieces, including van Eyck's *Madonna with Canon van der Paele* and Rogier van der Weyden's *Madonna and Child*. The latter was tested in 1999 and found to be primarily the work of van der Veken, not van der Weyden. His incredibly skillful but heavy hand in restoration prompted an exhibit in 2004 at the Groeningmuseum in Bruges called Fake or Not Fake, exploring the limits of acceptable restoration practices.

In the pre–World War II period, restorers tended to paint with a free hand, bringing back a damaged work to the most complete state possible but often adjusting the artist's intended design to match the values and beliefs of the time. Famously, Bronzino's *Allegory of Love and Lust* was subject to censorious restoration when it was acquired by the National Gallery of Art in London in 1860, the restorer adding a flower to cover the rear end of the adolescent, sexualized figure of Cupid, covering over one of Venus's exposed nipples, and retracting Venus's tongue, which in the original was extended to kiss Cupid, her son. In 1958 these prurient Victorian restorations were removed, the painting reverting to its original state, nipples, tongues, and all. Today, the prevalent theory is one of conservation rather than restoration—conservators seek to prevent deterioration and further damage to works of art, while touching up the work as little as possible. When conservators do add to paintings, in order to fill in damaged portions of the composition, they do so in a way that is

true to the original work but does not try to trick viewers into thinking that the work has not been restored. The restored portions are unapologetically distinct from the original parts of the painting, the restoration efforts are rigorously photographed and documented, and the paints used are chemically divergent from the original paints, so that they can be removed by future conservators if necessary without damaging the original paint. Not so in the 1930s, when van der Veken was at the peak of his career. In van der Veken's time, restorers were praised for their skill, if their additions to an artwork were indistinguishable from the original.

The great restorer's expertise and connoisseurship made him the preferred consultant of Emile Renders, a wealthy Belgian banker who assembled the world's most important private collection of Flemish Primitives, as fifteenth-century Flemish painters were sometimes called, in the years before the Second World War. He was also the author of the 1933 article that suggested that the inscription discovered on the back of the Joos Vijd panel, introducing Hubert van Eyck to the art world, was a sixteenth-century forgery by Ghent Humanists. Hermann Göring bought the entire Renders Collection in 1941 for three hundred kilograms of gold (about $4–5 million today), with the help of the Schmidt-Staehler organization, the Netherlands-based equivalent to the ERR, the Nazi art theft unit. Emile Renders maintains that he was coerced into selling his collection to Göring, though some sources believe that he was not the victim he made himself out to be. Whether van der Veken was involved in this wartime sale is unknown.

Van der Veken enjoyed a sideline in making "new" Flemish Primitives, copies of famous paintings or portions of them, using centuries-old panels as the support. He would then artificially age the works to give them the craquelure and patina of age. What distinguished him from a forger is that there is no record that he ever tried to pass off his own work as a Renaissance original.

There is a long and rich history of artists copying the work of more famous artists in order to learn their techniques. For a restorer, the ability to mimic the work of the masters whose work is theirs to preserve is a

critical component of their professional success. Copying and even aging works is only a crime when the creator tries to profit from his imitation, passing it off as an original. Though van der Veken, as far as is known, never tried to do this, his ability to mimic the great Flemish Old Masters is beyond question. As senior conservator at the Musée des Beaux-Arts in Brussels, he was the logical choice to create a replica of the lost Judges panel, which could once again "complete" *The Ghent Altarpiece*, filling the gaping hole in its lower left side.

Van der Veken finished his copy in 1945. It was placed in the frame along with the recovered Saint John the Baptist and the eleven original panels in 1950.

But some have suggested that van der Veken was involved in some aspect of the theft itself. It was odd that he began to make the replacement copy on his own, without the official prompting of the diocese. There is a touch of black humor in the restorer's choice to work on a copy of a panel that was still missing and that only a year before had been the subject of a renewed ransom attempt, four years after Goedertier's failure.

Oddest of all, on the back of the panel, still in place to this day, is a confusing inscription from the artist. Van der Veken wrote the following in Flemish rhyming verse:

> I did it for love
> And for duty.
> And to avenge myself
> I borrowed
> From the dark side.

It is signed Jef van der Veken, October 1945.

Van der Veken was interviewed on multiple occasions but each time replied that he knew no more than anyone else about the 1934 theft. His reticence made people believe that he knew more than he let on, but there was never any concrete evidence to suggest as much.

Questions about the replacement panel should have been raised in November 1950, when the defender of *The Lamb* during the First World

War, Canon Gabriel van den Gheyn, gave a lecture to the Ghent Historical and Archaeological Society entitled "Three Facts Related to the Mystic Lamb." He told the story of the adventures of *The Lamb*, from its theft by the French in 1794 through its theft by the Nazis, to which we turn next. In the course of his fifteen-page speech, no mention whatsoever was made of the 1934 theft. This is particularly strange, as the audience for the lecture would certainly remember the theft, and it would have seemed to them, as it does today, a conspicuous lacuna in an otherwise historically thorough presentation.

Was the one-time savior of the altarpiece party to the 1934 theft or its cover-up conspiracy? Van den Gheyn wore many hats: In addition to being an amateur archaeologist, he was custodian of the cathedral treasures, the diocese treasurer, and also the chief conservator of the cathedral artworks. So it is stranger still that he would not mention the theft even indirectly, in referring to the recently installed copy of the Judges panel by fellow conservator van der Veken. He had so tirelessly defended the altarpiece during the First World War. If the investment-group theory of the 1934 theft is true, then he was involved in the 1934 theft and conspiracy. During the Second World War, it was he who would accompany the Nazi art detective Oberleutnant Heinrich Köhn on his search for the Righteous Judges panel. Could van den Gheyn have been a Nazi collaborator, or was his accompaniment of Köhn a means to divert the Nazi art detective from his task? Köhn and van den Gheyn first spoke in September 1940, but Köhn's investigation continued through 1942. On 12 May 1942 van den Gheyn and Köhn toured the cathedral archives but found nothing that would lead them to the panel. It was then that they made the discovery that all of the files related to *The Ghent Altarpiece*, including the files that detailed the 1934 theft and investigation, had disappeared. Perhaps the canon had disposed of the files in anticipation of Köhn's investigation. They have never resurfaced, leaving a trail strewn with question marks.

This case is one of the great unsolved mysteries in the history of art theft. It colored the popular imagination, even winding its way into literature. Albert Camus's 1956 novel *La Chute* ("The Fall") is a monologue

in which a character speaks with a new acquaintance on a series of nights, while drinking at a seedy bar in Amsterdam. In the novel, the Judges panel had hung on the wall of this Amsterdam bar during the years following the theft. The reader later learns that it is currently hidden in a cupboard in the narrator's apartment. Camus uses the Righteous Judges to raise existential questions about the personal judgments and life decisions of the protagonist narrator, who refers to himself ambiguously as a "judge-penitent."

In Belgium, the mystery excites a passion reminiscent of the Kennedy assassination in the United States. It has inspired more than a dozen books, fiction and nonfiction, as well as documentaries, docudramas, and countless articles—none of which have been translated into English. The story is still fresh and the investigation, at least from an amateur perspective, still active.

Speculation abounds—the rocks in the background of van der Veken's copy of the Judges look just like those at Marches-les-Dames, where the Belgian king Albert mysteriously fell and died. Coincidence? To this day, every few months a new clue as to the location of the missing Righteous Judges is announced in Ghent newspapers. In the summer of 2008 the floorboards of a Ghent home were taken apart by the local police after a tip had suggested that the Judges panel was buried beside a skeleton between the floorboards. Authorities continue to investigate astonishing and unbelievable leads, as the search for the missing panel continues.

One final significant clue would present itself decades later. Though it did not solve the mystery of what happened, it may solve the mystery of where the panel is hidden today. But *The Ghent Altarpiece*, minus the Righteous Judges, would undergo one more hurricane of theft, smuggling, and ultimate salvation.

The Second World War was on the horizon, and Nazi wolves had their sights set on the Lamb of God.

CHAPTER EIGHT

The World's Greatest Treasure Hunt

The search for Nazi stolen art has been called the greatest treasure hunt in history. The supreme prize among the kidnapped treasures was *The Adoration of the Mystic Lamb*. And the fate of *The Lamb* during the Second World War, along with that of most of Europe's artistic masterpieces, was sealed by the heroism of an Austrian double agent, a group of salt miners, and a fortuitous toothache.

In May 1940 the German army invaded Holland and Belgium. Because many of Belgium's art treasures had been looted during the First World War, in the face of the advancing storm troopers the Belgian government sought a safe house to which its prized artworks could be sent. *The Adoration of the Mystic Lamb* was Belgium's national treasure; as long as it was safe from harm and foreign capture, Belgium was in control.

The government first considered the Vatican as a hiding place. A truck carrying the altarpiece in ten large wooden crates was en route to Italy when Italy joined the Axis and declared war. France then offered to guard *The Lamb*, and the truck veered west towards Chateau de Pau at the foot of the Pyrenees, birthplace of Henry IV. It was somehow poetic that the birthplace of the French king, whose conversions from Protestantism and Catholicism resulted in so much death and destruction, should protect a Catholic treasure that had nearly been burned by Protestant rioters during the uprising in 1566. Chateau de Pau already housed many of the works from French national museums, including the Louvre. *The Lamb* was added to its treasure trove. The default guardian of the chateau treasures,

189

and the guardian of all of France's art during the war, was Jacques Jaujard, director of the French National Museums and the Louvre itself.

Born in Asnières, France, Jaujard was a courageous man in a hopeless position—in charge of the safety of the French national art collections during the Nazi occupation from 1940 through 1944. With each defeat of the French army before the Nazi onslaught, Jaujard ordered the crated art treasures shipped ever further south, away from the front line, to locations that seemed inevitably safe from harm's way. Surely the Nazis would be stopped before they reached Lyon or Pau. But the tide pressed on with alarming speed. After Paris, Jaujard relocated to Chambord, the castle in the Loire Valley south of Paris that featured a torque double-helix staircase, with two monumental stairs wrapped around each other, yet never meeting, designed by Leonardo da Vinci. He was directing the shipment of art from Chambord to points further south, most to a series of museums and castles in Provence and along the Pyrenees, when the Germans surprised him. They informed him that he was the first important French official whom they had encountered thus far on duty, rather than fleeing or in hiding. He also then learned that Hitler had ordered that all artworks and historical documents in France be seized as collateral in peace negotiations with France—they would become German property in exchange for a cease-fire. There was little that Jaujard could do, other than move artworks further south and pray. While he was unable, in an official capacity, to guarantee that French artworks would remain in France, he had a strategy. He prepared an underground intelligence network that would keep track of which artworks were confiscated and where they were headed. That network consisted, primarily, of an unassuming librarian by the name of Rose Valland, a clerk at the Jeu de Paume Museum in Paris, which became the depot for Nazi-looted art in France.

By June the Germans had conquered all of Holland and Belgium. The Belgians were particularly concerned that Hitler would seek out *The Lamb* by way of revenge for its restitution through the Treaty of Versailles. The fact that Germany had been forced to return the wing panels at the end of the First World War had outraged the German populace.

Now, the seizure of *The Ghent Altarpiece* by Hitler would symbolically erase the perceived wrongs done to Germany at Versailles.

In May 1940, very soon after eleven out of twelve original panels of *The Lamb* were shipped to Pau for safekeeping, a Nazi officer arrived in Ghent: Oberleutnant Heinrich Köhn of the Nazi Art Protection Department. He had been commissioned specifically to investigate the unsolved 1934 theft of the Righteous Judges—and to hunt down this last missing panel.

Köhn, a fanatical Nazi and Hitler look-alike, sporting a smudge moustache, had been assigned this task by Josef Goebbels. Goebbels, the Nazi minister of propaganda with a doctorate in Romantic drama, rose to power alongside Hitler, making a name for himself early on by spearheading the burnings of books that were considered degenerate by the Nazi government. The mastermind behind the attacks on German Jews, including the infamous Kristallnacht of 1938, he also established a propaganda technique referred to as "The Big Lie," based on the principle that a lie, if audacious enough and if stated with sufficient conviction and repetition, will be accepted as truth by the masses. Heinrich Köhn was Goebbels's bloodhound, hunting for a unique gift for the führer. Goebbels had timed this assignment with the aim of presenting the Judges panel to Hitler in 1943, in celebration of the tenth anniversary of his assumption of power.

The people of Ghent had reason to be nervous, even with eleven-twelfths of the altarpiece in storage abroad. Why would a Nazi art detective be sent to find the one missing panel, if the Nazis did not intend to seize the other eleven?

Köhn was a meticulous investigator, but he did not read Flemish. He enlisted the aid of Nazi sympathizer Max Winders, an Antwerp architect and advisor to the Belgian Ministry of Education's Art Board, who accompanied him to Ghent. They arrived in September 1940. The first person with whom they spoke was the canon of Saint Bavo Cathedral. Gabriel van den Gheyn had seen *The Lamb* safely through the First World War and would do his best during the Second. The three men

went through every page of the archives on the history of *The Lamb* and Saint Bavo Cathedral, scouring the Ministry of Justice, the cathedral, and the Ghent city archives. But they encountered a surprising hurdle at each archive: Most of the pages on the Judges theft were missing.

At the time of the 1934 theft there had been talk of cover-up and conspiracy, including the suggestion that sometime hero van den Gheyn had been complicit. Though clues suggested that the panel had been hidden somewhere prominent, perhaps even on the façade of the cathedral, the case was closed, and the files stored in various archives. Now that Köhn was reopening the investigation, portions of the files from all the relevant archives were found missing. Someone had stolen them between the theft and the Second World War. If the investment-group theory was true, then it made sense that the archives had been doctored.

Köhn interviewed everyone who had any involvement in the Righteous Judges investigation, which by this time was six years old. Either the trail had grown stale, or there was a collective agreement on silence. That van den Gheyn accompanied Köhn on his investigations smacked to some of complicity; others thought that the best way for the canon to steer the Nazi detective clear of the truth was to work with him every step of the way. While Köhn's search for the Judges was fruitless, it indicated to the people of Ghent that the Nazis had serious designs on their treasure.

Although it was as yet unknown outside of Nazi circles, there was good reason to fear a widespread Nazi harvest of Europe's art treasures. Hitler had a plan to assemble every important artwork in the world and create a *kulturhaupstadt*, a citywide supermuseum, to be located in his boyhood hometown of Linz, Austria. To this end, Hitler instructed his officers to seize and send him works of art they came across during their conquests.

Various explanations have been offered for the passionate enthusiasm Hitler had for this project. Hitler was a failed art student. His work considered too poor, Hitler was rejected from studies as a painter and an ar-

chitect in Vienna. Here was an opportunity to show the lords of the art world not only that they had erred in rejecting him, but that he could deprive them of their greatest treasures. Hitler's inferiority complex, about which much has been written, may also have contributed to his choice of Linz, a working-class town without much in the way of culture, as his new world art capital. By elevating his boyhood hometown, Hitler could elevate his own modest origins. Hitler's Linz would be ever after known as the culture capital of the world, his *kulturhaupstadt*. Hitler's dislike for Vienna, a city he had once idealized before he was rejected from studies there and forced to live in low-income communal housing, may also have contributed to his choice of Linz. He would strip the old Austro-Hungarian culture capital and elevate its poor neighbor.

The entire city of Linz was to be converted into one expansive museum that would house all of the world's art. Every art historian would come there to study. Even the art that Hitler considered "degenerate," primarily nineteenth- and early-twentieth-century Impressionist, Post-Impressionist, and abstract works, would be placed in a special museum to be viewed by future generations as evidence of the grotesqueries from which the Nazis had saved humankind. The city, naturally, would have to be completely transformed, old buildings uprooted in favor of new state-of-the-art museum facilities. There was a joke that while Munich was the city of Nazi *Bewegung* (the Nazi movement), Linz would become the city of the Nazi *Bodenbewegung* (the Nazi earthquake).

Unsurprisingly, Hitler's artistic agenda followed his social one. He was passionately in love with art by northern European artists or of northern European subject matter. He sought works by Teutonic/Scandinavian artists or Teutonic/Scandinavian subjects—art that, to him, demonstrated Aryan greatness—by the likes of Breughel, Cranach, Dürer, Friedrich, Vermeer, Holbein, Rembrandt, Bouts, Grünewald, and Jan van Eyck.

Hitler already had experience with censorship. Early in his tenure as führer, he had ordered the closing of the modern wing of the former crown prince's National Gallery in Berlin, the same museum that had displayed

six panels from *The Ghent Altarpiece* until the Treaty of Versailles. He
referred to this wing, with its masterpieces by the likes of Kandinsky,
Schiele, Malevich, and Nolde, as the "Chamber of Horrors." It was closed
officially by the Ministry of Education on 30 October 1936, just months
after the departure of foreign visitors who had been in Berlin for the
Olympic Games. The timing of the closure indicates a Nazi awareness
that their views on art would not be well received by the world at large.

It was a sign of the times. Two months prior, the director of the Folk-
wang Museum in Essen had deaccessioned a Kandinsky painting and sold
it to a dealer for 9,000 marks, in what he called a public act of purification.
He went on to insist that degenerate art such as this would infect all who
looked upon it, and therefore it must be hunted down and removed not
only from museums, but from private collections as well. To establish an
edifying point of contrast, the House of German Art (Haus der
Deutschen Kunst) was set up in March 1937: an annual exhibition of
Reich-approved artworks that would set a morally elevating example for
what the art of the Reich should be. It was housed in the first building
constructed as an edifice of German propaganda, built between 1934 and
1937 in an adaptation of the Neoclassical style that would come to typify
Fascist architecture.

While the Nazis expressed their hatred for so-called degenerate art,
they were certainly aware of its monetary value. True iconoclasts would
want such art destroyed, but the Nazis did not hesitate to profit from the
art they were denouncing, selling the confiscated art to dealers and col-
lectors who prized it and would continue its legacy as an object of beauty
and veneration.

On 30 June 1937 Hitler authorized Adolf Ziegler, an artist and the
president of the Reich's Department of Plastic Arts, to seize for the pur-
pose of exhibition the examples of German degenerate art to be found in
German imperial, provincial, or municipal possession. Ziegler was one
of Hitler's art advisors and a longtime friend of the führer's. (Hitler had
commissioned Ziegler to paint a memorial portrait of Hitler's niece, who
had recently committed suicide.) Hitler collected a number of Ziegler's

paintings, which he displayed at his Munich residence. Ironically, Ziegler had begun his painting career in the Modernist vein, a movement he would later help to condemn.

Only twenty days after the mandate, Ziegler mounted the so-called Exhibition of Depraved Art, first in Munich and then in Berlin, Leipzig, and Düsseldorf. The exhibition was the result of the rapid and systematic roundup of the cream of modern art in German collections. Abstract or minimalist painters, and artists of non-Teutonic origin were best, or one might say worst, represented. Emil Nolde had the most paintings exhibited, with twenty-seven on display. Among the art of other condemned artists of note were nine works by Kokoschka, six by Otto Dix, and paintings by Chagall, Kandinsky, and Mondrian.

It was intentionally curated in the least flattering way. A total of 730 works were hung clustered together in long, narrow galleries with dim lighting. What light might have come in through the windows was mostly blocked by screens, which were pocked with holes in order to let in blinding spotlights of sunshine. Sculpture was placed in front of paintings. Placards that contained demeaning analyses hung beside certain paintings. A wall of works by German contemporary artists bore the inscription "Until today such as these were the instructors of German youth." This traveling exhibition made stops in Germany's most artistically endowed cities, much like accusers wheeling their captured witches for all the townspeople to see before sending them to the stake.

Following this exhibition, Hitler implemented a massive plundering of his own people, under the guise of "purification." Throughout Germany every artwork that Ziegler's committee deemed depraved, based on no further criteria, was confiscated without compensation, regardless of its location in a museum, gallery, private home, or church.

It seems that this plundering occurred before Hitler himself had a clear idea of what art he liked and admired. Artists who would soon become personal favorites of his and other Nazi leaders, such as Rembrandt and Grünewald, whose works represented some of the finest accomplishments of Teutonic artists, were included in this initial artistic witch hunt. In all,

12,000 drawings and 5,000 pictures and sculptures were seized from 101 public collections alone, not to mention countless private seizures. These included works by Cézanne, van Gogh, Munch, Signac, Gauguin, Braque, and Picasso. Perhaps the most famous item in this roundup was van Gogh's *Portrait of Dr. Gachet*.

Hitler inspected these confiscated works in a storeroom in Berlin. A six-volume catalogue lists its contents:

- 1,290 oil paintings
- 160 sculptures
- 7,350 watercolors, drawings, and prints
- 3,300 other works on paper stored in 230 portfolios

This made for a total of 12,890 items looted by Nazis from their fellow Germans. After his inspection, Hitler stated that on no account would any be returned, nor would any compensation be given. In anticipation of a similar action, a list was drawn up of the artistic holdings of both private and public collections in Vienna, the city that Hitler was so eager to depose as a cultural center.

What was to be done with all of this degenerate art? The Berlin Amt Bildende Kunst (Office for Pictorial Arts) was a subdivision of the Amt für Weltanschauliche Schulung und Erziehung (Office for World Political Education and Indoctrination). That meant that any Nazi operations related to pictorial arts, including confiscation, were driven by and had to answer to the Nazi propaganda and indoctrination office. This helps to explain how Nazi censorship of "degenerate" art morphed into art looting.

On instruction from Josef Goebbels of the Reich's Propaganda Committee, a task group was formed in May 1938 to determine how best to dispose of the seized artworks. This proved an important month in the formation of Hitler's plans for how to deal with art in the Third Reich. In April of that year, Hitler had first begun to plot the use of Linz as the future art center of the Third Reich. Then in May, Hitler visited Mussolini in Rome and was humbled by the majesty and palpable history of the city, which he thought made Berlin look like a sandcastle. He was in-

spired to replicate the Roman Empire not just geographically, but also through monuments that would proclaim the endurance of his empire. Art and architecture were the legacies of great civilizations. Ancient Rome had plundered the lands it conquered. The obelisks in Piazza del Popolo and in front of Saint Peter's were taken as trophies of war following the fall of Egypt. Hitler would follow in Rome's footsteps, even designing his own mausoleum, which would be the centerpiece of the Linz city plan, inspired by Hadrian's mausoleum at Castel Sant'Angelo.

During a visit to Florence that May, Hitler fell in love with the Ponte Vecchio. Then, to the annoyance of Mussolini, who was no art lover, Hitler spent a full three hours strolling the galleries of the Uffizi, marveling at that treasure house of wonders—and perhaps formulating a shopping list of what he would take when the time was right.

Back in Berlin, the Reich's Propaganda Committee met for the first time. It included Ziegler and a handful of dealers with connections abroad. The task group's members were allowed to choose any works from the storerooms and sell them abroad for foreign currency—on condition it was made clear that the works were of no value in Germany itself.

The main dealer selling Nazi-looted art abroad was the Galerie Fischer in Lucerne, Switzerland, which remains an auction house to this day. The gallery held an international auction, claiming that proceeds would fund purchases of new works for the museums from which the auction contents had come. In fact, the proceeds went to build Nazi armaments.

Those works that had not sold by 20 March 1939, when the storehouse was suddenly required for use as a grain depot, were burned in the yard of a nearby fire station. This pyre included 1,004 oil paintings and sculptures and 3,825 works on paper. But before the sales and the burnings, some of the choicest of the confiscated works were siphoned off by Nazi leaders for their own collections.

Hitler was not the only Nazi leader who ravenously collected art through war looting. Foremost among Nazi private collectors was Luftwaffe reichsmarschall Hermann Göring. During the Second World War, Göring assembled an enormous collection of the highest quality

at Carinhall, his estate near Berlin. This elaborate hunting lodge had been built in 1933 in memory of his first wife, a Swede named Karin, who had died in 1931. He would live in it with his second wife, Emily Sonneman, after whom he named his second home, Emmyhal. But it was his first wife whom Göring posthumously fetishized. He built up an elaborate art collection as a votive shrine to her. And he had no scruples about the manner in which he acquired artworks. As the war began, Göring infamously said, "It used to be called plundering. But today things have become more humane. Nevertheless, I plan to plunder, and to do so thoroughly."

Göring's tastes mirrored those of Hitler. By the end of the war he would own sixty stolen paintings by German sixteenth-century master Lucas Cranach the Elder, whose background and paintings were considered exemplary of the best of Teutonic artistry. His preference for Germanic art and artists was such that he once traded a hundred and fifty authentic nineteenth-century Impressionist and Post-Impressionist French paintings, looted from Paris galleries, for one Vermeer, *Christ and the Woman Taken in Adultery*, which turned out to be a two-year-old fake by the Dutch master forger Han van Meegeren.

On paper, Nazi policy in the Second World War abided by the guidelines on art protection set during the First World War—because great art was eternal, it should rise above war and be preserved as the greatest accomplishment of human civilization. Once again, while that sounded good, things were different in the heat of war.

On 26 June 1939 Hitler issued the official directive to gather works for the planned Linz museum. At the same time, Hitler was cautious as to how his actions would appear to the world at large, which made him hesitant to steal art outright, at least the most famous works. He went to great lengths, particularly through Goebbels and the Propaganda Ministry, to provide legal excuses, however flimsy, for the looting and destruction that he oversaw. This extended from the legalized seizure of goods belonging to "enemies of the Reich" (Jews, Catholics, Freemasons, or anyone who had something worth stealing) to the Napoleonically inspired acquisition of artworks as terms of an armistice.

In 1940, special divisions of art historians and archaeologists were charged with the task of making inventories of artistic possessions in each European country, ostensibly to protect them against theft and damage. They were led by Dr. Otto Kümmel, director of the Berlin State Museums. The inventory became known as the Kümmel Report. But the Nazi Party–controlled state had an ulterior motive. The Kümmel Report actually detailed a list of artworks that the Nazis considered to be the rightful possession of the Third Reich. The state secretly planned to use these inventories as wish lists, embarking on a program of plunder of which, at first, the army special divisions were unaware. The army obeyed orders regarding confiscation of property but for the most part did not participate in looting for themselves. The one great exception to this was Göring, who stole for his own collection.

The Kümmel Report included every work that had ever been completed or commissioned in Germany or by a German, every work that was in the "German style" (a blanket description that included every northern Renaissance and Romantic painting, along with anything else that tickled the führer's fancy), and any work that had been in Germany and was removed since 1500. *The Ghent Altarpiece* fit all of the categories, and the loss of its wings to the Treaty of Versailles was a raw and gaping wound for Hitler.

A hint at Hitler's grand plan became known in June 1940, when France fell to the Nazis. Hitler carefully orchestrated his revenge, ordering his troops to find the exact same railcar in which the Treaty of Versailles had been signed in 1918. He had the building that housed the railcar knocked down; the railcar was shipped to the same piece of land in Compiègne, near Versailles, where the treaty had been signed. Hitler sat down in the very chair that had been occupied by Marshal Foch, the leader of the French troops in the First World War, when the treaty was signed. Only then, in the same railcar, on the same piece of land, with Hitler now in the victor's chair, were the French forced to sign an armistice. After the ceremony, the railcar was shipped back to Berlin, where it was placed on display, to show how mighty Hitler had righted the wrongs of the Treaty of Versailles.

The Reich's Ministry of Foreign Affairs declared on 21 July 1940 that they would "safeguard" the art of France that was in private and public collections. The German army apparently believed that the Reich's declaration of art protection was genuine, while the Reich itself had no intention of keeping its word. The truth became clearer on 17 September 1940, when Hitler announced the formation of the Sonderstab Bildende Kunst (Special Operations Staff for the Arts), the primary task of which was to confiscate art from Jewish collections in France, beginning with the wealth of the Rothschild family. This unit was the precursor to the Einsatzstab Reichsleiter Rosenberg (Rosenberg Operational Staff, or ERR), run by Alfred Rosenberg.

The ERR began its work on 5 June 1940, when Reichsführer Alfred Rosenberg proposed that all libraries and archives in occupied countries be scoured for documents of value to Germany. Hitler agreed. The seizure of documents led to the abduction of artworks, as the ERR's mission broadened.

Alfred Rosenberg was born in Tallinn, where he supported the Whites during the Russian Revolution. When the Bolsheviks took over, he fled to Munich, arriving in 1918. He fell in with the new National Socialist German Workers' Party, soon to become the Nazi Party. He edited the party newspaper, befriended Hitler, and even claimed to have coauthored *Mein Kampf*. In 1929 he founded the Militant League for German Culture and lost to Joachim von Ribbentrop in the race to be Germany's foreign minister. Following the invasion of the Soviet Union during the war, Rosenberg would be appointed head of the Reich's Ministry for the Occupied Eastern Territories, and the running of the ERR fell to others.

Rosenberg had initially employed art historians in the ERR to compile lists of important monuments. These same art historians were now charged with overseeing the confiscation of artworks and documents, sometimes shamelessly out in the open, sometimes under the thinly veiled excuse of protecting the art from the turmoil and damages of war.

Hitler's and Göring's personal accumulation, through their own special agents, made even Alfred Rosenberg uneasy. When Hitler or Göring

wanted one of the confiscated artworks, it would for all intents and purposes disappear. Rosenberg began to insist that members of his staff obtain receipts from the agents of Hitler and Göring for any seized artworks that they, in turn, confiscated from the Einsatzstab Rosenberg.

In France alone, from 1940 to 1944, twenty-nine shipments of art were brought to Germany in 137 freight cars packed with 4,174 crates of art. And in a report dated 3 October 1942, Alfred Rosenberg reported to Hitler that, to date, he had overseen the confiscation and shipping to Germany of 40,000 tons of fine furniture.

The full extent of the Nazi art looting may never be known, but its spectacular breadth is indicated by the Einsatzstab Rosenberg inventories. As early as 20 March 1941, Rosenberg penned a cheerful, chatty report to the führer describing his successful looting of Paris, particularly the belongings of a who's who of leading Jewish art dealers.

> *I report the arrival of the principal shipment of ownerless Jewish cultural property in the salvage location of Neuschwantstein by special train on Saturday the 15th of this month [March 1941]. The special train, arranged for by Reichsmarschall Hermann Göring, comprised 25 express baggage cars filled with the most valuable paintings, furniture, Gobelins [tapestries], works of artistic craftsmanship and ornaments. The shipment consisted chiefly of the most important portions of the collections of Rothschild, Seligmann, Bernheim-Jeune, Halphen, Kann, Weil-Picard, Wildenstein, David-Weill, and Levy-Benzion.*
>
> *My Staff for Special Purposes started the confiscatory action in Paris during October 1940 on the basis of your order, my führer. With the help of the Security Service and the Secret Field Police all storage and hiding places of art possessions belonging to the fugitive Jewish emigrants were systematically ascertained. These possessions were then collected in the locations provided for by the Louvre in Paris [the Jeu de Paume Museum]. The art historians on my staff have itemized scientifically the complete art material and have photographed all works*

of value. Thus, after completion, I shall be able to submit to you shortly a definitive catalogue of all confiscated works with precise data on their origins, plus a scientific evaluation and description. At this time the inventory includes more than 4,000 individual objects of art of the highest artistic value [from Paris alone].

Two years later, in April 1943, the inventory had grown to include 9,455 artworks. On 16 April 1943 Rosenberg sent Hitler another telling letter, which accompanied albums of photographs of stolen art destined for the Führermuseum at Linz.

Mein Führer: in my desire to give you, my führer, some joy on your birthday, I take the liberty of presenting you with a folder containing photographs of some of the most valuable paintings which my Einsatzstab, in compliance with your order, secured from ownerless Jewish art collections in the occupied Western territories. . . . I beg of you, my führer, to give me a chance during my next audience to report to you orally on the whole extent and scope of this art seizure action. . . . I shall deliver further catalogues to you as they are completed. I shall take the liberty during the requested audience to give you, my führer, another twenty albums of pictures, with the hope that this short occupation with the beautiful things of art which are nearest to your heart will send a ray of beauty and joy into your revered life.

It would be the first of many albums created by the ERR. The official Rosenberg report, as of 15 July 1944, consisted of thirty-nine typed volumes, including 2,500 photographs, documenting a total of 21,903 looted artworks. These included:

+ 5,281 paintings, pastels, watercolors, and drawings
+ 684 miniatures, glass, enamel, books, and manuscripts
+ 583 pieces of sculpture, terracotta, medallions, and plaques
+ 2,477 pieces of furniture of historic and artistic value

- 583 tapestries, carpets, and embroideries
- 5,825 articles of craftsmanship, including porcelain, bronzes, jewelry, and coins
- 1,286 works of Oriental art
- 259 works of ancient art

This inventory did not include works confiscated by Hitler and Göring, which had been appropriated from the ERR.

Frequently Göring and Hitler sought the same works of art. Although the ERR had been established in a directive by Hitler, it was unofficially commandeered by Göring and used as a personal tool. Officially Göring had to defer to Hitler, but he showed a dexterous sleight of hand, particularly in Paris, siphoning off the cream of the looted collections and sending the rest back to Berlin. Confiscated artworks were shown first to Göring, who decided what he would take and then what would be sent on to Hitler or stored.

In an order from Göring that dates 5 November 1940, the ERR would be permitted to seize all "ownerless" artworks—those belonging to Jewish families (since Jews were not considered citizens, their property was ceded to the state). Göring would personally examine the works confiscated. Before this date, these responsibilities had fallen to the German military commander in chief in France and the German embassy in Paris. With this order, Göring had wrested power from the armed forces and placed himself as a filter between the stolen art and Hitler. Perhaps in direct reaction, thirteen days later Hitler issued an order that all confiscated works were to be sent directly to Germany and placed at his disposal. This tug-of-war between Hitler and Göring over the choicest loot would continue throughout the war.

The Allied report on the ERR, formulated after the war on 15 August 1945 at one of the major stolen art depots, Neuschwanstein Castle in Bavaria, explained that the important operations of the ERR were dominated by Göring. His control of the fruits of the ERR's labors was in formal contradiction to Hitler's order of 18 November 1940, and for the

next two years the ERR was Göring's tool. Rosenberg, while feeling obliged to stick to Hitler's orders, was not a strong enough political figure to say no to Göring. Göring was further aided by his control of the Luft-waffe, which could supply the ERR with much-needed security and trans-portation supplies that were hard to come by through over-the-table bureaucratic means.

Göring's mobility and wiles gave him the upper hand over Hitler, who watched, stewed, and relayed communications by messenger from Berlin. In fact, Göring visited the Paris confiscated art collection point, the Jeu de Paume Museum, on twenty occasions between 1940 and 1942, each time giving only forty-eight hours' notice of his arrival. These visits had no strategic military value. They were solely for him to select looted art for his personal collection.

Hitler played his cards close to his chest, with regard to his Linz Führermuseum and the seizure of artworks from across conquered Europe. In 1940 the extent of Hitler's plans for art confiscation was unknown to many in the military. Even high-up officials in the army, such as Count Franz von Wolff-Metternich, the art protection deputy for the chief of military administration in occupied France, did not know of the plan or of the false façade that the Art Protection Division represented. The following is an excerpt from Wolff-Metternich's written account:

> Early in August 1940 I received confidential information that a legation secretary, Freiherr von Kuensberg, had arrived in Paris, charged with a special commission to take possession of documents of the French Foreign Office in the war area. He said that he also had the task of confiscating a number of works of art, particularly such as were in the possession of Jews and other elements hostile to Germany. This was the first I had heard since taking over my duties of any attempt to misappropriate works of art, either by official orders or on that pretence. It was also the first I had heard of the confiscation of the artistic property of Jews. . . . I was convinced from the outset that von Kuensberg's activities were illegal

and that he was merely a sort of modern freeloader, all the more because, as I was assured, he was set on going about his business without the knowledge of the art protection authorities. His arrival coincided with a push by the ambassador, which obviously had for its objective the withdrawal of moveable works of art in France from the care of "Art Protection" into the power of the embassy. It was clear to me that if the care of moveable works of art was taken out of the hands of "Art Protection" and therefore of the commander in chief of the army, the door would be thrown wide open to depredation of every sort and that the protection of art would be reduced to a farce.

Count Wolff-Metternich was unaware of the existence of the Einsatzstab Rosenberg, with its mission of stealing art and bringing it to Berlin.

He was one of a small group of Germans to emerge from the smoke and mist of Nazi art looting as a hero. A professor at University of Bonn with a passion for Renaissance architecture of the Rhineland (northwestern Germany), Wolff-Metternich was an internationally renowned and respected architectural historian, an aristocrat with roots in the Prussia of Emperor Frederick Wilhelm. He rose to become head of the Kunstchutz, Germany's cultural conservation program that had been established during the First World War as a military art protection unit. The Kunstchutz was reestablished in 1940 as a branch of the Nazi occupational government in Belgium and France. Placing Wolff-Metternich at its helm would lend a sense of legitimacy and good intention to the Nazi occupation.

According to Jacques Jaujard, Wolff-Metternich confronted the Nazi ambassador to Paris, Otto Abetz, after the ambassador ordered the seizure of artworks from the collections of fifteen major art dealers in Paris, ostensibly for "safeguarding" in 1941. Wolff-Metternich was a staunch adherent to the Hague Convention's protection of cultural property during war. He would write: "The protection of cultural material is

an undisputed obligation which is equally binding on any European na-
tion at war. I could imagine no better way of serving my own country
than by making myself responsible for the proper observation of this prin-
ciple." While others made similar such statements, Wolff-Metternich was
one of the few whose actions matched the rhetoric. Wolff-Metternich in-
tervened above his rank in approaching the ambassador, with the result
that the German military prevented the embassy from commandeering
any other works of art from French citizens. It was be a brief triumph,
but one that showed Wolff-Metternich to be an honorable man who
thwarted Hitler's desires, although he was acting before Hitler had made
the true extent of his desires clear. For the first years of the war, Hitler
did not state his plans overtly but rather played his special divisions
against his army in order to steal what he wanted to steal, beneath the
veneer of honorable policies enforced by the army. Wolff-Metternich's ac-
tions made a strong impression on the helpless Jaujard, who later told
Monuments officer Lieutenant James Rorimer that Wolff-Metternich had
"risked his position, maybe even his life."

Count Wolff-Metternich finally received an order from the führer, near
the end of 1940, stating that the Einsatzstab was free to act by direct com-
mand of Hitler himself and was outside the jurisdiction of military ad-
ministration. Thoroughly dismayed by the situation, Wolff-Metternich
made one final effort, giving perhaps too much benefit of the doubt to
the Nazi officials. He met with Göring in Paris in February 1941. Of this,
he wrote:

> Although it was clear even by the end of 1940 that the booty would
> be carried off to Germany and that Hitler and Göring intended to
> share it out between themselves and some of the German public
> collections, I decided to report to Göring when he came to Paris
> in February of 1941 to inspect the spoil. I cherished some faint
> hope that it might be possible to say something of the objects and
> principles of Art Protection, and possibly to add a word or two
> about the scruples which might be felt over the treatment of Jewish

artistic property. The risk was considerable, as I found when I was roughly cut short and dismissed.

Officially, Göring's control of the ERR ended with a directive from Hitler, expressed in a letter from Rosenberg dated 18 June 1942. Rosenberg explained to Göring that it would no longer be possible for the ERR to make confiscated artworks available for Göring's personal collection. Had Hitler realized what was happening? In spite of this letter, the ERR director in France, Colonel Baron Kurt von Behr, continued to supply Göring with looted art, although Göring no longer made visits to Paris to select for himself.

Von Behr was actually not a colonel—he had no official position beyond, incongruous as it may seem, being the head of the local branch of the Red Cross in occupied Paris. He insisted on being addressed as colonel, though he did not even possess a proper uniform. He decorated his Red Cross uniform with a swastika, making it look something like an SS officer's garb. A man with a glass eye, prominent cheekbones, and the nervous habit of tucking his thumbs beneath his fisted fingers, von Behr was eventually given the position of head of the Dienststelle Westen (Western Division) of the ERR, in charge of the Nazi looting operation in France, headquartered at the Jeu de Paume Museum in Paris. The Jeu de Paume, a storehouse of French art looted by the Nazis, was also a place where Nazi officials stole the art from one another, snatching what treasures they could before a more senior officer got there. It was not until von Behr was finally removed from office on 21 April 1943 that the ERR ceased to feed Göring.

During his time as ERR puppet master, Göring selected approximately seven hundred masterpieces for his personal collection, far more than any of the world's top museums could boast.

The many stories of Second World War art theft and recovery, stories of individual and collective heroism, have filled books by themselves. Suffice to say that Ghent had reason to fear the stripping of its cultural heritage by more than one ravenous Nazi.

Jacques Jaujard was desperate to prevent the Nazi seizure of the treasures stored at Chateau de Pau. In June 1942, he obtained a written guarantee from the Germans that the art in Chateau de Pau would not be touched. This guarantee, confirmed by the Vichy Ministry of Fine Arts, specifically cited *The Lamb*. A clause ensured that it could not be moved from the chateau without three signatures: those of Jaujard, the mayor of Ghent, and Count Wolff-Metternich. Jaujard had done his conscientious best to preserve the treasures under his guard. But, as with so many Nazi promises, this too proved hollow.

On 3 August 1942, only two months later, a dismayed Jaujard learned that *The Lamb* had been seized by Dr. Ernst Buchner, director of the Bavarian state museums, and taken to Paris. Buchner, along with several officers, had arrived in Pau by truck. He demanded to be given *The Lamb*. The curator on duty stalled, insisting that he receive a confirmation telegram. He sent a message to Jaujard, but it never made it through the central switchboard at Vichy. Soon after Buchner arrived, so did an official yellow telegram from the Vichy Ministry, signed by Pierre Laval, head of the Nazi-controlled Vichy government in the south of France, requesting that the seventeen crates containing *The Lamb* be given to Buchner. The curator had no choice.

Soon after this incident, Belgian officials asked Jaujard at the Louvre if they might visit Pau to inspect *The Lamb*. When they learned of what had happened, they were outraged. Jaujard registered an official complaint with the Vichy government, but that was all he could do. Count Wolff-Metternich himself expressed his indignation and was fired from his post for doing so. At the time, no one knew who had given the orders for the removal of the painting.

It turned out that Dr. Martin Konrad, a professor in Berlin who had published three works on van Eyck, had written a letter in September 1941 to Heinrich Himmler, head of the SS and the Gestapo, suggesting that *The Ghent Altarpiece* be moved to Berlin for "safekeeping" and "analy-

sis." With Himmler's approval, Konrad had driven to Pau and then to Paris, only to be rebuffed twice by Wolff-Metternich. Himmler's interest in the altarpiece was more mystical than art historical. He believed not only that *The Ghent Altarpiece* was a prime example of Germanic/Nordic and therefore Aryan art, but also that it might contain occult elements, which fascinated him and warranted study.

News of the Nazi art looting drifted to the Allies in the form of rumors and sporadic shards of evidence. It would not be until the Allied offensive, which cut a swath through Europe, that the true extent of the looting was recognized. In anticipation of the Allied invasion, and based on the evidence that had come his way, General Eisenhower issued a statement to the Allied army during the summer of 1944, regarding the protection of art treasures: "Shortly we will be fighting our way across the continent of Europe in battles designed to preserve our civilization. Inevitably, in the path of our advance will be found historical monuments and cultural centers which symbolize to the world all that we are fighting to preserve. It is the responsibility of every commander to protect and respect these symbols whenever possible." Eisenhower's statement was a historical first. At no other time had an army entered a war with the expressly stated intention of avoiding damage to, and proactively seeking the preservation of, cultural monuments and artworks.

Early in the war the British recognized the need for a division of officers trained in, and dedicated to, the protection of art and monuments in conflict zones. In January 1943, during a pause in the fighting near Tripoli in North Africa, Mortimer Wheeler, the director of the London Museum and a renowned archaeologist, grew concerned about the fate of three ruined ancient cities nearby, along the coast of Libya: Sabratha, Leptis Magna, and Oea (the ancient city around which Tripoli grew). With the impending defeat of the Axis in North Africa, and the chaos of the war, Wheeler worried that the ancient monuments could become "easy meat for any dog that came along." Wheeler noted with concern that there was no system of any sort in place for the Allies to safeguard any archives, artworks, museums, or monuments in their path.

Wheeler grabbed a friend and fellow officer, a famous art historian and archaeologist in his own right, John Ward-Perkins, and they drove by jeep to the sites of Oea and Leptis Magna. Leptis Magna, birthplace of the emperor Septimius Severus, had recently been excavated by a team of Italian archaeologists under Mussolini's orders. This meant that the marvels of the ancient architecture, and even statuary, were unearthed but had not been secured and moved to museums. When they arrived, Wheeler and Ward-Perkins were dismayed to find a Royal Air Force team setting up a radar station in the ruins, which they thought would provide good cover against enemy bombardment.

The two archaeologists pretended to have an authority they did not possess. As Ward-Perkins would later write, "we bluffed our way through a number of fairly effective measures." They improvised "Out of Bounds" signs, which they mounted on key monuments and beside statues, and they began to provide informal lectures to troops about their surroundings, to instill a sense of respect and appreciation for the ruins and artworks around them. These measures would become standard procedure for the Monuments, Fine Arts, and Archives Division that their actions would in part inspire.

In June 1943 Wheeler decided to use his impressive list of contacts to make something official out of their improvised policy. He was spurred on by his knowledge of the planned Allied invasion of Sicily, which Wheeler described as "a top secret to which I happened to be a party. . . . The archaeologist in me was filled with anxiety." One of the richest places on earth archaeologically and artistically, Sicily's treasures were in serious danger if something was not done in anticipation of the invasion. Wheeler suggested that a small, well-organized group, led by a qualified archaeologist, be established to promote the protection of monuments in Sicily. This message eventually reached Secretary of State for War Sir P. J. Grigg and Prime Minister Winston Churchill himself. Agreeing with the idea, they immediately sought out an archaeologist to lead the operation.

In October 1943 the British established a division of the War Office, the Archaeological Adviser's Branch, that would deal with the recovery

and protection of art objects in newly liberated territories. It was originally a one-man operation, run by renowned archaeologist Sir Leonard Woolley, with his wife as his only assistant. Woolley liked it that way, rejecting the offer of staff. He liked to think that his uncluttered judgment was far superior to what a committee could produce, and he wanted to be able to boast of the triumphs he'd achieved ostensibly alone. In truth, he was a brilliant archaeologist and politician. The son of a clergyman, Woolley was a curator at Oxford's Ashmolean Museum and was best known for leading archaeological excavations at Ur in present-day Iraq, but he had also worked alongside T. E. Lawrence in Syria in 1913. The budding novelist Agatha Christie was a great admirer of Woolley's, particularly noting his capacity to galvanize listeners about the wonders of archaeology. (Christie spent a lot of time with Woolley—she married Woolley's assistant from his Ur excavation in 1930.) She wrote, "Leonard Woolley saw with the eye of the imagination. . . . Wherever we happened to be, he could make it come alive. . . . It was his reconstruction of the past and he believed it, and anyone who listened believed it also."

When the war began, Woolley corresponded with art and archaeological institutions to compile lists of artworks and monuments in the path of the fighting. Very much against his will, he eventually began to recruit personnel as it became clear that a field force would be needed to accompany Allied armies. Woolley thought that his role, and therefore the role of anyone working in the sphere of the protection of art and monuments, should be to note sites for the army to avoid and to plan the restitution of art and artifacts after the war—not to send out field officers. He wrote, "The idea that we should leave the most eminent experts who have high artistic or archaeological qualifications to walk about the battlefields for this purpose is really one which I think would not be accepted as at all suitable." There was an element of classism in this statement—the lives of the highly educated should not be risked in combat zones—in addition to the desire to be the one and only operator in the tiny, newly founded "theater" of art and archaeological protection during war. It would take a strong American push to dislodge Woolley's

hands-off policy and encourage Allied field work in the protection of art and monuments.

Over the course of Woolley's operations, intelligence established that art, including the art of German citizens, was being confiscated in all Nazi-occupied territories and that stolen art, through barter and sale abroad, provided one of the largest economic assets of the Reich.

On 10 April 1944 a sister division was established, known as the Vaucher Commission or, more fully, the Commission for the Protection and Restitution of Cultural Material. It was run by Professor Paul Vaucher, the cultural attaché of the French embassy in London. Its job was to track down documentation on works that had been seized by the Nazis.

In May 1944 another, larger division was organized by direct command of Winston Churchill. Under the supervision of Lord Hugh Pattison Macmillan, the British Committee on the Preservation and Restitution of Works of Art, Archives, and Other Material in Enemy Hands was established. This rather unwieldy nomenclature was cast aside in favor of the simpler Macmillan Committee. The Macmillan Committee would now be in charge of the planned postwar restitution of looted works of art, with Woolley acting as their civilian leader. Woolley's motto was "We protect the arts at the lowest possible cost," an odd banner under which to fight, but one that was, at least initially, politically necessary in order to garner support for a role that was considered of secondary importance by those who simply wanted to win the war.

Meanwhile, the United States was forming its own art protection divisions. In March 1941 the United States had established the Committee on Conservation of Cultural Resources, designed to protect and conserve art in American collections from the perceived impending threat of Japanese invasion, after the December 1941 attack on Pearl Harbor.

Early on during the war, certain art organizations, including the American Harvard Defense Group and the American Council of Learned Societies, worked with museums and art historians to identify European monuments and artworks that would require protection. These groups began to lobby for a national organization for the preservation of cultural

properties during times of war. Much of this was spearheaded by Paul Sachs, associate director of the Harvard Fogg Museum, and by Francis Henry Taylor, director of the Metropolitan Museum of Art, who called an emergency meeting of museum directors on 20 December 1941 at the Met to determine wartime and emergency policies. This resulted in the movement of some art from museums into storage facilities. At the same time, many galleries remained open during the war, allowing civilians a respite from the turmoil that filled the newspapers. Paul Sachs's statement following the resolution of the museum directors is a poetic testament to what art can do for a nation at war:

> If, in time of peace, our museums and art galleries are important to the community, in time of war they are doubly valuable. For then, when the petty and trivial fall way and we are face to face with final and lasting values, we must summon to our defense all our intellectual and spiritual resources. We must guard jealously all we have inherited from a long past, all we are capable of creating in a trying present, and all we are determined to preserve in a foreseeable future.
>
> Art is the imperishable and dynamic expression of these aims. It is, and always has been, the visible evidence of the activity of free minds. . . . Therefore, be it resolved:

1) That American museums are prepared to do their utmost in the service of the people of this country during the present conflict
2) That they will continue to keep open their doors to all who seek refreshment of spirit
3) That they will, with the sustained financial help of their communities, broaden the scope and variety of their work
4) That they will be sources of inspiration, illuminating the past and vivifying the present; that they will fortify the spirit on which victory depends.

With these stirring sentiments in mind, and with the practical con-
cerns of protecting art during war both in the United States, should the
war cross the North American threshold, and in Europe, Taylor, Sachs,
and others took their concerns to President Franklin D. Roosevelt.

President Roosevelt had made clear his own sympathetic attitude to-
wards art three years earlier, at the dedication ceremony of the newly
founded National Gallery of Art in Washington, DC. His words encap-
sulate the capacity for art to inspire, the basic freedom of the mind that
it represents, and the need for its preservation.

> Whatever these paintings may have been to men who looked at
> them a generation back, today they are not only works of art. Today
> they are the symbols of the human spirit, and of the world the free-
> dom of the human spirit made. . . . To accept this work today is to
> assert the purpose of the people of America that the freedom of the
> human spirit and human mind which has produced the world's
> great art and all its science, shall not be utterly destroyed.

The audience of this speech would have had fresh in their minds the
ruthless Nazi censorship and "Degenerate Art Cleansing" of recent years.
Whereas art, to the Nazis, was a propagandistic tool to be controlled,
censored, stolen, and sold, art for the democratic world was an expression
of human freedom and the greatest capability of any civilization.

In the spring of 1943, Francis Henry Taylor and his associates estab-
lished the world's first program of study on the protection of monuments.
Held in Charlottesville, Virginia, the program, first taught by the director
of the Yale University Art Gallery, Theodore Sizer, would train officers
in the protection of art and monuments in conflict zones. The program
was a great success, even if it began before the U.S. government had de-
termined how best to use the skills taught there. Sizer wrote: "[The gov-
ernment doesn't] know just how to tackle the problem yet, but it is the
sort of thing that the likes of us should be concerned with, if Uncle Sam
is to use our services to the utmost. . . . They will need all of us as they

can lay their hands on. As you can imagine, every half-baked 'art lover' is trying to get in. Let's hope for the best."

Also in the spring of 1943, the American Council of Learned Societies, led by Francis Taylor and William Dinsmoor, president of the Archaeological Institute of America, began an extensive project to catalogue important cultural heritage sites in possible European war zones and to superimpose these sites on military maps provided by the armed forces. Teams worked in New York's Frick Art Reference Library and at Harvard to create the maps in time for the Allied invasion of continental Europe. These two initiatives, the academic program and the mapmaking, worked to both draw attention to the problems of the protection of cultural heritage in conflict zones and give the future officers charged with protecting cultural heritage a significant head start. That an impressive committee, consisting of the cream of the American art community, with connections throughout the U.S. government, spearheaded this initiative proved critical in its success.

Roosevelt eventually brought into being the American Commission for the Protection and Salvage of Artistic and Historic Monuments in War Areas, established 23 June 1943. This committee was chaired by Supreme Court Justice Owen J. Roberts and therefore became known as the Roberts Commission. By the summer of 1943, the Roberts Commission had finished 168 maps covering all of Italy, its islands, and even the Dalmatian coast. A total of around 700 maps would be produced, covering all of Europe, including detail maps of the major cities, and a significant number of Asian cities, as well.

The Roberts Commission was further charged with protecting cultural properties in conflict zones, provided that their preservation did not impede active and necessary military operation. The commission's first project was to compile exhaustive lists of European cultural treasures within current or possible future war zones, in the hope that these objects would be preserved whenever possible. The map project, began at the initiative of Francis Taylor and William Dinsmoor, was absorbed into the Roberts Commission.

The Roberts Commission then established the Monuments, Fine Arts, and Archives branch of the Civil Affairs and Military Government sections of the Allied army, to act as their agents in the field. Referred to as the MFAA or the Monuments Men, this division consisted of approximately 350 officers, primarily architects, art historians, historians, artists, and conservators in civilian life. Several Monuments Men were assigned to each of the Allied armies. These officers had exceptional knowledge of art or archaeology and fluency in the language of the territory in which they would work; to appease those officials who were dubious of shifting manpower away from the fighting force, these arts officers had to be older than the age for fighting eligibility; most were in their late thirties or older.

The establishment of the MFAA was a significant victory in what had become a tug-of-egos between the laissez-faire Sir Leonard Woolley working alone in England and the huge committee of American art historians and museum directors led by Francis Henry Taylor. Woolley lobbied with the War Office in England not to send out field officers, and at first succeeded—the Macmillan Committee only handled restitution of displaced artworks after the war. But it was not quite as Woolley hoped, as he was obliged to act as British representative to the Roberts Commission, which set up the MFAA for field work.

Monuments Men were charged with following just behind the front line as the Allied army liberated parts of Europe, doing their best to protect all cultural heritage in the wake of warfare. This included conservation of architecture damaged by fighting, preservation of archives, and the protection of libraries, churches, museums, and their artistic content. Though they did not realize it at the time, the Monuments Men would also be charged with the detective work of hunting thousands of stolen masterpieces across bullet-torn Europe.

The central operative figure among the American Monuments Men was an ingenious Fogg Museum conservator called George Stout. He would be the de facto leader of the otherwise largely undersupported MFAA. Stout was a pioneer among art conservators. He had worked with

Paul Sachs in envisioning the need for field conservators who might accompany the Allied army and mitigate the damage that was inevitable in the wake of fighting. In the summer of 1942, Stout published a short treatise entitled *Protection of Monuments: A Proposal for Consideration During War and Rehabilitation*, expressing what he perceived as the greatest concerns for art and monuments during the war effort.

> As soldiers of the United Nations fight their way into lands once conquered and held by the enemy, the governments of the United Nations will encounter manifold problems. . . . In areas torn by bombardment and fire are monuments cherished by the people of those countrysides or towns: churches, shrines, statues, pictures, many kinds of works. Some may be destroyed; some damaged. All risk further injury, looting or destruction. . . .
>
> To safeguard these things will not affect the course of battles, but it will affect the relations of invading armies with those peoples and [their] governments. . . . To safeguard these things will show respect for the beliefs and customs of all men and will bear witness that these things belong not only to a particular people but also to the heritage of mankind. To safeguard these things is part of the responsibility that lies on the governments of the United Nations. These monuments are not merely pretty things, not merely valued signs of man's creative power. They are expressions of faith, and they stand for man's struggle to relate himself to his past and to his God.
>
> With conviction that the safeguarding of monuments is an element in the right conduct of the war and in the hope for peace, we . . . wish to bring these facts to the attention of the government of the United States of America, and urge that means be sought for dealing with them.

When it came time to nominate MFAA officers, Stout was clearly the man for the job.

The establishment of the MFAA and Eisenhower's statement about the need to preserve cultural heritage were historic firsts. Sir Leonard Woolley acknowledged this:

> Prior to this war, no army had thought of protecting the monuments of the country in which and with which it was at war, and there were no precedents to follow. . . . All this was changed by a general order issued by Supreme Commander-in-Chief [General Eisenhower] just before he left Algiers, an order accompanied by a personal letter to all Commanders. . . . The good name of the Army depended in great measure on the respect which it showed to the art heritage of the modern world.

Eisenhower did add a caveat to his original statement: "If we have to choose between destroying a famous building and sacrificing our own men, then our men's lives count infinitely more and the buildings must go." He was a pragmatic general, for all his artistic sympathies, but few could argue with this statement, especially from a soldier's-eye view. A general could not tell his soldiers that he would swap a number of their lives to preserve what many would dismiss as some four-hundred-year-old pigment daubed on canvas.

There was an additional reason for this caveat. At the Italian monastery of Monte Cassino, the Allies spent weeks trying to extract entrenched Germans whom they believed to have been hiding in the ancient cliff-top monastery. Dozens of ground offensives failed to make headway, as German snipers cut down Allied assaults. The weighty decision was finally made to send in an air strike. Allied bombers dropped 1,400 tons of bombs, decimating the monastery that had been founded in 529 by Saint Benedict—shattering the frescoed walls and destroying the masterpieces stored there—only to learn afterwards that the Germans were not in the monastery itself. Further, German paratroopers took up defensive positions in the ruins that resulted from the Allied air attack, and the Battle of Monte Cassino raged on from 15 January until 18 May 1944. The treasures and the monastery had been destroyed for naught.

Eisenhower's 26 May 1944 general directive to all Allied Expeditionary Forces continued:

> In some circumstances the success of the military operation may be prejudiced in our reluctance to destroy these revered objects. Then, as at Cassino, where the enemy relied on our emotional attachments to shield his defense, the lives of our men are paramount. So, where military necessity dictates, commanders may order the required action even though it involves destruction to some honored site.
>
> But there are many circumstances in which damage and destruction are not necessary and cannot be justified. In such cases, through the exercise of restraint and discipline, commanders will preserve centers and objects of historical and cultural significance. Civil Affairs Staffs at higher echelons will advise commanders of the locations of historical monuments of this type, both in advance of the frontlines and in occupied areas. This information, together with the necessary instruction, will be passed down through command channels to all echelons.

A world war would inevitably result in unavoidable tragedies like Monte Cassino. But Eisenhower's conscientious recognition that, whenever possible and even where it seemed impossible, art and monuments should be preserved set an important precedent. For the Allies, this was not a war of obliteration, of pillage, of empire. It was an intervention against the actions of an evil enemy. That enemy army and its leaders would be incapacitated, but its people, its country, and its civilization would be neither plundered nor eradicated.

Despite Eisenhower's words of support, from the start, the MFAA was sidelined and often dismissed by the commanders of the Allied armies. It was a well-meaning but undersupported and incompletely conceived effort that frustrated its officers. The MFAA generally followed the policies that Wheeler and Ward-Perkins had improvised back at Leptis Magna in 1943. When a Monuments Man reached a new site, his duty

was first to survey previously identified monuments and artworks to assess the damage. He was then to organize on-site repairs as best he could, often by recruiting the locals to help when military personnel could not be spared. He was finally to secure the sites and objects if at all possible. But Monuments Men often had no equipment to aid them, frequently having to bum rides off of fellow soldiers, while others assigned to the MFAA were left for months at base camps, all but forgotten, before they were finally deployed.

At a practical level, the main weapon in their arsenal was a sign that read "Off Limits to All Military Personnel; Historic Monument: Trespassing on or Removal of Any Materials or Articles from These Premises Is Strictly Forbidden by Command of the Commanding Officer." This was meant to keep their own soldiers away from sensitive sites, for fear of souvenir-hunters and postfighting vandalism. When they ran out of "Off Limits" signs, Monuments Men would occasionally improvise, erecting instead signs that read "Danger: Mines!" a perhaps even more effective means of keeping people clear of a protected area. The MFAA's strength was its person-to-person intelligence operation. Monuments Men interviewed locals (in the local languages) in the wake of the fighting, in an attempt to learn the location of missing treasures.

It was only when the Allies finally captured Paris that the MFAA found a wealth of documents relating to Göring's personal activities and the ERR cache at the Jeu de Paume Museum. Most of this valuable information came from one source: a mousy clerk at the Jeu de Paume named Rose Valland, who, unbeknownst to the Nazis, understood German and worked as a spy for the French Resistance during the occupation of Paris, reporting directly to Jacques Jaujard. Thanks to her passion for art, her ingenuity, and her bravery, when the Allies rolled into Paris, she had a trove of information, including copies of receipts, photographs, and inventories, to pass on to the Monuments Man stationed in Paris, Second Lieutenant James J. Rorimer. They began to understand the extent of the Nazi looting, though the overall plan, to sweep all of Europe to fill the Linz museum, would not become clear for another six months.

In November 1944 the MFAA was aided by the newly established U.S. Office of Strategic Services (OSS), headed by General "Wild Bill" Donovan. The OSS was an intelligence service, the direct predecessor of the CIA. Along with its British counterpart, the OSS launched several programs aimed at Nazi economic destabilization by severing the stolen art assets. A subdivision of the OSS was formed, called the Art Looting Investigation Unit (ALIU). This group embarked in August 1944 on the Safehaven Programme, an Allied operation to seek out and seize Nazi assets hidden in neutral countries, particularly Switzerland, where it was known that Nazis had been selling stolen art to raise funds.

Intelligence rolled in not only about theft but also about the wanton destruction of art by Nazis. Art as a financial asset was one worry. Now rumors were slowly fed by evidence that Nazis were destroying art and monuments. One repository of French national museum collections, at the chateau Valencay, was torched by the Second Das Reich SS Panzer Division in the summer of 1944. Chateau Rastignac, in the Dordogne, was burned by SS troops on 30 March 1942, after a presumably failed search for thirty-one Impressionist masterpieces that had been hidden in a false-bottomed trunk in the castle attic. Whether the art was discovered and removed before the burning is unknown, but none of the works have resurfaced. The number of such stories increased and, with them, the Allied fears for the survival of Europe's art treasures.

On 2 November 1944 Sir Leonard Woolley wrote to Lord Macmillan of a discovery that confirmed these fears:

> *Our informant reports that he was in Munich in October 1943 and there learnt from a Bavarian state functionary to whom it had been officially circulated that Hitler had issued a secret order to all responsible authorities to the effect that in the last resort all historic buildings and works of art in Germany, whether of German or of foreign origin, whether legally or illegally acquired, should be destroyed rather than allowed to fall in the hands of Germany's enemies. . . . Literal obedience to Hitler's orders will result not only in the destruction of the artistic*

treasures of Germany itself, but of a great deal of the artistic heritage
of many of our Allies. In view of this threat, therefore, it seems essential
that His Majesty's Government be now recommended to take some
anticipatory action.

This letter prompted the organization of a secret counter-mission in-
volving several Austrian double agents. Their remarkable adventure,
known as Operation Ebensburg, is integral to the story of the rescue of
The Ghent Altarpiece by Allied Monuments Men. It should be noted that
mutually contradictory accounts of the race to save Europe's artistic trea-
sures emerged from the chaos of the war. The rest of this chapter will ex-
plore the various versions of the story and discuss the reasons why the
accounts differ, in order to identify the most probable among the many
"truths" that have been preserved in primary source documents.

The future leader of Operation Ebensburg was an Austrian Luftwaffe
fighter named Albrecht Gaiswinkler. Born in 1905 in the town of Bad
Aussee to a salt miner, Gaiswinkler grew into a dynamic, charismatic
man, with a dark goatee, intense narrow eyes, and a hairline that receded
into a tonsure. He worked in various industrial jobs before joining in
1929 the Social Security Office in Graz, capital of the alpine Austrian
province of Styria. Gaiswinkler was an active union supporter and a
member of the Social Democratic Party. Most importantly, he was a
steadfast anti-Nazi, serving some months in prison for his political dis-
sension in 1934. He joined the regional underground Resistance in 1938,
and eventually his activities drew the attention of the Gestapo. In order
to avoid imprisonment, Gaiswinkler enlisted in the Luftwaffe on 20
March 1943. He served in Belgium and France, where he witnessed the
execution of members of the French Resistance—a sight that prompted
him to decide to desert. During this time his family wrote letters to him
regularly, several of which mentioned truckloads of artworks in wooden

crates arriving by night at the salt mine at Alt Aussee, near his home, some hundred miles from Linz.

In the spring of 1944 Gaiswinkler's unit moved to Paris. There he made contact with the Maquis, France's underground guerrilla Resistance movement. He managed to vanish from his German division by trading identities with a bomb victim who had been disfigured beyond recognition. He joined the Maquis with a stolen haul that included half a million francs and four trucks full of arms and ammunition. In September of that year he and sixteen other German prisoners surrendered themselves to American soldiers of the U.S. Third Army at Dinan, in Alsace. In his first postcapture interrogation, he convincingly expressed his strong anti-Nazi inclinations. More importantly, he mentioned his knowledge of an art depot at Alt Aussee.

The Austrian Resistance provided some information about Alt Aussee, to supplement Gaiswinkler's personal knowledge from having grown up in the region. The area had been mined for salt for over 3,000 years. It was mined not with picks but with water, which dissolved the salt crystals in the rock. The brine was piped through the mine and out to the surface, where the water was later evaporated, leaving the salt behind. Since a royal grant was declared in 1300, a small group of families had been in charge of mining the area. The families had remained isolated from other communities, not permitting outsiders to mine their territory. The result was a cluster of families blighted by physical deformities resulting from 650 years of inbreeding and working conditions in stooped darkness inside the mines. The community of roughly 125 miners and their families spoke a strange dialect that was a closer relation to medieval German than to the contemporary language. Even their uniforms were of a different era: white linen suits and peaked caps of the sort that may be seen worn by miners in woodcuts from the sixteenth century.

The salt mine honeycombed through a mountain, full of caverns of varying sizes, all interconnected. In 1935 the miners had even consecrated a chapel in one of the vaulted caverns dedicated to Saint Barbara, patron saint of miners. Nazi art historians who examined the mine saw the

excellent state of preservation of the painted altarpiece in this Chapel of Saint Barbara, and determined that the atmospheric conditions were ideal for the storage of art. The humidity inside was consistently at 65 percent. In the summer the mine naturally maintained an ambient temperature of 40° Fahrenheit. Strangely enough, in the winter the ambient temperature was always 47°. At first, the mine was used for the storage of the collection of the Kunsthistorichesmuseum in Vienna. The mine was later chosen, in 1943, by Dr. Hermann Michel, chief of the Viennese Service for the Protection of Historical Monuments and a mineralogist, as the perfect collection point for all of the Nazi looted art that was destined for Hitler's supermuseum at Linz.

From 1942 to 1943, engineers created within the salt mines a state-of-the-art storage facility. The caves inside the mine, some spacious and lofty like underground rock cathedrals, were lined with waterproofed wood and wired for electricity. Metal gallery racks were installed, the sort used for museum storage. Paintings were hung from hooks on vertical mesh racks, which were stacked side by side and mounted on sliders; the art could be accessed by sliding the rack out from the stack. Some of the caves were tall enough to contain three tiers of racks, reached by pulley elevator. Special boxes were constructed to protect works on paper. There were thousands of meters of bookshelves. A staff of 125 was maintained at all times at the facility. Engineers checked daily for temperature, humidity, and potential signs of geological collapse. Art restorers and art historians made regular rounds, repairing objects that had been damaged in transit or in the process of having been looted. There were even offices and spaces in which workers could sleep in the converted mine.

Most of the treasures were moved to Alt Aussee beginning in May 1944, with the remainder arriving by April 1945, when Allied bombings made precarious the existing storage points, which included six German castles and one monastery. More than 1,680 paintings arrived from Hitler's Munich office, the Führerbau, which was an assembly point for the führer's Linz collection. Much more would come from other sources. Just how high-tech a treasure house it was, and what prizes would be

found within, were questions that Gaiswinkler's team had to wait just a bit longer to answer.

The Americans contacted the London-based Special Operations Executive (SOE), thinking that Gaiswinkler might be a valuable asset if he could be convinced, as seemed feasible, to work for the Allies. He was flown to London and offered the chance to be trained as a secret agent to fight the Nazis and free his native Austria.

Gaiswinkler eagerly accepted and was sent to a training facility in the English countryside. At Wandsborough Manor in Surrey he was taught sabotage, demolitions, camouflage, cartography, outdoor survival, marksmanship, and deception during interrogation—the tricks of the trade for undercover field agents. He learned how to parachute over the Ringway Airfield near Manchester. In Surrey Gaiswinkler was introduced to a group of fellow Austrians who had joined the Allies as double or undercover agents. Many more who had volunteered ultimately had been deemed unsuitable. Psychologically, ideologically, and physically, these were the cream of the recruits.

The Special Operations Executive had great success throughout the war in training double agents and, through them, securing priceless intelligence for the war effort. An assignment was constructed for Gaiswinkler to lead: Operation Ebensburg. He and three other Austrian agents, Karl Standhartinger, Karl Schmidt, and Josef Grafl, would be entrusted with a twofold secret mission, half of which would provide the Allied answer to the call for action in Sir Leonard Woolley's letter to Lord Macmillan.

Their mission was to rescue Europe's kidnapped art treasures from Alt Aussee. Though they did not yet know it, the magnum opus among the countless masterpieces stored in the hidden salt mine was Jan van Eyck's *Adoration of the Mystic Lamb*.

There was another element to their mission—the assassination of Josef Goebbels.

Attempts on the lives of Nazi leaders had been as frequent as they were unsuccessful. Hitler seemed to many of the Nazis to be a blessed man, perhaps supernaturally protected; he had survived at least twelve

assassination attempts. In the first, a bomb narrowly missed him at the Burgerbrau beer hall in Munich on 8 November 1939. Hitler was giving a speech, which he ended abruptly, before his scheduled finish, at 9:12 PM. The bomb went off at 9:20, caving in the roof of the beer hall, killing eight and wounding sixty-five, including the father of Hitler's lover, Eva Braun. Surviving a dozen plots on his life only strengthened Hitler's conviction that he was a Chosen One, who would cleanse the world and lead his people to victory. The Third Reich was driven by its dynamic leaders, Hitler most of all. If the key figures could be eliminated, the war might be brought to a hasty end. And while multiple attempts on the heavily guarded führer had failed, perhaps the members of his inner circle, such as Goebbels, could be reached. British intelligence had heard that Goebbels was planning a holiday in the resort town of Grundlsee, Austria, near Alt Aussee. It could be a chance to eliminate one of the most powerful heads of the Nazi hydra.

Beyond Gaiswinkler, the only Operation Ebensburg team member about whom much is known is the radio operator, Josef Grafl. Grafl was born in 1921 in Schattendorf, Austria—a community with a strong social democratic bent, situated along the Hungarian border. He worked as a bricklayer in Vienna and, from 1934, was a member of the Communist Party of Austria. Working with the Socialist Worker Youth organization, he trained as a radio operator. For his Communist activities, Grafl was imprisoned for three months in Wöllendorf. After release, he trained as a master mason, but his education was cut short when he was drafted for military service on 17 October 1940. Once his Communist background was rediscovered he was classified as "unfit for military service" and was sent to Aurich for further training in radio operations.

In 1941 Grafl was deployed in the Ukraine, as part of the Nazi army's radio news department. That same year, while on duty in Bulgaria, Grafl sabotaged his own army by sending secret radio messages to the Russians. Caught in the act, Grafl was brought to Varna, Bulgaria, where he was sentenced to death. With the help of two friends, he managed to escape Varna, boarding a ship in the Black Sea. But the ship was halted at the

Romanian port of Constanta. Grafl, fearful of recapture, set out on foot with the hope of reaching Athens and joining the Andart, the Greek partisan force. He got as far as Kilkis, when he was caught and arrested as a deserter.

Once again, Grafl outmaneuvered his captors. He escaped with the help of two Bulgarian partisans, who brought him to their Greek counterparts in the mountains separating the two nations. But there was confusion and miscommunication—the Greek partisans thought that he was a Nazi enemy, and Grafl was forcibly detained for the third time. Unable to communicate that he was on their side, Grafl managed to seize his captors' guns and march the partisans to Athens. In the process of the march he managed to convince his one-time captors that they were all against the Nazis, and Grafl ultimately joined the Greek partisans in the Dourgouti district of Athens. The British provided arms and supplies to the partisans, who regularly did battle with local Nazi forces in the streets and the woods nearby. Taking advantage of these contacts with the British, Grafl accepted an offer to work for them in the SOE, which was actively recruiting German and Austrian deserters who might be trained as double agents.

Grafl joined the Allies earlier than Gaiswinkler, but he was initially accepted by the Royal Air Force, not the SOE. In early 1942 he was driven by submarine from Greece to Alexandria, Egypt, for basic training, after which he received further pilot training in Haifa. Grafl was deployed against the Japanese and worked as crew member on a fighter plane in China and Burma, escorting bombers. After dozens of missions, Grafl began to feel that he was too far from where his heart was; he wanted to be fighting for the freedom of his native Austria. He requested a transfer, and it was then that he was interviewed for the SOE. In 1944 he was given the pseudonym Joseph Green and received the majority of his training in sabotage and parachuting in Hong Kong. He participated in thirty-four sabotage missions before he joined Operation Ebensburg.

The team's training was complete by late January 1945. The agents were given aliases—false papers and identities. Drilled in the memorization of

their fraudulent biographies, and transferred to Bari in southern Italy, they received their assignments. The primary task was to investigate the Alt Aussee mine depot and to organize a local resistance movement. The secondary agenda, should their primary task be successful, was to lead the local Resistance, gathering intelligence on enemy units and activity in the area. They were to disrupt enemy operations through sabotage and guerrilla tactics, and attempt to secure the mine until the arrival of an Allied army division. And finally, when he arrived for his planned stay in Grundslee, they were to attempt the assassination of Josef Goebbels. They would liaise with the SOE branch based in Bari by radio transmitter, which they would carry with them when dropped by parachute into the Austrian Alps. The codeword communications with HQ in Bari was "Maryland."

After delays due to inclement weather, the team set out on 8 April. Their equipment, including machine guns, grenades, explosives, detonators, and the radio transmitter, would be dropped in crates with automatic parachutes. They carried with them only handguns and survival knives. They would be met on the ground by members of the Austrian Resistance.

The pilot of the Halifax aircraft that would deliver the special agents, Bill Leckie of the Scottish Saltire Branch of the 148th Royal Air Force Special Duties Squadron, recalled the assignment:

> At this time we had absolutely no previous idea of our role in this situation concerning the German threat to destroy Nazi loot. Security at that time was 100% efficient, with no indication of what was about to take place, other than fulfilling our own particular task to the best of our ability. As pilot and captain of a Halifax aircraft about to embark on an SD operation, I was fully briefed with the exception of . . . learning any details about the four persons we had been instructed to drop over our specific dropping zone. To ensure maximum security in line with Special Duties practice, there was no communication between aircrew and the SOE agents,

other than the dispatcher making them familiar with dropping procedures.

The Halifax aircraft took off from the base at Brindisi in southern Italy at just before midnight, against a backdrop of bright moonlight, Leckie recalled. The seven-man aircraft crew knew only that they had to drop the four SOE agents at specified coordinates. They flew north along the Italian coastline, the moonlight reflecting off the stark mirror of the sea below them, the night clear and crisp. Leckie turned the plane northwest as they passed Ancona, and then wove between Venice and Trieste en route to the Austrian Alps.

Leckie later said:

> I now wonder what my feelings would have been, then, if I had known one of my passengers was a former Luftwaffe paymaster who had defected to the French Resistance. He was a native of the area to which we were now heading, and had discovered from relatives the Nazi plan to conceal massive collections of art treasures in this area, which was well known to him from childhood. Albrecht Gaiswinkler ... seemed to be the ideal person to receive specialist training in England to become one of the four special agents I was now transporting to the site of this clandestine operation.

At 2:50 AM, the dispatcher on the Halifax, Sergeant John Lennox, indicated to Gaiswinkler and his team, shivering and cramped in the unheated fuselage, that it was time to drop. The Halifax began its run at a height of eight hundred feet to drop the equipment containers first, the automatic parachutes billowing gently as the cargo floated down towards the mountain slopes, silhouetted sharply against the white moon and smothered in snow.

As the Halifax banked and circled for the second run, the parachutists prepared to jump. Against the biting wind high above the Austrian mountains, the four-man team jumped from their bomber transport. They

parachuted safely, despite the difficult landing in enormous snowdrifts in which they sank up to their armpits.

But when they landed they could not find the equipment crates, which had sunk into the deep snow. There was no one from the Resistance there to meet them. After a search, they located only the crate containing the radio transmitter. Their relief was cut quick—the radio had been irreparably damaged in the landing. They were without help and without means to contact Bari, with only sidearms and knives for weaponry.

The team suddenly realized that they had been dropped on the wrong slope. Instead of the Zielgebiet am Zinken Plateau, they had landed some kilometers away, on the ominously named Höllingebirge, "Hell Mountain."

Then they heard the sounds of dogs and soldiers echoing in the distance around the pine-clad mountainside.

Patrols all around had certainly heard the bomber and perhaps saw the parachutes against the night sky. The team checked the roads down the mountain slope but found roadblocks, checkpoints, and patrols. Fortunately the snowbound woods were not patrolled. They made their way slowly through the drifts in the blue light of breaking dawn.

The team had to navigate to Gaiswinkler's hometown, Bad Aussee, where his brother Max would house them. They arrived at the town of Steinkogl bei Ebensee at the foot of Hell Mountain. Stripping off their jumpsuits, they tried to appear as normal as possible in the civilian clothes they wore underneath.

They boarded a train to Bad Aussee. Onboard rumors circulated that some English soldiers had been spotted parachuting in. No one suspected that the English might have sent Austrian double agents. Gaiswinkler and his team also learned that the German Sixth Army under General Fabianku had been chased out of northwestern Italy and the northern Balkans by the Yugoslav Partizan Army and was encamped throughout the region.

Some kilometers before the Bad Aussee station, the team jumped from the moving train, rightly anticipating checkpoints at transit stations. They

hiked through the woods, avoiding roads, until they collapsed, exhausted, at the home of Max Gaiswinkler.

Without the radio, the team was cut off from headquarters, meaning that they had no way of learning of the travel plans of Joseph Goebbels, one of their two targets. They would have to find another radio, but by the time they did, they learned that Goebbels would not be visiting the area. The assassination plan, wild and unlikely as it had been, was off. Their sole focus was on salvation of the treasures of Alt Aussee.

Their adventures were about to begin.

The Austrian double agents were unaware that a parallel operation was under way. The Allied Third Army, under General Patton, raced towards Alt Aussee even as Gaiswinkler was trying to secure it. In this army were Monuments Men Robert K. Posey and Lincoln Kirstein.

Baby-faced Captain Robert Kelley Posey was an architect as a civilian, born in 1904 and raised in relative poverty by Alabama farmers. Fresh out of Auburn University, he became a liberal activist, speaking out at political rallies against Fascism and the Ku Klux Klan. He taught at Auburn briefly, before spending the body of his professional career at the prestigious New York architectural firm of Skidmore, Owings, and Merrill. He left a rich archive of letters written to his wife, Alice, and his young son, Dennis (affectionately known as Woogie), while he was in Europe during the war.

Posey had grown up hard and poor. Giftless Christmases were the norm, as his family struggled to survive as farmers. His only playmate was the family goat, which died the same year as his father—when he was only eleven. From that tender age, he began working two jobs to help his family through the Depression: at the local grocery store and at a soda fountain. It was the ROTC that gave him hope for a brighter future. Even with the ROTC scholarship, he intended to attend university for only one year, to allow his brother a chance to study as well, as funds were too

tight for both of them to go. When he saw how strong a student Posey was, his brother deferred and encouraged him to finish his degree at Auburn.

Posey had military aspirations throughout his life. Much of his time at Auburn was spent in the company of the army ROTC, and he enlisted in the Army Reserves the moment he graduated. When Pearl Harbor was bombed by the Japanese, he felt a nationalistic pull and wanted to ship off immediately, but it was six frustrating months before he was called up from the Reserves. After training in the thick of a Louisiana summer, which Posey described as the most humid and uncomfortable experience of his life, he was shipped off for the coldest: a Canadian port on the Arctic Ocean in Churchill, Manitoba. There Posey's skills as an architect were put to use, as part of a team designing Arctic runways that would permit planes to land safely, should the Nazis invade North America by that most unlikely of attack routes—the North Pole. From there, thanks to his architectural training, he was picked for the new Monuments, Fine Arts, and Archives section of the army—a role that would prove a good deal more dramatic than duty within the Arctic Circle.

Posey was a man of high morals, with a tender heart. While stationed in Germany during the war, he came across a group of American soldiers who had found a rabbit in a cage in the yard beside a German cottage. Having eaten nothing but K rations for weeks, the GIs planned to kill and cook it. But as they approached, a woman opened the door to the cottage and called out in halting, accented English that it was her son's rabbit. Her husband had been an SS officer, but he was dead, and the rabbit was the only thing her eight-year-old son had left of his father. Posey walked over to the cage and hung one of his "Off Limits" signs on it, adding by hand "By Order of Captain Robert Posey, U.S. Third Army." The soldiers slunk away. From that point on he made a habit of feeding lonely animals he encountered on his wanderings, animals abandoned by owners who were lost or dead or had fled. He wrote, "I suppose the stern and the cruel ones rule the world. If so, I shall be content to try to live each day within the limits of my conscience and let great plaudits go to those who are willing to pay the price for it."

Posey was a practical joker. When he first joined the Third Army, he shaved either end of his moustache so it looked like Hitler's—a gag that General George Patton found less than amusing. But his sense of humor was balanced by a pride in service; his family had been soldiers since the Revolutionary War. Intent on honoring his family and serving his country in combat, Posey volunteered as a grunt for the Battle of the Bulge. He survived the battle, though he injured his foot, and he never knew if he had inflicted any damage on the enemy—his eyesight was so poor he had been told simply to keep firing in the appropriate direction until he ran out of ammunition. But a sense of outrage also kept him going when his legs could barely keep up and sleep swelled his eyes. Upon visiting the recently liberated concentration camp of Buchenwald, Posey would take a souvenir he came across in an abandoned office and keep it with him for the rest of the war: a photograph of a Nazi concentration camp officer, beaming with pride as he holds aloft a noose.

Posey's partner in the MFAA was already a cultural icon in the United States at the start of the war and would go on to a stellar career at the forefront of American arts. Born in 1907 in Rochester, New York, and raised in Boston, the physically towering Lincoln Kirstein was the son of a Jewish businessman who embodied the American dream, working his way up from a start without advantage to great success, counting President Roosevelt among his friends. Young Lincoln attended Harvard, where he founded the Harvard Society for Contemporary Art, the precursor to New York's Museum of Modern Art. He also founded a literary magazine called *Hound and Horn*, which published the works of major writers like e. e. cummings as well as the first warning about Hitler's stance on so-called degenerate art, authored pseudonymously by Alfred Barr, the first director of the Museum of Modern Art. Kirstein worked as an artist and writer, having already published six books by his thirty-seventh year, and was one of the central figures of New York City culture in the years before the war. He married the artist Fidela Cadmus in 1941, though he was involved in same-sex relationships throughout his life. Kirstein was charismatic and driven, but he suffered from depression that may have been undiagnosed bipolar disorder.

Kirstein enlisted with the Naval Reserves in 1942. He was turned down for reasons that most Americans fail to remember: Until the war grew so extensive that more troops were needed and restrictions loosened, one had to be a third-generation American citizen in order to serve as an officer in the U.S. armed forces. Kirstein did not fit the bill. America, too, at this time had its own racial profiling system, and many Jews, blacks, Asians, and immigrants were not permitted to serve as officers. Adding insult to injury, Kirstein was next rejected from the Coast Guard because of his poor vision. So the wildly accomplished Lincoln Kirstein, already a prominent artist and intellectual, had to enlist as a private, which he did in February 1943.

Even after having completed basic training, Kirstein was rejected by three different departments in which he sought to serve: counterespionage, army intelligence, and the Signal Corps. He finally found a post as a combat engineer, writing instructional manuals while posted in safe but thumb-twiddling Fort Belvoir, Virginia. To occupy his time, he worked with other members of the art community on the War Art Project, in which known artists donated works for display and sometimes sale to raise funds for the war. Thanks to his involvement, this project shifted from being an independent fund-raiser to an army-supported endeavor. Kirstein selected nine artworks to be featured in an issue of *Life* magazine, then to be exhibited with others in the American Battle Art exhibits, held at the Library of Congress and the National Gallery of Art in Washington, DC, in an effort to support the war effort.

Noting his service, and his outstanding qualifications and connections, the Roberts Commission tapped Kirstein to join the MFAA division even though he was not an officer. In June 1944 Kirstein arrived in Shrivenham, England, to join the other MFAA recruits. But when he arrived, he found the division in disarray. There was no organization to speak of, and the Civilian Affairs officers in charge at Shrivenham had never even heard of the MFAA. Kirstein and the other recruits were told to wait until the situation could be clarified. The commission wanted Kirstein to serve as MFAA representative to one of the Allied armies, but a legal clause in

the military bureaucracy prevented a private from serving in the MFAA. By October 1944, Kirstein was depressed and dismayed, writing, "I, for one, think the behavior of the [Roberts] Commission has been, to put it mildly, callous and insulting." It was not until December 1944, after six months in bureaucratic Limbo, that Kirstein was assigned to the Allied Third Army to assist Robert K. Posey.

Posey had already been active with the MFAA for months, and he trained Kirstein at an army base in Metz, Germany. They were a decidedly odd couple. Posey, the Alabama farm boy, was a true soldier and knowledgeable architect but lacked any knowledge of foreign languages or fine arts background. Kirstein was an erudite Jewish artist and intellectual celebrity in New York, fluent in French and with passable German.

Posey instructed Kirstein in the role of Monuments Men. At this stage, gathering information was key, as were locating local artworks and rigging damaged buildings and monuments in the wake of the fighting. The extent of the Nazi art looting plan was as yet unknown to the MFAA, and their days were spent interviewing locals, piecing together possible locations of missing art, securing that which remained, and writing reports on their progress—or lack thereof. Van Eyck's *Adoration of the Mystic Lamb* had been specifically named as one of the most important works to seek and protect.

As the Third Army entered France, the first rumors filtered in regarding the wholesale Nazi looting of art and antiquities, thanks in large part to the individual efforts of the spy Rose Valland. Before this time none of the Allies knew of Hitler's planned supermuseum or of the Nazis' widespread proactive hunting of artworks. The rumors were disturbing indeed.

Posey and Kirstein gathered frustratingly contradictory tidbits of information on the location of *The Lamb*. It was often singled out as the subject of gossip, but the rumors served only to tease. Their best source, at first, was Dr. Edward Ewing, an archivist whom they interviewed in Metz. He told them that Goebbels's Nazi propaganda division had long been claiming that the Allies intended to steal Europe's artworks and that

the Nazis should therefore confiscate all they could to keep it from thieving Allied hands. A similar deception had occurred in 1941, when Italian propagandists published a pamphlet to incite anti-British sentiment. It was entitled "What the English Have Done in Cyrenaica" and showed photographs of looted antiquities, broken statuary, and graffiti-covered walls at the ancient Greco-Roman city in modern-day Libya. What no one realized was that the damage supposedly done by the English had actually occurred centuries ago—the entire site was a ruin. What was left had been looted by the Italians themselves, and the Italians had added graffiti, all in a setup to frame the Allies as vandals and thieves.

Posey and Kirstein asked about major works they knew had disappeared, focusing on *The Ghent Altarpiece*. Ewing had heard rumors that it was in Germany, in a bunker at the Rhine fortress of Ehrenbreitstein, near Coblenz. Another rumor suggested that it had been taken by Göring to Carinhall. It was at Berghof, Hitler's villa in the Austrian Alps, or at Neuschwanstein Castle in Bavaria. Was it in a vault at Berlin's Reichsbank? At Buchner's office in Munich? In Sweden, in Switzerland, in Spain? Or perhaps, as some sources suggested, it was in a salt mine in Austria. Which of the rumors, if any, were true?

On 29 March 1945 the Third Army was camped at Trier, an ancient German town full of Roman antiquities and the birthplace of Karl Marx. Trier had been decimated by Allied bombs. Kirstein wrote of the once-glorious city:

> The desolation is frozen, as if the moment of combustion was suddenly arrested, and the air had lost its power to hold atoms together and various centers of gravity had a dogfight for matter, and matter lost. For some unknown reason one intact bridge remained. . . . The town was practically empty. Out of 90,000 [inhabitants] about 2,000 were there, living in a system of wine cellars. They looked very chipper, women in slacks, men in regular working suits. The convention is to look right through them. Some of the houses have white sheets or pillow cases hanging out. Hardly

a whole thing left. 15th century fragments of water spouts, Baroque pediments and Gothic turrets in superb disarray mixed up with new meat cutters, champagne bottles, travel posters, fresh purple and yellow crocuses, and a lovely day, gas and decomposition, enamel signs and silver-gilt candelabra, and appalling, appalling shivered, subsided blank waste. Certainly Saint Lô [a French city likewise demolished by fighting] was worse, but it didn't have anything of importance. Here everything was early Christian, or Roman, or Romanesque, or marvelous Baroque.

In an effort to instill in their fellow soldiers a level of respect for their surroundings, Posey and Kirstein had developed a habit of writing up a short history of the towns that the Third Army was occupying. Their hope was to educate the troops and minimize looting and defacement. This strategy had been successful in the French towns of Nancy and Metz, and so, when the immediate work was done, the Monuments Men set about putting together an introduction to Trier.

Captain Posey had been nursing a pain in one of his wisdom teeth for months, which finally became too much to bear. The army dentists were stationed nearly one hundred miles away. So Kirstein walked into town to see if he could find a local dentist. He encountered a teenage boy in the street who seemed friendly and eager to interact with an American soldier. Kirstein barely spoke German, and the boy no English, but Kirstein thought the boy might be willing to help. He offered the boy some Pep-o-Mint chewing gum, and a bond was established. Kirstein then mimed a toothache, puffing up his cheek and wincing in pain. The boy seemed to understand. He led Kirstein by the hand through town and pointed to the office of a local dentist.

Kirstein went back for Posey and brought him to the dentist's office. To their surprise, the dentist spoke some English. As the dentist went to work in Posey's gaping mouth, he began to chat with Kirstein, who sat waiting beside them.

What was their role in the U.S. Army?

They explained that they were there to protect art and monuments.

The dentist looked up suddenly. His son-in-law, he explained, was a former major in the German army and had the same job. Would they like to meet him? He lived in a village nearby.

Posey and Kirstein jumped at the offer to meet the dentist's son-in-law. Perhaps he had information that could clarify the conflicting rumors about the location of the Nazi stolen art. It was this sort of happenstance detective work on which the Monuments Men relied. The dentist climbed into their jeep and directed them out of Trier, into the countryside.

But something seemed wrong. The dentist kept asking for them to stop along the way, with various suspicious excuses. Could they stop at this farm so he could buy vegetables? Would they stop at this house so he could pick up two bottles of wine to bring to his son-in-law and daughter? Could they make one more stop, at the inn up ahead, where he wanted to get a piece of news? As the town thinned to village and on to countryside, signs of welcome to the Allies waned. In Trier, every house flew a white flag, symbolizing that the inhabitants welcomed the Allied army. Wherever the dentist was leading them, there were no flags to be seen. Posey and Kirstein began to suspect a trap.

Then the dentist indicated a forest cottage up ahead at the foot of a hill, some distance outside of the nearest village. Wary, Kirstein and Posey sent the dentist into the weathered wooden cottage first. They heard the sounds of joyous greeting and a baby's coo, and they decided it was safe to join him.

Inside the small, dark cottage the dentist introduced them to his son-in-law, Hermann Bunjes; his wife, Hildegard; his mother; his daughter, Eva; and Hermann and Eva's infant son, Dietrich. The cottage was a fascinating tranquil oasis compared to the chaos of the war's endgame, the disintegration of the German army playing out mere kilometers away. Kirstein described the cottage as having "the agreeable atmosphere of a scholar's cultivated life, a long way from war." Kirstein and Posey studied its walls, which were covered in prints of French Gothic art and architecture: Notre Dame de Paris, Cluny, La Sainte Chapelle, Chartres—places

that the American GIs had seen for the first time in their lives as officers during the war. Chartres had mesmerized Posey, who rhapsodized about it in one of his many letters home to his wife. He had souvenir cards in his rucksack of many of the French Gothic monuments that he had seen, which he would give to his son, Woogie, on his return.

Hermann Bunjes spoke with them in French, Kirstein translating for Posey. He explained that he was a former SS officer, having been dismissed from duty by Count Wolff-Metternich after working as an art advisor to both Rosenberg and Göring himself. The Allied postwar report on ERR activity noted that, while Bunjes was never a member of the ERR, he was present in Paris as director of the German Art Historical Institute, and he acted initially as an advisor to Göring as an attaché to the ERR. He was a scholar, unsurprisingly, of French Gothic sculpture. Bunjes had been educated at the University of Bonn before doing postgraduate work at Harvard. He'd begun his book at Cluny in Paris, writing with the famous Harvard professor Arthur Kingsley Porter. His great passion was a book he had been writing for years on the twelfth-century sculpture of Île-de-France on Paris.

Kirstein described his feelings in meeting Bunjes:

> It was an odd and somehow symbolic entrance into contemporary German culture. Here, in the cold Spring, far above the murder of the cities, worked a German scholar in love with France, passionately in love, in that hopeless frustrated fatalism described by the German poet Rilke. When and how did he think he could go back? Yet his one desire was to finish his book. . . . It was hard to believe that this man had, for six years, been the confidant of Göring, the intimate of Hitler's closest guards, that he had been in the SS.

Bunjes had information—lots of information. But there would be a price for what he knew. He wanted a promise of protection for himself and his family. From whom? Kirstein and Posey asked. As a former SS officer, Bunjes was a trained killer, the elite of Hitler's army.

Bunjes needed protection from other Germans. The SS were so hated and feared by their fellow countrymen that he was in greatest danger of falling victim to their vigilante justice. Kirstein and Posey were not in a position to be able to guarantee protection and safe conduct for his family. But Bunjes agreed to talk anyway. Though once an enthusiast, he had sickened of Nazism—or so he claimed. He had certainly been complicit in art looting and cronying up to Göring. Did he truly regret what he had done, or was he simply currying favor with the powers at his doorstep?

As Bunjes spoke, new and critical information came to light. He had records of what art had been stolen by the Nazis from France. He seems to have acted as a sort of art agent, dealing with the ERR on Göring's behalf. In March 1941 Bunjes had traveled to Berlin with a large portfolio containing photographs of ERR material, which he presented for Göring's approval. He had also met with Alfred Rosenberg to discuss the availability of stolen art items for Göring's personal acquisition. Bunjes knew the contents of that portfolio and more. He knew where the looted art described within was being stored.

Kirstein wrote of the encounter, "As we spoke in French, information tumbled out, incredible information, lavish answers to questions we had been sweating over for nine months, all told in ten minutes." For the first time, Bunjes gave the Monuments Men a sense of what they were up against, of Hitler's plans, of the fate of thousands of the world's most important and beautiful works of art.

Bunjes later wrote of his experiences as an officer and his encounters with Göring:

> I was ordered to report to the reichsmarschall [Göring] for the first time on 4 February 1941 at 6:30 PM in the Quai d'Orsay, in Paris. Herr Feldführer von Behr of the Einsatzstab Rosenberg [in charge of ERR operations in France] was also there. [Göring] wanted to know details of the actual situation regarding the confiscation of Jewish art in occupied territories. He took the oppor-

tunity to give Herr von Behr photographs of the objects the führer wished to acquire for himself, and also of those that [Göring] himself desired.

As a matter of duty I informed the reichsmarschall of the meeting to discuss the protest of the French government about the work of the Einsatzstab Rosenberg. . . . The reichsmarschall said he would mention the matter to the führer. . . . On Wednesday 5 February I was summoned by the reichsmarschall to meet him in the Jeu de Paume, where he was inspecting the Jewish art treasures recently accumulated there. The reichsmarschall inspected the exhibition, escorted by myself, and made a selection of the works to be sent to the führer and those he wished to include in his own collection.

I took the opportunity of being alone with the reichsmarschall to draw his attention again to a note of protest from the French government against the activity of the Einsatzstab Rosenberg, in which they referred to the clause in the Hague Convention [exempting cultural heritage from seizure in war]. . . . The reichsmarschall went into the matter thoroughly and directed me as follows, saying, "My orders are authoritative. You do exactly as I order. The works of art accumulated at the Jeu de Paume will be loaded immediately onto a special train bound for Germany. Those items which are for the führer and those which are for the reichsmarschall will be loaded into separate carriages attached to the reichsmarschall's train on which he will return to Berlin at the beginning of next week. Herr von Behr will accompany the reichsmarschall in this special train on his journey to Berlin."

When I objected that the lawyers might be of another opinion and that the commander in chief [of the German armed forces] in France might make protestations, the reichsmarschall replied with these words: "Dear Bunjes, leave that to me. I am the highest lawyer in the state."

Bunjes had recognized the hypocrisy of a so-called Art Protection unit stripping Europe of its artistic treasures, but he was far from guiltless. According to the postwar Allied ERR report, on May 16, 1942, Göring asked Bunjes to prepare a paper detailing the Einsatzstab confiscations and the protests of the defeated French government. The report describes Bunjes's active attempts to rationalize the seizure of Jewish art and to quell the French protestations.

In essence, the Bunjes paper stresses the ingratitude of the French state and the French people for the altruistic efforts of the Einsatzstab, without which the destruction and loss of invaluable cultural material would have been inevitable. The paper is a classic in the literature of political treachery. Briefly stated, Bunjes offers the following transparent legal justification for the German action: The Hague Convention of 1907, signed by Germany and France, and observed in the armistice terms of May 1940, calls in Article 46 for the inviolability, among other things, of private property. Bunjes states, however, that the Compiègne armistice of 1940 was a pact made by Germany with the French state and the French people, but not with Jews and Freemasons; that the Reich, accordingly, was not bound to respect the rights of Jewish property owners; and further, that the Jews, in company with Communists, had made innumerable attempts since the signing of the armistice on the lives and persons of Wehrmacht personnel and German civilians, so that even sterner measures had to be taken to suppress Jewish lawlessness. Bunjes contends that the basis for the French protests, and petitions for the return of ownerless Jewish property, is the desire on the part of the French government to deceive Germany and further the prosecution of subversive activity against the Reich.

Was Bunjes forced by circumstance to prepare such a report? Could he have believed what he wrote, in love as he was with French art and culture? One may only guess at his true feelings, though he must have experienced at least some conflict. Bunjes was suffering from severe depression by the time Posey and Kirstein reached him.

Then Bunjes related, for the very first time to Allied ears, the plans for Hitler's supermuseum. Files had been found indicating the mass seizure

of artworks. Rose Valland's reports to Jacques Jaujard had revealed the extent of the looting from France. But documentary evidence had not yet surfaced detailing the supermuseum. Bunjes described a number of Nazi art depots in castles: Neuschwanstein, which housed the collections stolen from French Jews; Tambach, filled with art looted from Poland; Baden Baden, with the art stripped from Alsace; and on. But the biggest cache of all, he said, was in a salt mine in the Austrian Alps. It had been converted into a high-tech storehouse for all of the looted art destined for Linz. It contained thousands of objects stolen from across Europe, including *The Adoration of the Mystic Lamb* by Jan van Eyck.

But, he warned, the SS guards of the secret salt-mine storehouse had been ordered to blow it all up if they failed to defend it against the Allies. The intelligence about which Woolley had written to Lord Macmillan was true. Hitler had released what became known as the Nero Decree on 19 March 1945, stating that everything that could be of any use to the Allies, particularly industrial and supply sites, should be destroyed if it could not be defended. It was thought that this included the looted art. Furthermore, what Bunjes could not have known is that August Eigruber, the ruthless Nazi official in charge of the Ober-Donau region of Austria, had received a personal letter from Hitler's private secretary, closest friend, and reichsminister, Martin Bormann, instructing him to take all measures necessary to prevent the Alt Aussee treasure house from being captured by the Allies.

Eigruber's total dedication to Hitler had seen him rise quickly through the Nazi ranks. He had been the gau director of the Nazi Party in Upper Austria and had served several months in prison when Nazism was banned there in May 1935. From 1936 until the Anschluss in 1938, when Austria officially became part of Greater Germany and Nazism was both legal and dominant, he was the leader of the underground party within that region. He joined the SS as an officer in 1938 and became the gauleiter of Oberdonau in Austria on 1 April 1940. In November 1942 he was appointed reich defense commissar, and by June 1943 he was an SS *obergruppenführer*—only one step down from Himmler himself.

There is a photograph of Eigruber, with the facial expression of an awestruck groupie, his lips thin to the point of invisibility, upper lip ever curled under his lower lip in a childish manner, enthusiastically poring over the designs for Hitler's citywide supermuseum in Linz, with the architect, Hermann Giesler, and Hitler himself. There was an air of Charlie Chaplin to Eigruber, with his Hitler-style smudge moustache and slightly stooped stance, his shoulders curled in, though his awkward physicality belied his iron-worker strength and sociopathic determination and the confidence instilled by his quick rise through the Nazi ranks.

Eigruber interpreted the unclear order from Bormann to prevent Allied seizure of the mine's content as an instruction to destroy the art within it. His determination to see through his own interpretation of Hitler's orders extended beyond the artworks in his charge. He had been an enthusiastic concentration camp officer at Mauthausen-Gusen during the war, and now he arranged for the gassing of mental patients and others who had been deemed unable to work before the war began. On 8 April, he would order the execution of every political prisoner in his region awaiting trial—at least forty-six people were shot the next morning.

What Bunjes related to Posey and Kirstein was incredible. "It must have been a great exercise in discipline on Captain Posey's part as on mine to betray no flicker of surprise or recognition," wrote Kirstein. Bunjes apparently thought that the Allies already knew all he had to say.

Posey and Kirstein rushed back to camp and informed their commanders. Bunjes had noted the location of the salt mine on a map. It was beside the village of Alt Aussee, near the spa town Bad Aussee, outside of Salzburg. This was off the path of the Allied strike. As it was of no strategic importance, Allied armies had not planned to clear that area for many weeks to come. The region was particularly dangerous. Its densely forested, steep mountains were thick with wandering small bands of scattered SS and the remnants of the German Sixth Army, retreating over the Italian Alps. The Nazi army was disintegrating, but the remaining pockets of soldiers, acting independently with guerrilla methods, were particularly dangerous and unpredictable.

To arrive at Alt Aussee would be easier said than done. Kirstein wrote:

> The terrain was extremely difficult. The mountains were lousy
> with SS and retreating German Sixth Army streaming over the
> Italian Alps. Two days before we had been caught, turning off from
> a back road, in the middle of a German motorized convoy. For ten
> miles we couldn't figure out whose prisoner was whose. They must
> have been going somewhere to surrender, since they were armed,
> yet nothing happened.

It was a confusing time. The German forces were falling apart, the end
of the war no longer in doubt. The only question was how long it would
take before total German surrender and how much destruction would be
wrought before that could happen. Would the Nazis obliterate a huge
percentage of the history's art treasures, simply out of spite, to prevent
the world from ever seeing them again? They had shown themselves ca-
pable of such an atrocity, and worse. By 1942 the Allies knew of Hitler's
plans for the mass extermination of blacks, Jews, and other minority
groups deemed racially inferior by the Nazis, although the full extent of
the genocide only became clear when the first concentration camps were
liberated in 1945. When SS leader Heinrich Himmler, by that time di-
sheveled and wearing a patch over his left eye, was arrested by British sol-
diers while crossing a bridge at Bremervorde in northern Germany as he
tried to escape to Switzerland, remaining SS burned all of Himmler's
stolen art before the British army could arrive and recapture it. And there
were the precedents for similar destruction at the two French chateaux,
Valencay and Rastignac.

According to Bunjes, *The Ghent Altarpiece* was hidden in the mine at
Alt Aussee. But General Patton's Third Army was headed towards Berlin.
There was a friendly race between the Allied First, Third, Fourth, Sev-
enth, and Ninth armies to be the first to fight their way to Berlin. It was
only after Eisenhower determined that the Red Army would reach Berlin
long before the Allies could, and General Omar Bradley's grim estimate

that it would take another 100,000 Allied lives to capture the city, that the American military effort was redirected towards Austria. The so-called Alpine Redoubt of the Austrian Alps, particularly around Hitler's holiday residence at Berghof, was thought to be the place where the Nazis would dig in for the final showdown. It was feared that it could take years, and thousands of lives, to extract the SS units entrenched in the steep alpine forests. Kirstein admitted his doubts in a letter back home to his sister: "As far as Germany goes I think they'll be fighting for some time. In spite of the collapse of the Wehrmacht and the triumphant newspapers, there has been so far no place where a great many people were not killed winning it. . . . Hoping to see you before my retirement pay starts."

Posey and Kirstein told General Patton what they had learned from Hermann Bunjes, and the decision was made. The Third Army would cut across to Austria in April 1945—a route that would place them squarely in the path of Alt Aussee. Kirstein wrote: "We were still some days away. . . . Captain Posey went forward to prime the tactical commanders. If they had not been pinpointed for our spot, American troops would have had no reason to occupy it until weeks later." Now the entire Third Army, and a shift in the Allied strategic policy, might cash in on the unbelievable report of one disillusioned former SS scholar of twelfth-century French sculpture, hiding in a forest cottage and fearing attack from his fellow countrymen.

It was early April 1945. Posey and Kirstein contacted the Austrian Resistance movement. They were a few days away from Alt Aussee. It was only then that they learned of the parallel mission, Operation Ebensburg.

At this point the reports from Resistance members vary as to what happened at Alt Aussee before the arrival of the Third Army. The historical account of Operation Ebensburg is based on three documents: Gaiswinkler's memoir, Grafl's memoir, and a book about the Resistance published by the Austrian government in 1947. Other primary source accounts tell different versions of the story; even Grafl's rendition of the story differs from that of his teammate, Gaiswinkler. Hermann Michel,

the mine's technical director; Emmerich Pöchmüller, the civilian director of the mine; and Sepp Plieseis, another Resistance leader, penned accounts that were often contradictory. It is only with the arrival of the Third Army at Alt Aussee that the waters clear.

The Austrian Resistance confirmed all Bunjes had said. The salt mine at Alt Aussee was guarded by SS and indeed contained a huge amount of stolen art. Still more worrisome, scouts confirmed that the mine was wired with explosives, dynamite charges, and detonators.

While Posey and Kirstein had warned General Patton of what Bunjes had told them, the division of the army that was nearest to Alt Aussee, led by a Major Ralph E. Pearson, was incommunicado and unaware of the Alt Aussee salt mine, its contents, or the danger to it. When Pearson finally received a message about the mine, in May 1945, it was from a non-Allied source, which has never been identified. Hermann Michel, technical director of the mine, claimed to have been the one who sent the warning, but its author is unknown. Pearson got the message and directed his forces straight for the mine. He would be the first Ally to reach it.

Meanwhile in Bad Aussee, Gaiswinkler and his team learned about the local Resistance from his brother Max. The Resistance was led by a Communist and member of the local gendarmerie called Valentin Tarra and consisted of a relatively inactive but well-meaning and brave group of mountain rescue service personnel and local police. Gaiswinkler had first met Tarra, along with a clerk at the Alt Aussee salt mine, Hans Moser, on 13 February 1940, before Gaiswinkler had been drafted into the Wehrmacht. Tarra and Moser had led the local Resistance together, but Moser had been killed in an air raid in the fall of 1944 along with several other resistance fighters, shortly after a Ukrainian informer had notified the local Gestapo of Moser's activities. Tarra was one of the few Resistance fighters who escaped capture and remained active.

Gaiswinkler renewed contact with Tarra and established a base of operations with him. Within days of Gaiswinkler's arrival, Tarra was able to rally about 360 Resistance volunteers through his network of local contacts, primarily with the gendarmerie, who could provide guns when necessary. He was able to provide Gaiswinkler's team with weapons and, most importantly, a new radio transmitter so that Grafl could contact the headquarters in Bari for the first time since their landing. Tarra put them in touch with sympathetic miners from Alt Aussee and a contact working with Ernst Kaltenbrunner, Himmler's second in command of the SS, who had set up a headquarters at the nearby Villa Castiglione. Finally, the Resistance linked Gaiswinkler with the two German officers in charge of the art at the Alt Aussee mine depot, Professor Herman Michel and an art conservator, Karl Sieber.

Michel, a secret Communist, was the man who had recommended that the Alt Aussee salt mine be used as an art depot. Before the war, Michel had been the director of the Natural History Museum in Vienna; he was an expert in mineralogy. He resembled a caricature of a mad scientist, with his green Austrian hunting jacket and shock of white hair that bounced of its own volition and seemed to defy gravity. At the war's end, Michel would claim to have been instrumental in the effort to save the Alt Aussee treasures, and he may well have been. But like many in the service of the Nazis, his activities during the Third Reich did not reflect his stated objections to Nazism once the Reich had fallen.

In 1938 Michel had been fired from his role as director of the Natural History Museum because of the institution's new agenda of propagating the Nazi Aryan concepts of racial superiority. A new director was installed, handpicked to lead a new propagandistic era for the museum. This was one of Goebbels's strokes of genius as minister of propaganda: If the premiere natural history museum in central Europe began to run exhibits on Aryan superiority and the derogation of "inferior" races, then these theories would be believed. Michel, of no standing in the Nazi Party, was bumped down the hierarchy and became the director of the museum's

Mineralogy Department. Throughout this time he did his best to endear himself to the Nazi leaders around him, even to the point of supporting anti-Semitic and racist exhibits and pseudoscholarly material. He even became the head of public relations for the local branch of the Nazi Party in an effort to ingratiate himself.

Was Herman Michel indeed a secret Communist, as he claimed to be when the Allies arrived? His shifts in ideology to match the prevailing winds of victory—a Nazi when the Nazis were in power, a Communist when the Nazis fell—suggest that he was an opportunist more than a resistor. The Second World War provides scores of stories of Germans who would not normally have supported the Nazis but did so out of necessity, weakness, wile, or fear. Over time, retrospect and opportunity made "heroes" out of some who claimed a greater role in the victory against the Axis than they may have deserved. Michel seems to have been one such figure.

Karl Sieber, chief conservator in charge of maintaining the mine's treasures, had been a quiet but respected art restorer in Berlin before the war. He saw himself as an honest craftsman, without grand aspirations and with no inclination towards Nazism. In fact, he had a number of Jewish friends. It was one of his Jewish friends who suggested that he join the Nazi Party, as it seemed the best way to advance oneself in the late 1930s. A steady flow of art had been entering Berlin since the Nazis took power, which meant, whether the art was stolen or not, that it needed the attention of good conservators. Sieber had spent the war years with his wife and daughter in relative seclusion from the fighting that raged around him, in the company of hundreds of famous works—a conservator's dream, albeit one woven tight with moral dilemma. There was no question that masterpieces must be conserved for the ages, and to be fair, there were few options, even for Germans who did not support the Nazis, other than to cooperate. Conserving art was perhaps the least of all Nazi evils in which one might be complicit, and Sieber dedicated himself to binding the wounds of the masterpieces that came his way. He was particularly proud of his work on *The Ghent Altarpiece*, which had been damaged in

transit from Pau to Neuschwanstein, where it was first stored, leaving Sieber to repair a split in the wood of one of the panels.

Michel and Sieber oversaw all operations at the mine, though they had no authority beyond supervision of the mine's functionality and content. The acting director of the Alt Aussee mine was Emmerich Pöchmüller. He was more of an administrator, whereas Michel and Sieber were in contact with the art on a daily basis. They were passionate lovers of the art in their charge and would do everything in their power to preserve it. But the SS were their superiors, and they answered to the regional SS commander Gauleiter Eigruber. When Michel and Sieber began to suspect that Eigruber was willing to destroy the art rather than let it fall to the Allies, they made covert contact with the local Resistance.

Gaiswinkler, Tarra, and the local Resistance achieved a series of small successes through covert and guerrilla actions, before the larger (and, by some historians, disputed) heroism that would ultimately decide the future of the Alt Aussee treasures. They stole police files from the local Gestapo office, as well as Gestapo forms, stamps, and passes with which forged papers were made. These allowed two of their men to slip through checkpoints in order to make contact with the Allied army near Vöcklabruck. There the Resistance detailed the position and layout of German forces in a region between Bad Aussee and Goisern known as the Pötschen Pass, which permitted a devastating Allied air attack. At a later date, as the German Sixth Army was retreating, the Resistance was able to pick off straggling units with quick, sharp surprise attacks in the alpine forests, capturing heavier armaments and even two German tanks.

Then an ominous event sprung the Resistance into sudden action.

During the nights of 10 and 13 April SS soldiers, led by a man called Glinz, Eigruber's henchman and the local *gauinspektor* (district inspector), drove into the mine with six heavy wooden crates. Stamped on the side of the crates were the words *Vorsicht! Marmor: Nicht Sturzen* ("Attention! Marble: Do Not Drop"). One crate was placed in each of the six main storage rooms. But the crates, the size of refrigerators, did not contain marble. They contained five-hundred-kilogram aircraft bombs. On in-

struction from Eigruber they were placed at select points in the mine. If detonated, they would cause complete collapse and water damage, totally destroying all of the art inside.

Eigruber was determined that the art should never surface from the belly of the mine. But had Hitler ever intended to destroy all of the art that had been so painstakingly stolen? Historians have debated the question. Hitler had at times wantonly permitted the destruction of art, as in the case of the most beautiful bridge in Florence, Ponte Santa Trinita by Bartolomeo Ammanati. He had ordered the demolition of Paris when it was clear that the city would be lost to the Allies. He also issued his infamous Nero Decree, as it became known, to all commanding officers on 19 March 1945:

> The struggle for the very existence of our people forces us to seize any means which can weaken the combat preparedness of our opponents and prevent them from advancing. Every opportunity, whether direct or indirect, to inflict the most resonant possible damage on the enemy's ability to strike us, must be used to its utmost. It is a mistake to believe that when we win back lost territories we will be able to retrieve and reuse our old transportation, communications, production, and supply facilities that have not been destroyed or crippled; when the enemy withdraws he will leave us only scorched earth and will show no consideration for the welfare of the population.
>
> Therefore, I order: 1) All military, transportation, communications, industrial, and food supplying facilities, as well as all resources within the Reich which the enemy might use either immediately or in the near future to continue the war, must be destroyed. 2) Those responsible for these measures are: the military commands for all military objects, including the transportation and communications installations; the gauleiters and defense commissioners for all industrial and supply facilities, as well as other resources. When necessary, the troops are to assist the gauleiters

and the defense commissioners in carrying out their duties. 3)
These orders are to be communicated at once to all troop com-
manders; contrary instructions are invalid.

Adolf Hitler

It was feared that the order to destroy anything that the Allies might
use would include looted artworks. From its phrasing, it is not clear—
artworks could be useful to the war effort, in terms of resale value, but
the types of things Hitler focused on were industrial and supply-related.
The result was that this decree was variously interpreted by those who
received it. For a gauleiter like August Eigruber, with thousands of price-
less artworks under his control, the Nero Decree was unambiguous.

But it is highly unlikely that Hitler ever intended for the art at Alt
Aussee to be destroyed. While he supported the burning of books and
degenerate art, examples of the führer's command that art and monu-
ments be preserved abound. While Hitler permitted the destruction of
Ponte Santa Trinita to impede the Allied advance from the south side of
the city while the Nazis escaped from the north bank of the river Arno,
he famously demanded that the bridge only a few hundred meters further
upriver, the Ponte Vecchio, be spared. Indeed, Florence's Ponte Vecchio
was Hitler's single favorite monument. It was the first item on his list of
artworks and monuments that under no circumstances were to be dam-
aged. Number two was the entire city of Venice. In the Nazi retreat from
Florence, all of the bridges across the Arno were destroyed except for the
Ponte Vecchio. But in order to stall the Allied advance, the Nazis blew
up a large neighborhood at the end of the Ponte Vecchio, to create a bar-
rier of debris while sparing the bridge from destruction. In his will, which
Hitler dictated to his secretary on 29 April 1945, just after having married
his lover, Eva Braun, and mere hours before their suicide, he underscored
that the pictures he had collected (as he euphemistically put it) for the
Linz museum should be given to the German state. Had he intended that
the art should be destroyed, he would not have bequeathed it to the Ger-
man state upon his death.

But by this time, it was Eigruber's decision that mattered. And he was determined to fulfill the death sentence.

During the day of 13 April 1945 the Alt Aussee mine was visited by Martin Bormann's secretary, Dr. Helmut von Hummel, along with the officer Glinz, who had brought in the bombs, and a number of other German officials. Though Eigruber was unaware of it, Albert Speer, Hitler's confidant and minister of armaments and war production, had convinced the führer to temper the infamous Nero Decree's call for the complete destruction of nonindustrial sites that the Allies might use to their benefit, instead issuing a new order that the sites be incapacitated, so that they would be of no immediate use. In large part this change was aimed at preserving the stolen art treasures, and Martin Bormann had dispatched von Hummel to pass these orders on to Eigruber: "the artwork was by no means to fall into enemy hands, but in no event should it be destroyed." Only Glinz and Eigruber knew that two of the "marble" crates containing bombs had already been moved into place. More would be rolled in on 30 April.

Emmerich Pöchmüller, the unprepossessing civilian director of the mine, learned of the new order on 14 April, when he was contacted by von Hummel. But von Hummel deferred his role as emissary, instead instructing the acting director of the mine to explain the new situation to Eigruber. The hapless Pöchmüller, who had no authority within the Nazi Party, stood no chance of convincing Eigruber that the destruction decree from the führer had been changed.

Eigruber would not accept Pöchmüller's phone call, so the desperate director traveled to the gauleiter's headquarters in Linz to speak with him in person. On 17 April, Pöchmüller arrived and met Eigruber in his office. He informed the gauleiter that he had received instructions that the mine's treasures were under no circumstances to be allowed to fall into enemy hands and that this meant that the mine *shaft* should be demolished, sealing the mine but preserving the art within. According to Pöchmüller's own account of the meeting, Eigruber said that he did not believe these new secret orders, which came directly from Bormann through von

Hummel, orders that the lowly Pöchmüller had heard but Eigruber had not. "The main point is total destruction," he said. "On this point we will remain bull-headed." He added that he would "personally come and throw grenades into the mine" if he had to.

Pöchmüller was dismayed, but he had an inclination that this might be Eigruber's response. He had a backup plan. Along with the mine's fore-man, Otto Högler, and its technical director, Eberhard Mayerhoffer, Pöchmüller planned to line the entrance to the mine with what are known as "palsy charges," or paralysis charges—bombs intended to prevent entry to the mine without damaging it and its contents irrevocably. Whether the sealing of the mine's entrance was to keep out the Allies, as von Hum-mel expected, or to keep out Eigruber and his men was of little concern to Pöchmüller. There were two reasons to block the mine's entrance.

Because it would have been nearly impossible to lay the palsy charges in secret, Pöchmüller managed to convince Eigruber that a series of strate-gically placed smaller charges could destroy the mine, causing it to col-lapse on the art inside. Eigruber agreed to the laying of these other charges, but he expected them to be placed in the mine itself, not only in the entrance shafts. The foreman Högler estimated that it could take nearly two weeks. That was too long to wait, if Eigruber was as eager as he seemed to destroy the artworks.

Gaiswinkler, too, had learned of the marble crates. He, like Pöchmüller, needed to know how much time he had. Was the threatened destruction imminent? Was immediate action needed?

Two brave miners volunteered to infiltrate the mine by night to check the contents of the crates in secrecy. Salt mining had continued through-out the time that Alt Aussee was being used as an art depot, so the com-ings and goings of miners carrying equipment appeared normal to the SS guards. It is not clear whether it was Gaiswinkler or Pöchmüller who gave the order for the miners to enter under cover of darkness—each later claimed to have done so. One of the two miners was most likely Alois Raudaschl, the leader of the miners working with the Resistance. The miners, whose families had worked the mine for centuries, knew its bee-

hive of caves and passages inside out. By navigating secret passages, the two miners avoided the SS guards. As quietly as possible they pried open one of the crates that supposedly contained marble.

It was full of hay.

Did marble lie beneath, after all? They pushed aside the hay and found a bomb nestled inside. The detonators, however, were not affixed and were nowhere to be found.

Gaiswinkler and Pöchmüller now knew about the bombs, but the Resistance did not have the manpower to attack the mine, nor was either man confident that the bombs would not be set off if the mine came under attack. Gaiswinkler contacted Michel to warn him of the threat, while Pöchmüller ordered foreman Högler to remove the bombs from the crates, but to keep the crates in place, to avert suspicion that their cargo had been ferreted away.

The next night Michel, the two miners, and an assistant followed the mountain passages into the mine, circumventing the guards at the entrance. Inside, they secretly moved the most valuable of the artworks stored in the mine to a separate location—the subterranean Chapel of Saint Barbara. The chapel, with its raw stone walls, was filled with wooden pews, a holy water font, candles, and even its own painted altarpiece. It was the sturdiest space in the mine, least likely to be damaged by bombs set off in the storage chambers nearby.

The first item transferred to the underground chapel was *The Ghent Altarpiece*, which had been stored in a room referred to as the Mineral Kabinett.

On 28 April Pöchmüller sent the following message to the foreman, Högler: "You are hereby instructed to remove all 8 crates of marble recently stored within the mines in agreement with Bergungsbeauftragter Dr. Seiber and to deposit these in a shed which to you appears suitable as a temporary storage depot. You are further instructed to prepare the agreed palsy as soon as possible. The point in time when the palsy is supposed to take place will only be presented to you by myself personally." Pöchmüller was risking his life in sending this message. While it reached

Högler without event, on 30 April Eigruber's assistant, District Inspector Glinz, overheard Högler discussing the arrangement of trucks to cart off the bomb crates with one of the miners. Though Glinz didn't know of Pöchmüller's involvement, nor of the palsy charges, the plan to remove the bombs was blown. From that day on, six SS guards were stationed at the entrance to the mine twenty-four hours a day.

By this time, Gaiswinkler had received word that the American Third Army was approaching. But he had no idea when they would arrive and if it might be too late. It is not clear whether Gaiswinkler and Pöchmüller were working together in their mutual goal of preserving the mine's contents. When each wrote of his efforts after the war, the other was conspicuously excluded, as both men tried to vie for the greatest measure of heroism. Therefore it is unclear whether Gaiswinkler knew of Pöchmüller's actions at the mine, although it seems likely that he would have, as both men worked with the miners in the Resistance. Whatever the extent of their cooperation, Gaiswinkler thought that time was running out and decided to take what action he could.

He began with a tactical bluff. His team seized the region's principal radio transmitter, Vienna II, which had been stored in Bad Aussee, in order to broadcast misleading reports that the Yugoslav Partizan Army was approaching over the mountains to the south, out of Slovenia. To reinforce this subterfuge, the Resistance lit fires along the mountainside, to give the impression of a vast encampment.

The Resistance next captured two armored personnel carriers and SS uniforms. Disguised as SS, they managed a daring operation during which they successfully kidnapped three important local Nazi leaders: the heads of the regional Gestapo unit and Franz Blaha, Eigruber's deputy who had been placed in charge of the destruction of the salt mine.

Blaha reiterated to the Resistance that August Eigruber was determined to destroy the mine. By this time all lines of Nazi communication had been cut by the Allies, so each remaining local officer was acting of his own accord. Neither von Hummel nor Martin Bormann could be

reached to clarify their order and save the mine's contents. Eigruber's SS unit was still too strong to overthrow with a direct attack. Something else had to be done.

In a move of stunning courage, the leader of the miners, Alois Raudaschl, volunteered to reach out to the most powerful Nazi official in the area and one of the most powerful of all—SS chief Ernst Kaltenbrunner, Himmler's number two, entrenched at the nearby Villa Castiglione. The Austrian Kaltenbrunner, a lawyer by training, had the face of a classic, sinisterly handsome Hollywood villain: scarred and pockmarked skin from childhood acne, offset crystalline eyes, blond hair, and an upturned lip. He held an array of titles: chief of the Reich Security Main Office (Reichssicherheitshauptamt), chief of the Gestapo, and SS *Obergruppen-führer*, among the unit's elite leaders. For one year, from 1943, he even held the post of president of the International Criminal Police Commission (ICPC), the organization that would become Interpol. Kaltenbrunner's power increased steadily throughout the war, particularly after the 20 July 1944 assassination attempt made against Hitler. From that point Hitler entrusted Kaltenbrunner with hunting down the conspirators, and Kaltenbrunner enjoyed direct access to the führer. He reached the pinnacle of his power on 18 April 1945, when Himmler made him commander in chief of the remaining German forces in southern Europe— albeit at a time when the end was in sight. Many have considered this elevation to a position of high power at so late a date the equivalent to throwing Kaltenbrunner under an approaching train, but his Nazi bona fides were sterling. If anyone had the power to overturn Eigruber, it was he.

Alois Raudaschl and Kaltenbrunner had a mutual friend who lived near the Villa Castiglione. At 2 PM on 3 May 1945, Raudaschl met with Kaltenbrunner at this friend's home. He told Kaltenbrunner about Eigruber's renegade behavior, the secret bombs in the marble crates, and the direct disregard for von Hummel's orders. Moved by a sense of nationalism and the desire to preserve the irreplaceable cultural icons stored inside

the mine, Kaltenbrunner granted his permission that the bombs be re-
moved, despite Eigruber's insistence. The miners would try again, this
time with Kaltenbrunner's blessing.

In other accounts it was Gaiswinkler, not Raudaschl, who met with
Kaltenbrunner and convinced him to intervene to save the art. And
Michel would later claim that the removal was his initiative.

The miners spent four hours removing the bombs and their crates.
At midnight, as the bomb removal was nearly complete, another of
Eigruber's henchmen, Tank Staff Sergeant Haider, arrived at the mine.
Seeing what was afoot, he threatened that, if the bombs were removed,
Eigruber would "come himself to Alt Aussee . . . and hang each and every
one of you himself."

Fearful of the repercussions, Raudaschl contacted Kaltenbrunner, who
personally phoned Eigruber at 1:30 AM on 4 May, hours after Sergeant
Haider's threat, ordering Eigruber to allow the bomb removal. Eigruber
relented and said that no repercussions would be taken. The SS guards
were instructed by Eigruber to allow the miners into the mine, and
Haider could only watch.

But Eigruber had other plans. He would not be bossed around, not
now, when it was his duty to fulfill the führer's final command—for Hitler
had taken his own life five days earlier. Eigruber planned to send a de-
tachment of soldiers to the mine, where they would destroy the art inside
by hand, with flamethrowers, if necessary. The destruction of the world's
art treasures would be Eigruber's final legacy.

The American Third Army was past Salzburg now, closing fast on Alt
Aussee. The SS soldiers who had been guarding the mine's entrance fled
their posts in anticipation of the coming Allies.

Aware of this threat and what the intransigent Eigruber might do, Hö-
gler and Pöchmüller followed through with the planned destruction of
the mine's entrance. At dawn on 5 May, as soon as the charges were ready,
the miners who had spent the past two weeks laying the palsy charge
threw the detonator switch. Six tons of explosives linked to 502 timing
switches and 386 detonators sealed 137 tunnels into the Alt Aussee salt

mine, the world's greatest museum of stolen art. There was nothing now that Eigruber could do to harm what lay locked inside.

Eigruber learned of the explosion and gave his orders for a troop of his men to rush to the mine.

Meanwhile, Gaiswinkler and his men stalked through the dense forest to the mine's entrance and then set up a defensive perimeter around the area, in anticipation of the arrival of Eigruber's detachment. Even if they could no longer enter the mine itself, Eigruber could still carry out reprisal executions of the miners and the resistors. And if the Allies were delayed long enough, Eigruber might try to blast his way back into the mine. The resistors and the mine itself had to be defended.

By nightfall, Eigruber's men still had not arrived. Had they been recalled? Gaiswinkler was worried, as his men waited, rifles at the ready, for some sound beyond the wind in the trees.

Raising the Buried Treasure

The sun rose upon Gaiswinkler and the Resistance fighters the next morning, 5 May, with still no sign of Eigruber's SS squad. Perhaps they were summoning reinforcements? The unexpected inactivity concerned Gaiswinkler more than a frontal assault. They dug into defensive positions at the mine's entrance and continued to wait. They would protect the mine with their lives until the American army arrived.

The sound of the detonating mine shaft had alerted a patrol from the German Sixth Army, the remnants of which was encamped nearby. The patrol stealthily surveyed the mine and reported to the army's remaining leader, General Fabianku, that they had seen entrenched Resistance fighters and no SS. Fabianku immediately sent a mobile attack force to retake the mine.

A mêlée took place at the mine's entrance on 6 May—the same day that, 513 years earlier, *The Ghent Altarpiece* was presented to the public for the first time. During the fight, Gaiswinkler sent two scouts to try to contact the American army to warn them, should the defense of the mine fail.

Gaiswinkler's actions were unknown to the Third Army until his scouts made contact. The scouts reached the Americans beyond the Pötschen Pass, several hundred kilometers away. Robert Posey and Lincoln Kirstein followed just behind the army's front line. Kirstein described the advance into Austria: "Austria breathed a different atmosphere. In Germany you saw no flags but white pillowcases. In Austria, as soon as

we crossed the Danube, from every house flew the long red-white-red banner of the resistance movement. The Germans, superficially at least, did not seem to have had much effect on the country."

Kirstein and Posey had to wait in the town of Alt Aussee, a few kilometers from the mine itself, while the army secured the area. They were frustratingly close to the mine yet had no idea whether its contents had been destroyed. Word from the scouts would not reach the Monuments Men for one more agonizing day of waiting.

By the spring of 1945 the liberation of concentration camps revealed the horrors of Nazi atrocities. After U.S. forces liberated Buchenwald in Germany on 11 April 1945, many GIs had visited the camp. Emaciated bodies were still strewn around the camp, unburied and fly-swarmed. Posey had gone to see the camp, returning with the aforementioned chilling photograph he'd found in an abandoned office there, of a bright young Nazi camp officer smiling with pride as he held a noose in his hand. Kirstein did not visit the camp, feeling that it would be too upsetting. He had every reason to stay away—when tough-as-nails General George Patton toured Buchenwald with Eisenhower and other generals, he vomited in the midst of the horrors and couldn't sleep for days afterwards.

Despite his hatred for Nazism, Kirstein still loved Germanic culture and its artistic legacy. That had nothing to do with the current, crumbling, diabolical regime. He wrote:

> The horrid desolation of the German cities should, I suppose, fill us with fierce pride. If ever the mosaic revenge was exacted, lo, here it is. The eyes and the teeth, winking and grinning in hypnotic catastrophe. But the builders of the Kurfürstliches Palais, of the Zwinger, of Schinkel's great houses, and of the Market Places of the great German cities were not the executioners of Buchenwald or Dachau. No epoch in history has produced such precious ruins. To be sure, they are rather filigraine, and delicate in comparison to antiquity, but what they lack in romance and scale is made up by the extension of the area they cover. . . .

To make a loose summation: Probably the State and private col-
lections of portable objects have not suffered irreparably. But the
fact that the Nazis always intended to win the war, counting nei-
ther on retaliation nor defeat, is responsible for the destruction of
the monumental face of urban Germany. Less grand than Italy, less
noble than France, I would personally compare it to the loss of
Wren's London City churches, and that's too much elegance to re-
move from the face of the earth.

The destruction in Germany was not at the hand of the Allies alone.
Hitler's Nero Decree had debilitated his own people's livelihood. Boats
were sunk in rivers to make passage impossible. Bridges and tunnels were
destroyed, roads mined, factories dynamited. Destruction surged across
the German landscape. In view of all that had been lost, it was that much
more critical to save what could still be saved.

Gaiswinkler's Resistance fought on. In the end, no reinforcement was
needed. Fabianku had not anticipated the strength and determination of
the Resistance defenders, and they held strong. The German attack force
was sent into retreat.

The next day, 7 May, the Germans surrendered unconditionally at
Reims. The war was over, and the Allies had won.

On 8 May, the first American troops crested the mountainside and ar-
rived at the mine. The Eightieth U.S. Infantry, under the command of
Major Ralph Pearson, took over the protection of the mine. Gaiswinkler
and the Resistance had protected the mine and its precious contents, and
Eigruber had never made good on his promise to destroy its treasures
forever.

Despite Posey and Kirstein's efforts to inform the forward-most Allied
units, which would be certain to reach the mine before them, Major Pear-
son had been unaware of the treasures at Alt Aussee until he received a
message. It remains a mystery as to who sent this message. According to
Michel's own report, it was he who notified Major Pearson. Michel also
claimed responsibility for having ordered the removal of the bombs from

the marble crates. His statements were backed up by some, but he may have coerced support from them. At the war's end, collaborating with the Allies, and sometimes inventing stories of resistance to one's Nazi colleagues, was a good strategy to avoid imprisonment or execution. Therefore the statements made by Nazi staff are suspect.

Michel's version of the Alt Aussee story was the first to be heard by an American, as Michel greeted Major Pearson upon his arrival at the mine. He even gave the major a guided tour, pointing out the demolished mine entrance. At the time, there was no reason to doubt Michel's story, with no contradictory versions forthcoming. And, after all, Michel was the only man present who spoke English.

Gaiswinkler was not present at the mine when the Americans arrived. According to his own account, although not seconded by other sources, he and his team spearheaded a stealth counterattack that very night. They crept through the snow-hung pine forest and sprung on General Fabianku's headquarters. The raid caught the general and his bodyguard completely by surprise, and, quite miraculously, Gaiswinkler's hard-nosed Resistance fighters actually captured General Fabianku himself.

While waiting on tenterhooks to learn the fate of the mine's contents, Posey and Kirstein sat at the window of an inn, mere kilometers away from the salt mine. From out the window came a surprising sight. An armed SS unit approached, only to turn themselves in. Kirstein described the scene: "Now from our window at the inn in Alt Aussee we watched the stupefying spectacle of the surrender of an SS unit. The trimly uniformed professional murderers wished to volunteer to fight the Russians, from whom they were sure the Americans would protect them. They wanted to keep their weapons until they could get into the safety of the POW cage, since they thought their own men might shoot them."

As Kirstein and Posey watched, a cheer came from upstairs at the inn. They ran up to learn the cause. A cluster of officers listened to the radio, celebrating and cheering. Over the wire came the news: Austrian moun-

taineers had guided U.S. soldiers on an all-night manhunt. As 12 May dawned on the horizon, they caught their quarry. They had arrested Karl Kaltenbrunner. He had thrown his uniform and identification into a lake and assumed a civilian disguise as a doctor. It was only when his mistress saw him marching with a cluster of German prisoners and called out his name that he was recognized and captured. He would be the highest-ranking SS leader to face trial at Nuremberg, for which he was executed on 16 October 1946.

Then word reached Posey and Kirstein that the mine had been secured by the Allies and the Resistance. They rushed to the scene, arriving hours after Gaiswinkler had left to chase down and capture General Fabianku. They would never meet their Austrian counterpart.

Only when they reached the mine's entrance did Posey and Kirstein learn that six dynamite charges had been set off at the main entrance to the storerooms deep inside the mine shaft. The result was a wall of stone and earth blocking access to the art. At first, they thought they had arrived too late. Had explosives gone off inside the mine as well?

Did this destruction extend beyond the entrance shaft? The contents of Hitler's looted museum waited on the other side of a wall of rubble, if there was another side to it. What if the entire mine had been demolished, the roof caved in, the passages flooded?

They finally found an interpreter who explained the situation. The shaft was demolished as a defensive measure, to prevent the destruction of the mine's contents. But it would take time to clear the debris that blocked the tunnel, as the Austrian miners were unsure as to how much rubble blocked the tunnel. At first the miners said it might take seven to fifteen days to clear it away. Posey and Kirstein hoped it could be done in two or three days. The miners set to work, and the debris was cleared the next day. Posey and Kirstein would be the first to set foot inside.

With one of the miners as their guide, Posey and Kirstein moved through the darkness of the shaft, the dim light of their acetylene lamps revealing the red rock glittering with salt crystals.

A half mile into the shaft beyond the rubble, Posey and Kirstein reached an iron door. Beyond it was a shocking expanse and the stolen jewels of the Nazi art theft program.

As they explored cavern after cavern, the extent of the hoard came quickly to light. Three-quarters of a mile into the mine, a cavern referred to as the Kammergraf housed multiple galleries of art storage, each one three stories tall. Another of the caverns, known as the Springerwerke, was only fifty feet long and thirty feet wide, yet contained 2,000 paintings stashed in two-story storage racks along three walls and in a column down the center of the chamber. The lamplight seemed dim against the vast darkness inside the caverns. Blades of light exposed gilded frames, marble arms, the weft of canvas, painted faces in the dark.

Then they came upon the Chapel of Saint Barbara, where Michel had hidden a few of the most treasured pieces.

There, unwrapped on four empty cardboard boxes one foot off the mine's clay floor lay eight panels of Jan van Eyck's *Adoration of the Mystic Lamb*. Someone, just before the mine's entrance was sealed, had looked lovingly and admiringly on this greatest treasure. How close it had come to being forever buried alive. How close to complete destruction.

There was evidence of fond and mournful farewells. Also in the chapel, on an old brown-and-white-striped mattress, they found the *Madonna and Child* marble sculpture by Michelangelo that had been looted from the church of Notre Dame in Bruges, Jan van Eyck's hometown. It had remained in Bruges throughout the war until 8 September 1944, when the Germans removed it, claiming that they wanted to protect it from falling into the hands of the barbarous Americans. It had been smuggled out of Bruges in a confiscated Red Cross truck only eight days before British soldiers had recaptured the city. And now here it was, lying on a mattress on the floor of a subterranean chapel. Had Michel taken one last look at beloved works before fleeing?

The fifty-three finest objects in the mine, those that would be the trophy pieces of any museum in the world, bore the label "A. H. Linz"—artworks reserved for Adolf Hitler's supermuseum.

The soldiers and miners, led by Posey and Kirstein, spent four days cataloguing the stolen hoard. In all, the Alt Aussee treasure consisted of the following objects:

- 6,577 oil paintings
- 2,030 works on paper (watercolors and drawings)
- 954 prints (etchings and engravings)
- 137 statues
- 128 pieces of arms and armor
- 79 containers full of decorative arts
- 78 pieces of furniture
- 122 tapestries
- 1,500 cases of rare books

These objects included works by most of the greatest artists in history: van Eyck, Michelangelo, Vermeer, Rembrandt, Hals, Reynolds, Rubens, Titian, Tintoretto, Brueghel, and on. There were hundreds of nineteenth-century German paintings of the sort Hitler prized, as well as Egyptian tomb statuary, Greek and Roman busts and marble sculptures, bronzes, porcelain, inlaid wood furniture, ornate tapestries—the finest content of the looted museums, galleries, and private collections of Nazi-occupied Europe.

There is a lingering debate among historians as to whether or not Leonardo's *Mona Lisa*, perhaps the only painting more famous than *The Ghent Altarpiece* (although nowhere near as influential), was successfully stolen by the Nazis and stored at Alt Aussee. *Mona Lisa* is not mentioned as having ever been in the mine in any extant wartime document, Nazi or Allied. Whether it might have been at Alt Aussee was a question only raised when scholars examined the postwar SOE report on the activities of Albrecht Gaiswinkler. This report states that Gaiswinkler and his team "saved such priceless objects as the Louvre's *Mona Lisa*." A second document, from an Austrian museum near Alt Aussee, dated 12 December 1945, states that "the *Mona Lisa* from Paris" was among "80 wagons of art

and cultural objects from across Europe" that had been taken into the mine.

For its part, the Louvre museum has remained surprisingly silent regarding the whereabouts of its treasures during the war. After years of refusing to respond to inquiring scholars, the Louvre finally admitted that the *Mona Lisa* had indeed been in the Alt Aussee mine. But why, then, was there no record of it, either at the Munich Collection Point or in any extant document from either the Allies or the Axis, for that matter?

The Louvre now states that a sixteenth-century copy of the *Mona Lisa* had been found at Alt Aussee and was on a list of several thousand works assembled at the Musées Nationaux de la Recuperation—works whose owner could not be traced. This *Mona Lisa* copy was marked MNR 265 on the list. After five years had passed, with no proven owner coming to light, the copy was presented to the Louvre for indefinite safekeeping. From 1950 to the present, it has been hanging outside the office of the museum's director.

An intriguing story of what might have happened to the *Mona Lisa* during the Second World War emerges if one pieces together the known facts. The *Mona Lisa* would certainly have been an important target for the ERR, Göring, and Hitler. Nazis would have sought the *Mona Lisa* without rest, demanding that it be handed to them upon their entry into Paris and hunting it down if it were not. A nearly identical contemporary copy of the painting had been placed in the specially marked wooden crate labeled "Mona Lisa" and shipped for storage with the rest of the national museum collections, while the original was craftily hidden away. The ERR then chased what they believed to be the original *Mona Lisa* and, upon capturing it, sent it to Alt Aussee for storage. All the while, the original lay in hiding, officially resurfacing only on 16 June 1945—the very day that the first of the Alt Aussee treasures were carried up out of the mine. This explains how the *Mona Lisa* did return from Alt Aussee: restitution number MNR 265, which now hangs in the Louvre's administrative offices. It also explains why the *Mona Lisa* was not noted in any of

the records related to Alt Aussee—some officers recognized that the Alt Aussee painting was a copy, while others, and evidently the ERR, thought it was the original.

Posey and Kirstein learned the story of *The Ghent Altarpiece* from Karl Sieber, the German art conservator who had been in charge of caring for the Alt Aussee hoard. After Buchner had driven *The Lamb* from Pau to Paris, it had been taken to Neuschwanstein, the fairy-tale palace in Bavaria that served as the model for the Disneyland castle. Neuschwanstein was originally meant to be the main storage depot for all of the Nazi stolen art. The first trainload of art arrived there in April 1941. An alternative had only been sought and found in Alt Aussee when Neuschwanstein, a monastery, and five other castles all became overfilled with loot. Alt Aussee, having already been converted into a covert art depot, began to fill from February 1944 on, as Allied air attacks threatened the existing castle storage centers.

At Neuschwanstein, a restorer from Munich had treated *The Lamb* for blisters it had developed during its years of exile and transport, adding facing to the areas where the paint had peeled away from the panel as a result of changes in humidity. When *The Lamb* was found in the mine, it still had wax paper bandages on certain sections. The Saint John the Baptist panel that had been stolen from the Cathedral of Saint Bavo and recovered in 1934 was still in Sieber's workshop for treatment.

It was then that Posey and Kirstein received unfortunate news. The man who had helped them to save all this, Hermann Bunjes, had shot his family before taking his own life. His guilt, hopelessness about his future, and fear of reprisals from his countrymen took a heavy toll on him—a weight too strong for him to bear. The only consolation to that tragic coda is that history can remember with thanks the part he played in saving these treasures—although such recognition must be cut with contrition, for he also had played a role in stealing them.

Captain Posey and Pfc. Kirstein were relieved by the Monuments Men of the Twelfth Army, George Stout and Lieutenant Thomas Carr Howe

Jr. Posey and Kirstein continued north with the Third Army, while their replacements prepared the Alt Aussee treasure for transport and brought it to a collection point in liberated Munich.

The Munich Central Collection Point was established in July 1945 in Hitler's former headquarters and was to be the primary destination for all objects of cultural heritage that had been displaced by the ERR. There a team of scholars, led by the brilliant American art historian Craig Hugh-Smyth, would be charged with sorting out what belonged to whom and arranging for the return of each piece of stolen art to its rightful country. In turn, each country would take charge of returning art taken from its private citizens.

In order to remove the treasures from the mine, Stout and Howe had the mine shaft equipped with rails. Specially designed five-foot-long flat-cars were fitted with narrow running boards and pulled by small gasoline engines. The Michelangelo *Madonna and Child* was the first object to leave the mine, wrapped in padding, on 16 June. Howe describes it in his memoir as looking like "a trussed-up ham." The next masterpiece to be liberated was *The Ghent Altarpiece*. A low-riding flatcar had to be designed especially for this purpose, so that the height of the enormous painting would not brush against the jagged rock outcroppings of the mine shaft ceiling.

Even out of the mine, the road from Alt Aussee to Munich was far from safe. A line of trucks was defended by a heavily armed escort. Howe wrote, "Between Alt Aussee and Salzburg the road led through isolated country. Conditions were as yet far from settled. Small bands of troops lurked in the mountains." Under Howe and Stout's supervision, the entire contents of the mine made the trip safely to the Munich collection point.

While most of the objects at the collection point were to be retrieved by representatives from each victimized country, the most important art-works would be taken back to their homelands directly. General Eisenhower personally requested the immediate restitution of these selected masterpieces, at U.S. expense, as evidence of American policy. Jan van Eyck's *Adoration of the Mystic Lamb* was very first of these most important artworks to be returned. A chartered plane was to fly the altarpiece from

Munich to Brussels. The panels were tied to specially fitted metal supports in the plane's hull. It would have only one passenger to ensure its safe arrival—Captain Robert K. Posey.

A parade and grand welcome waited at Brussels airport. After five hundred years of kidnapping, smuggling, dismemberment, looting, successful and attempted vandalism, ransom, near destruction, and a dizzying array of thefts, *The Adoration of the Mystic Lamb* could finally rest, safely on its way home.

Or could it? One more twist would occur on its odyssey homeward.

Where to pin the badge of heroism? With a number of mutually contradictory accounts, from Gaiswinkler, Grafl, Michel, Pöchmüller, and others, one must sift out the ulterior motives to seek the truth from among the various versions proffered. That Gaiswinkler's adventures are incredible is certainly no reason to discount them. It is a cinematic tale—one that inspired the 1968 film *Where Eagles Dare*, starring Clint Eastwood and Richard Burton. True history is full of stories that seem impossible outside the realm of fiction, never more so than during the Second World War, when the unlikeliest of peons became heroes. Is the story of Gaiswinkler any less plausible than the thirteen crimes surrounding *The Ghent Altarpiece*, than the serial thievery of Napoleon's Citizen Wicar, than Canon van den Gheyn's heroic hiding of *The Mystic Lamb*, than the bizarre and conspiratorial theft and ransom of the Righteous Judges?

Numerous primary source documents attest to the truth of the Gaiswinkler story, but they are, in the main, German and Austrian sources. These sources have incentive to frame an Austrian double agent as the savior of the Alt Aussee treasures. That it is in their interest does not discount the potential truth of the matter. There are, however, conflicting testimonies by other primary sources, such as Pöchmüller, which discount Gaiswinkler's role in the salvation of the mine and shift the heroism to anonymous miners, to Pöchmüller himself, to the leader of another

Austrian Resistance group named Sepp Plieseis, to Josef Grafl, or to Alois Raudaschl, the head of the Alt Aussee miners in the Resistance. By the war's end there were really only five insiders during the last days of the Alt Aussee mine left who could tell the story, each one providing their own version of the truth: Hermann Michel, Emmerich Pöchmüller, Sepp Plieseis, Josef Grafl, and Albrecht Gaiswinkler. Each had reasons to declare himself the hero of the day. Other sources lean more heavily on the Allied Monuments Men—it was they who saved the treasures with the help of the miners and the Resistance, not some Austrian. But those sources are, of course, British and American, and therefore their agenda is to support the efforts of the Allies. We may never know the precise truth, which most likely encompasses elements of all of the surviving versions of the story.

Those who downplay Gaiswinkler's role note that, while he was briefly used by the Allies as the district governor of Aussee and then launched a successful political career after the war as a member of the Austria National Assembly (based largely on the perception of his heroism at Alt Aussee), he was later voted out of the Assembly in 1950. While in office, he ran a successful campaign for the region of Ausseerland (in which Alt Aussee is located) to be included in the province of Styria. His eventual ejection from office could have been because his stories had become discredited, as his detractors say, but it could also have been for other, more subtle political reasons.

The primary documents that relate Gaiswinkler's story in full are his own 1947 memoir, *Leap into Freedom* (*Sprung in die Freiheit*), and the oddly named *Red-White-Red Book* (the title refers to the Austrian flag), which bears the unusual subtitle *Justice for Austria!* This latter book was published by the Austrian state in 1947, its authors remaining anonymous. It was also translated into English, with the possible motive of improving the negative opinion of Austrians among English speakers immediately after the war. There is no doubt that it was a piece of propaganda, as was Gaiswinkler's own memoir, in which he added to his list of heroic deeds the plan to assassinate Josef Goebbels. But this propagandistic bent does not mean that the stories contained in the works were untrue.

In the end, there proved no need to assassinate Goebbels—he did the job himself soon after Gaiswinkler parachuted into Austria. The Nazi minister of propaganda remained in Berlin through the end of April 1945, as his world disintegrated around him. On 23 April Goebbels gave a speech in the Reich's capital, which included the following passage:

> I call on you to fight for your city. Fight with everything you have got, for the sake of your wives and your children, your mothers and your parents. Your arms are defending everything we have ever held dear, and all the generations that will come after us. Be proud and courageous! Be inventive and cunning! Your *Gauleiter* [Hitler] is amongst you. He and his colleagues will remain in your midst. His wife and children are here as well. He, who once captured the city with 200 men, will now use every means to galvanize the defense of the capital. The battle for Berlin must become the signal for the whole nation to rise up in battle.

But the battle for Berlin went nowhere. On 30 April, with Soviet troops less than a mile away from the Berlin bunker in which Hitler was entrenched, Goebbels was one of only four eyewitnesses to the dictation of the führer's last will and testament. Hours later, Hitler shot himself.

On 1 May, a day that might have been the target for the assassination attempt, Goebbels was determined to follow the führer's example. One of the last men to speak with Goebbels, Vice Admiral Hans-Erich Voss, recalled him saying, "It is a great pity that such a man is not with us any longer. But there is nothing to be done. For us, everything is lost now and the only way left for us is the one which Hitler chose. I shall follow his example." Goebbels and his wife arranged for the sedation and cyanide poisoning of their six children; then they took their own lives.

The Goebbels assassination plot is the least plausible aspect of Gaiswinkler's story, but it is seconded by his fellow double agent, Josef Grafl. The only part of the story that seems to have been physically impossible is Gaiswinkler's claim that he and his team oversaw the setting

and explosion of the palsy charges that sealed the mine in one night—this procedure, involving six tons of explosives, 502 timing switches, and 386 detonators in 137 tunnels was complex, to say the least, and would have taken far longer than one night to accomplish. It is possible that Gaiswinkler was referring only to the six charges that sealed the entrance to the main mineshaft, although he did not specify this. The other remarkable stories—of seizing the radio transmitter to broadcast false messages about the impending arrival of the Yugoslav army, of Eigruber's order for an SS detachment to personally destroy the treasures in the mine—are all plausible.

Fellow British-trained double agent Josef Grafl's own testimony diverges in a number of ways from that of Gaiswinkler. Grafl underscores the fact that the primary mission for the parachutists was the assassination of Josef Goebbels and that this mission was only abandoned when it was learned that Goebbels never made it to the area. Gaiswinkler claims that the Goebbels assassination had to be abandoned when the radio was damaged beyond repair during the initial parachute jump onto the mountainside, while Grafl stated that the radio was in fact not damaged, but it was determined that the parachutists could not navigate the deep snow of the mountainside if they were to carry the radio, so it was abandoned in the snow. Many years after the war, Grafl raised allegations that Gaiswinkler had been relatively inactive and played only a minor role in the salvation of the mine treasures. At the same time, Grafl scrambled to increase his share of glory, claiming that it was he who led the Allied soldiers, when they did arrive on the scene, to help capture Kaltenbrunner. Grafl's allegations have caused some to dismiss Gaiswinkler's story. Others view the two SOE agents as disagreeing out of a mutual animosity, each trying to make himself look like the hero while undermining the word of the other. The truth is unknown.

The other primary-source account of the Austrian resistance at Alt Aussee comes from another Resistance leader. Sepp Plieseis was a mountaineer and hunter born in 1913 in the alpine town of Bad Ischl. A Com-

munist, he fought first with the International Brigades in Spain. He then joined the French but was captured by the Gestapo and sent first to Dachau and then to a labor camp at Hallein, where, incredibly, he escaped in August 1943 in a mass prison break with 1,500 men. He dedicated himself to fighting the Nazis and, having made his way back to Austria, led a local Resistance group under the nickname he'd given himself, "Willy." The ragged band of refugees, deserters, and others who had been persecuted by the Nazis began with as few as thirty people. This Resistance group contacted the team of eighty miners who worked Alt Aussee and who would form their own subgroup of resisters, led by Mark Danner Pressl and the miner called Alois Raudaschl, who, through a mutual friend, had access to Ernst Kaltenbrunner at his nearby alpine retreat. From May 1945 on, once the Allies had seized the area around Bad Ischl and Alt Aussee, Plieseis was made the local security consultant to the Allies. After the war Plieseis became an official in the town of Bad Ischl and worked as a functionary for the local branch of the Communist Party. In 1946 he published a memoir with an appropriately Communist title: *From the Ebro to Dachstein: The Life Struggle of an Austrian Worker*.

Sepp Plieseis mentions Gaiswinkler in his book only once, describing him as the leader of the "best group" among the resistance fighters. However, he later changed his statement, saying, "We freedom fighters at that time had no connection with the parachutists [Gaiswinkler and his team], and they had no idea of the art that lay in the mine shafts. They parachuted in only a few days earlier, and sought shelter for themselves."

Most likely these are all variations on fact. The core events took place, but they were much more of a collective effort, the combined forces of many smaller heroes, rather than the genius of one. Various members of those left standing at the war's end claimed shares of the glory that may have been disproportionate to the reality—but we may never know the whole truth of the mine's salvation.

The greatest measure of credit should go to the unsung miners. It was almost certainly the miner Alois Raudaschl, or Gaiswinkler with the help

of Raudaschl, who contacted Kaltenbrunner in order to convince him to intervene with Eigruber to prevent the mine's destruction. It is also probable that the eighty miners in the Resistance were responsible for the slow and steady placement of the palsy charges, whether at their own impetus or under orders from a group leader. Pöchmüller claimed to have been the man to order the removal of the bombs hidden in the crates disguised as marble; again, it might have been him, but in truth the miners were the ones who took the greatest risk in planting the palsy charges and removing the bombs from the crates. In a 1948 report to the Austrian government, signed collectively and anonymously as the "Freedom Fighters of Alt Aussee," the miners claimed to have acted at their own discretion, having discovered the bombs inside the marble crates accidentally, then moving the bombs into the woods and out of harm's way. Yet the same report claims that they planted the palsy charges, when logic tells us that such an enterprise would require a knowledge of engineering and demolitions that the miners alone might not have possessed.

Thus it remains a mystery whom we have to thank for the preservation of *The Ghent Altarpiece* among more than 7,000 masterpieces that were so nearly lost forever. Lincoln Kirstein himself wrote in *Town and Country* magazine in the autumn of 1945 that "so many witnesses told so many stories that the more information we accumulated, the less truth it seemed to contain." There is a tendency to want to raise one person on the plinth because history and memory is easier to sort out if we can account for individual heroes. Often the badge of hero is pinned on the man who gives the order, not the nameless workers who carry those orders out, at greatest personal risk. In the end, it was certainly a collective effort, with bold and prominent heroes among Austrians and Allies. Particular credit should go to those unable or unwilling to vaunt their roles in the salvation of the mine treasures—the local miners who worked with the Resistance, whether at their own discretion or under orders from Pöchmüller, Michel, or the man with the most dramatic story to tell, the swashbuckling Albrecht Gaiswinkler.

Whatever myriad of brave men helped to preserve Europe's treasures, it should suffice that we thank them, be they Austrian or Ally, whoever they were, and in whatever capacity they served.

On 21 August 1945 Robert Posey was the only passenger in a chartered cargo plane bound for Brussels. Trussed beside him in the cold, gaping cargo bay were wooden crates containing *The Ghent Altarpiece*. He would see them home, on Eisenhower's orders. But the trip would not be a smooth one.

During the flight back to Brussels, a sudden and violent storm struck. The chartered plane and its precious cargo were rocked by relentless turbulence, high winds, and bullets of rain. The pilot told Posey that he couldn't land safely in Brussels: The city was locked in with clouds. After they flew another hour, the storm had cleared slightly but was still heavy over Brussels itself. The pilot located a small military airfield about an hour outside of Brussels. The landing was treacherous, the plane tossing in gusts of wind. It was 2 AM when they landed. There was no one on hand at the airfield to welcome them, least of all to help with their most precious cargo.

Through the curtain of rain, Posey ran from the plane to the airfield office. He called the operator and asked her to patch in an emergency call to the U.S. embassy in Brussels. There was no answer. Desperate, Posey convinced the operator to call around to different residences in the Brussels area in which American soldiers were billeted. Finally, she reached an American officer. Posey recalled:

> I told him to get everybody he could and come to the airport. I had a treasure on my hands and I wanted to guard it the right way. He shanghaied a couple of trucks, went to some bars and rounded up some enlisted men. I also asked him to try to find someone who

knew something about moving works of art, and he turned up a mess sergeant who had some experience. They backed the trucks right up to the plane. It was still dark and raining and thundering.

This motley convoy brought *The Lamb* to the Royal Palace in Brussels, after a hair-raising forty-five-minute drive through the torrential rain. It was now 3:30 AM. After a moment of confusion, the night staff let them into the palace, realizing that this soaked group of GIs had the van Eyck that had been expected to land hours ago. They laid out the panels on the long table in the dining room of the palace.

Posey needed nothing more than a soft, dry bed, but he wasn't going to leave his charge until he got a written receipt. *The Lamb* had slipped through too many fingers too often. Posey wrote, "I needed a receipt so that if someone asked me what happened to the panels, I would have it on paper." A Belgian official on night duty provided. A suite was offered to Captain Posey, one normally reserved for visiting royalty. He collapsed into bed. Posey returned the next day to join his Third Army, stationed in Paris.

After the war, Robert Posey resumed life with his wife, Alice, and son, Woogie. As an architect with the firm of Skidmore, Owings, and Merrill, he worked on such prominent buildings as the Sears Tower in Chicago and the Lever House in New York. Lincoln Kirstein returned to the New York arts scene of which he was already a prominent member and fell in love with ballet. He cofounded and ran the New York City Ballet with George Balanchine and cofounded with him the School of American Ballet. He went on to direct the Metropolitan Opera House in New York and published over five hundred books, articles, and monographs. Today he is considered one of the most important figures in twentieth-century American arts.

Days after its dramatic flight to Brussels, the U.S. ambassador officially presented the rescued *Lamb* to the Prince Regent of Belgium, on behalf of General Eisenhower. There was rejoicing throughout the country. This painting symbolized much more than a merely marvelous work of art. It

represented the defeat of Hitler's plan to steal the world's art—it signified the defeat of Hitler himself.

The Belgians remembered the last time *The Lamb* came home from exile, after the Treaty of Versailles in 1919. Then, as now, speeches were made, and parades were held. Belgium welcomed home its greatest treasure, like a kidnapped and rescued prince. Jan van Eyck's *Adoration of the Mystic Lamb* was displayed for one month at the Royal Museum in Brussels, as it had been in 1919. In November 1945, *The Lamb* was returned to Saint Bavo Cathedral in Ghent.

Beginning in late March 1945, the various Allied armies began to discover repositories of art. The largest was Alt Aussee. But in Germany alone, Allied soldiers uncovered approximately 1,500 caches of stolen art. It is likely that countless others remain still buried and hidden throughout Germany and Europe. A few other examples of hidden depots of stolen art, found at the end of the war, offer a glimpse of the extent of the Nazi thefts.

In a jail in the northern Italian town of San Leonardo, Monuments Men discovered much of the contents of the Uffizi Museum, which had been hurriedly stashed by Nazi soldiers during their retreat from Florence.

Castle Neuschwanstein was still brimming with treasures at the war's end. The most significant of these was not an artwork but the complete files of the ERR. It was an exceptional discovery to find the documents of this important department almost completely intact.

With the help of Hermann Bunjes during the last weeks of his life, and with support from OSS intelligence, other salt mines were identified and secured by Allied armies. On 28 April 1945, at a munitions factory depot called Bernterode in the German region of Thuringia, 40,000 tons of ammunition were found. Inside the mine, investigating American officers noticed what looked like a brick wall painted over to match the color

of the mineshaft. The wall turned out to be five feet thick, the mortar between the bricks not yet fully hardened. Breaking through with pickaxes and hammers, the officers uncovered several vaults containing a wealth of Nazi regalia, including a long hall hung with Nazi banners and filled with uniforms, as well as hundreds of stolen artworks: tapestries, books, paintings, and decorative arts, most of it looted from the nearby Hohenzollern Museum. In a separate chamber, they came upon a ghoulish spectacle: three monumental coffins, containing the skeletons of the seventeenth-century Prussian king Frederick the Great, Field Marshall von Hindenburg, and his wife. The Nazis had also seized human relics of deceased Teutonic warlords.

At Siegen near the city of Aachen, a mine contained paintings by van Gogh, Gauguin, van Dyck, Renoir, Cranach, Rembrandt, and Rubens (who had been born in Siegen), as well as the treasures of Aachen Cathedral, including the silver and gold reliquary bust of Charlemagne, which contained a fragment of his skull.

Two hundred miles southwest of Berlin, the Kaiseroda mine might have escaped Allied attention. But as fate would have it, in April 1945 Allied military police picked up two French women who had been driving illegally, at a time when civilian movement was restricted. As they passed the mine in the police jeep, the women mentioned that a large amount of gold was buried there. The military police radioed in the report, and soldiers were sent to investigate. After descending 2,100 feet in a rusty elevator, they were confronted with the shock of their lives.

Five hundred wooden crates, containing a total of 1 billion reichsmarks, was just the start. After dynamiting open a locked steel door, they found 8,527 gold ingots, thousands of gold coins, currency, and further crates full of gold and silver bars. Artworks and rare books were found as well, including Botticelli's *Virgin with a Choir of Angels*. They would later learn that this was the largest part of the reserve of the Reichsbank, the official bank of the Third Reich. The officers then made a horrifying discovery: countless containers full of precious stones and gold dental fillings, all taken from concentration camp victims.

The mine that attained the greatest notoriety was at Merkers, and it was Posey and Kirstein who oversaw inventory, on 8 April 1945—the same day that Gaiswinkler and his team parachuted onto snowbound Hell Mountain. The mineshaft ran 2,100 feet into the earth and included a steel bank vault door that the Nazis had installed that had to be dynamited open—a risky business when an explosion takes place a half mile underground. Room Eight alone was 150 feet long by 75 feet across and at least 20 feet high. It contained thousands of what looked like brown paper bag lunches, laid out in neat rows. In actuality these were filled with gold: approximately 8,198 gold bars, 1,300 bags of mixed gold coins, 711 bags of American twenty-dollar gold pieces, printing plates used by the Reich to stamp its currency, and $2.76 billion reichsmarks—most of the reserve of Germany's national treasury. It also contained art and antiquities, including Albrecht Dürer's *Apocalypse* woodcuts, paintings by Caspar David Friedrich, Byzantine mosaics, Islamic carpets, and between 1 and 2 million books. Most of the contents of the Kaiser Friedrich Museum, in forty-five cases, was stored at Merkers. The museum had not been looted, but its contents were sent there from Berlin for safekeeping. The final MFAA inventory listed 393 uncrated paintings, 1,214 cases of art, 140 textiles, and 2,091 boxes of prints.

There was so much gold that soldiers were pocketing souvenirs that could help them to an early retirement. Posey wrote to his wife on 20 April: "At the gold mine they filled my helmet with twenty dollar American gold pieces and said I could have it. I couldn't lift it off the ground—it contained $35,000—so we poured it back in the sacks and left it. I seem to have absolutely no greed for money for I felt no thrill at seeing so much of the stuff. Your poem means more to me." Kirstein was similarly uninterested in claiming souvenirs. In all his time as an MFAA officer, he only permitted himself to take one keepsake of his adventures: a single Nazi paratrooper's knife.

With its combination of stolen art and buried gold, Merkers was the first stolen art story to attract international media attention, although the gold was of greater popular interest than the artworks. It is interesting to

note that the U.S. government considered Merkers a financial operation, not one reserved for the MFAA. Eisenhower, Patton, and an assortment of other generals paid an official visit to the mine, further elevating the profile of the discovery. George Patton cracked a joke as the generals slowly descended in the service elevator into the earth: "If that clothesline should part, promotions in the United States Army would be greatly stimulated." Eisenhower didn't find it funny.

And what of Hermann Göring's personal hoard of stolen art? The Allied 101st "Screaming Eagles" Airborne Division found more than 1,000 paintings and sculptures that had composed part of Göring's collection. They had been evacuated from Carinhall on 20 April 1945 and moved to a series of other residences, in a continued attempt to keep them out of the hands of the Russian army, whose art looting rivaled that of the Germans. Göring left eight days later, ordering Carinhall blown up after his departure. He escaped with only a few small paintings, including six works by Hans Memling, a generation younger than van Eyck and a fellow resident of Bruges; one van der Weyden; and *Christ and the Woman Taken in Adultery*, which Göring was convinced had been painted by Vermeer, when in fact it had been painted by Dutch forger Han van Meegeren only a few years before. Göring was arrested on 5 May 1945. He was tried at Nuremberg but poisoned himself before he could be officially executed.

Justice found its way to Gauleiter August Eigruber, as well. He was arrested by the Third Army mere days after they had reached the mine. He was brought as a witness to the Nuremberg Trials and was put on trial himself in the Mauthausen-Gusen camp trials. He was sentenced to death by hanging in March 1946 by the Dachau International Military Tribunal and was executed on 28 May 1947.

At the Nuremberg Trials, the counsel prosecuting Nazi war criminals presented slides of a selection of the confiscated material that had been rescued from Alt Aussee. As the slide show ended and statistics on the stolen objects were read, the counsel said, "Never in the history of the world was so great a collection assembled with so little scruple."

Back with the Third Army in Paris, Captain Robert K. Posey was summoned to meet his commanding officer. He had been awarded the highest honor of the Belgian government, the Order of Leopold—an equivalent to being knighted. It was the duty of the commanding officer to bestow the Order upon Captain Posey, war hero and one among the saviors of the greatest treasure stolen by the Nazis. Posey's commander enacted the ritual of the Order of Leopold in the traditional fashion: by kissing Captain Posey on both cheeks.

Art is a symbolic magnet for nationalism, more so than any flag. Artworks resemble lambs in an open field by night. The nations are the shepherds. Their ability or failure to defend the lambs, not only from midnight wolves but also from other thieving shepherds, is a sign of their country's strength. These artworks are imbued with more value than any other inanimate objects. Their preservation has long been considered more important, in times of war, than any quantity of human lives. Should art be displaced from its home nation, that nation loses a piece of its civilization. Should art be altogether destroyed, the civilized world is rendered less civilized.

Through six centuries and countless crimes, Jan van Eyck's first masterpiece, one of the world's most important paintings, has survived. In the end, the most desired artwork in history has outlasted its assailants and remains what all great art should be—a treasure cherished by humankind, outliving its hunters and protectors alike, eternally proclaiming the greatest capability of human creation.

Safely back in Belgium at the end of the Second World War, the restless *Ghent Altarpiece* had at last come to the end of its long journey.

Or had it?

Hidden in Plain Sight?

Conservator and Surrealist painter Jos Trotteyn could not stop staring at the panel. It had been his honor to clean *The Ghent Altarpiece* every Easter for the last twenty years. But on this day in March 1974, something was different. He took a step back. The eleven other panels had the tone of old oils and spider web craquelure on the paint's surface that could only come naturally, with age. But this one had it too: the Righteous Judges.

He knew that the Righteous Judges panel had been painted during the Second World War by another conservator, the now-deceased Jef van der Veken. He had signed it on the back and inscribed it with his enigmatic poem: "I did it for love / And for duty / And to avenge myself / I borrowed / From the dark side." There were also the elements van der Veken added, to make the work his own: the profile portrait of the Belgian king, Leopold III; one of the judges no longer hidden behind a fur hat; a ring removed from one finger. These were all elements that distinguished his work from the original.

But scholars and conservators, with an intrinsic knowledge of the art they love, an almost supersensory connoisseurship that defies science, can *feel* authenticity, like a bell that sounds when they see an original artwork. And for Jos Trotteyn, for the first time in twenty years of cleaning the Righteous Judges, alarms were ringing. Suddenly, this forty-year-old panel copy felt like it was the five-hundred-year-old original.

He shook his head. It was impossible. Maybe he needed a holiday.

But just to be certain, he picked up his magnifying glass. He leaned in close to the portrait of Leopold III. That was Leopold, alright. But could he faintly see another face ghosted beneath it? Were there pentimenti suddenly revealing themselves through the surface of the painting?

He called Hugo de Putter, his friend and fellow painter. Together they compared the known original panels with the Judges. De Putter agreed with his friend. The patina of age on the Judges looked identical to that on the other panels. But Trotteyn had never before noted the patina, despite two decades of conservation and direct, up-close contact with the masterpiece.

Trotteyn reported his discovery to the bishopric and the local museum officials. Word leaked out, and a reporter, Jos Murez, ran their story in a Belgian newspaper on 26 March. This led to further reports and drew the attention of the international art community.

The issue at hand was whether or not van der Veken had painted his copy from scratch, using a two-hundred-year-old cupboard shelf for his panel as he claimed. Was there any chance that he had painted *over* the missing original, thereby "returning" it to its place in the altarpiece?

It was an astounding suggestion. It implied that van der Veken was complicit in the theft, or at least inherited information about it that he withheld from the police. And why, after all those years, return the stolen panel? Was this the best way to do so, taking six years to paint over it, so it could be replaced surreptitiously? Why not simply abandon it some-where and call in an anonymous tip to lead the police to it? And what of the timing of the last ransom attempt, in 1938? The year after this last attempt failed, van der Veken began his copy. Coincidence?

The questions still outnumbered the answers.

The bishopric and university experts ran tests on the Judges panel. In a final irregularity that suggested cover-up, the results of these tests were not published. Rather, they were announced by one of the cathedral staff, Monsignor van Kesel. He said that while the panel had aged remarkably, there was no irregular underpainting detected. The particular mixture of plaster and glue that van Eyck used to make his white gesso preparatory layer was different from that in this copy of the Judges. Wood and grain

particles had been tested. Unfortunately, van Kesel announced, this was indeed van der Veken's copy and not the missing original.

But many remain unconvinced. Waves of theories have proliferated over the years. The Judges was sliced into sections and hidden in Saint Bavo. The panel was buried in a tomb in the cathedral crypt. It was hidden behind a stone panel on the cathedral façade. It was buried in the coffin with Goedertier. Hitler's agent Köhn had found it—and secreted it away. Or perhaps van der Veken painted over it and returned it to its place on *The Ghent Altarpiece*, but after thirty years his layers of paint faded, and the original figures and craquelure ghosted through, pentimenti suddenly visible to the naked eye. Perhaps the bishopric was involved in the theft or its cover-up after all? Had someone used van der Veken to return the panel covertly, rather than expose their complicity? This last hypothesis would explain why the test results were not made public.

The investment-group theory, which remains the most compelling explanation for the Judges theft, suggests a solution to the remaining mystery involving Jef van der Veken's replacement copy of the Righteous Judges. If the investment group tried and failed to extract a ransom, and their debts and broken contracts were glossed over or forgotten during the Second World War, then there would be no reason to retain the missing panel. Who would want it returned more than the diocese itself? It would be out of the hands of the criminals. Could the diocese really be found guilty of theft if they stole their own property, hid it on their own property, and then arranged for a ransom demand to be made to themselves for its return? It is easy to see how those involved could have rationalized their activities as a "no one gets hurt" situation. The Judges panel never left the diocese; it was never in any danger. But the John the Baptist panel was taken away from the cathedral, to be used as the bargaining chip. And it was assumed that the Belgian government would ultimately pay the ransom, as indeed they might have, had Attorney de Heem not demurred; therefore the crime was attempted extortion from the Belgian government. The shoddy police work of both Luysterbourgh and the cheese-focused Chief of Police Patijn may be explained by one of two

possibilities, neither complimentary: They were either lousy police or also complicit.

Perhaps Jef van der Veken had painted over the stolen original, in order to return the panel after the ransom plan failed, and to avoid further inquiries? Van der Veken's complicity would explain the mysterious poetic couplet he added to the back of his panel—though such a suggestive clue was playing with fire. An ongoing knowledge of the truth, at least among certain members of the Ghent clergy, would explain the refusal of the diocese to publish any of the test results that might have proved Trotteyn wrong, indicating that the Righteous Judges was not the stolen original. Circumstantial evidence leads to this conclusion, but shadows and silence remain.

The truth may be revealed in the near future. In 2010, the Getty Foundation, in conjunction with the Belgian government, announced plans to fund a thorough restoration of *The Ghent Altarpiece*. The eyes of the world will follow this process and eagerly await word of what lies beneath the Righteous Judges.

Part of the pleasure of this lingering mystery is that it remains unsolved. Perhaps one day the truth will come to light, the Judges panel will be found, and *The Ghent Altarpiece* may be whole once more—if it is not already.

ACKNOWLEDGMENTS

First and foremost, I cannot thank my wife enough for her patience, support, and assistance. My primary research assistant as well as my best friend, she is inordinately patient, as she hears me talk about art and art crime far more often than most sane people could handle. Urška, *te ljubim in bom za vedno*. She even permitted me to name our dog Hubert van Eyck, which is several steps beyond the call of duty. I like the idea that Jan's mysterious brother might be reincarnated as a Peruvian Hairless, and this allows me to say, with some regularity, that I wake up to Hubert van Eyck licking my face.

The seed for this book was planted when I founded ARCA, the Association for Research into Crimes Against Art—an international nonprofit think tank and research group. Special thanks for the tremendous support ARCA has received since its inception, from trustees, staff, volunteers, and colleagues around the world. Art crime has never been better understood, and by so many people, than it is today, thanks in a great part to your efforts.

Thanks go to the institutions who hosted me while this book was being written and supported the work that this book expresses: Yale University, Yale Art Gallery, the Institute of Criminology in Ljubljana, University of Ljubljana, Amsterdam's Rijksmuseum, the Yale British Art Center, the Peabody Museum of Natural History, Venice in Peril, the Royal Geographic Society, the National Library of Spain, the University of Cambridge, Madrid's Museo Thyssen-Bornemisza, the International Foundation for Cultural Property Protection, the European Society of Criminology and the American Society of Criminology, the Union des Avocats, the American Bar Association, Saint Stephen's Academy, and the American University of Rome, to name a few.

Thanks for the research assistance of Lee-Ann Rubinstein, Nathalie di Sciascio, and Aaf Verkade, whose assistance with Flemish and Dutch sources was invaluable. Pioneers in research on the Righteous Judges theft were of great help: Johan Vissers, Karel Mortier, and particularly Patrick Bernauw. I am grateful to my writer friends, great editors and patient listeners: Nathan Dunne and fellow Slovenophile, John Stubbs.

Thanks are due to my priceless agents, Eleanor Jackson in the United States and Laetitia Rutherford in the United Kingdom, who sculpted this project

along with me. And to the PublicAffairs team, especially Morgen van Vorst, Clive Priddle, and Lindsay Jones, who saw the promise in this book and made it a reality.

I would never have become an art historian had not three wonderful professors steered the course for me and inspired in me a lifelong passion for the story of art: David Simon, Michael Marlais, and Veronique Plesch. It was David Simon who first mentioned not only that *The Ghent Altarpiece* was the most frequently stolen artwork in history but that it was also a candidate for the title of most desired object of all time.

Thank you for reading—and try not to steal anything.

To learn more about art crime and about ARCA, please visit www.artcrime.info.

NOTES ON SOURCES

The story of *The Ghent Altarpiece*, and the history of art crime mirrored within it, is interdisciplinary. It is a story that traverses the continent of Europe and spans six centuries. It is a history of art and of crime, but also of collecting, religious and political intolerance, conservation, war, policing, and the sociopolitics of cultural heritage. As a result, the sources are diverse, as are the research languages, which include English, French, Italian, German, and Flemish. Some translations are from the secondary sources in which they were found, and primary sources were translated by me with the help of translation software for the Flemish and Dutch, supplemented by help from Dutch and Belgian friends and colleagues.

It was particularly difficult to find primary source material for many of the crimes discussed in this book, since all of the files on the history of *The Mystic Lamb* from the Ghent diocese and city hall disappeared after the 1934 theft—further suggesting cover-up. If the Nazi art detective Heinrich Köhn, with the persuasive methods available to him during the Second World War, was unable to make headway, then the chances of primary source material falling into the hands of a less-intrusive researcher in the twenty-first century were slim indeed. As a result, for many of the earlier thefts, as well as the 1934 theft, I have had to rely more than I would like on secondary sources.

Information that sets the scene for the various incidents involving *The Mystic Lamb* is largely based on the secondary sources. Likewise many of the quotations included here may be found in these secondary sources, and I have not necessarily listed the primary source of them in the bibliography. A surprisingly strong field of *Mystic Lamb* scholarship has risen online. In the Selected Bibliography I have listed these websites, almost all in Flemish, which provide a wealth of photographs and theories, ranging from the probable to the conspiratorial, all of which helped me to map out the story of *The Lamb* and to select the versions of the truth that I found most convincing based on my analysis of the material available.

Regarding the altarpiece itself and the story of Jan van Eyck, Hubert van Eyck, and their contemporaries, excellent art history books cover the material from a variety of theoretical angles. Often the best art history books are the

most concise, and the Taschen *Jan van Eyck* by Till-Holger Borchert summa-
rizes the past few centuries' theories and arguments, as well as furnishing a
number of quotations from famous thinkers in praise of the artist and the al-
tarpiece, from Goethe to Hegel, from Lessing to Dürer, from Burckhardt to
Panofsky. I have not referenced the original sources of these quotations of pass-
ing praise, as they may be found in many of the secondary sources. Nor have
I included in the bibliography every book and academic article on van Eyck,
when the most recent and strongest summarize those previous, and help the
art historian to discern which past theories are the fruit of incomplete infor-
mation and which remain at the fore. The stories of Ghent, Philip the Good,
and Saint Bavo Cathedral are available in any good guidebook or history of
the area, several of which are cited.

The earliest crimes involving *The Lamb*, including the attempted destruc-
tion of it during the sixteenth-century Calvinist riots and the censorship re-
lated to the visit of Emperor Joseph II, are summarized in a number of
excellent Flemish books that focus on the 1934 theft, including works by Karel
Mortier, Patrick Bernauw, and Maria de Roo, as well as in the histories of
Ghent and Belgium listed in the bibliography.

The Napoleonic era is well covered in biographies of Napoleon and Denon,
as well as some of the broader histories of art looting, of which the best is Karl
Meyer's *The Plundered Past*. Quotations related to the gathering of looted art
in Paris and the foundation of the Louvre, such as those by Citizen Barbier
and Napoleon himself, are found in the books on Denon, as well as French
sources like Edouard Pommier and Dominique Poulot, and above all in Cecil
Gould's excellent *Trophy of Conquest: The Musée Napoléon and the Creation of
the Louvre*. The chapter on nineteenth-century collecting and "illicit art
tourism" owes a debt of gratitude to Jennifer Graham's informative *Inventing
van Eyck*, which discusses the "van Eyck mania" that seized Europe in the nine-
teenth century. The majority of the quotations by nineteenth-century com-
mentators may be found in her book, including the quotations from the
Manchester Guardian, George Darley, and Eugene Fromentin.

The story of art during the First World War is strikingly underdocumented,
particularly in comparison to the riches of scholarship on looting in the Second
World War. The quotation from Paul Clemen's obituary was published in the
College Art Journal in 1953. Material for this period has been culled from a va-
riety of sources that touch on it indirectly, both from works on German art
collecting, including Bruno and Paul Cassirer, Günther Hasse, and Peter
McIsaac, and from the historical summary sections of books devoted to the
Second World War, including those by Jonathan Petropoulos and George
Mihan. The best two histories of the looting of art during war remain Karl
Meyer's *The Plundered Past* and Peter Harclerode and Brendan Pittaway's *The
Lost Masters*, both of which contributed to this chapter.

Instrumental to research of the elusive 1934 theft and its many conspiracy theories, the adventures of Canon van den Gheyn, and the later suspicions of conservator Jos Trotteyn were a number of highly informative, well-researched websites. These sites are particularly impressive for their scholarly citations— not in the form of footnotes but in the reproduction of actual digitized articles from a century of Belgian newspapers, scanned photographs, and the careful mapping out of various theories. The sites are, in the main, dedicated to the Righteous Judges mystery, but in exploring it, they provided a good deal of information about the other crimes, offering up gems that would otherwise have taken months of archive trawling to uncover. The quotations from Belgian newspapers come from these sites, listed in the bibliography. The site judges.mysticlamb.net, for instance, will be an invaluable supplement to readers of this book, as it reproduces scanned copies of Goedertier's ransom letters, with the complete text of each, among other valuable images. The site users.kbc.skynet.be/drr/, run by Johan Vissers, is the primary source of the investment-group theory about the Judges theft; it includes brief biographies of the many people involved, with photographs. Likewise speurrsite.erdasys .com brims with digital reproductions of Belgian newspaper articles about the Judges theft and, if you can read the Flemish, provides invaluable primary source material. It also has stills from the 1994 documentary film *Trix* produced by KRO Reporter out of the Netherlands. The movie includes interviews with Karel Mortier about his investigation. These multimedia sources complemented the various Flemish books on the subject, none of them available in English. Those by Mortier and Bernauw were particularly helpful.

The Second World War has been the subject of extensive, excellent scholarship. The best summaries of the fate of art during the war are the books by Petropoulos and Lynn Nicholas, and many of the quotes reproduced here, including those of Roosevelt and Eisenhower, may be found within them. Two strong books from 2009 summarize the activities of the Monuments Men, and I recommend them for further reading. Ilaria Dagnini Brey's *The Venus Fixers* and Robert Edsel and Brett Witter's *Monuments Men* are an ideal pair, as Edsel and Witter cover the activities of the Monuments Men throughout Europe without dwelling on Italy, while Brey's book tells the story of Italy alone. Edsel and Witter's work in particular is full of quotations from the likes of Posey and Kirstein, taken from documents and archives preserved by the admirable Monuments Men Foundation.

Numerous German-language sources contributed to tell the story of the salvation of the Alt Aussee salt mine. The article by Christian Reder provides a thoroughly researched summary of Gaiswinkler's role and was helpful in unraveling the conflicting testimonies of the Austrians who each claimed to have spearheaded the resistance at Alt Aussee, as was Harclerode and Pittaway's *The Lost Masters*, which remains the book I assign to my university

and postgraduate students as the best summary of twentieth-century art loot-
ing in war. The *Red-White-Red Book* and Gaiswinkler's memoir must be read
with a grain of salt, as they are clearly propagandistic, but that does not mean
that they are untrue. I have attempted to provide an unbiased account of the
Alt Aussee salvation, as most versions I have read are skewed in favor of the
Austrians or the Allies, each side discounting the efforts of the other in favor
of its own story.

My thanks go out to all of the scholars, detectives, and passionate investi-
gators on whose fine work this book is built.

SELECTED BIBLIOGRAPHY

JAN VAN EYCK, GHENT, AND *THE GHENT ALTARPIECE*

Baldass, Ludwig von. *Jan van Eyck.* London: Phaidon, 1952.

Blom, J. C. H., and E. Lamberts, eds. *History of the Low Countries.* Trans. James C. Kennedy. New ed. New York: Bergahn, 2006.

Bol, L. J. *Jan van Eyck.* Trans. Albert J. Fransella. London: Blandford, 1965.

Borchert, Till-Holger. *Jan van Eyck.* London: Taschen, 2008.

Boulger, Demetrius C. *The History of Belgium.* 2 vols. London: Demetrius C. Boulger, 1902–1909. Reprint, Boston: Adamant Media, 2001.

Cammaerts, Emile. *A History of Belgium from the Roman Invasion to the Present Day (1921).* Ithaca, NY: Cornell University Press, 2009.

Campbell, Lorne. *Fifteenth-Century Netherlandish Paintings.* London: National Gallery, 1998.

Chatelet, Albert. *Jan van Eyck Enlumineur: Les "Heires de Turin" et de "Milan-Turin."* Strasbourg: Presses Universitaires de Strasbourg, 1993.

Clark, Gregory T. *Made in Flanders: The Master of the Ghent Privileges and Manuscript Painting in the Southern Netherlands in the Time of Philip the Good.* Turnhout, Belgium: Brepols, 2000.

Conway, William Martin. *Early Flemish Artists and Their Predecessors on the Lower Rhine.* London: Seeley and Co., 1887.

Cortemans, Paul. *L'Agneau Mystique au Laboratoire: Examen et traitment.* Antwerp: De Sikkel, 1953.

Dhanens, Elizabeth. *Hubert and Jan van Eyck.* New York: Alpine Fine Arts, 1980.

——. *Van Eyck: The Ghent Altarpiece.* London: Allen Lane, 1973.

Graham, Jenny. *Inventing Van Eyck.* London: Berg, 2007.

Kris, Ernst, and Otto Kurz. *Legend, Myth, and Magic in the Image of the Artist.* New Haven, CT: Yale University Press, 1979.

Mander, Karel van. *Lives of the Illustrious Netherlandish and German Painters.* Ed. Hessel Miedema. Doornspijk, Netherlands: Davaco, 1994.

Nicholas, David. *The Metamorphosis of a Medieval City: Ghent in the Age of the Arteveldes, 1302–1390.* Lincoln: University of Nebraska Press, 1987. Reprint, New York: ACLS Humanities, 2008.

Panofsky, Erwin. *Early Netherlandish Painting*. Cambridge, MA: Harvard
 University Press, 1953.
Philip, Lotte Brand. *The Ghent Altarpiece and the Art of Jan van Eyck*. Princeton,
 NJ: Princeton University Press, 1972.
Puyvelde, Leo van. *Van Eyck: The Holy Lamb*. London: Collins, 1947.
Raspe, Rudolf Erich. *A Critical Essay on Oil-Painting: Proving that the Art of
 Painting in Oil Was Known Before the Pretended Discovery of John and Hubert
 van Eyck*. London: T. Cadell, 1781.
Renders, Emil. *Hubert van Eyck, personnage de legende*. Paris, 1933.
Vasari, Giorgio. *Lives of the Painters, Sculptors and Architects*. Trans. Gaston du
 C. de Vere. London: Everyman's Library, 1996.
Wealee, W. H. James. *Hubert and John van Eyck: Their Life and Work*. London,
 1908.

THE FRENCH REVOLUTION, NAPOLEON, AND COLLECTING

Bazin, Germain. *The Louvre*. London: Thames and Hudson, 1971.
Benoist-Méchin, J. *Bonaparte en Égypte, ou le rêve inassouvi*. Paris: Perrin, 1978.
Dodge, Theodore Ayrault. *Napoleon: A History of the Art of War*. New York:
 AMS Press, 1970.
Englund, Steven. *Napoleon: A Political Life*. New York: Scribner, 2004.
Gould, Cecil. *Trophy of Conquest: The Musée Napoléon and the Creation of the
 Louvre*. London: Faber and Faber, 1965.
Impey, Oliver, and Arthur MacGregor, eds. *The Origins of Museums: The
 Cabinet of Curiosities in 16th and 17th Century Europe*. London: House of
 Stratus, 2001.
McClellan, Andrew. *Inventing the Louvre: Art, Politics, and the Origins of the
 Modern Museum in 18th Century Paris*. Cambridge: Cambridge University
 Press, 1994.
Miles, Margaret M. *Art as Plunder: The Ancient Origins of Debate About
 Cultural Property*. New York: Cambridge University Press, 2008.
Meyer, Karl E. *The Plundered Past*. London: Hamish Hamilton, 1973.
Passavant, Johann David. *Tour of a German Artist in England*. London: Saunders
 and Otley, 1836.
Pearce, Susan M. *On Collecting: An Investigation into Collecting in the European
 Tradition*. London: Routledge, 1995.
Pommier, Edouard. *L'Art de la liberté: Doctrines et débats de la revolution
 française*. Paris: Gallimard, 1991.
Poulot, Dominique. *Musée, nation, patrimonie, 1789–1815*. Paris: Gallimard, 1997.
Reynolds, Joshua. *A Journey to Flanders and Holland*. Cambridge: Cambridge
 University Press, 1996.

Russell, Terrence. *The Discovery of Egypt: Vivant Denon's Travels with Napoleon's Army*. London: History Press, 2005.

Siborne, William. *History of the War in France and Belgium in 1815*. London: T. and W. Boone, 1848.

Schom, Alan. *Napoleon Bonaparte*. New York: HarperCollins, 1997.

Vaughn, William. *German Romanticism and English Art*. New Haven, CT: Yale University Press, 1979.

Waagen, Gustav. *Treasures of Art in Great Britain*. London: John Murray, 1854.

Walpole, Horace. *Anecdotes of Painting in England*. Strawberry Hill: Thomas Farmer, 1762.

THE JUDGES THEFT

Bernauw, Patrick. *Het Bloed van Het Lam*. Antwerp: Manteau, 2006.

———. *Mysteries van Het Lam Gods*. Antwerp: Manteau, 1991.

De Roo, Maria. *Vilains*. Unpublished manuscript. 29 November 2009.

Esterow, Milton. *The Art Stealers*. New York: Macmillan, 1966.

Hammer-Kaatee, Karl. *Satans Lied: De Jacht van de CIA op Jezus: Waargebeurd verhaal*. Rijswijk, Netherlands: Uitgeverij Elmar, 2006.

McLeave, Hugh. *Rogues in the Gallery: The Modern Plague of Art Thefts*. Boston: David Godine, 1981.

Mortier, Karel. *De diefstal van de Rechtvaardige Rechters: Kriminologische studie*. Antwerp: De Vlijt, 1966.

———. *Dossier Lam Gods: Zoektocht naar De rechtvaardige rechters*. Gent: Stichting Mens en Kultuur, 1994.

Trix (documentary). Produced by KRO Reporter, the Netherlands. Aired April 1994.

Walters, Minette. "Whodunnit?" *Daily Telegraph* (London), 9 November 1996.

FIRST AND SECOND WORLD WARS

Becker, Hans. *Österreichs Freiheitskampf*. Vienna: Verlag der Freien Union der ÖVP, 1946.

Benjamin, Walter. *Das Passagen-Werk*. Berlin: Suhrkamp, 1982.

Bibliotheca Rosenthaliana. *The Return of the Looted Collections 1946–1996*. Amsterdam: University of Amsterdam Library, 1997.

Bode, Wilhelm von. *Die Meister Der Hollandischen und Vlamischen Malerschulen (1919)*. Whitefish, MT: Kessinger, 2009.

Brey, Ilaria Dagnini. *The Venus Fixers: The Untold Story of the Allied Soldiers Who Saved Italy's Art During World War II*. New York: Farrar, Straus and Giroux, 2009.

Cassirer, Bruno, and Paul Cassirer. *Kunst und Kunstgewerbe am Ende des Neunzehnten Jahrhunderts von Wilhelm Bode*. Whitefish, MT: Kessinger, 2010.

Chamberlain, Russell. *Loot! The Heritage of Plunder.* London: Facts on File, 1983.

De Jaeger, Charles. *The Linz File: Hitler's Plunder of Europe's Art.* London: Webb & Bower, 1981.

de Ville, Jean Baptiste. *Back from Belgium: A Secret History of Three Years Within the German Lines.* New York: H. K. Fly, 1918. Reprint, n.p.: Nabu Press, 2010.

Duberman, Martin. *The Worlds of Lincoln Kirstein.* New York: Knopf, 2007.

Edsel, Robert M., and Brett Witter. *Monuments Men: Allied Heroes, Nazi Thieves, and the Greatest Treasure Hunt in History.* New York: Center Street, 2009.

Feliciano, Hector. *The Lost Museum: The Nazi Conspiracy to Steal the World's Greatest Works of Art.* New York: Basic Books, 1997.

Flanner, Janet. *Men and Monuments.* New York: Harper, 1957.

Gaiswinkler, Albrecht. *Sprung in die Freiheit.* Vienna-Salzburg: Ried-Verlag, 1947.

Gheyn, G. van den. "Les tribulations de l'Agneau Mystique." *Revue belge d'archéologie et d'histoire de l'art* 15 (1945): 25–46.

Gilbert, Martin. *The First World War: A Complete History.* New York: Holt, 2004.

Göhringer, Walter, and Herbert Hasenmayer. *Zeitgeschichte.* Vienna: Hirt-Verlag, 1979.

Harclerode, Peter, and Brendan Pittaway. *The Lost Masters: The Looting of Europe's Treasurehouses.* London: Gollancz, 1999.

Hartt, Frederick. *Florentine Art Under Fire.* Princeton, NJ: Princeton University Press, 1949.

Hasse, Günther. *Kunstraub und Kunstschutz.* Norderstedt, Germany: Satz, Herstellung, 2008.

Howe, Thomas C. *Salt Mines and Castles: The Discovery and Restitutions of Looted European Art.* New York: Bobbs-Merrill, 1946.

Hugh Smyth, Craig. *Repatriation of Art from the Collecting Point in Munich After World War II.* New York: Abner Schram, 1989.

Kammerstätter, Peter. *Material-Sammlung über die Widerstands und Partisanenbewegung Willy-Fred im oberen Salzkammergut-Ausseerland 1943–1945.* Linz: Eigenverlag, 1978.

Kirstein, Lincoln. *The Poems of Lincoln Kirstein.* New York: Atheneum, 1987.

———. *Rhymes of a PFC.* New York: New Directions, 1964.

Kubin, Ernst. *Sonderauftrag Linz.* Vienna: ORAC, 1989.

Kurtz, Michael J. *America and the Return of Nazi Contraband: The Recovery of Europe's Art Treasures.* Cambridge: Cambridge University Press, 2006.

Leckie, Bill. "Special Duties of the 148 Squadron." *Military Illustrated* (April 2002).

Lipkes, Jeff. *Rehearsals: The German Army in Belgium, August 1914*. Leuven, Belgium: Leuven University Press, 2007.

Luza, Radomir. *Resistance in Austria, 1938–1945*. Minneapolis: University of Minnesota Press, 1984.

Mackenzie, William. *The Secret History of S.O.E.: Special Operations Executive 1940–1945*. London: St. Ermin's, 2000.

McIsaac, Peter M. *Museums of the Mind: German Modernity and the Dynamics of Collecting*. State College: Pennsylvania State University Press, 2008.

Melden, Otto. *Der Ruf des Gewissens. Der österreichische Freiheitskampf 1938–1945*. Vienna: Herold, 1958.

Michel, Hermann. *Bergungsmaßnahmen und Widerstandsbewegung*. Vol. 56. Vienna: Annalen des Naturhistorischen Museums, 1948.

Mihan, George. *Looted Treasure: Germany's Raid on Art*. London: Alliance, 1942.

Nicholas, Lynn H. *The Rape of Europa: The Fate of Europe's Art Treasures in the Third Reich and the Second World War*. New York: Vintage, 1995.

Ohlsen, Manfred. *Wilhelm von Bode: Zwishcen Kaisermacht und Kunsttempel*. Berlin: Gebr. Mann, 2007.

ORF-Nachlese (Vienna) 2 (1983).

Petropoulos, Jonathan. *Art as Politics in the Third Reich*. Chapel Hill: University of North Carolina Press, 1996.

———. *The Faustian Bargain: The Art World in Nazi Germany*. Oxford: Oxford University Press, 2000.

Pichler, Cathrin, and Roman Berka. *TransAct: Transnational Activities in the Cultural Field*. New York: Springer, 2010.

Plieseis, Sepp. *Vom Ebro zum Dachstein: Lebenskampf eines österreichischen Arbeiters*. Linz: Neue Zeit, 1946.

Pöchmüller, Emmerich. *Weltkunstschätze in Gefahr*. Salzburg: Pallas-Verlag, 1948.

Rayssac, Michel. *L'Exode des Musées: Histoire des Oeuvres d'Art Sous l'Occupation*. Paris: Editions Payot et Rivages, 2007.

Reder, Christian. "Im Salzberwerk." *Falter Verlag* (Vienna) 1 (1985).

Red-White-Red-Book: Justice for Austria. Vienna: Austrian State Printing House, 1947.

Rorimer, James. *Survival: The Salvage and Protection of Art in War*. New York: Abelard Press, 1950.

Shirer, William. *The Rise and Fall of the Third Reich*. London: Book Club, 1983.

Simon, Matila. *The Battle of the Louvre: The Struggle to Save French Art in World War II*. New York: Hawthorne, 1971.

Slapnicka, Harry. *Oberösterreich als es "Oberdonau" hieß (1938–1945)*. Linz: OÖ Landesverlag, 1978.

Topf, Christian. *Auf den Spuren der Partisanen, Zeitgeschichtliche Wanderungen im Salzkammergut*. Edition Geschichte der Heimat. 3rd ed. Grünbach, Germany: Franz Steinmassl, 2006.

Treue, Wilhelm. *Art Plunder*. London: Methuen, 1960.

Valland, Rose. *Le Front de l'Art: 1939–1945*. Paris: Librairie Plon, 1961.

Warmbrunn, Werner. *The German Occupation of Belgium 1940–1944*. New York: Peter Lang, 1993.

Witte, Els, Jan Craeybeckx, and Alain Meynen. *Political History of Belgium from 1830 Onwards*. Brussels: VUB Brussels University Press, 2000.

Woolley, Sir Leonard. *A Record of the Work Done by the Military Authorities for the Protection of the Treasures of Art and History in War Areas*. London: HMSO, 1947.

Yeide, Nancy. *Beyond the Dreams of Avarice: The Hermann Göring Collection*. Dallas: Laurel, 2009.

WEBSITES

The Adoration of the Mystic Lamb: The Theft of the Just Judges. http://judges.mysticlamb.net.

Bernauws Blog. http://www.bernauw.com.

SeuRRsite: Rechtvaardige Rechters by ErDaSys. http://speurrsite.erdasys.com.

Vilain: Het Lam Gods, bekeken door een Wetteraar. http://www.rechtvaar digerechters.nl/home.htm.

Vissers, Johan. Dossier Rechtvaardige Rechters. http://users.kbc.skynet.be.

ILLUSTRATION CREDITS

Royal Institute for Cultural Heritage, Brussels (top) 06

© Lukas-Art in Flanders VZW (bottom) 06

© Lukas-Art in Flanders VZW (top) 07

© Lukas-Art in Flanders VZW (bottom) 07

© Lukas-Art in Flanders VZW (top) 08

© Lukas-Art in Flanders VZW (bottom) 08

INDEX

Noah Charney is the author of the international bestselling novel *The Art Thief* and the founding director of The Association for Research into Crimes against Art, an international nonprofit think tank. His work in the field of art crime has been praised in such forums as *The New York Times* Magazine, *Time* Magazine, *Vanity Fair*, *Vogue*, *BBC Radio*, and *NPR*. Currently a professor of art history at the American University of Rome, he lives in Italy with his wife and Hubert van Eyck, their Peruvian Hairless.